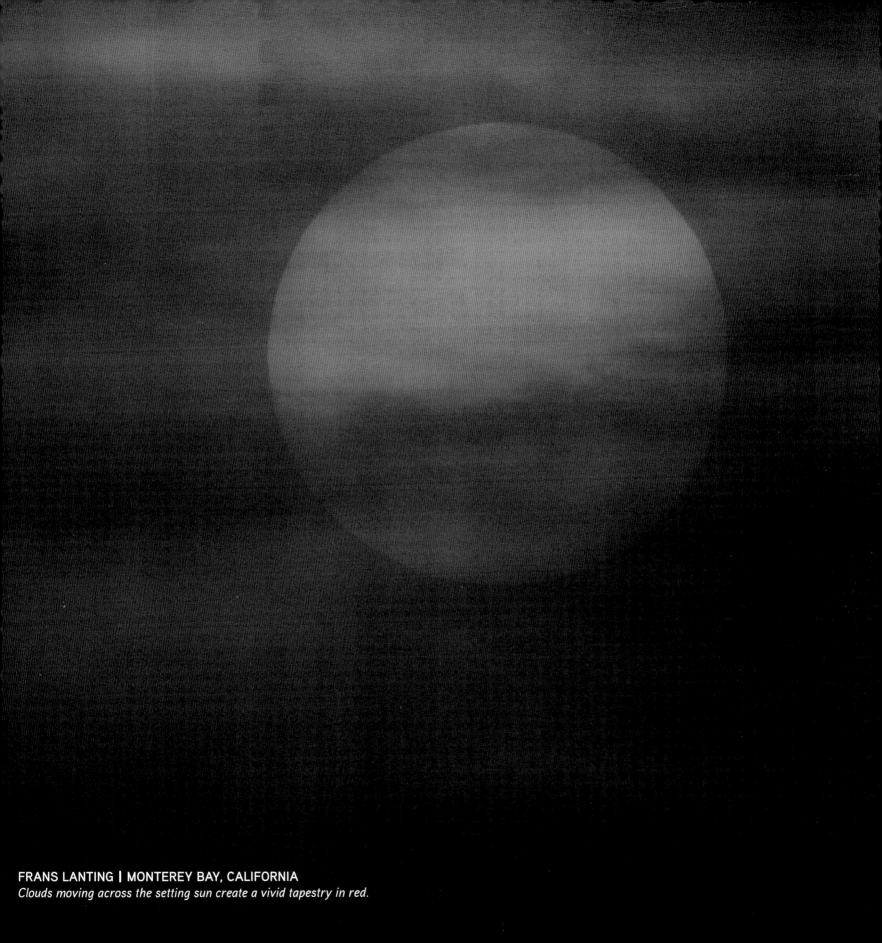

FRANS LANTING | MONTEREY BAY, CALIFORNIA
Clouds moving across the setting sun create a vivid tapestry in red.

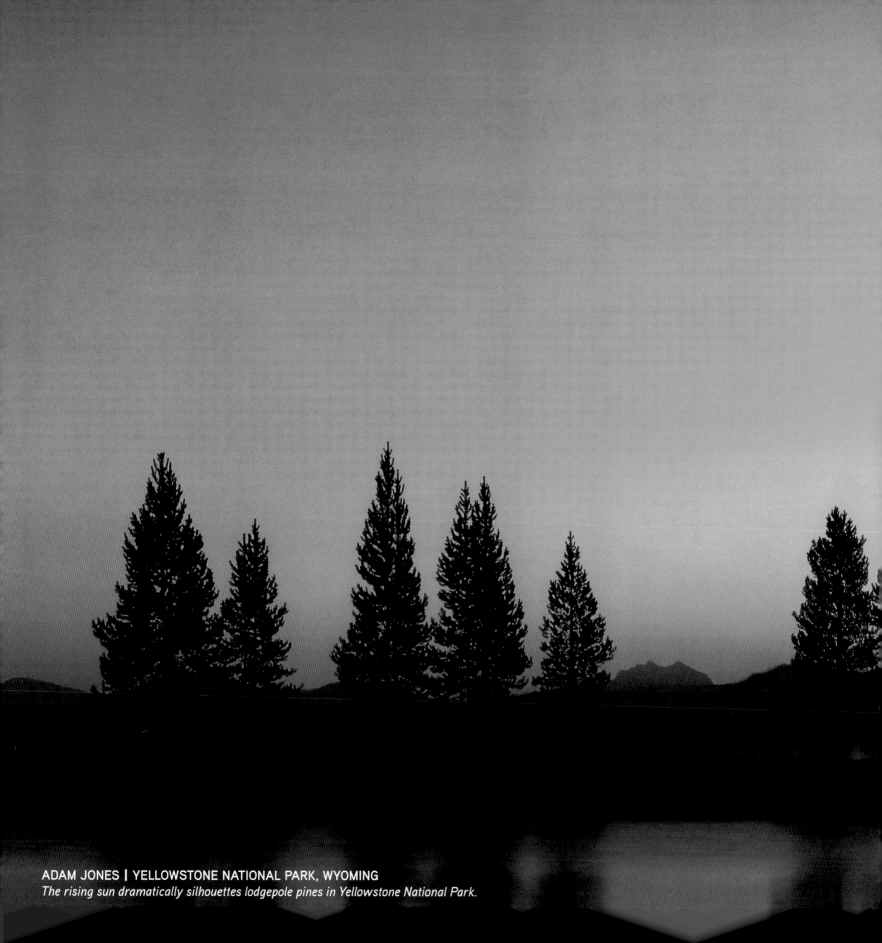

ADAM JONES | YELLOWSTONE NATIONAL PARK, WYOMING
The rising sun dramatically silhouettes lodgepole pines in Yellowstone National Park.

DAWN TO DARK
PHOTOGRAPHS
THE MAGIC OF LIGHT

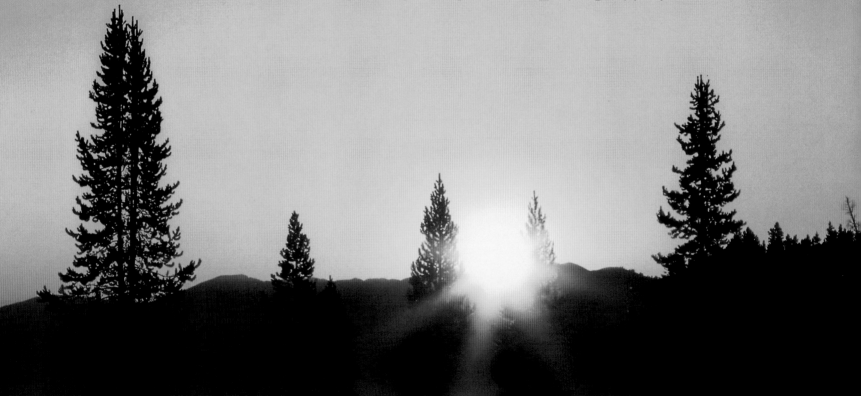

NATIONAL GEOGRAPHIC
Washington, D.C.

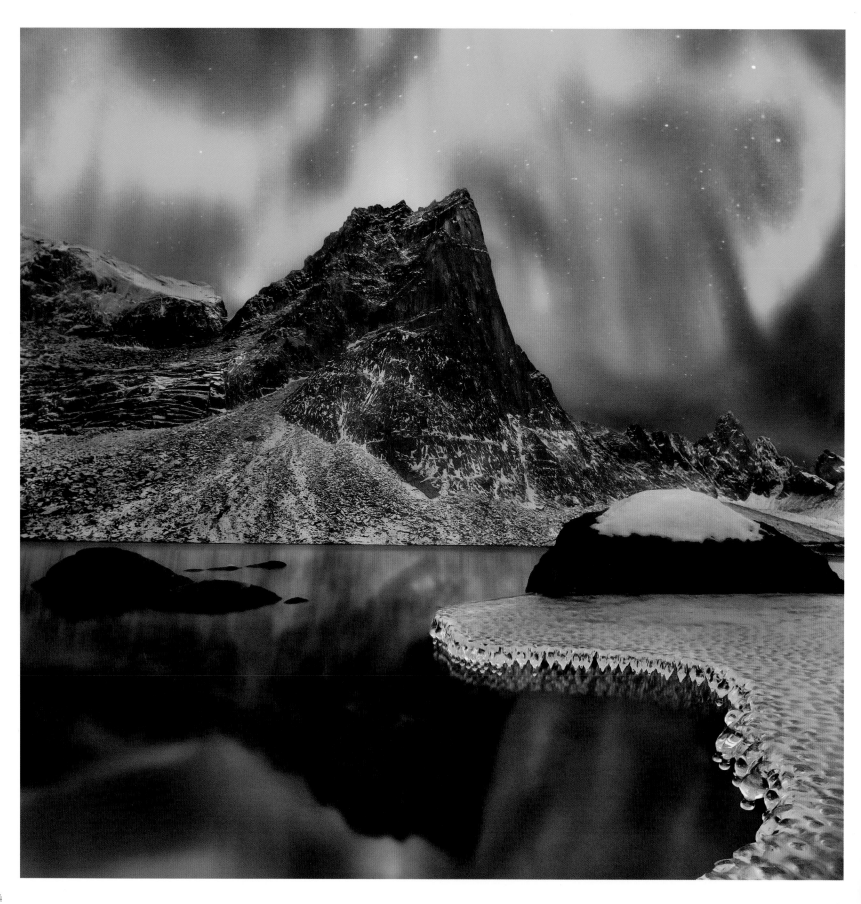

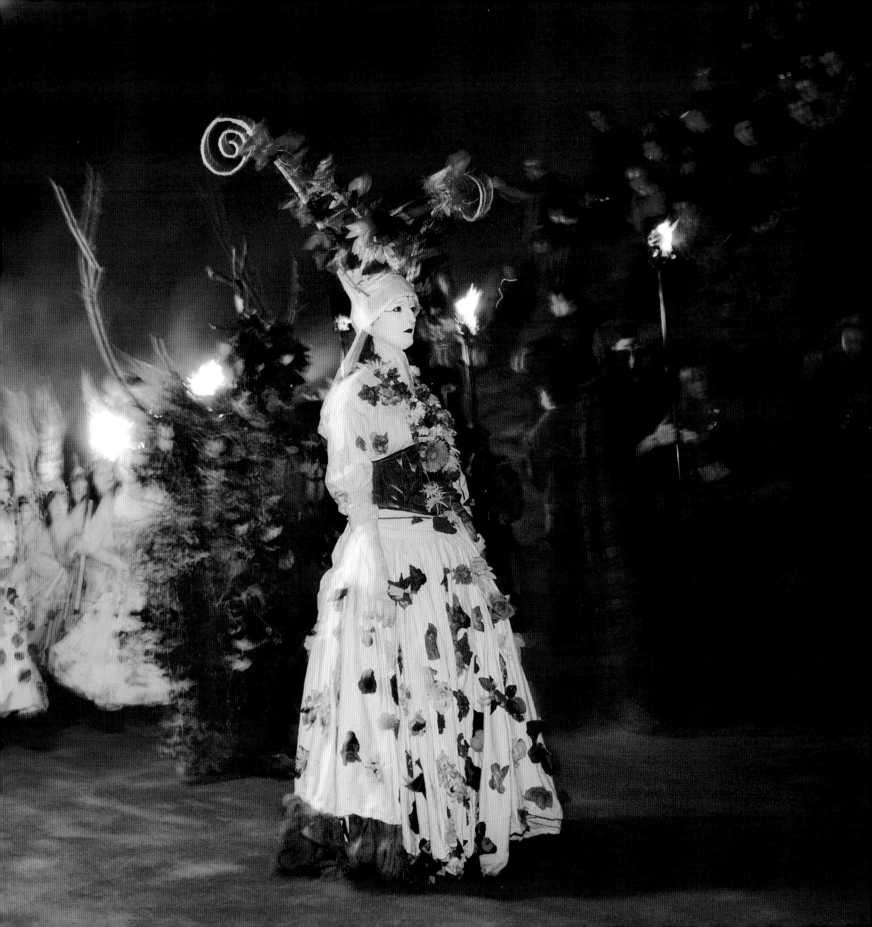

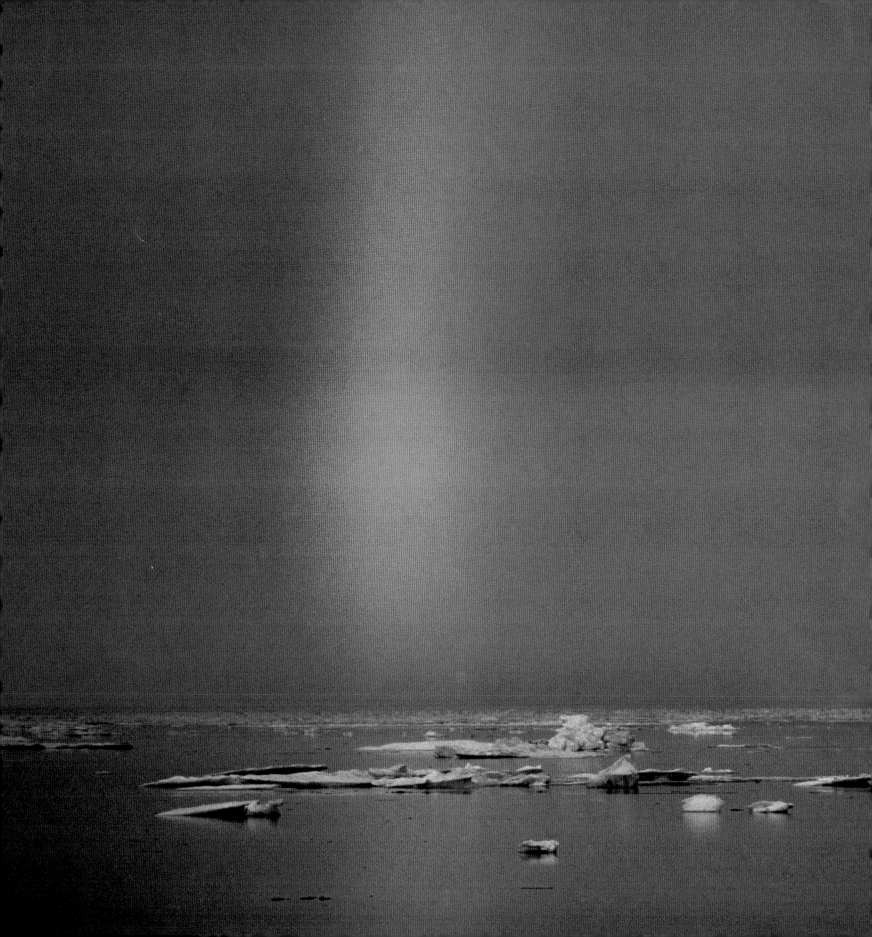

PAUL NICKLEN | NUNAVUT, NORTHWEST TERRITORIES, CANADA

The arc of a fogbow, similar to a rainbow, glows with a bright orange-red light over the Arctic Ocean. The fogbow's smaller droplets help create an otherworldly scene.

ILLUSTRATIONS CREDITS

DAWN TO DARK PHOTOGRAPHS

SUSAN T. HITCHCOCK AND JIM RICHARDSON

Published by the National Geographic Society

John M. Fahey, *Chairman of the Board and Chief Executive Officer*

Declan Moore, *Executive Vice President; President, Publishing and Travel*

Melina Gerosa Bellows, *Executive Vice President; Chief Creative Officer, Books, Kids, and Family*

Prepared by the Book Division

Hector Sierra, *Senior Vice President and General Manager*

Janet Goldstein, *Senior Vice President and Editorial Director*

Jonathan Halling, *Design Director, Books and Children's Publishing*

Marianne R. Koszorus, *Design Director, Books*

Hilary Black, *Senior Editor*

R. Gary Colbert, *Production Director*

Jennifer A. Thornton, *Director of Managing Editorial*

Susan S. Blair, *Director of Photography*

Staff for This Book

Gail Spilsbury, *Project Editor, Text Editor*

Meredith C. Wilcox, *Illustrations Editor*

Melissa Farris, *Art Director*

Michelle Harris, *Contributing Writer*

Marshall Kiker, *Associate Managing Editor*

Judith Klein, *Production Editor*

Mike Horenstein, *Production Manager*

Katie Olsen, *Production Design Assistant*

Manufacturing and Quality Management

Phillip L. Schlosser, *Senior Vice President*

Chris Brown, *Vice President, NG Book Manufacturing*

George Bounelis, *Vice President, Production Services*

Nicole Elliott, *Manager*

Rachel Faulise, *Manager*

Robert L. Barr, *Manager*

CELEBRATING 125 YEARS

The National Geographic Society is one of the world's largest nonprofit scientific and educational organizations. Founded in 1888 to "increase and diffuse geographic knowledge," the Society's mission is to inspire people to care about the planet. It reaches more than 400 million people worldwide each month through its official journal, *National Geographic,* and other magazines; National Geographic Channel; television documentaries; music; radio; films; books; DVDs; maps; exhibitions; live events; school publishing programs; interactive media; and merchandise. National Geographic has funded more than 10,000 scientific research, conservation and exploration projects and supports an education program promoting geographic literacy. For more information, visit www.nationalgeographic.com.

For more information, please call 1-800-NGS LINE (647-5463) or write to the following address:

National Geographic Society
1145 17th Street N.W.
Washington, D.C. 20036-4688 U.S.A.

For information about special discounts for bulk purchases, please contact National Geographic Books Special Sales: ngspecsales@ngs.org

For rights or permissions inquiries, please contact National Geographic Books Subsidiary Rights: ngbookrights@ngs.org

To Purchase Prints
High-quality prints of many of the spectacular photographs featured in this book can be ordered for your personal enjoyment at www.PrintsNGS.com. To see if your favorite image is available, please visit our site and click on the gallery entitled "Dawn to Dark." Ordering instructions and our everyday low prices can be found on the site.

Professional Photo Buyers
Most of the photographs in this book are available for editorial and creative licensing. For details please visit www.NationalGeographicStock.com.

Library of Congress Cataloging-in-Publication Data
National Geographic dawn to dark photographs : the magic of light / preface by Jim Richardson ; text by Susan Tyler Hitchcock.
 pages cm
 ISBN 978-1-4262-1179-9 (hardback)
 1. Landscape photography. 2. Day. I. Hitchcock, Susan Tyler. II. National Geographic Society (U.S.) III. Title: Dawn to dark photographs. IV. Title: Magic of light.
 TR660.5.N368 2013
 779.36--dc23
 2013001847

Printed in China

13/RRDS/1

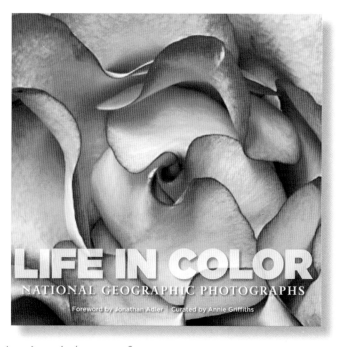
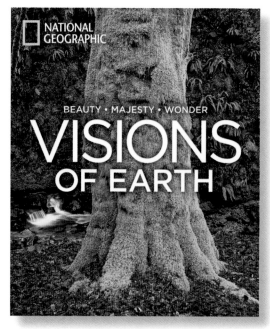

CONTENTS

MARC ADAMUS | TOMBSTONE MOUNTAINS, YUKON TERRITORY, CANADA *Ice formations on the shore of a wilderness lake deep in the mountains of the northern Yukon catch the glow of a vibrant aurora display.*

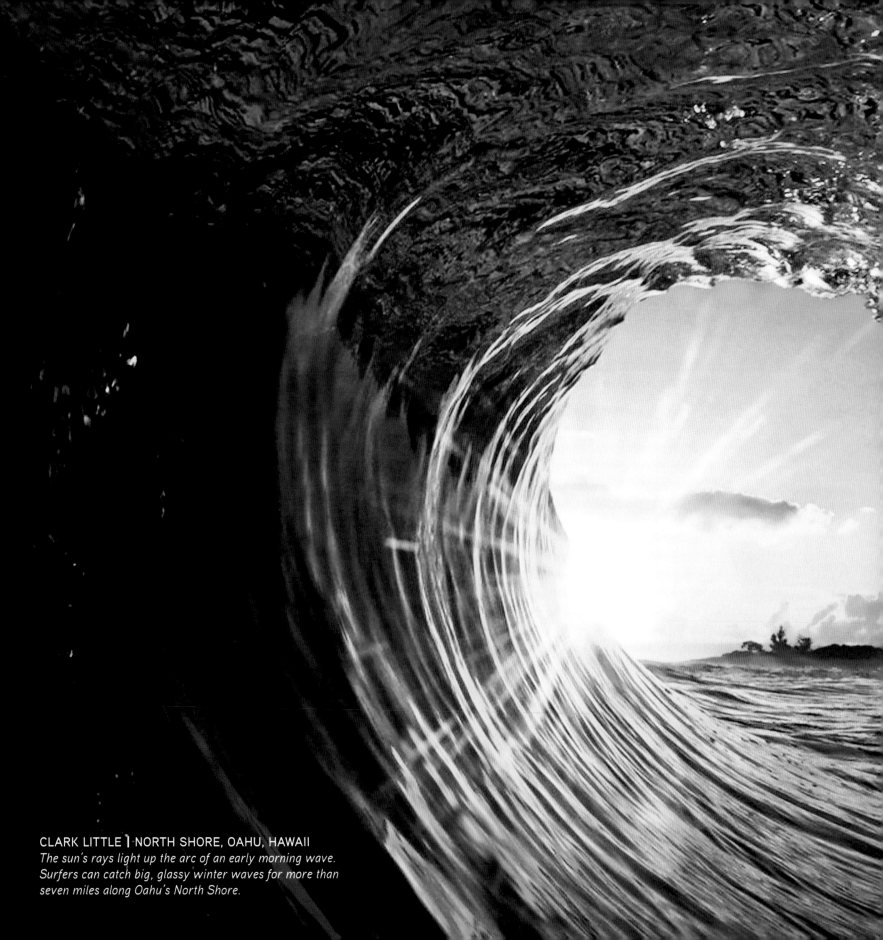

CLARK LITTLE | NORTH SHORE, OAHU, HAWAII
The sun's rays light up the arc of an early morning wave. Surfers can catch big, glassy winter waves for more than seven miles along Oahu's North Shore.

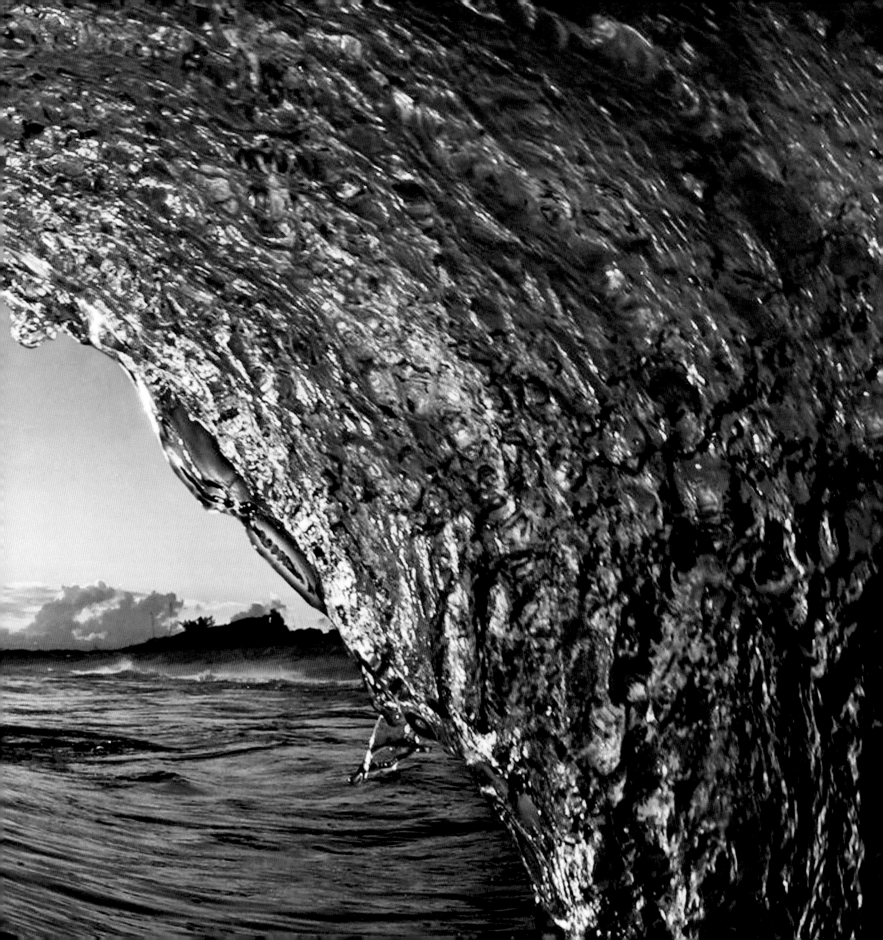

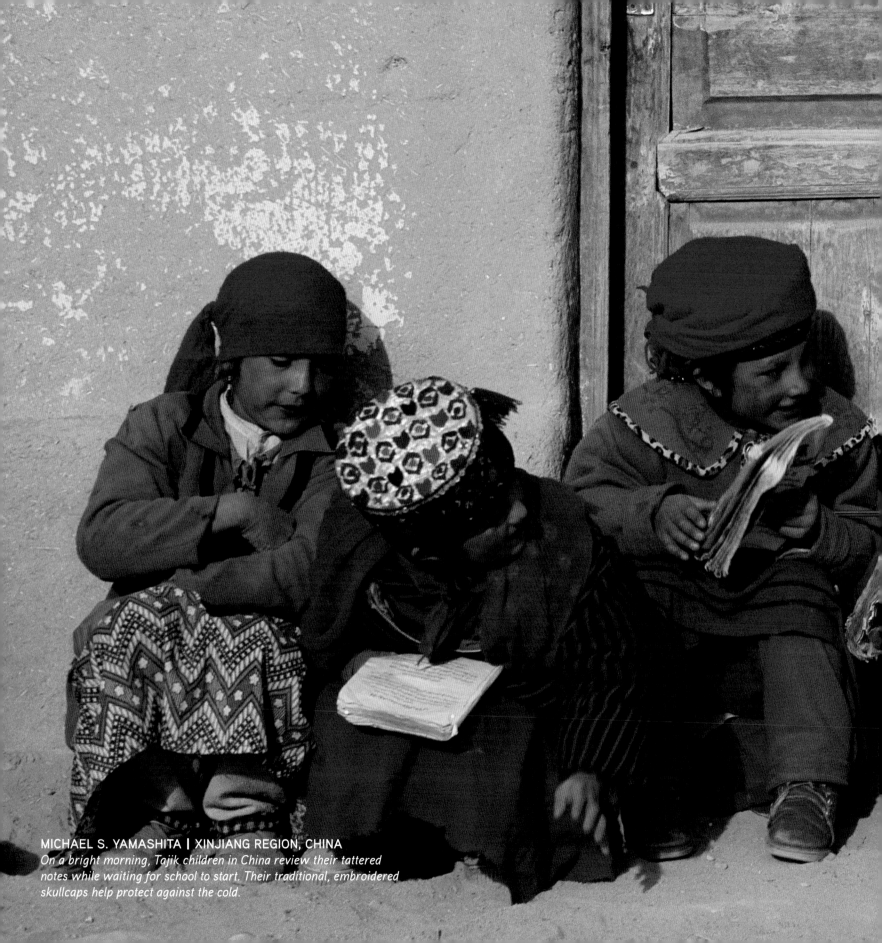

MICHAEL S. YAMASHITA | XINJIANG REGION, CHINA
*On a bright morning, Tajik children in China review their tattered
notes while waiting for school to start. Their traditional, embroidered
skullcaps help protect against the cold.*

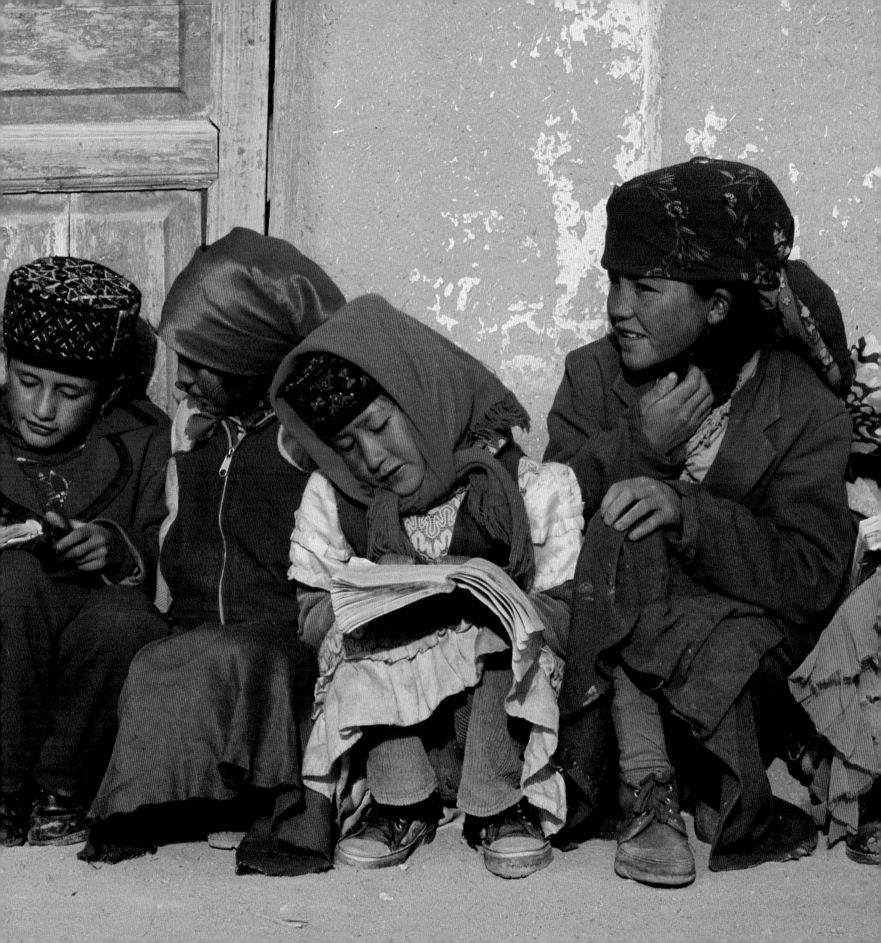

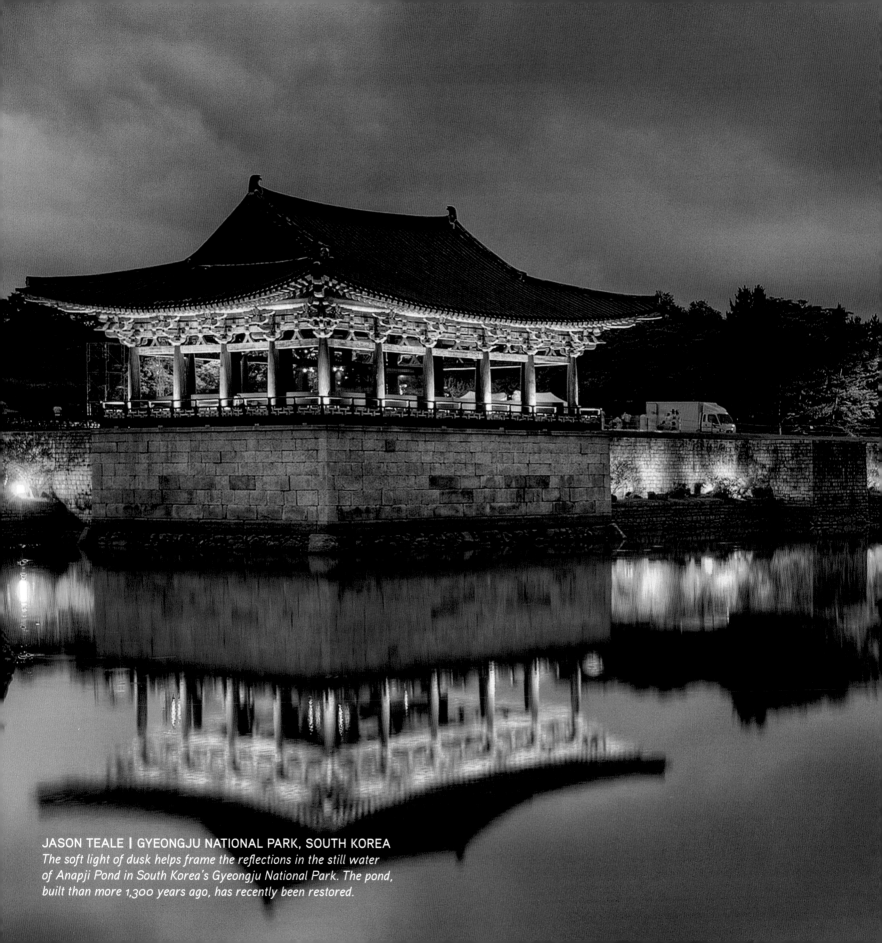

JASON TEALE | GYEONGJU NATIONAL PARK, SOUTH KOREA
The soft light of dusk helps frame the reflections in the still water
of Anapji Pond in South Korea's Gyeongju National Park. The pond,
built than more 1,300 years ago, has recently been restored.

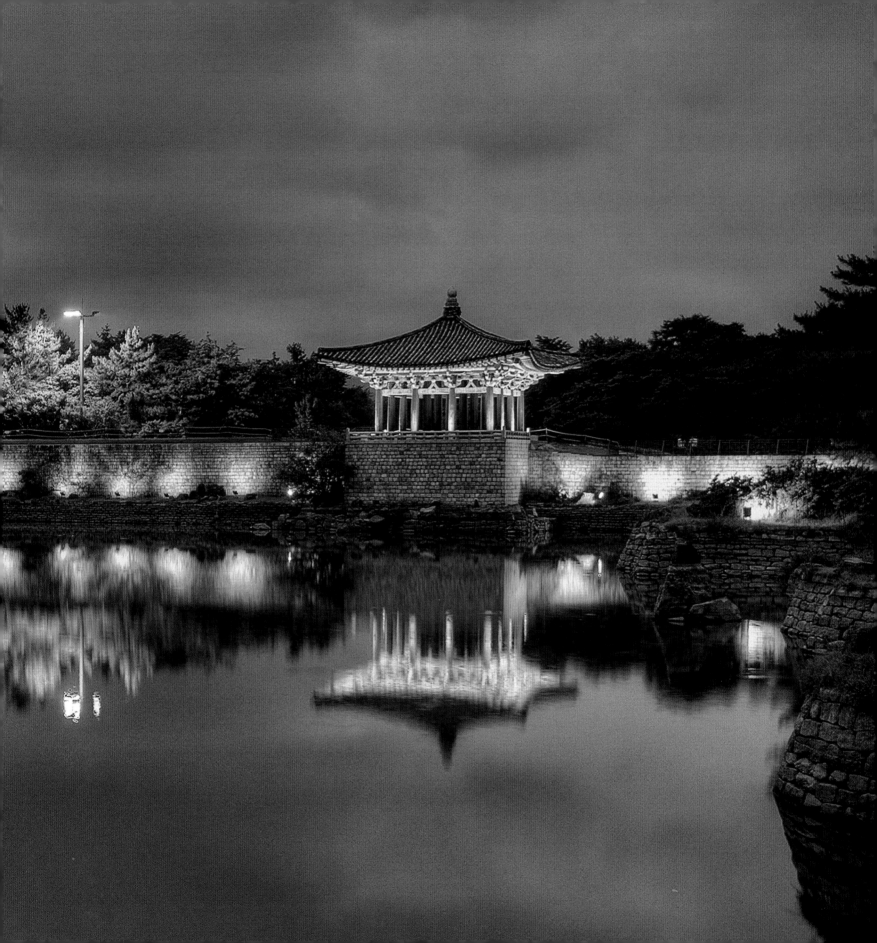

STEVE WINTER | HUAI KHA KHAENG WILDLIFE SANCTUARY, THAILAND
Caught by a remotely triggered camera, an Indochinese tiger hunts under a cloak of darkness. Camera traps help keep tabs on these endangered cats.

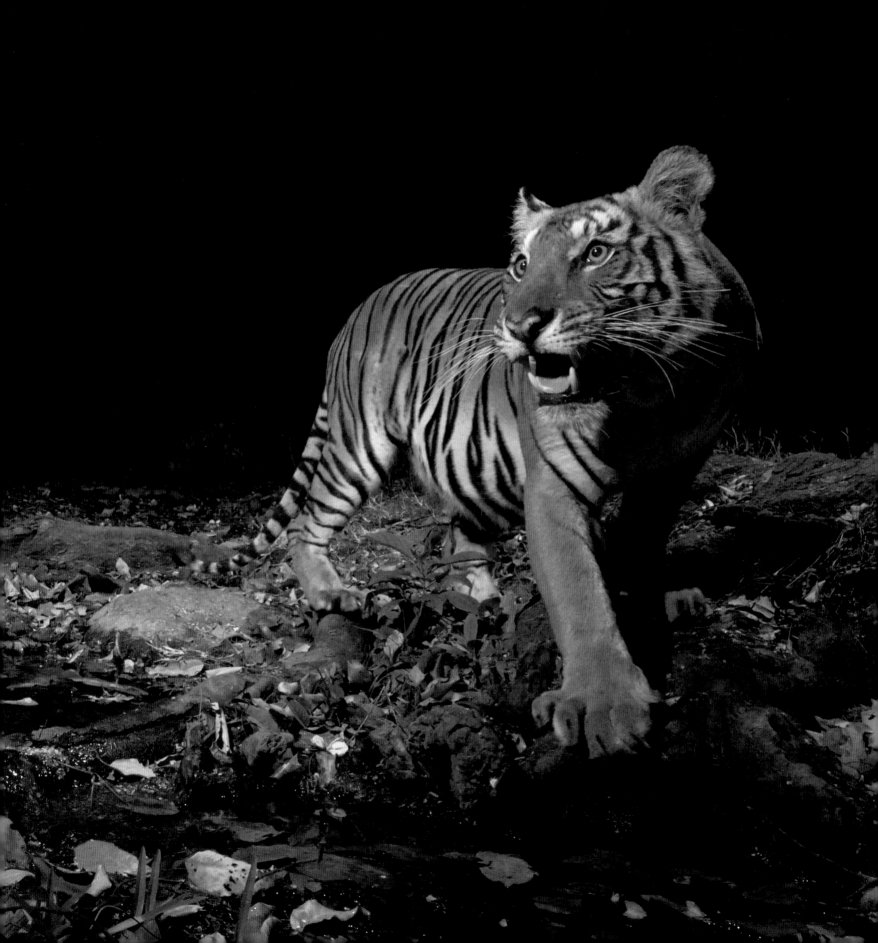

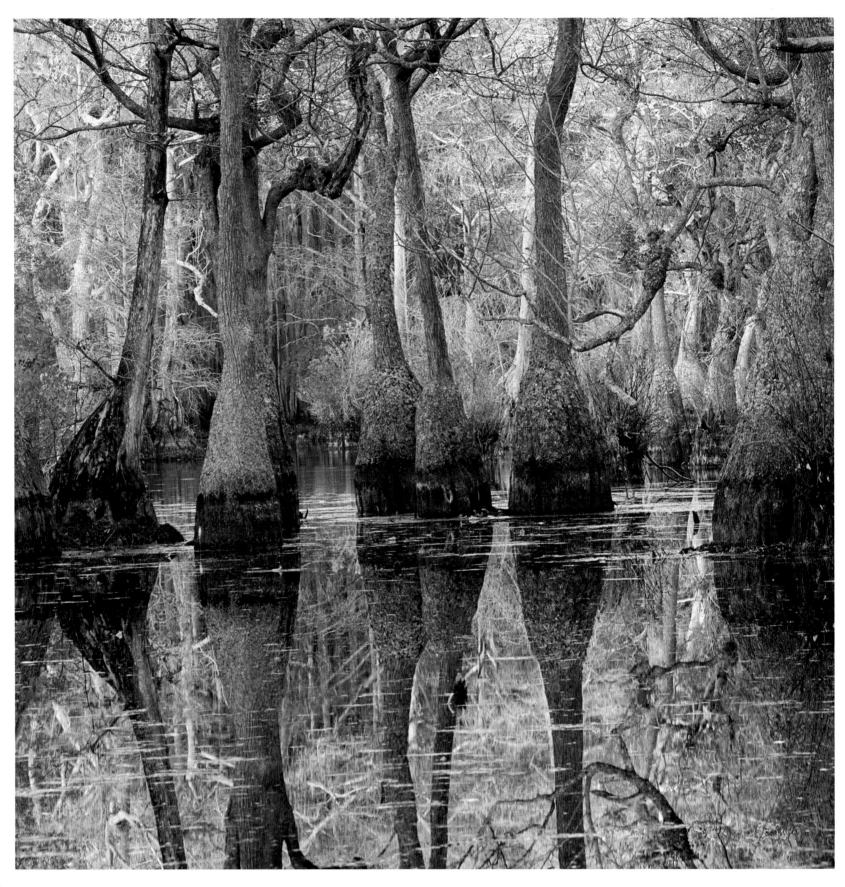

Light makes photography. Embrace light. Admire it. Love it. But above all, know light. Know it for all you are worth, and you will know the key to photography.

-GEORGE EASTMAN

George Eastman captures it so well: Photography is always about the light, no matter what the subject. *National Geographic Dawn to Dark Photographs* uses light—this first and primary tool of photography—as its organizing structure, following the sun's arc from daybreak to night. This stunning collection of images celebrates the power of light to transform a landscape, inspire awe, create mystery, or evoke a nostalgic memory. Medford Taylor's fantastical masterpiece (opposite page) blends light and reflection and belongs in a fairy tale. Stephen Alvarez (pages 140–141) astonishes us with his image of a lone individual dangling from a rope in a deep, vast, cave, illuminated by a column of light. We are part of a meeting of two worlds: light and dark, above and below. And Jim Richardson's expert use of light (pages 342–343) transports us back to summer evenings in childhood when fireflies sparkled above a field.

It was magic when we first saw them. And it was—and still is—the magic of light.

MEDFORD TAYLOR | MERCHANTS MILLPOND STATE PARK, NORTH CAROLINA
Sunlight in a cypress swamp creates reflections.

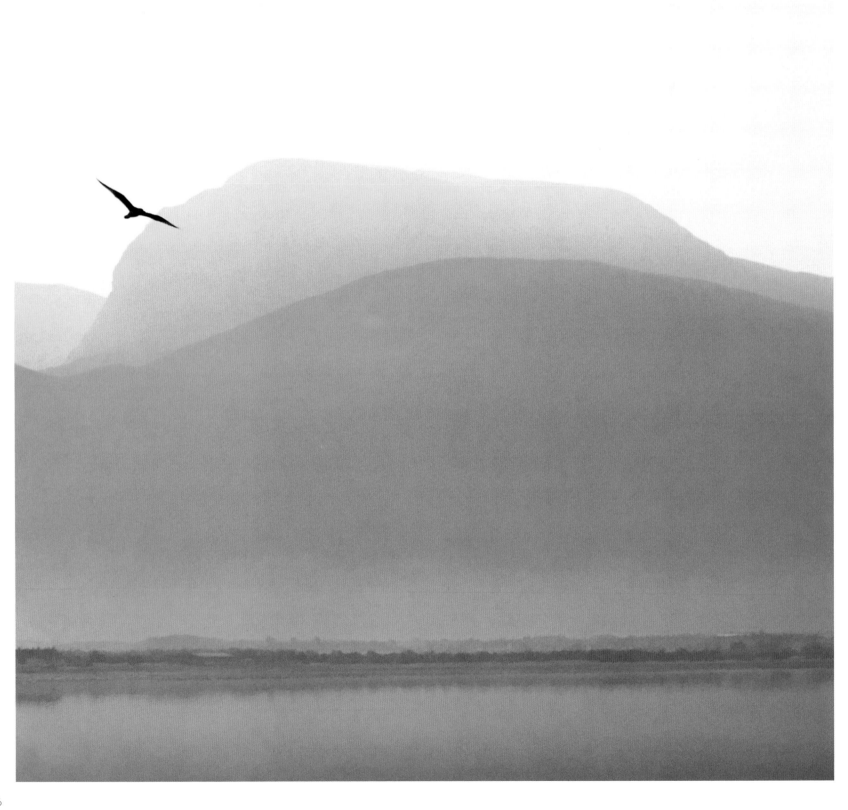

AS I REFLECT ON THE PHOTOGRAPHS IN THIS BOOK,

the dawn is just breaking outside my window. In the dimness, the sun is lurking, waiting for the Earth to turn and bring us once again into its warmth, to transform the night into another day, to make the moments of this world beautiful. We are locked in a cosmic waltz with time, our planet, and our sun.

From that simple bit of planetary geometry—our star, our orbit, the tilt, the spin, the light— comes everything: the sunsets and the seasons, the energy and bustle of mornings, the longings and melancholy of afternoons, the poetry of twilight, the secrets of night.

The years, the days, and the hours mark the passages of our lives—but we live in the moments. This book is full of such moments, caught in breathtaking photographs by talented National Geographic photographers. Gifts of seeing from our hearts and souls, transported across time, these images are bits of creation held still.

Photographs often resemble meditations. Medieval monks used the Book of Hours to measure their days, its pages beautifully illuminated. And so are these. *Dawn to Dark* is a rare collection of stunning scenery, natural life, and real-world moments. In such a singular visual journey we are given a chance to muse on the miracle of light and appreciate its infinite and astonishing variety. No wonder we feel a certain serenity when we pause—as these photographs ask us to pause—to think the thoughts of our ancestors, who linger just there in the gloaming.

As you turn the last page in this book and return to this moment, this hour, this day—when you reenter the swirl of the cosmic waltz—I hope you may do so with a lighter step and a flourish of your own to add to our dance.

JIM RICHARDSON | SCOTTISH HIGHLANDS, SCOTLAND *Morning comes to Ben Nevis, the highest mountain in the British Isles. "It was a beautifully still morning," says Richardson, "and I waited forever for that bird to come by."*

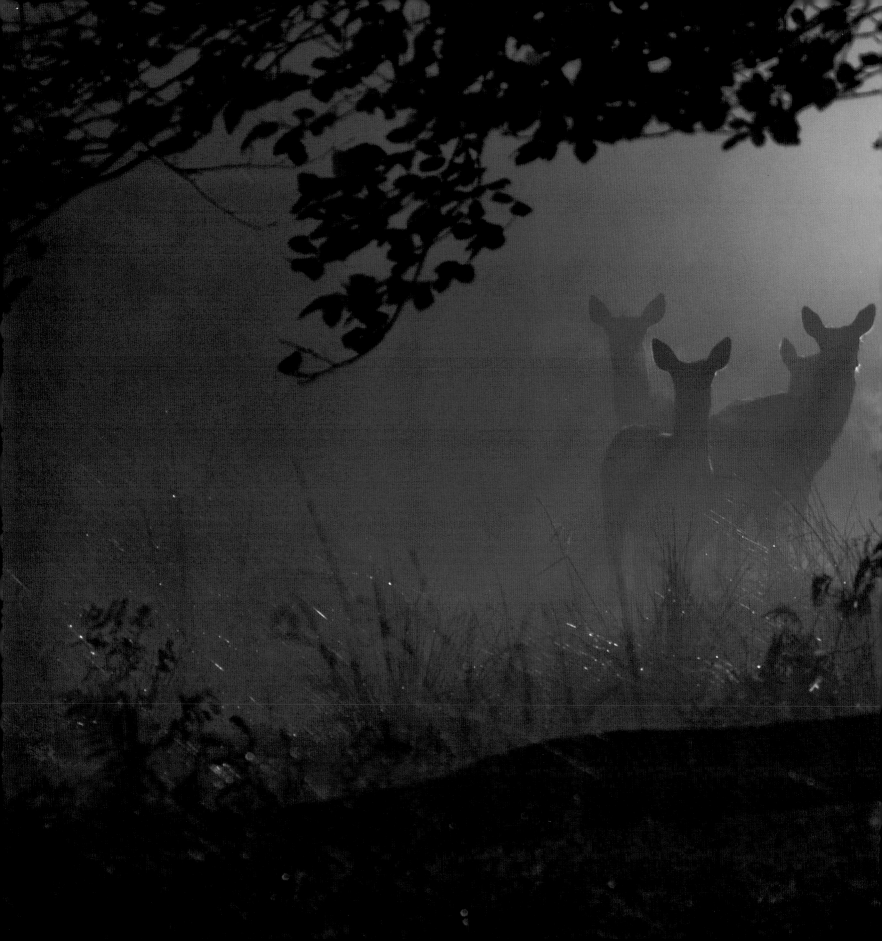

DAWN

ALEX SABERI | LONDON, ENGLAND

*Red deer gather on a misty morning in Richmond Park, London.
Deer have been grazing this parkland since 1529, which helps
keep London's largest enclosed space open.*

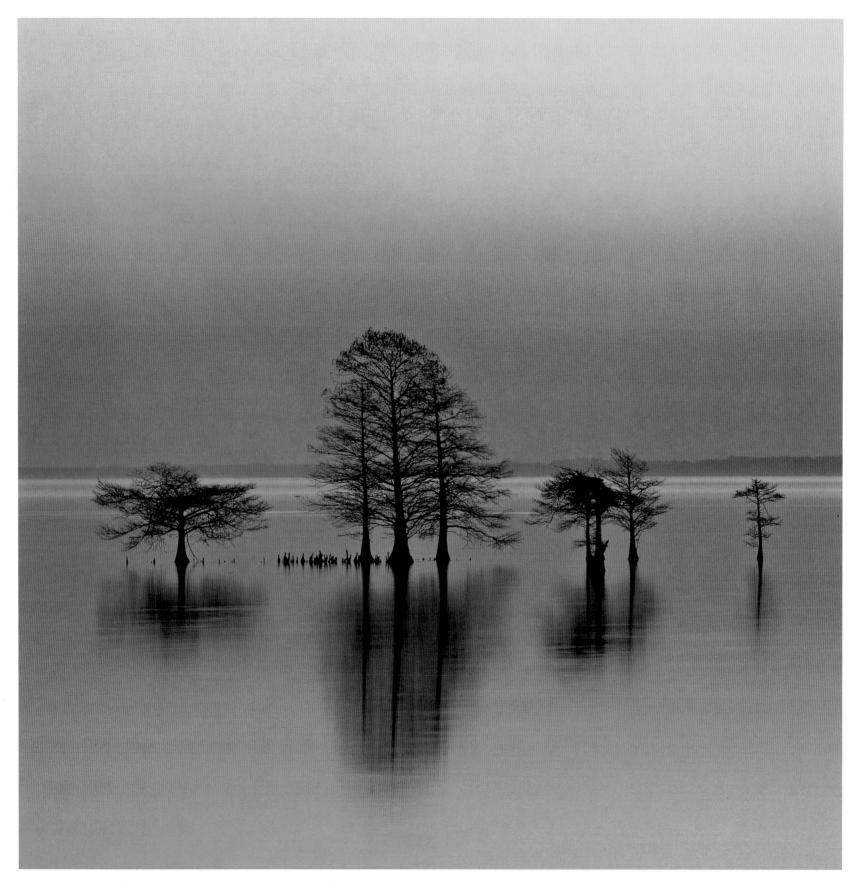

WE DREAM THE DAY

is beginning. A gauzy glow finds its way up the sky. First dawn arrives so quietly, one can hardly call it light. The glow grows. Things assume the suggestion of shape; few have hard edges. Objects still blur, melt into one another. Now present, now absent, they mingle with specters left over from the night. There is room still for mistakes and imaginings.

Dawn's soft touch is sweet and benign: beauty, harmony, anticipation. Dawn's light brings hope, not fear; comfort, not anxiety. New light, growing ever stronger, promises clearer vision, a sense of orientation, the certainty that now you can see the world again and know the way.

In the ancient Hindu tradition, the goddess Ushas embodies the dawn. Radiant and ever youthful, she wraps her body in graceful garments of red. She travels in a gleaming chariot drawn by a team of golden oxen, who sweep up and across the sky, pushing back the curtain of darkness. The brilliance of this vision fills the day with light.

Dear Ushas, protectress, help us see the dawn become the day. As first light warms, one dares to lean back, close eyes a few more hazy moments, secure and comfortable, knowing that change moves slowly and that daylight soon will come.

ROBBIE GEORGE | MATTAMUSKEET NATIONAL WILDLIFE REFUGE, NORTH CAROLINA *Silhouetted bald cypress trees cast slender shadows across Lake Mattamuskeet's rose-tinted waters. Cypress trees dot the largest natural lake in North Carolina.*

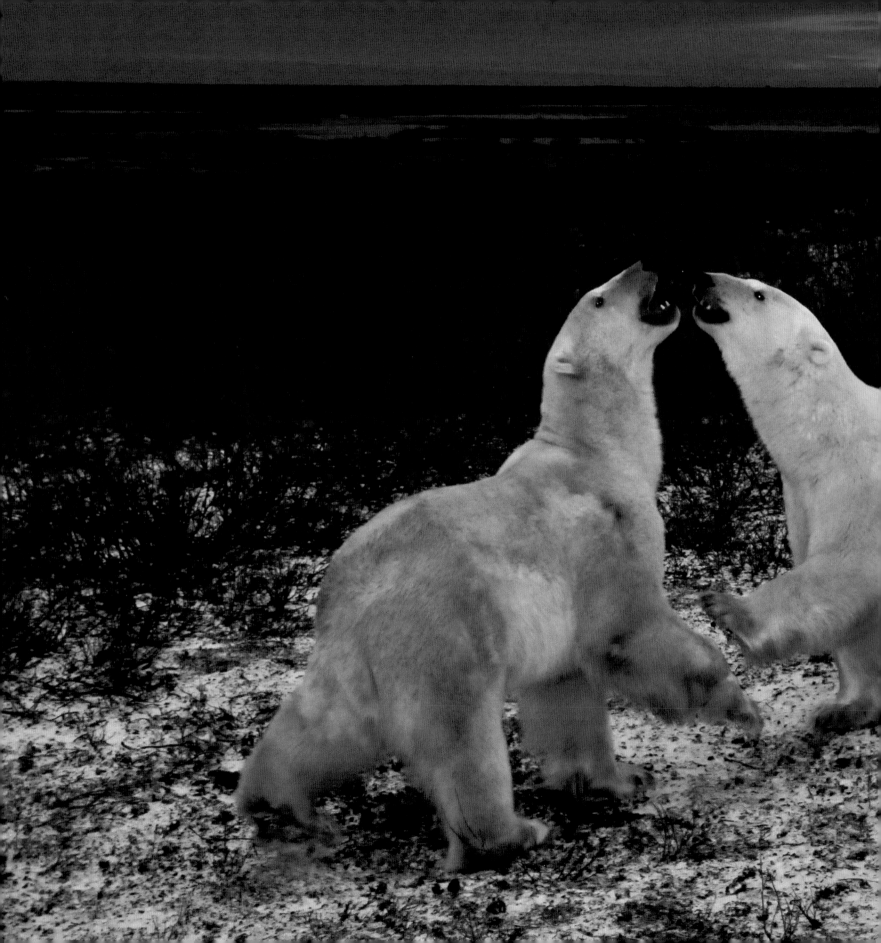

MENG HORNG | MANITOBA, CANADA
Sunrise just starts to tint the clouds pink as two polar bears begin the day tussling in a snow-blanketed field.

23

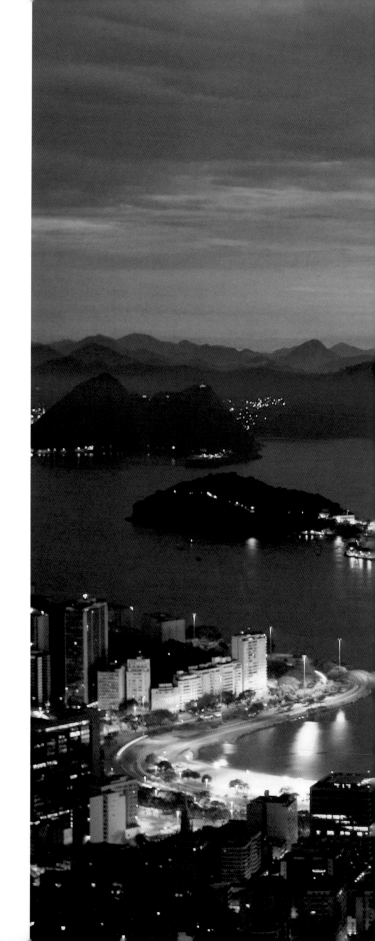

Dawn and
resurrection
are synonymous.

–VICTOR HUGO

MARCO ANTONIO TEIXEIRA | RIO DE JANEIRO, BRAZIL
*The harbor lights of Rio de Janeiro welcome the day in this view
from the hillside favela of Dona Marta.*

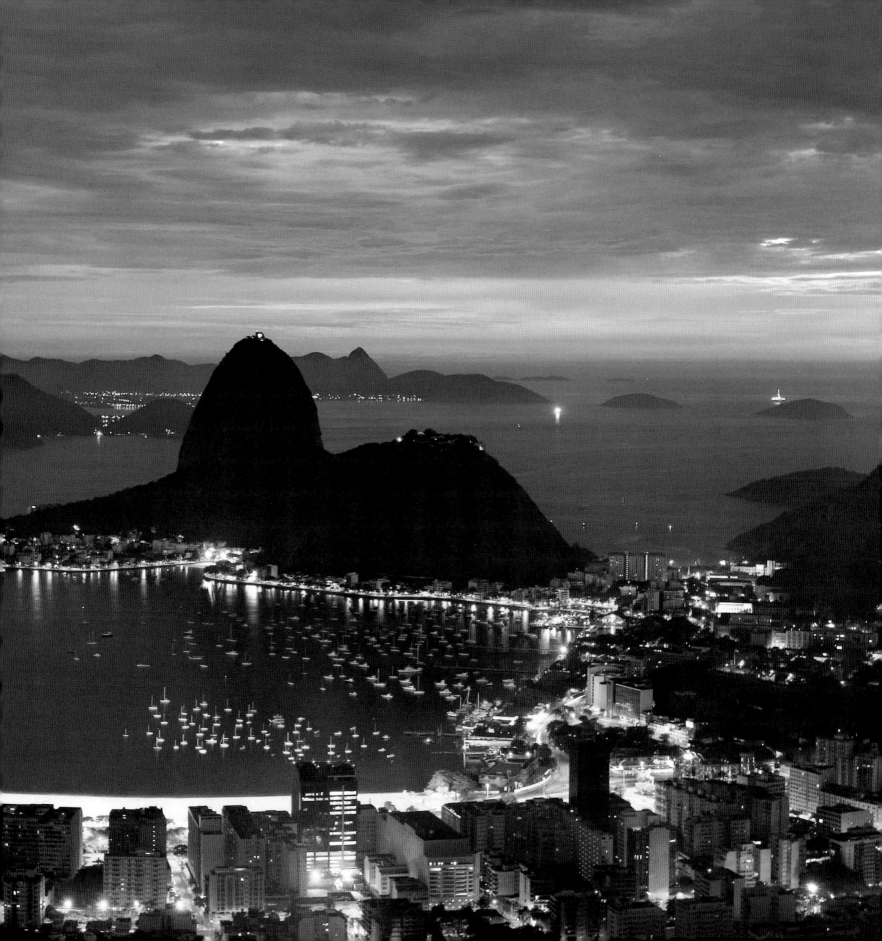

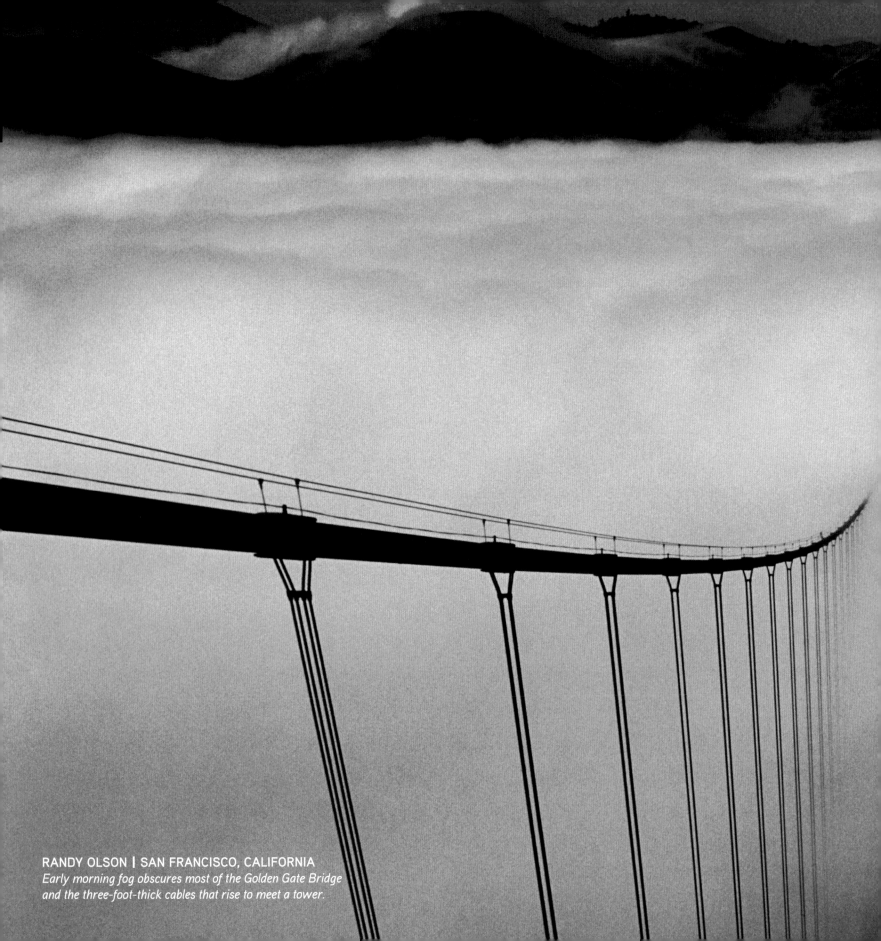

RANDY OLSON | SAN FRANCISCO, CALIFORNIA
*Early morning fog obscures most of the Golden Gate Bridge
and the three-foot-thick cables that rise to meet a tower.*

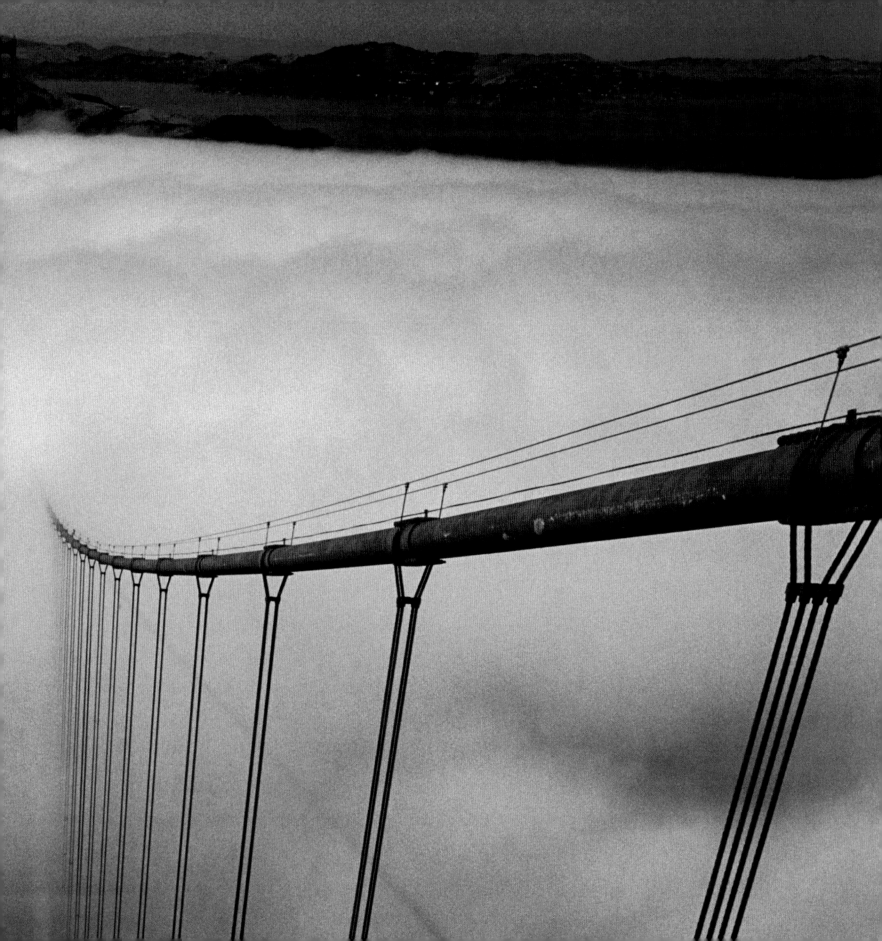

For a photographer, light is like a blessing, and in the case of this photograph—for a story on the Zambezi River—I can say in all sincerity that I was led to the light by a priest. He was a Catholic missionary in the area and told me about the Luvale circumcision ceremony for boys. With his help I was able to photograph a ceremony in a remote area along the Zambia and Angola border. The boys were shirtless; they were chanting and beating drums in the bitter cold. It was a rite of passage for them, and for me a chance to capture a vision of simple purity, touched by the light of a beautiful dawn.

CHRIS JOHNS

Zambia, Africa
Newly circumcised Luvale boys greet the dawn.

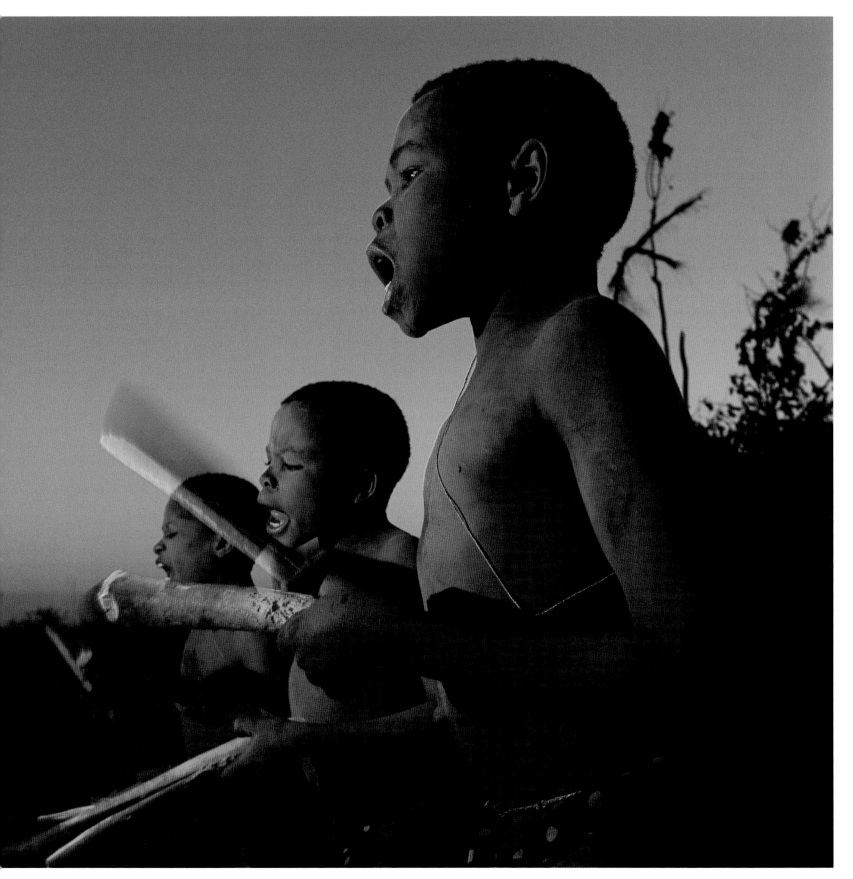

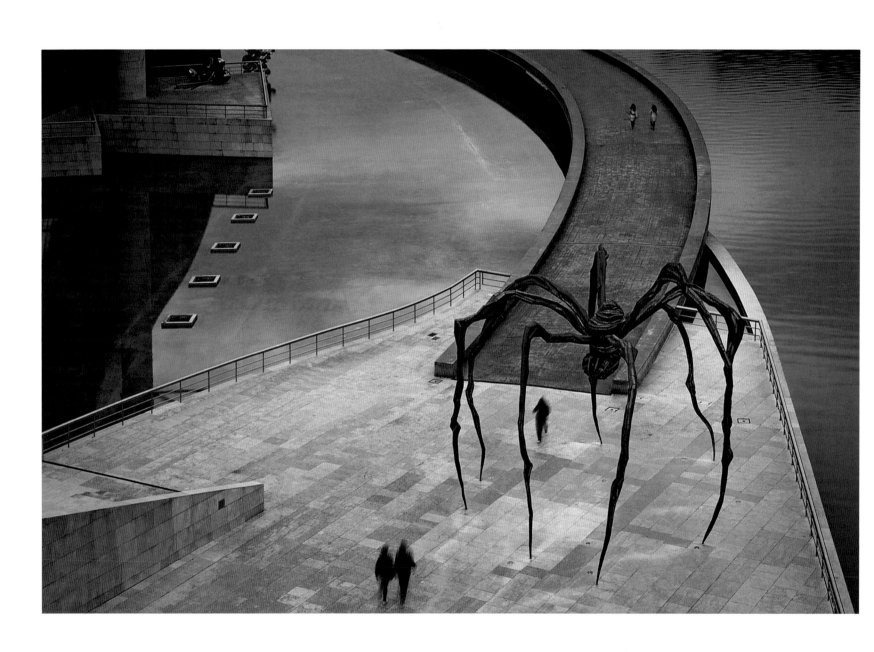

YEN BAET | BILBAO, SPAIN

Early morning walkers pass unfazed by Louise Bourgeois's giant spider, "Maman," at the Guggenheim Bilbao. The 30-foot-tall sculpture appears both fearsome and vulnerable.

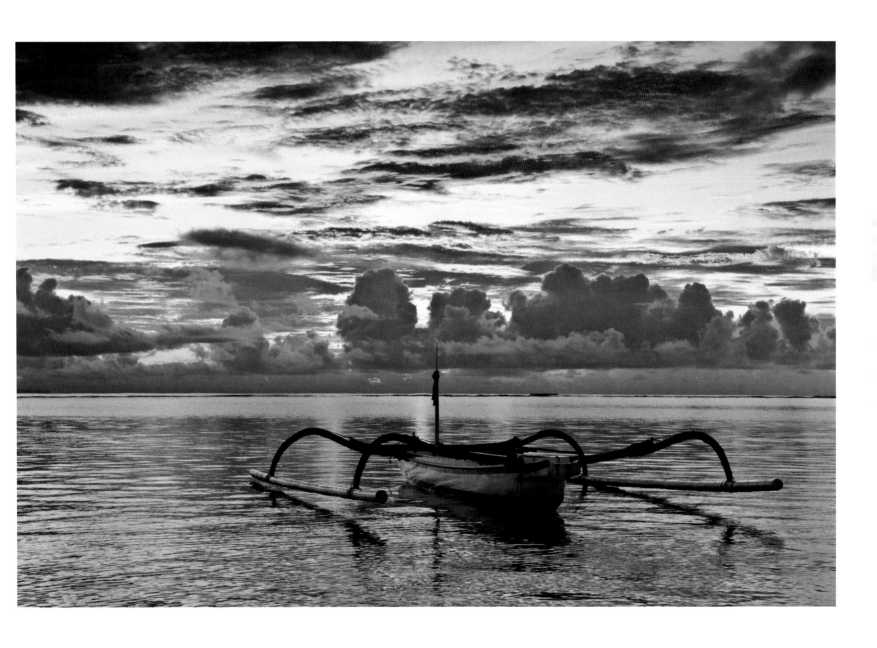

SCOTT BYCROFT | NUSA DUA, BALI
A traditional Balinese fishing boat rests on quiet waters.
Fishermen take to coastal waters for night fishing, returning
to sell their catch in the morning markets.

PHILIPPE HUGUEN | VILLERS-BRETONNEUX, FRANCE
As part of an ANZAC Day ceremony, an Australian soldier plays bagpipes during a dawn service at the Australian National Memorial in the northern French city of Villers-Bretonneux.

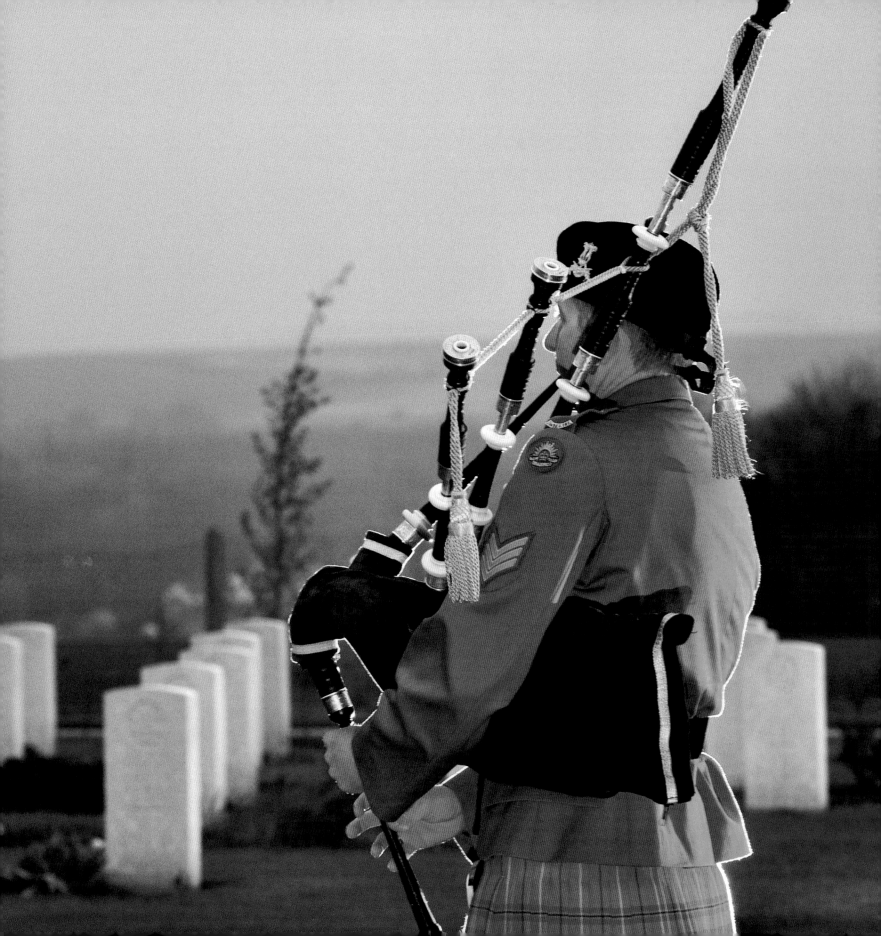

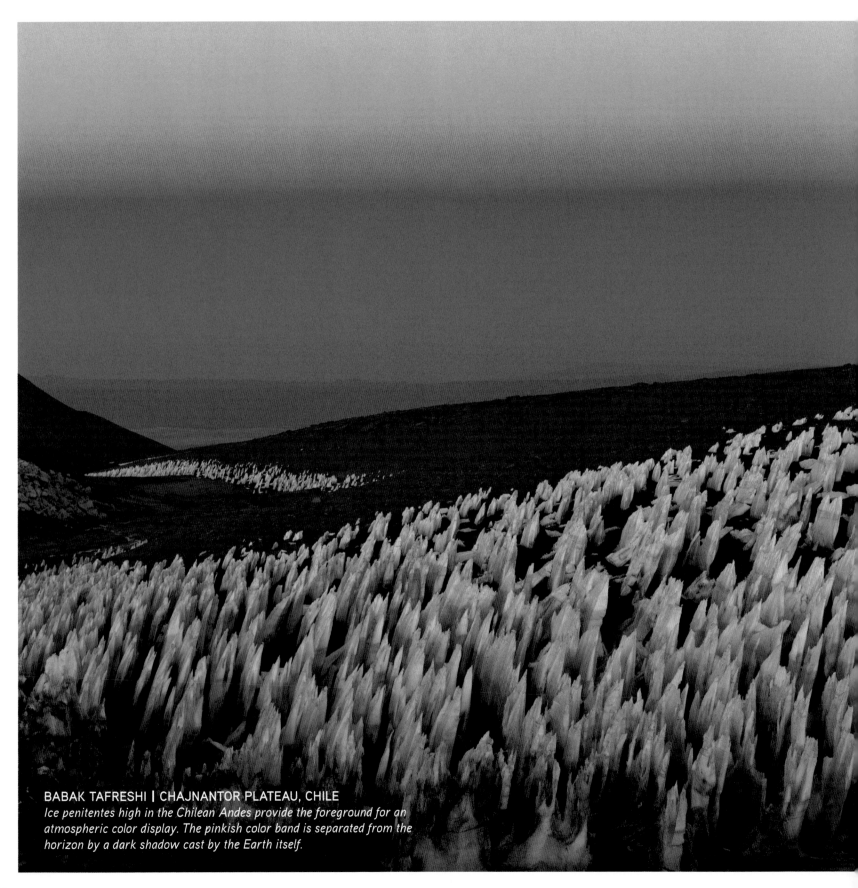

BABAK TAFRESHI | CHAJNANTOR PLATEAU, CHILE
Ice penitentes high in the Chilean Andes provide the foreground for an atmospheric color display. The pinkish color band is separated from the horizon by a dark shadow cast by the Earth itself.

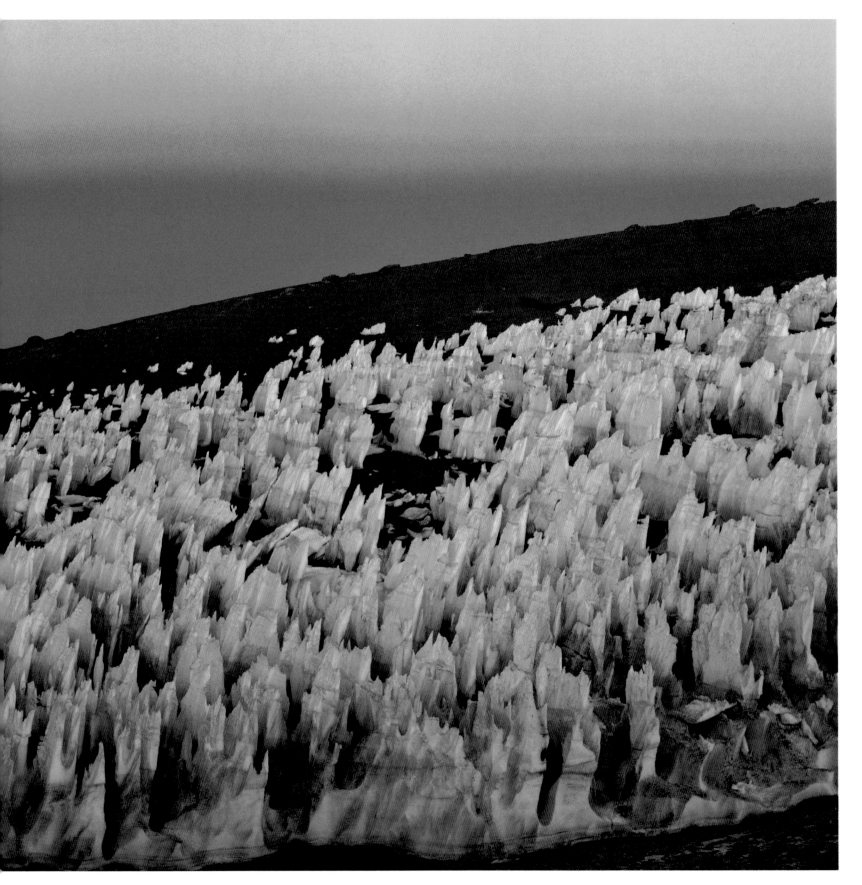

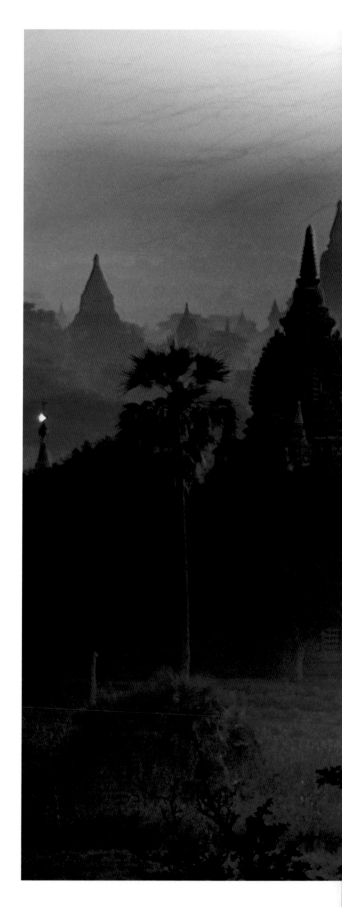

I'll tell you
how the Sun rose—
A ribbon at a time.

–EMILY DICKINSON

KAVIN HO | BAGAN, MYANMAR
*Early morning casts a soft light on pagodas and temples of the
ancient capital of Bagan. Some 2,000 structures from the royal
kingdom fill the landscape.*

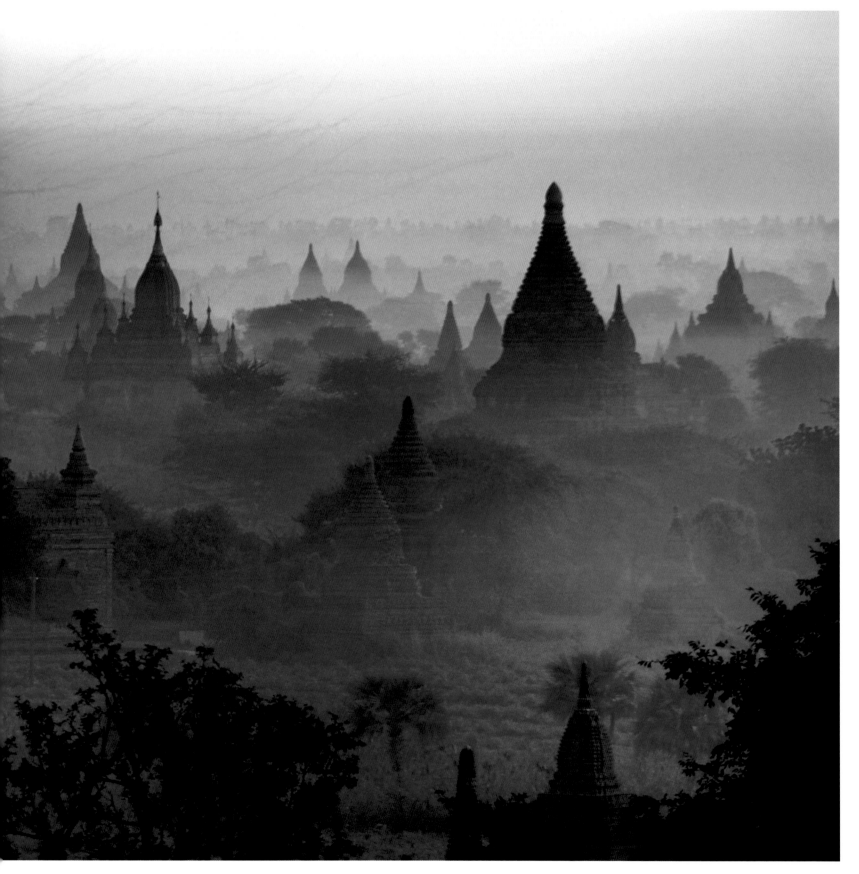

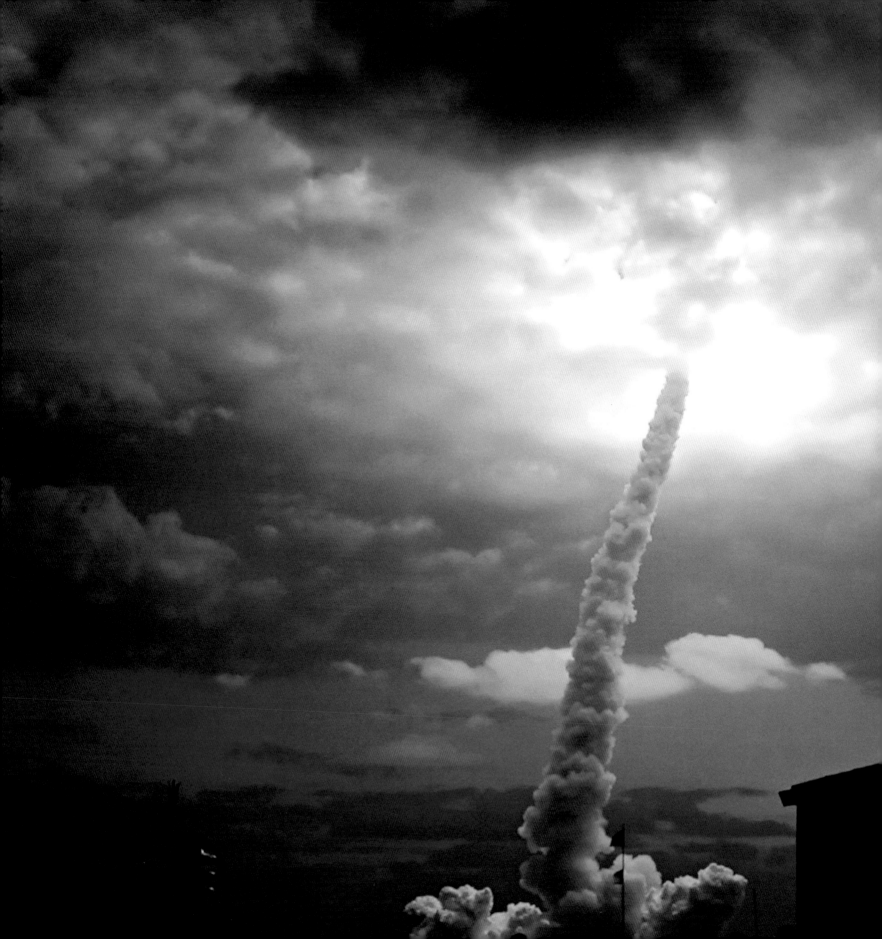

NASA MARSHALL SPACE FLIGHT CENTER | KENNEDY SPACE CENTER, FLORIDA
In March 2002, the space shuttle Columbia *lights up the clouds over Kennedy Space Center during liftoff. Its crew would spend nearly 11 days in space.*

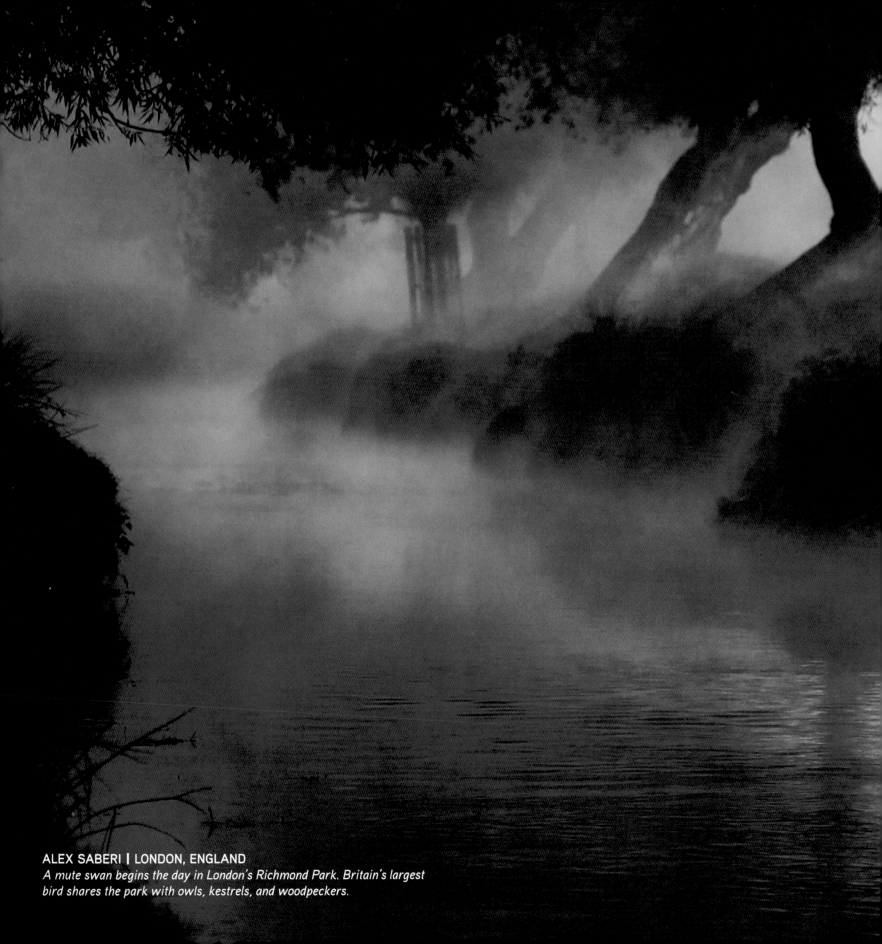

ALEX SABERI | LONDON, ENGLAND
A mute swan begins the day in London's Richmond Park. Britain's largest
bird shares the park with owls, kestrels, and woodpeckers.

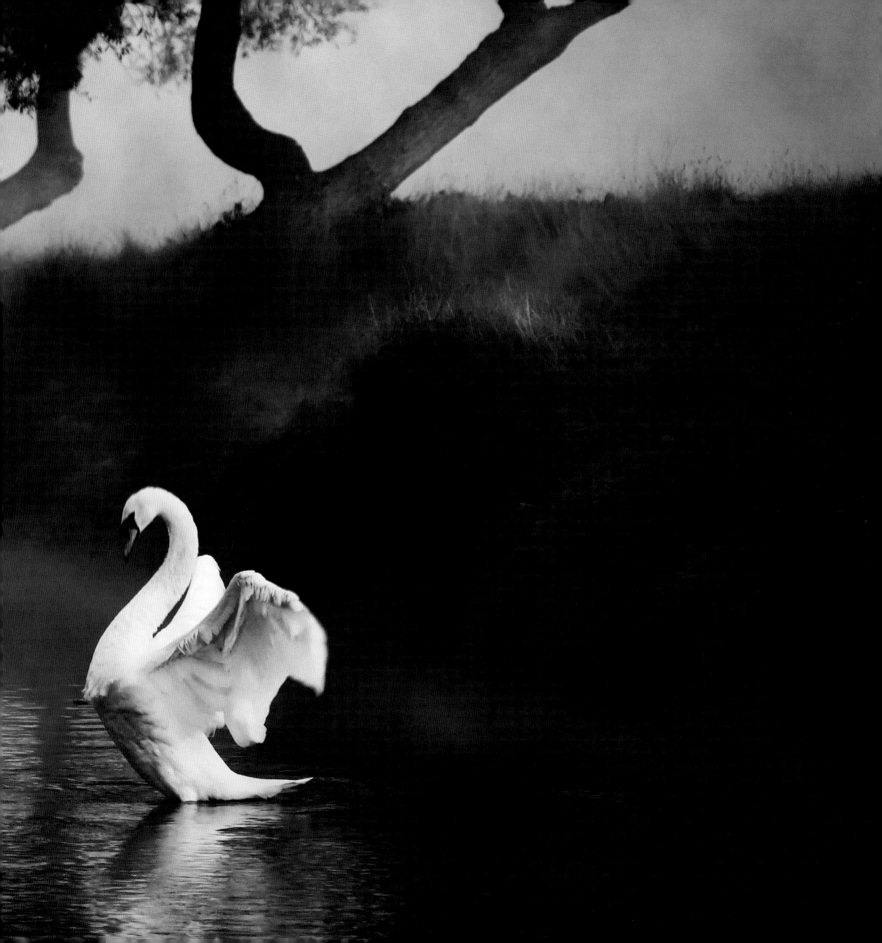

We both love to shoot in the early morning, before sunrise, as well as at dusk, after the sun has set. This is called the "blue hour," where you can capture a variety of mixed lights and moods. For a story about the Austrian Lake District, we went out with local fishermen who start their day long before sunrise. For this predawn photo on a foggy, cloudy morning, the light was very blue. With the latest digital cameras, we were able to shoot at high ISO settings to capture the mood of the place. We set to work right away and kept shooting until full daylight appeared.

SISSE BRIMBERG AND COTTON COULSON

Hallstatt, Austria
Dawn breaks over a fishing village in Austria's Lake District.

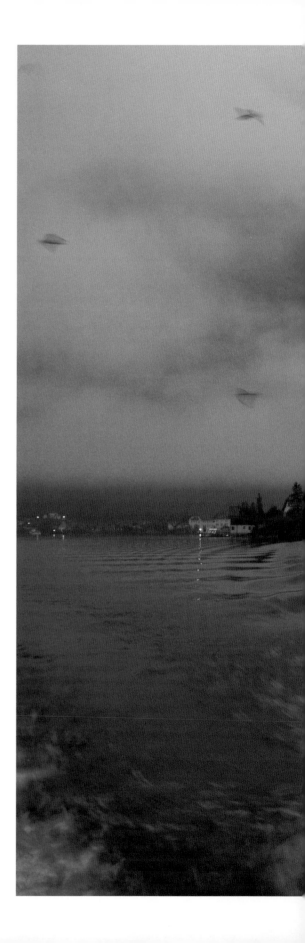

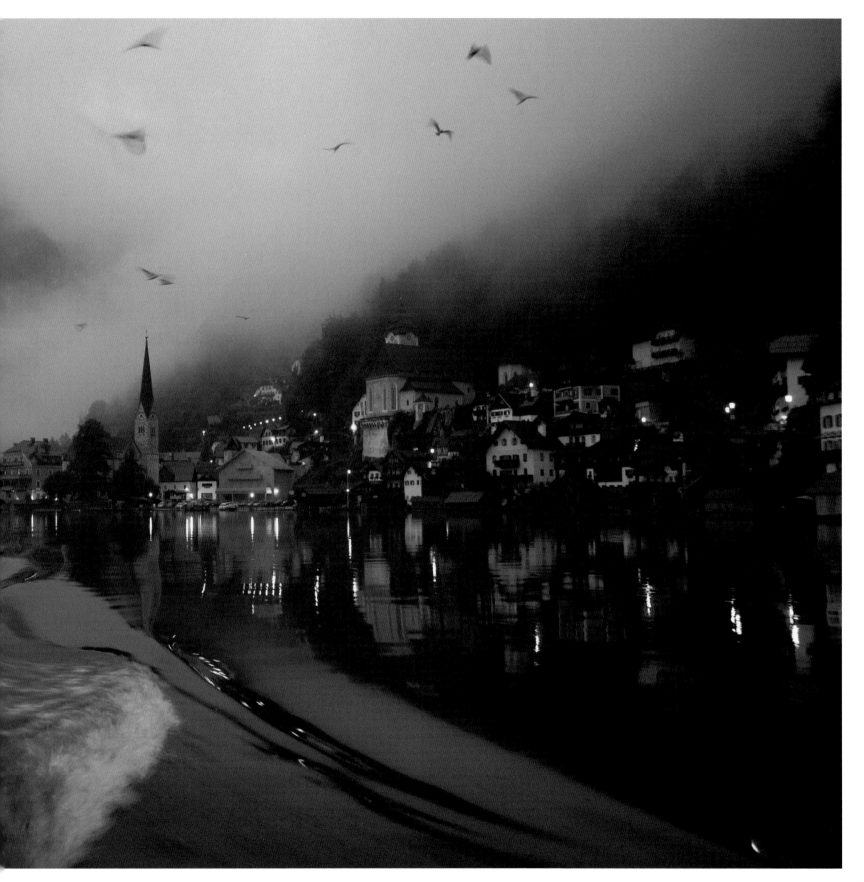

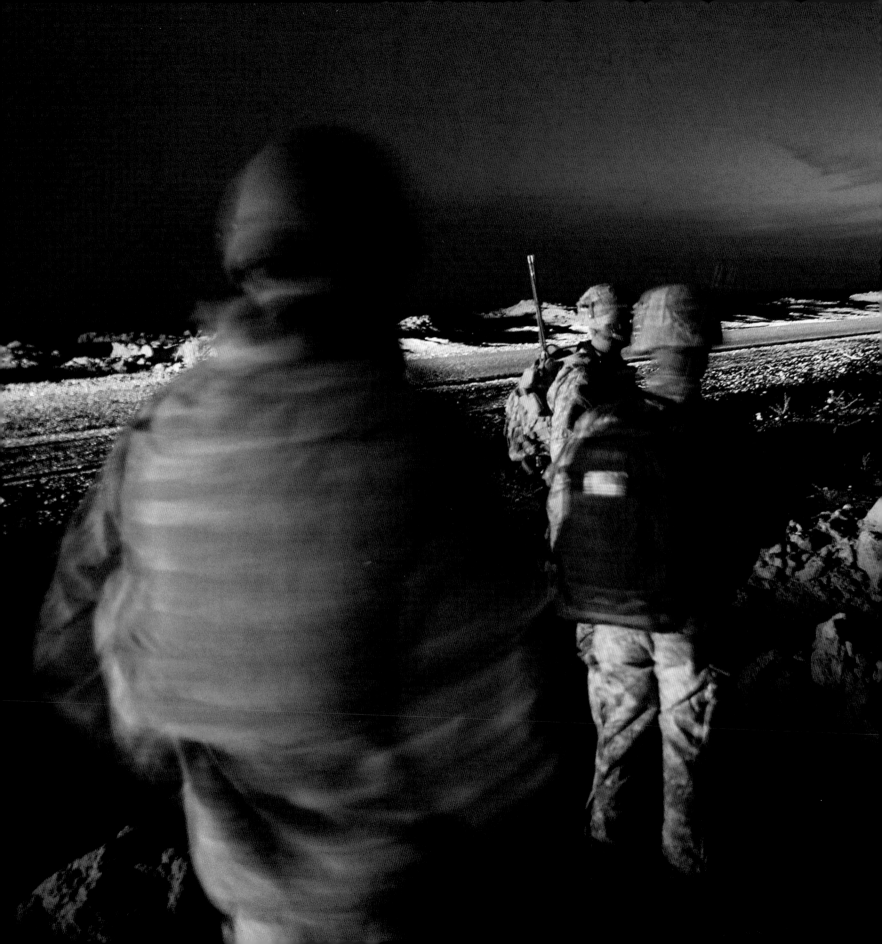

JOHN MOORE | HOWZ-E-MADAD, AFGHANISTAN
The sky is barely light as U.S. Army soldiers move toward an observation post at dawn in Kandahar Province, Afghanistan.

45

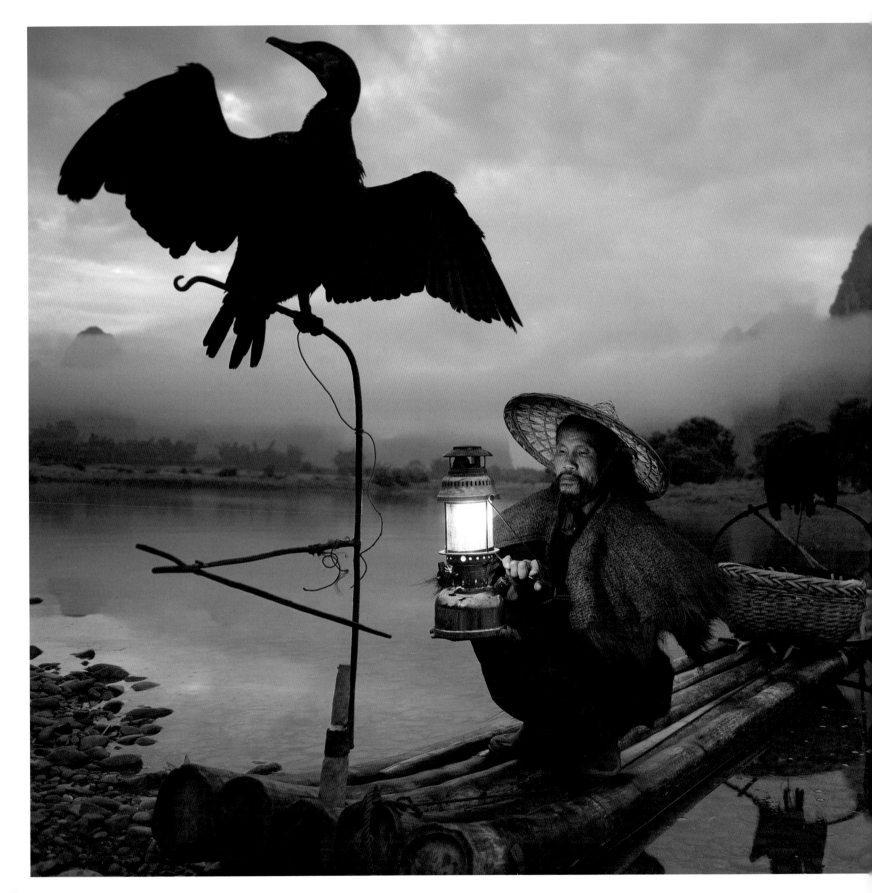

The past is the beginning
of the beginning
and all that is
and has been
is but the twilight
of the dawn.

–H. G. WELLS

KE YU | GUILIN, CHINA
*A Guilin fisherman on a bamboo raft uses tame cormorants to catch
(and then disgorge) fish. The strong light attracts fish at dawn.*

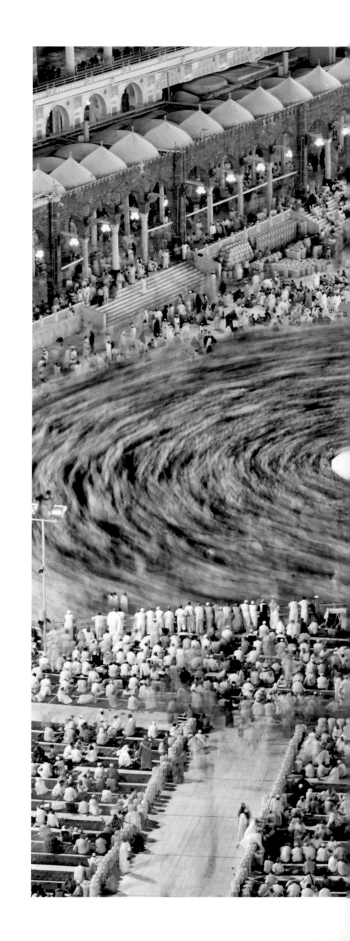

AMER HILABI | MECCA, SAUDI ARABIA
Muslim pilgrims become a sea of motion as they circle the Kaaba during Ramadan in this long exposure taken in Mecca's Grand Mosque.

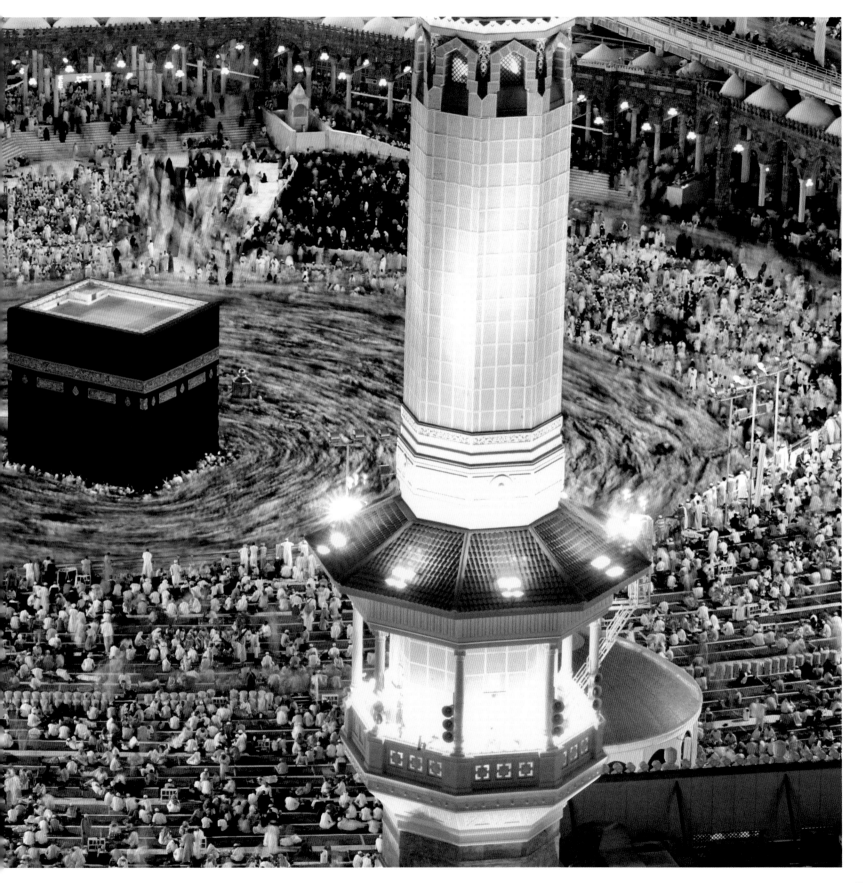

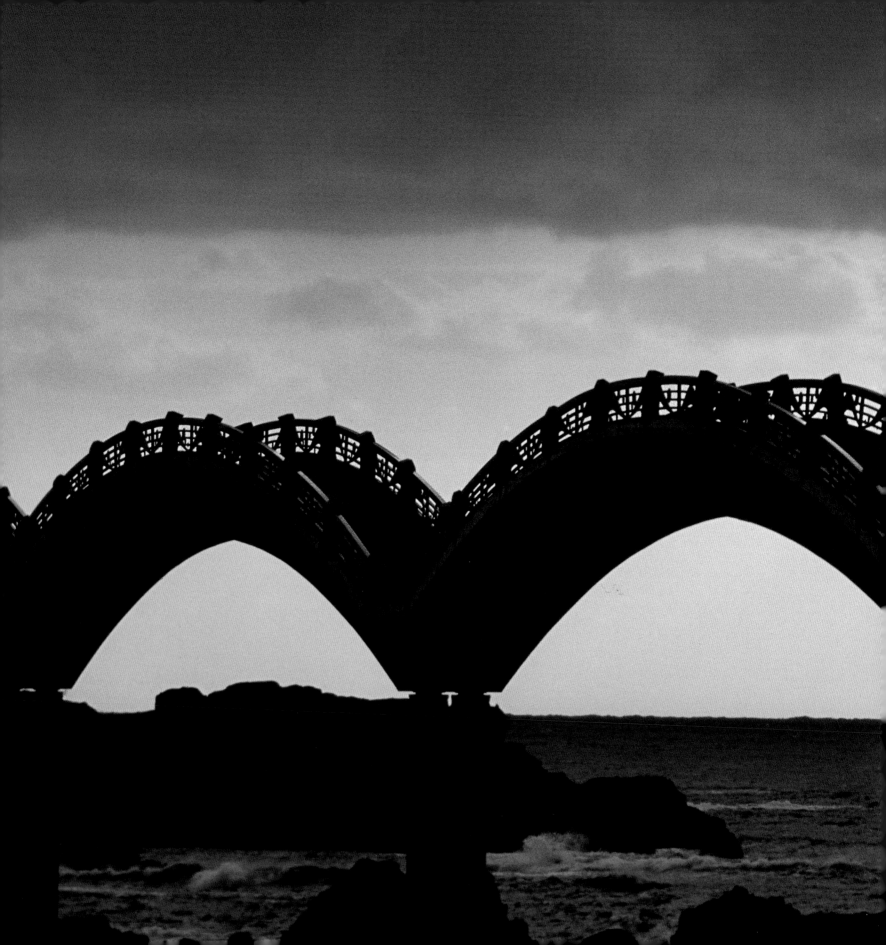

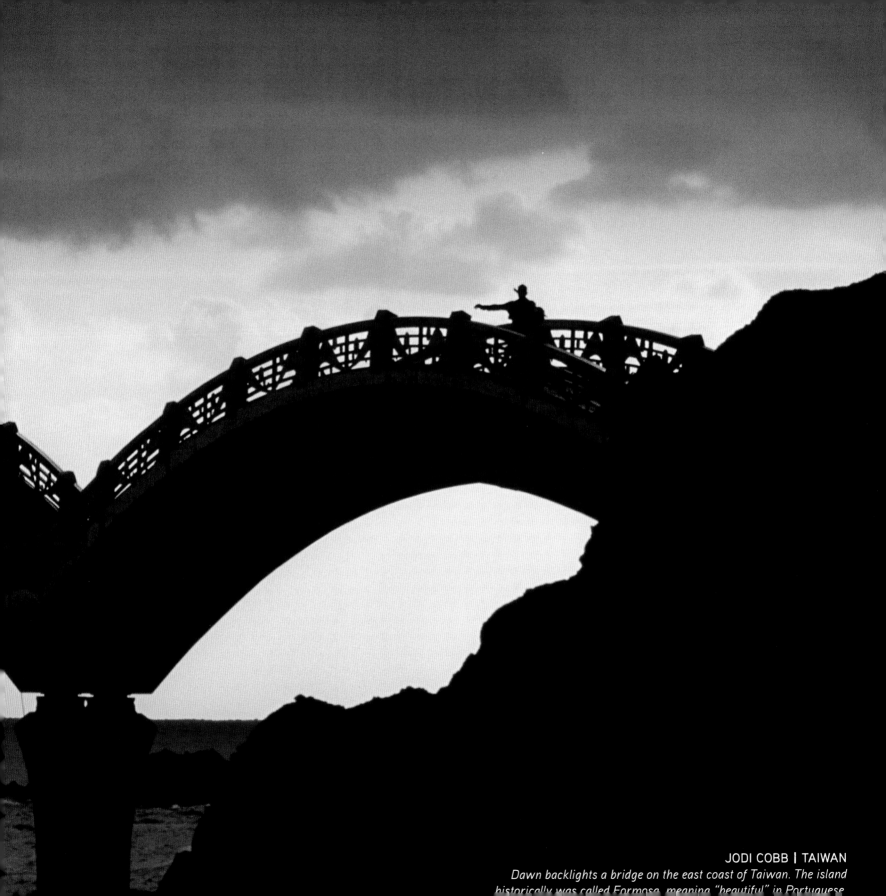

MANOOCHER | NEMRUT DAĞ, TURKEY
The rising sun silhouettes musicians performing Kurdish dances and music on the mountaintop of Nemrut Dağ. The World Heritage site preserves the first-century B.C. mausoleum of Antiochus.

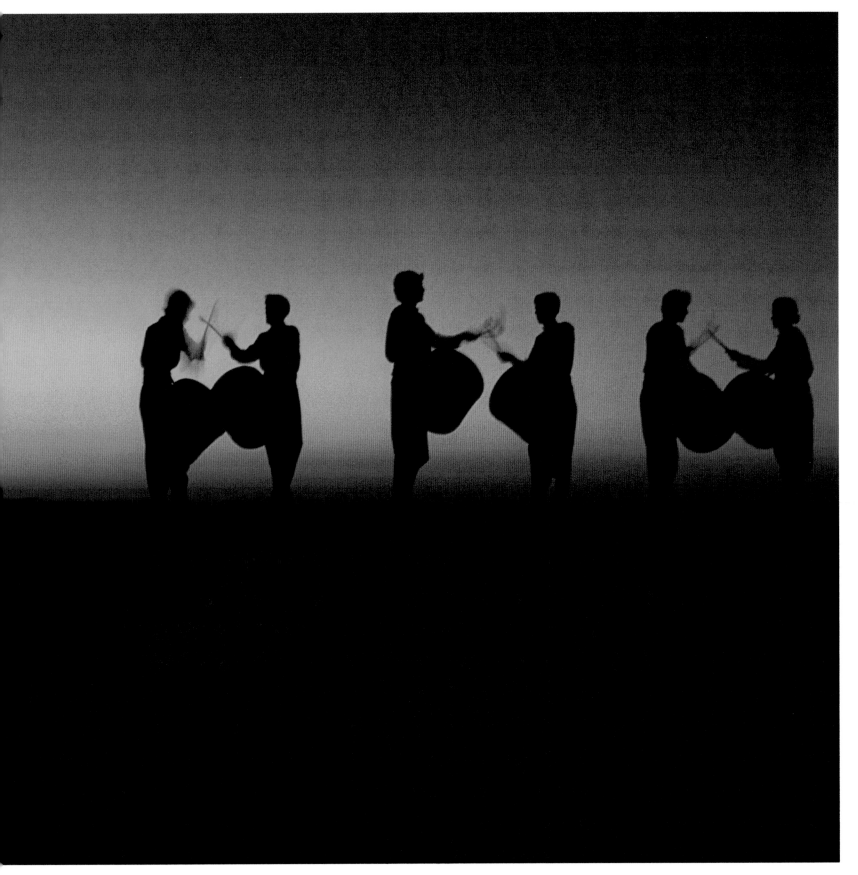

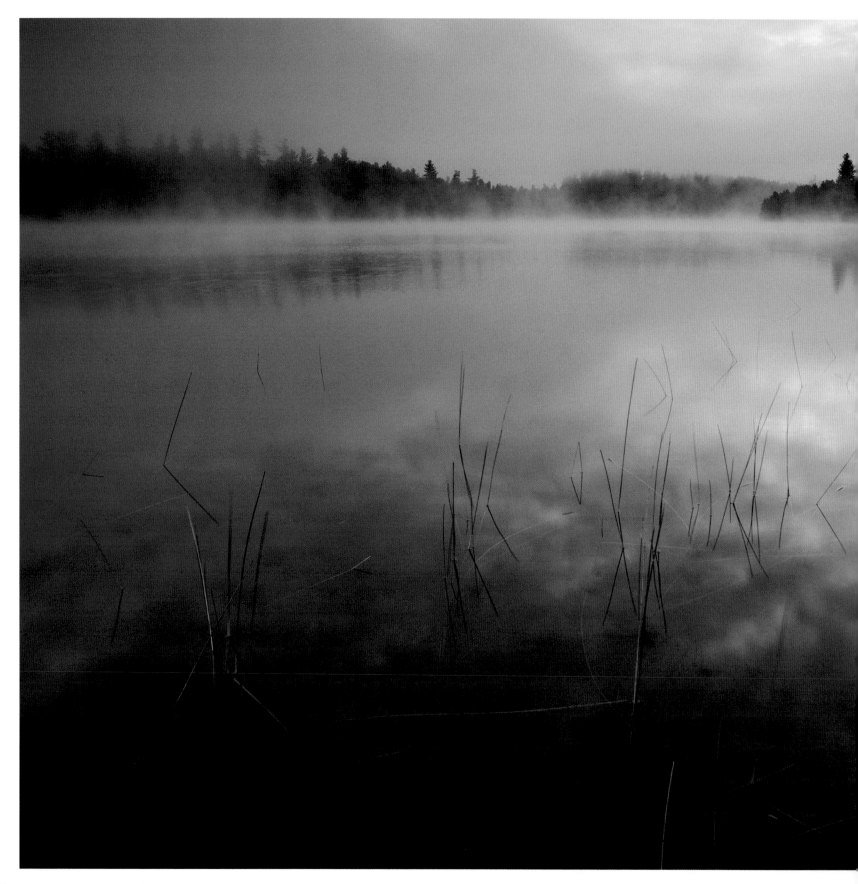

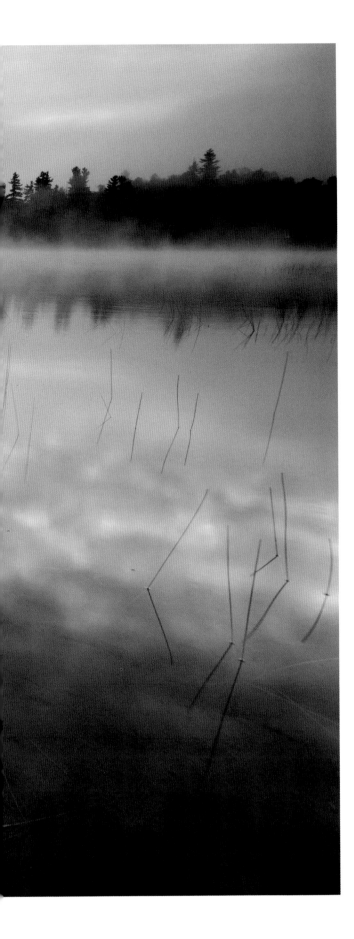

I return to Connery Pond whenever

I am in the Adirondacks, and I'm always alone when I go there at dawn. I know at that hour there will be a good chance of morning mist hanging over the pond, with the sun rising to my right as I look north toward Whiteface Mountain. The surrounding mountains help provide calm conditions, creating a mirrorlike effect on the water. On this particular morning, I found nice, broken clouds overhead and used their reflection and the rising mist off the lake with a few reeds to create this simple composition with mood. A friend of mine says, "Find the light, and shoot what's in it." I love this saying and often repeat it to myself when looking for images. Dawn attracts me—I like its solitude and peace.

MICHAEL MELFORD
Adirondacks, New York
Dawn mist hangs over Connery Pond.

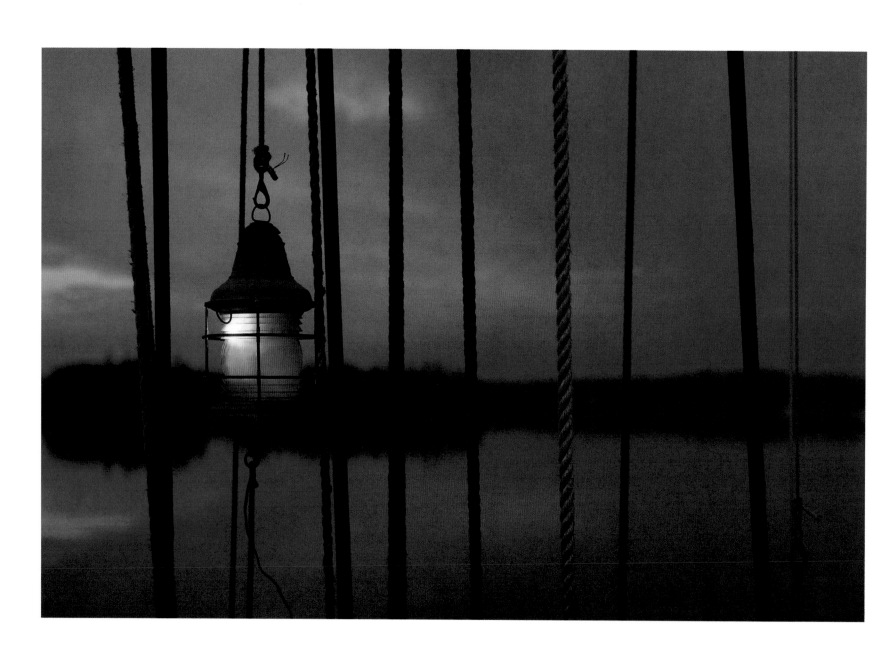

DENNIS WELSH | MAINE
A lantern on the 130-foot windjammer Angelique *offers
its light to the coming day.*

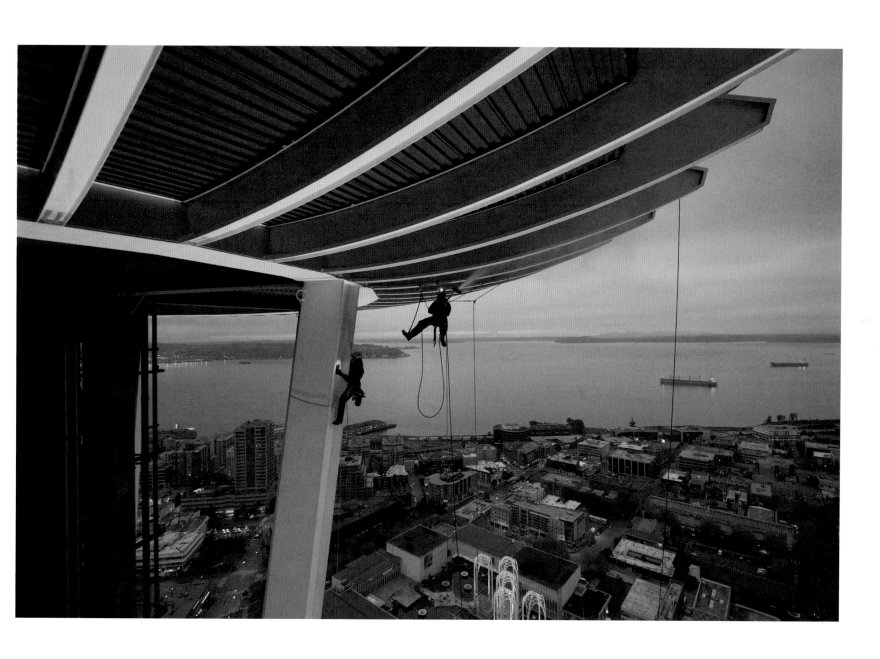

FRANK HUSTER | SEATTLE, WASHINGTON
Two technicians pressure-wash Seattle's Space Needle during its first cleaning since it opened in 1962. The photographer rappelled down the 605-foot-tall landmark to get this shot.

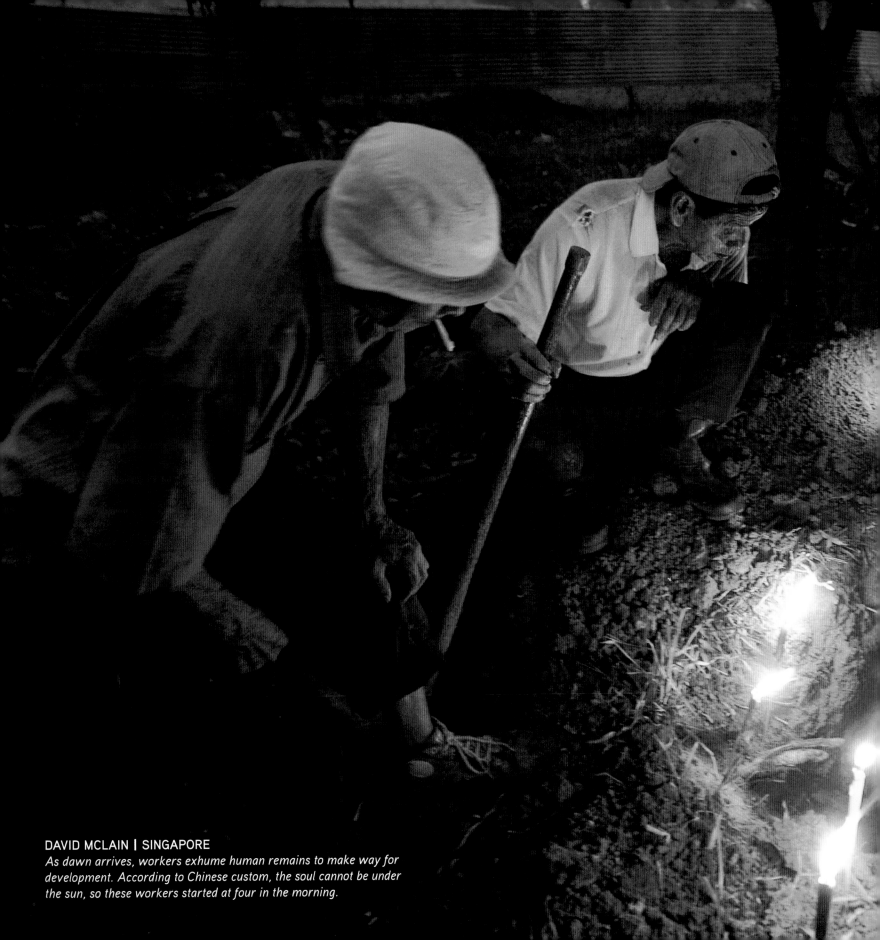

DAVID MCLAIN | SINGAPORE
As dawn arrives, workers exhume human remains to make way for development. According to Chinese custom, the soul cannot be under the sun, so these workers started at four in the morning.

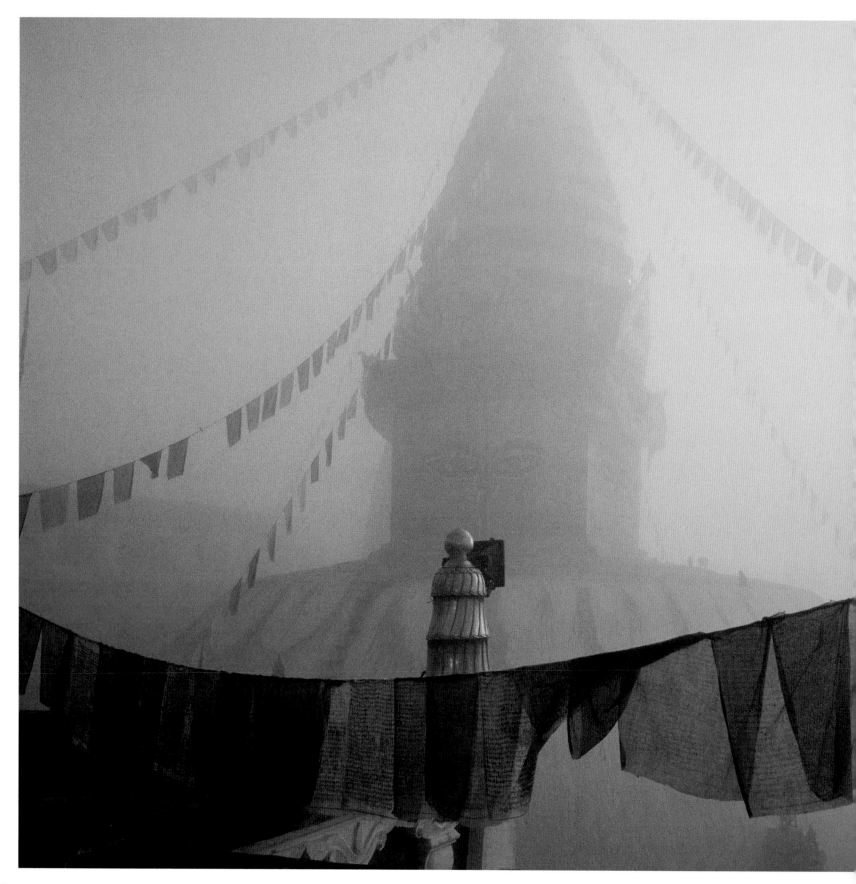

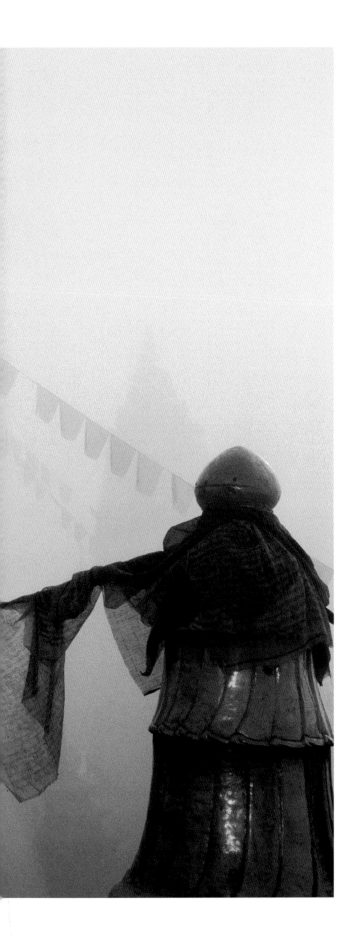

DAVID EDWARDS | KATHMANDU, NEPAL
Fog shrouds a Buddhist temple and gossamer prayer flags in Nepal's capital, Kathmandu. The Lord Buddha (Siddhartha Gautama) was born in Lumbini, Nepal, more than 2,500 years ago.

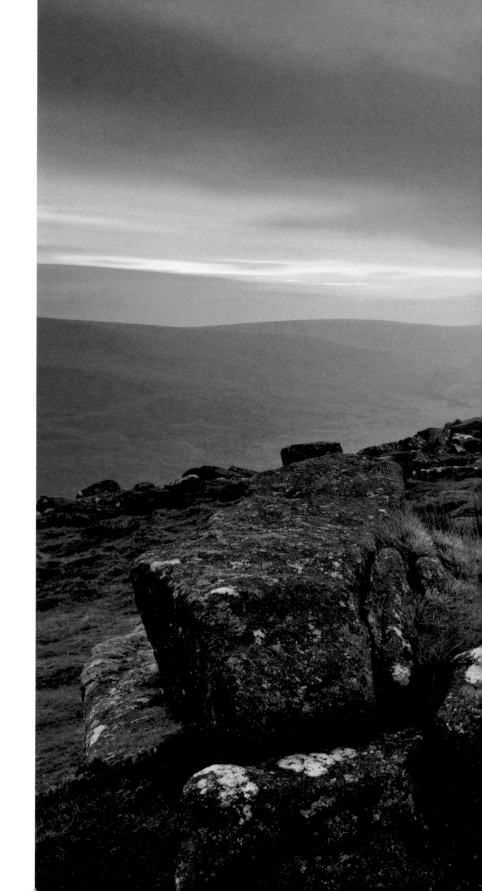

By the time
we can truly see it,
dawn is over.

–JIM RICHARDSON

ADAM BURTON | BELSTONE TOR, ENGLAND
*A saturated sky accentuates the timelessness of
Belstone Tor, striated granite rocks balanced in the
breathtaking moorland of Devon, England.*

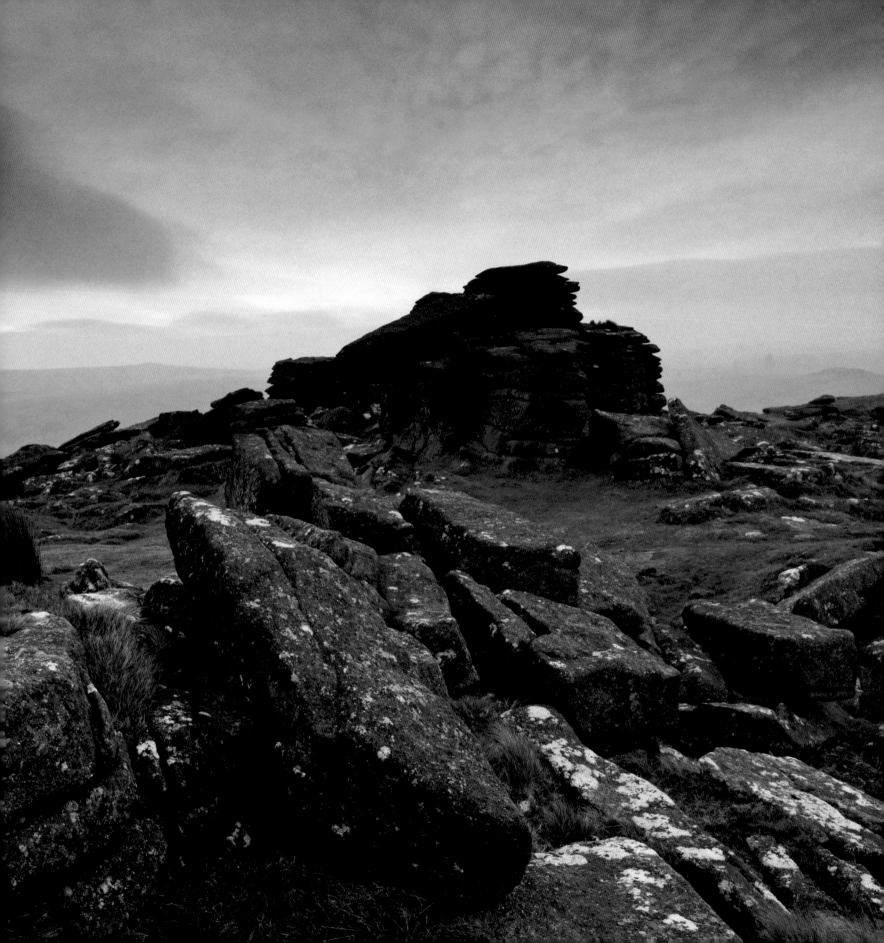

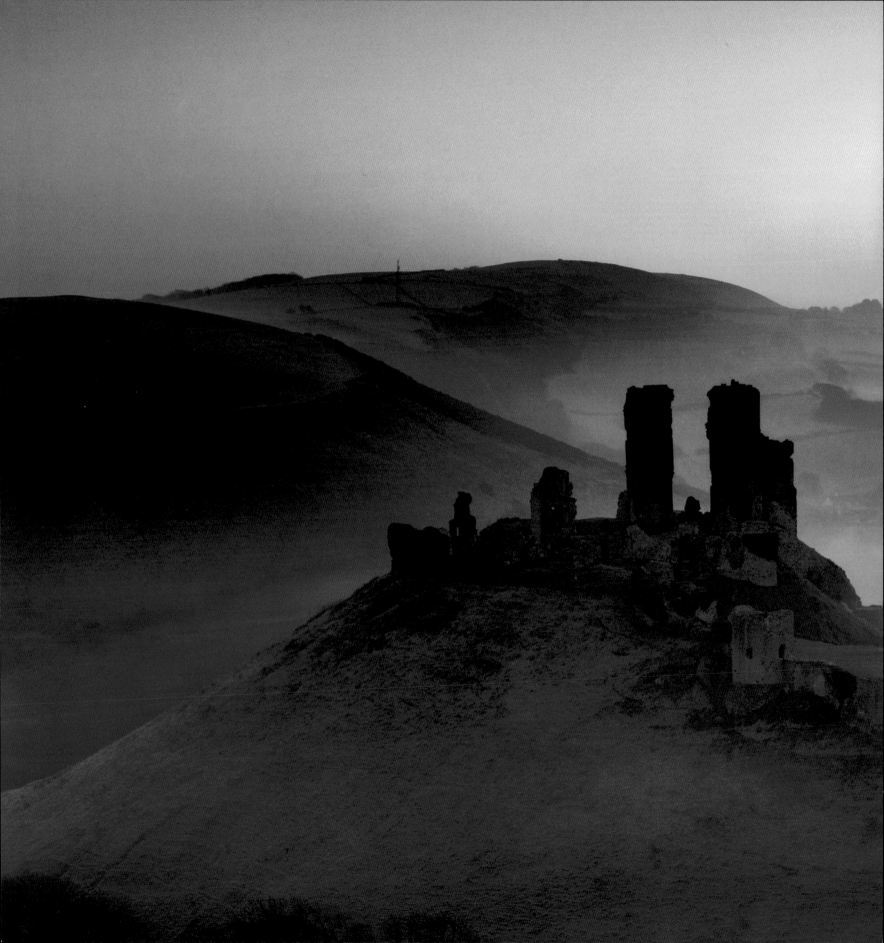

SUNRISE

ADAM BURTON | DORSET, ENGLAND
The sun rises above the horizon as early morning mists surround Corfe Castle. Originally built more than 1,000 years ago, the castle was partially destroyed in 1646 by an act of Parliament.

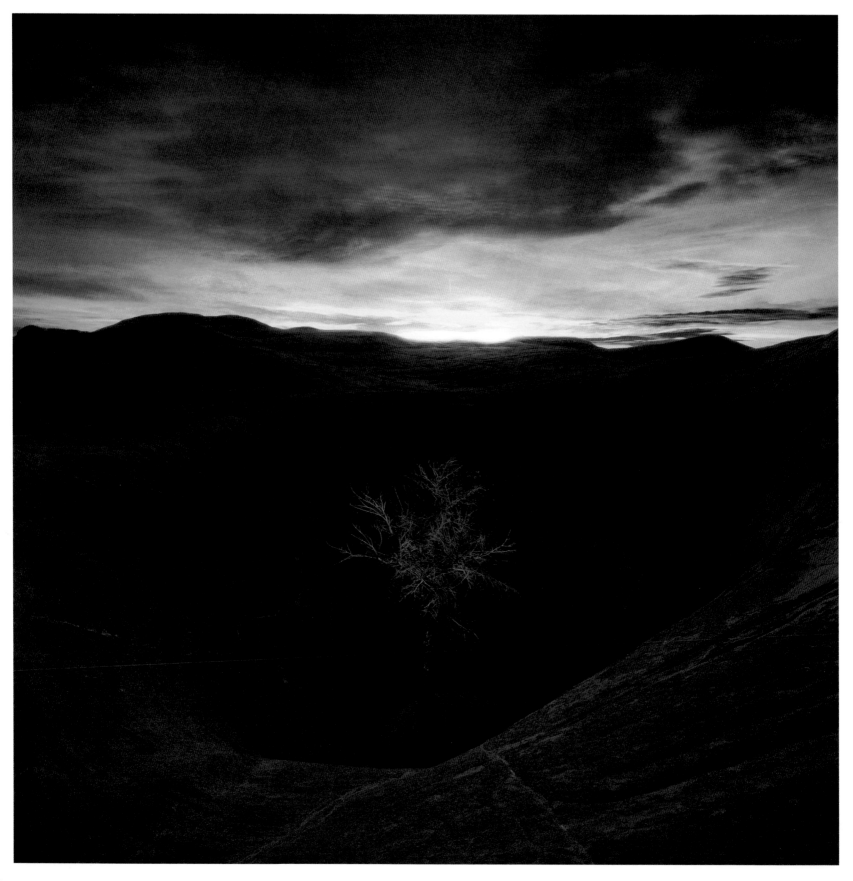

PIERCING THROUGH

the early haze, the sun declares itself: distinct, bold, brilliant, divine. First a gleam, then a burst, then a bundle of flame so bright we must look away: Sunrise establishes the dominance of day. Its magnificence flashes forth, and it feels as if for just that moment we can stand in the presence of some power greater than human. Then it gains on us, and we must look away.

In this daily occurrence, the ancient Egyptians saw the ritual of Khepera, god of the rising sun. Like the scarab beetle whose shape he wears on his head, Khepera works diligently and rolls before himself a sphere, perfecting its geometry as he pushes it up into the sky. In the fullness of the sun, Khepera becomes Re, glorious god of full daylight. When daylight dwindles and the sun's work is almost done, Atum overtakes Re and folds in the evening.

In these three forms, the sun in its glory passes through the sky. Nothing can stop this passage of time, this appearance we have watched for millennia. The rising of a brilliant orb into the heavens—this phenomenon called sunrise—has signified the spinning of our planet in the last blink of an Earth-age eye.

MARC ADAMUS | UTAH *Red sandstone and heavy clouds take on nearly the same hue as the sun rises over a lone cottonwood.*

ROBBIE GEORGE | SNOWMASS, COLORADO
*A man and child get an inside view of the bright colors of a hot air balloon
as it's inflated during the annual Snowmass Balloon Festival.*

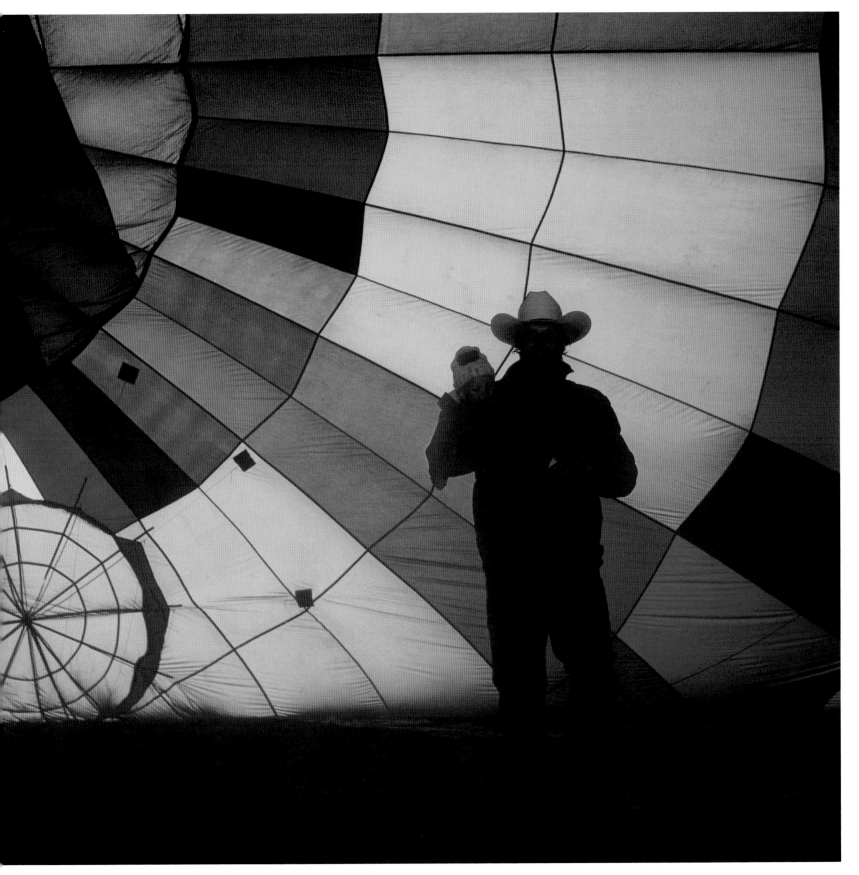

Snow on the ground with an early

dawn light reflecting a soft blue—the blue light of winter—always attracts my attention, perhaps because of my love for black-and-white photography that this monochromatic light resembles. I love photographing in early morning because the day holds hope, the mind is still waking and uncluttered, and the light is often magical.

For a story about winter in Wyoming I took this photo on Togwo-tee Pass at sunrise. This pass marks the continental divide in the Absaroka Mountains, just above the Jackson Hole valley, and offers sweeping views of the Teton Range. It's known for heavy snows, and one morning, cruising the backcountry on a snowmobile, I watched the sun tap a distant hill with a tinge of pink. I captured the moment, and it lives with me now as a favorite moment in time.

RICHARD OLSENIUS

Absaroka Mountains, Wyoming
Sunrise lights up a sliver of hillside.

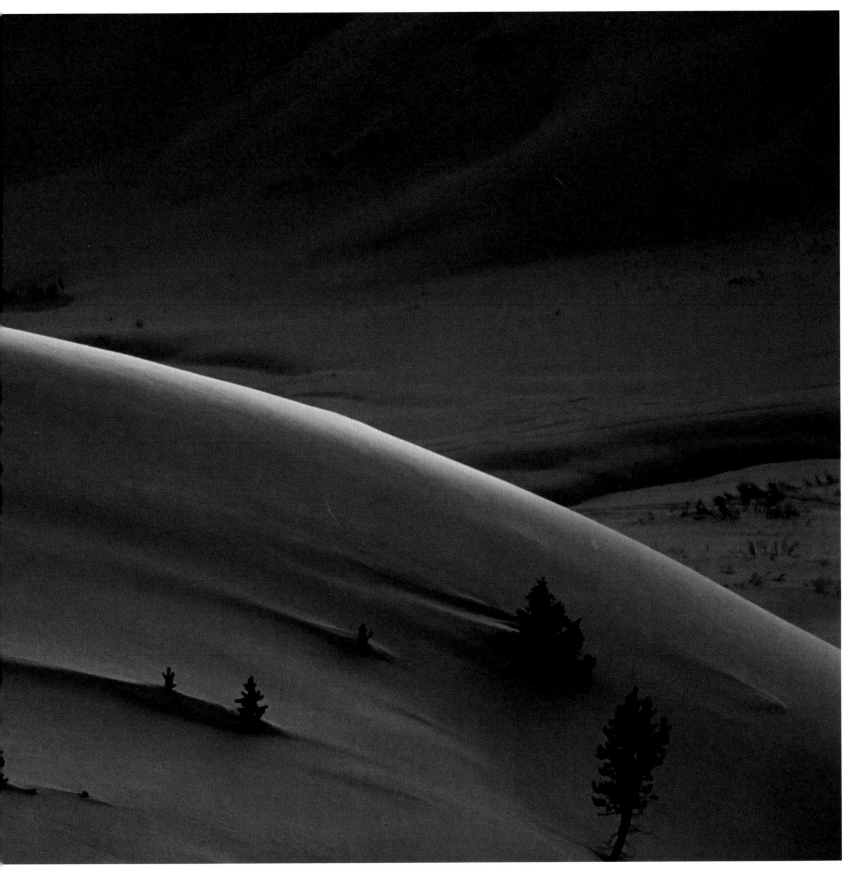

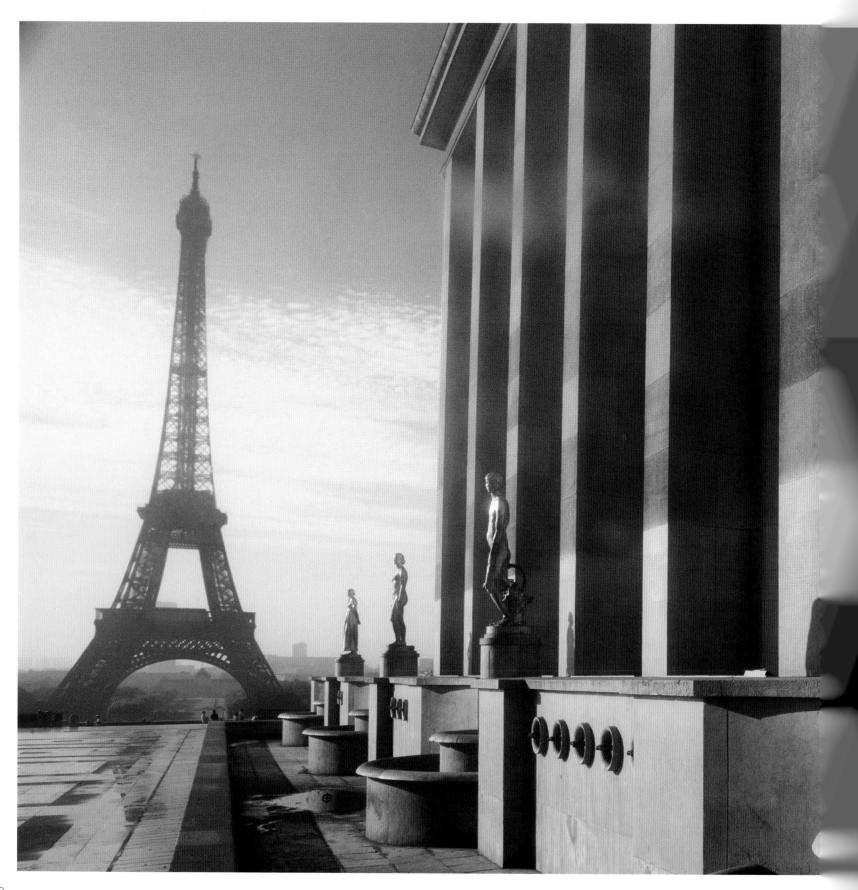

CHAD EHLERS | PARIS, FRANCE
*The rising sun brings a golden touch to the right bank of the Seine
as figurines at Chaillot Palace catch its rays. In the background,
the Eiffel Tower can't be missed.*

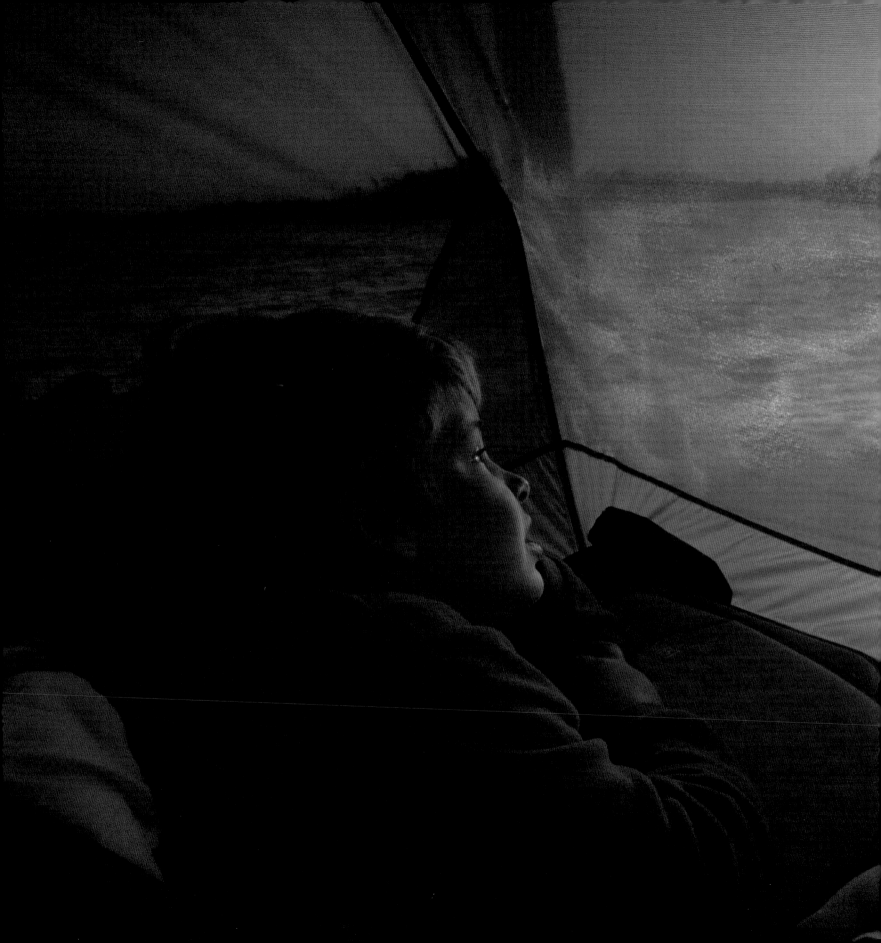

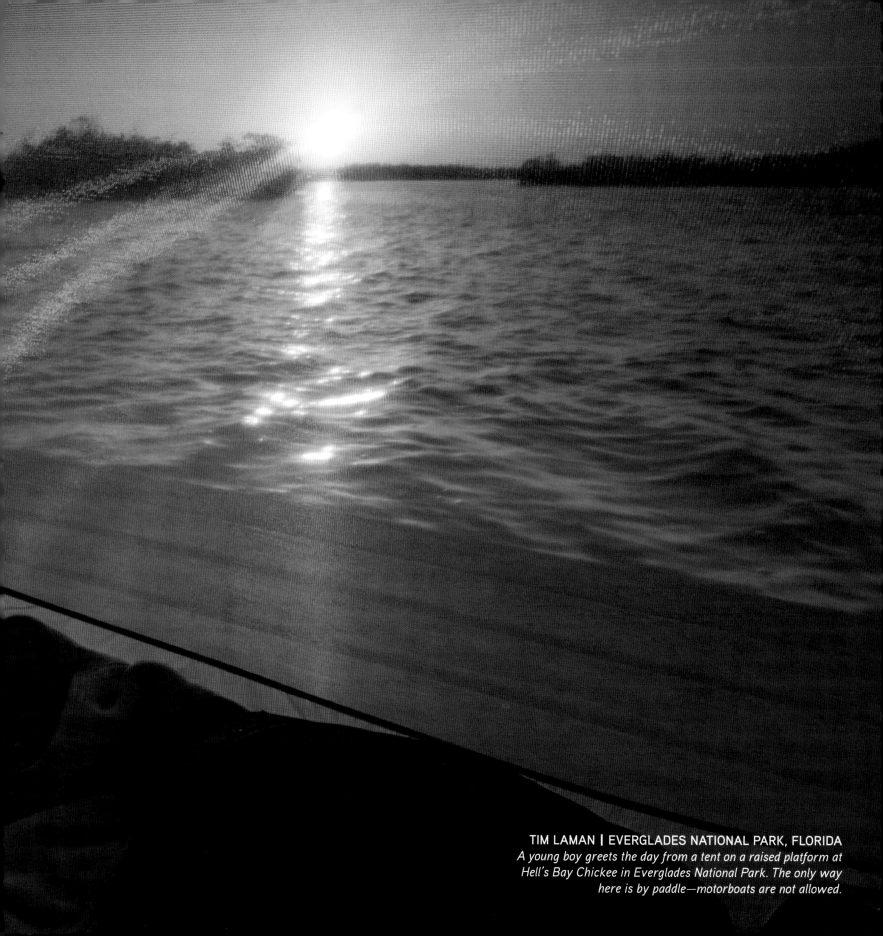

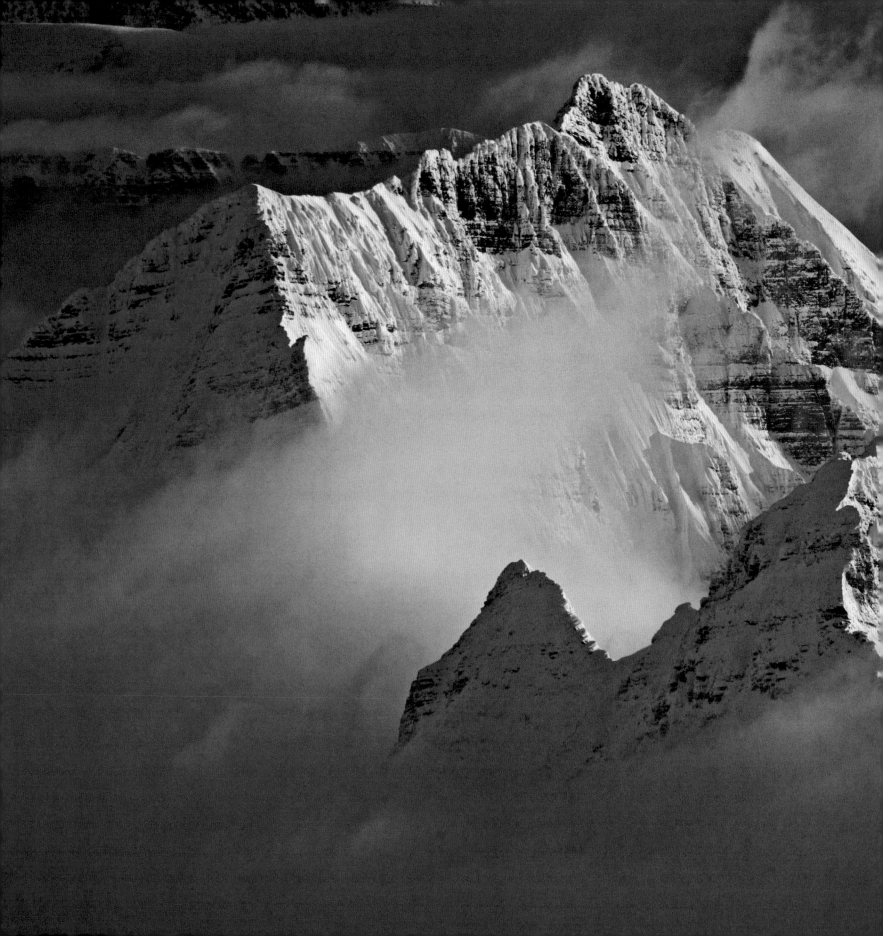

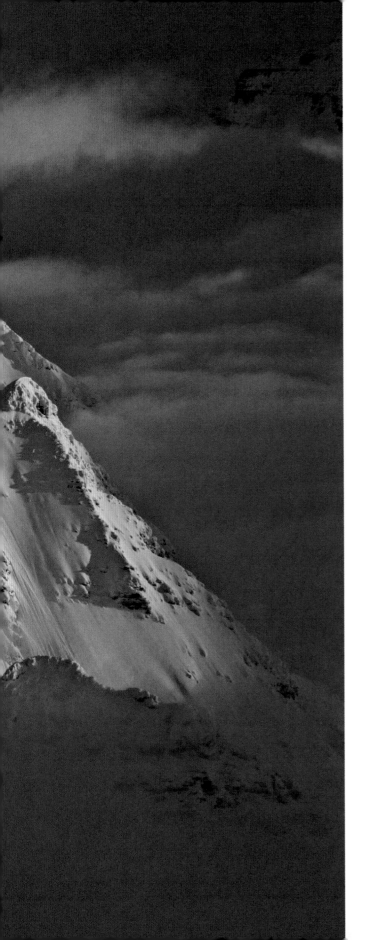

How glorious a
greeting the sun
gives the mountains!

~

–JOHN MUIR

MICHAEL MELFORD | GLACIER NATIONAL PARK, MONTANA
*Sunlight touches a banded face of 9,616-foot Vulture Peak
in Glacier National Park, Montana, where more than 100 glacier-
carved mountains rise above 8,000 feet.*

Sunrise almost photographs itself. We just mechanically put the camera to our eye, rest our finger on the shutter and wait for glory.

–JIM RICHARDSON

ADAM BURTON | EXMOOR, SOMERSET, ENGLAND
The first light of morning brings a warm blush to the sky and snow-covered bushes in the moorland of Exmoor, England.

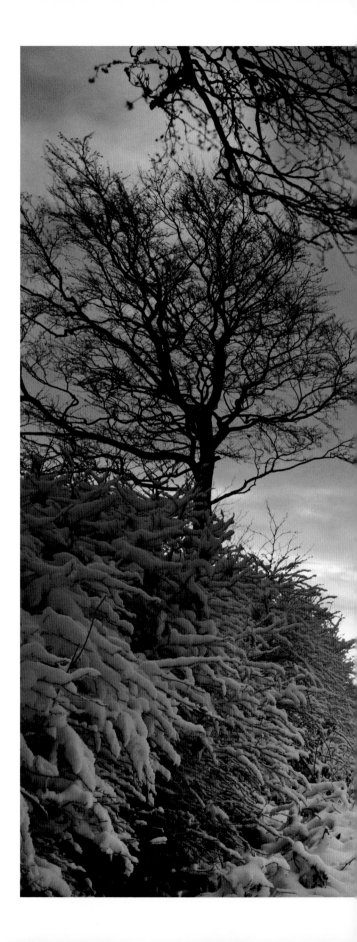

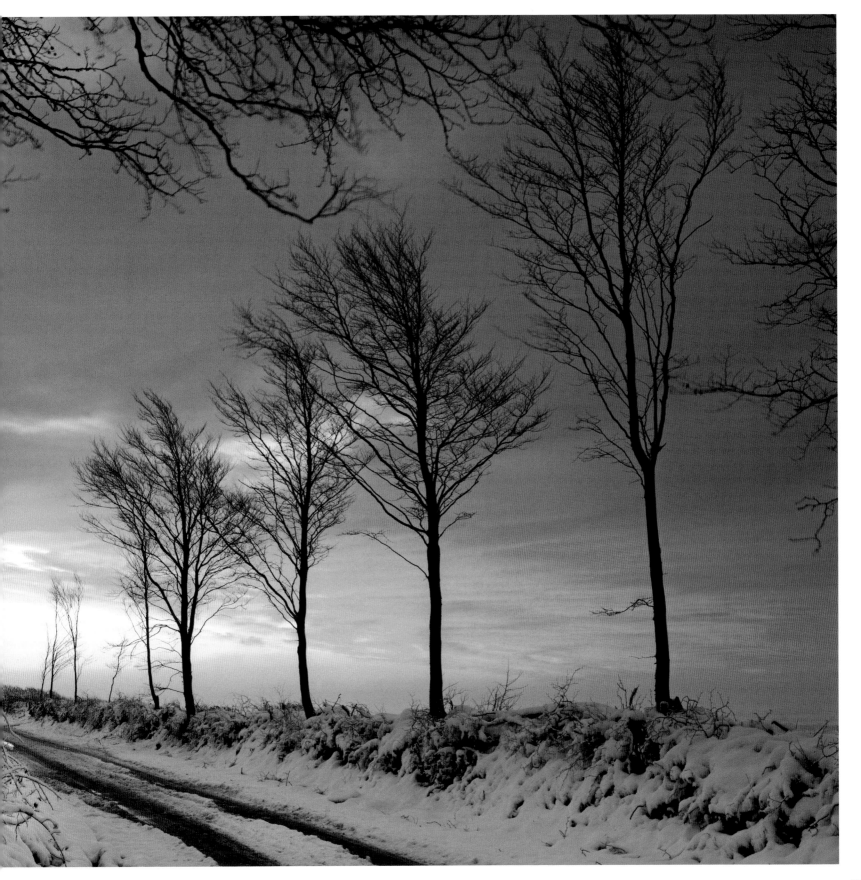

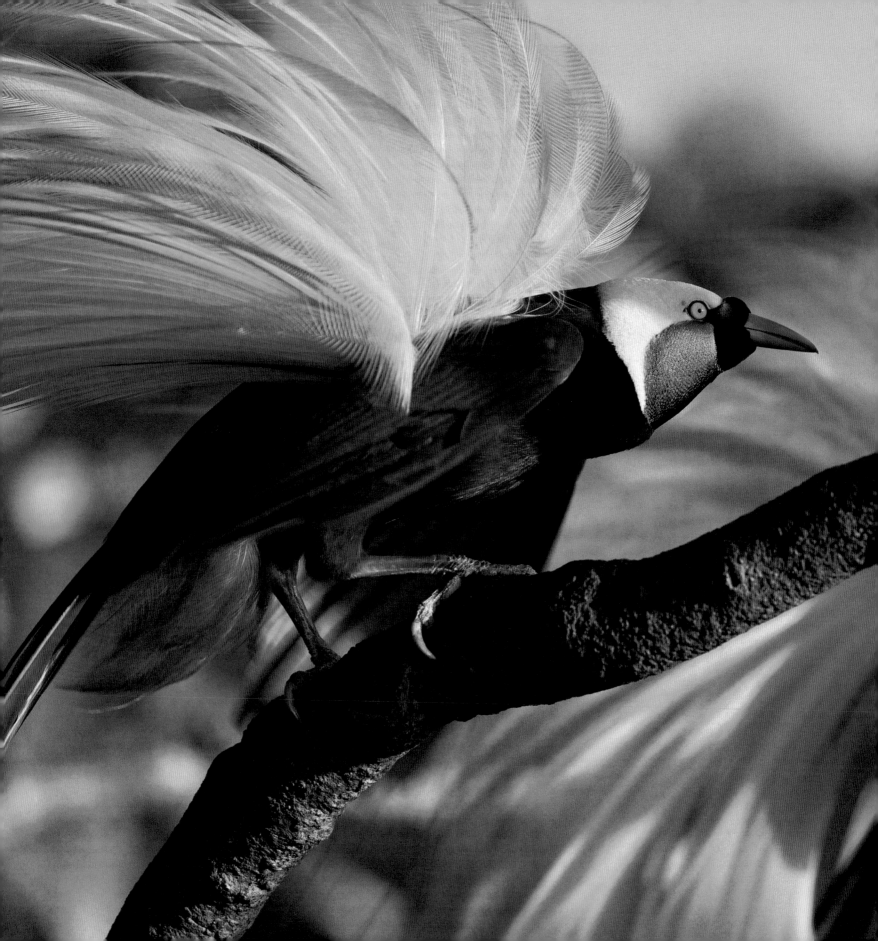

TIM LAMAN | ARU ISLANDS, INDONESIA
Two male greater birds-of-paradise perform a joint courtship display high in a tree in the Aru Islands, Indonesia. The colorful males use elaborate dance moves to attract mates.

81

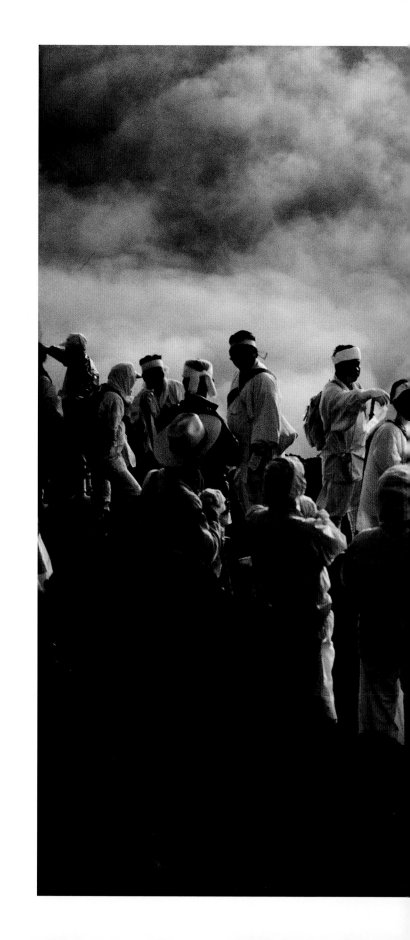

ALLAN SEIDEN | MOUNT FUJI, JAPAN
Sunrise lights up cottony clouds on Mount Fuji as pilgrims dressed in native dress prepare to hike the 12,388-foot volcano. July and August are popular months for a summit hike.

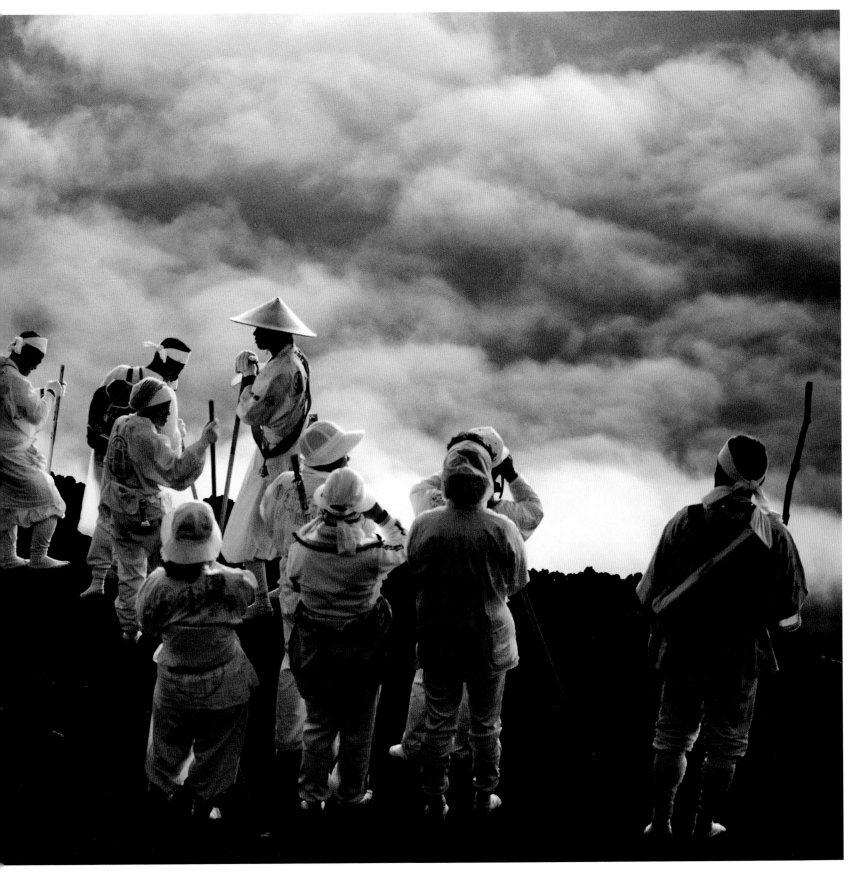

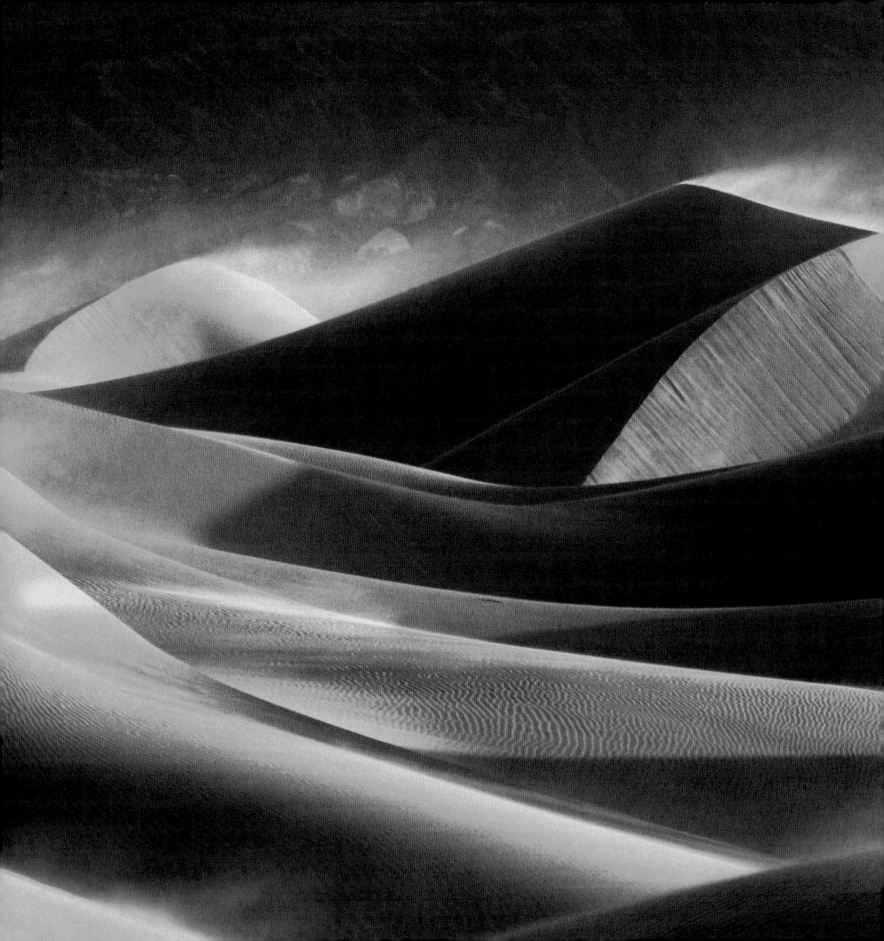

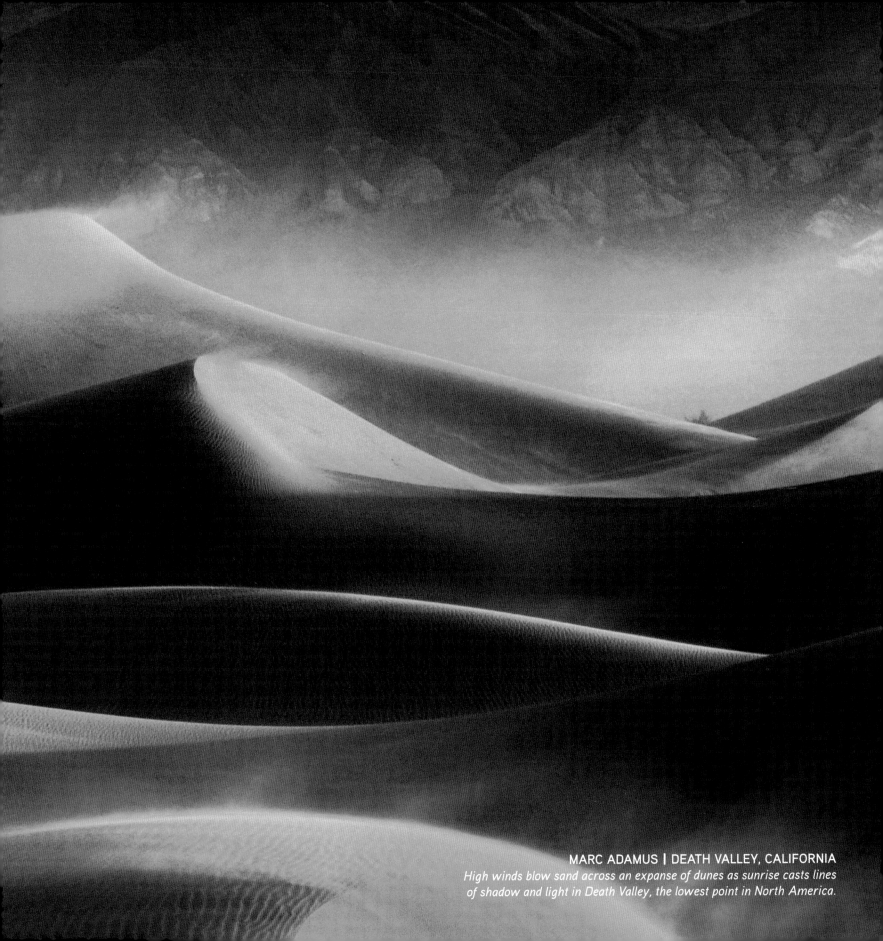

MARC ADAMUS | DEATH VALLEY, CALIFORNIA
*High winds blow sand across an expanse of dunes as sunrise casts lines
of shadow and light in Death Valley, the lowest point in North America.*

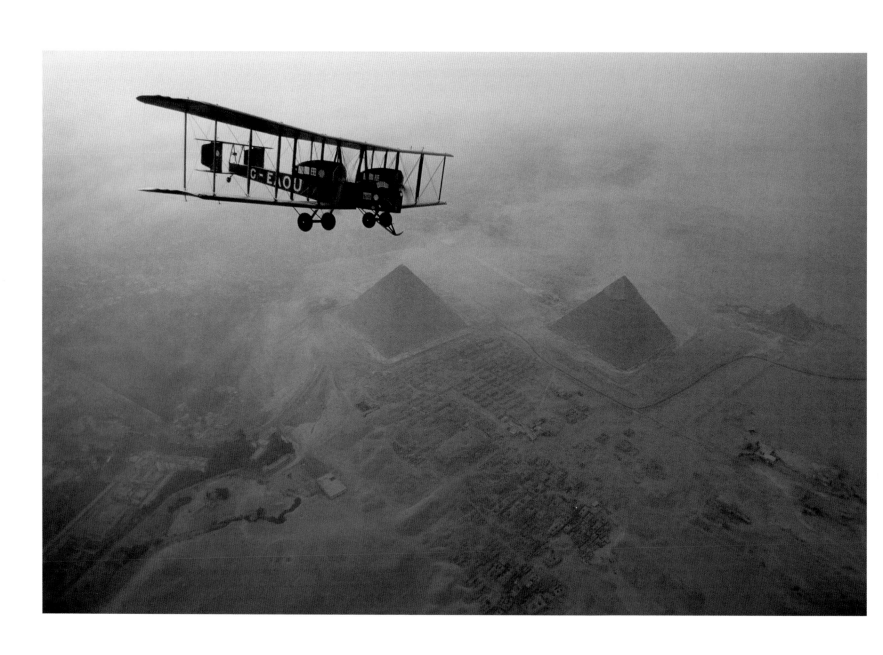

JAMES L. STANFIELD | GIZA, EGYPT
A Vickers Vimy biplane circles the Pyramids at Giza during a dawn tour.
No stranger to the sky, the Vimy holds three long-distance flight "firsts."

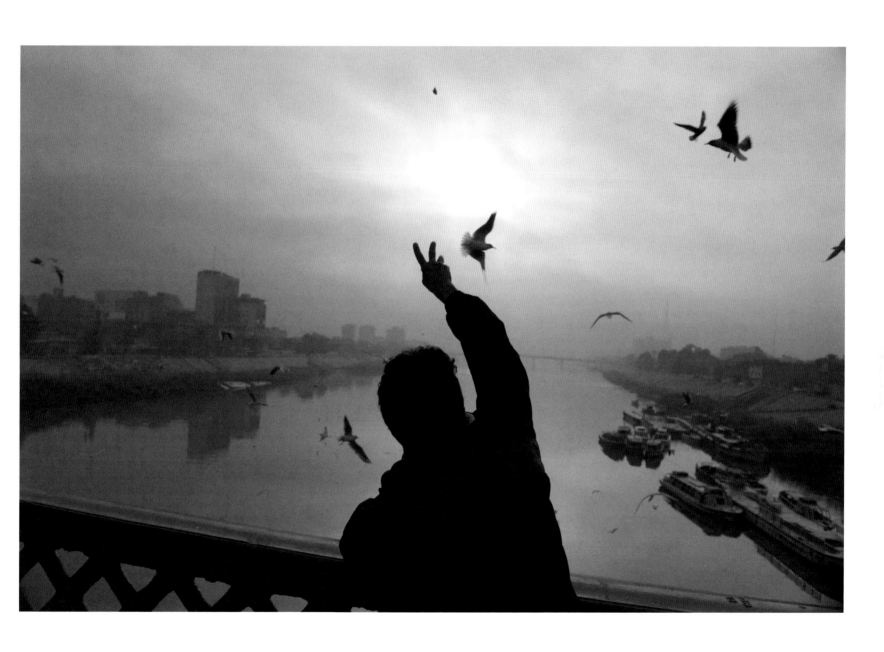

LYNSEY ADDARIO | IRAQ
*An Iraqi man feeds seagulls on the Tigris River during the early morning quiet.
Baghdad's al-Zawraa soccer club is also known as the White Seagulls.*

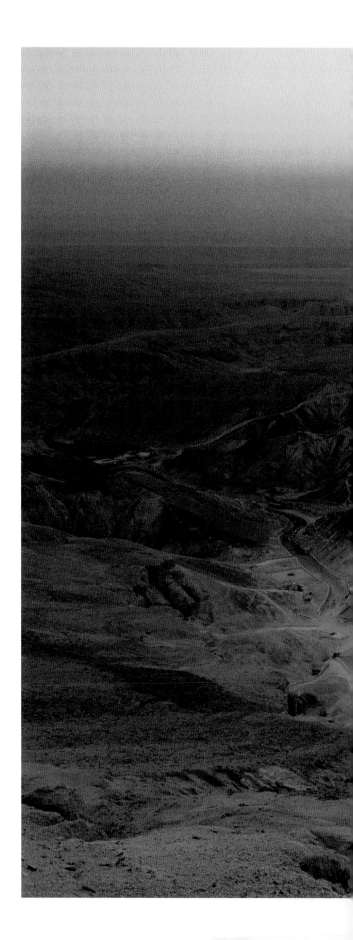

I took this photo at sunrise from

the top of Theban Mountain, from the peak known as the Qurna, located on the west side of the Nile, in the land of the setting sun, or the land of the dead. Because of the great sweeping Qena Bend in the Nile just north of Luxor, this sunrise appears over the Nile as we look down into the Valley of the Kings. The photo can only be taken in the summer when the sun is at its northernmost movement of the year. As dawn breaks, enough reflected light fills the Valley of the Kings, which falls into harsh shadow moments after sunrise. Thus there was a tiny window of time when this photo could be made.

KENNETH GARRETT

Valley of the Kings, Egypt
A strong summer sun rises over the Valley of the Kings.

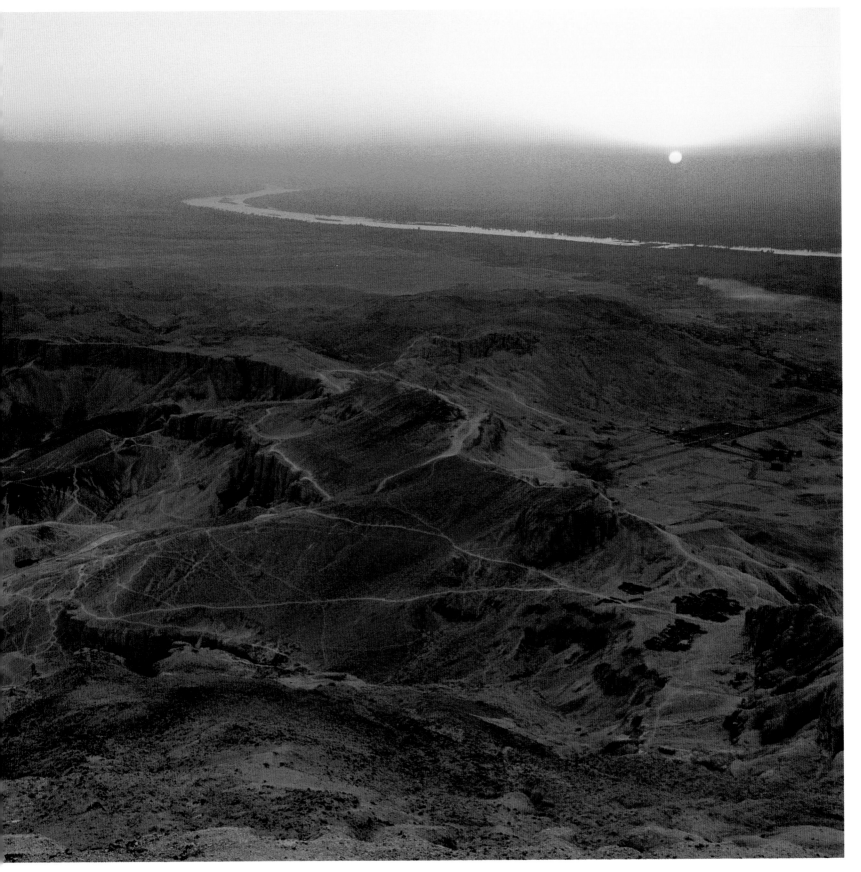

JOE PETERSBURGER | VENICE, ITALY
An orange sky, turquoise feathers, and a Carnival mask combine to create a surreal Venetian scene.

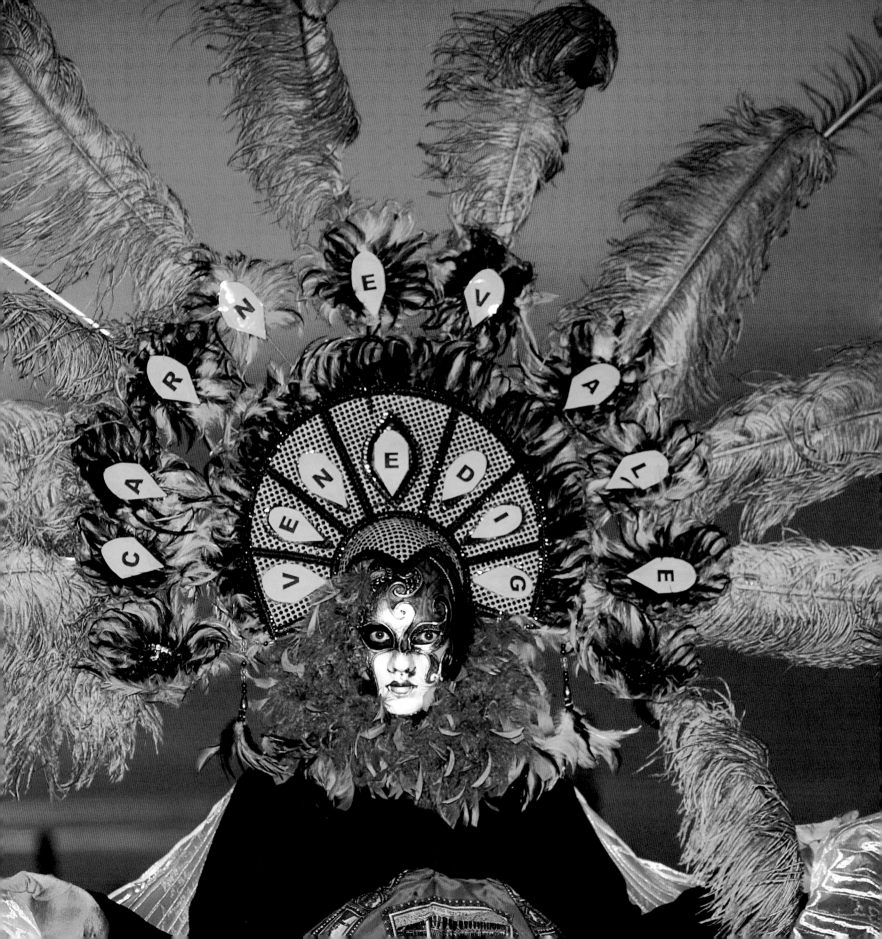

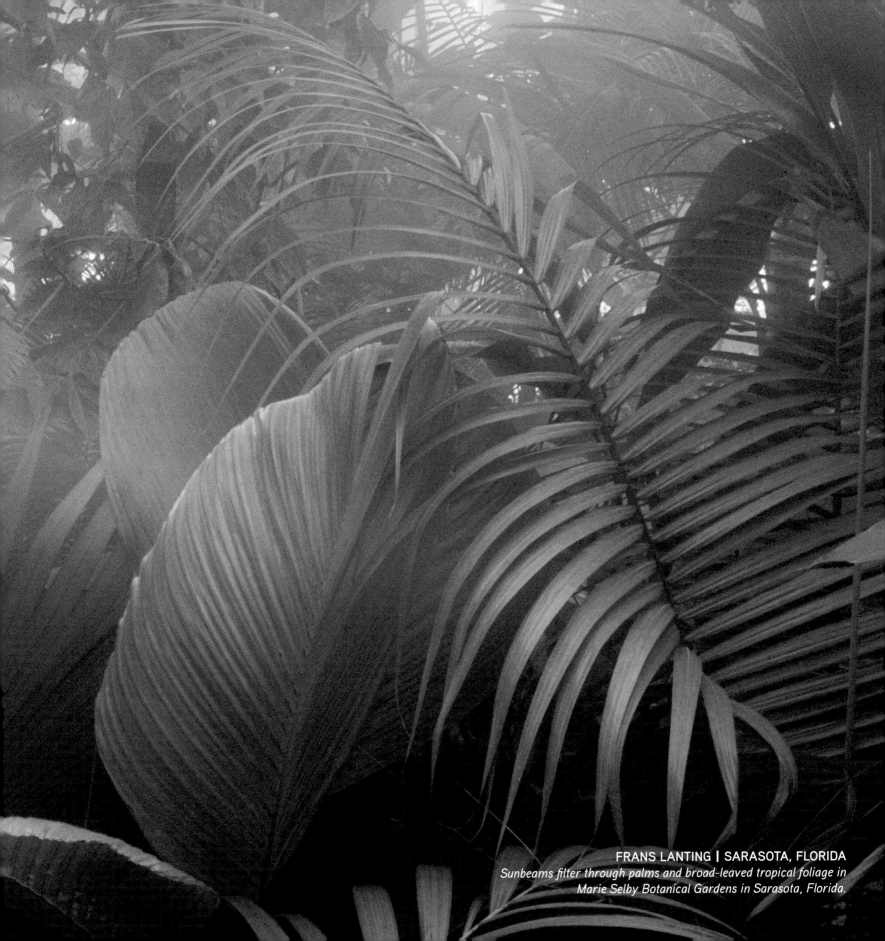

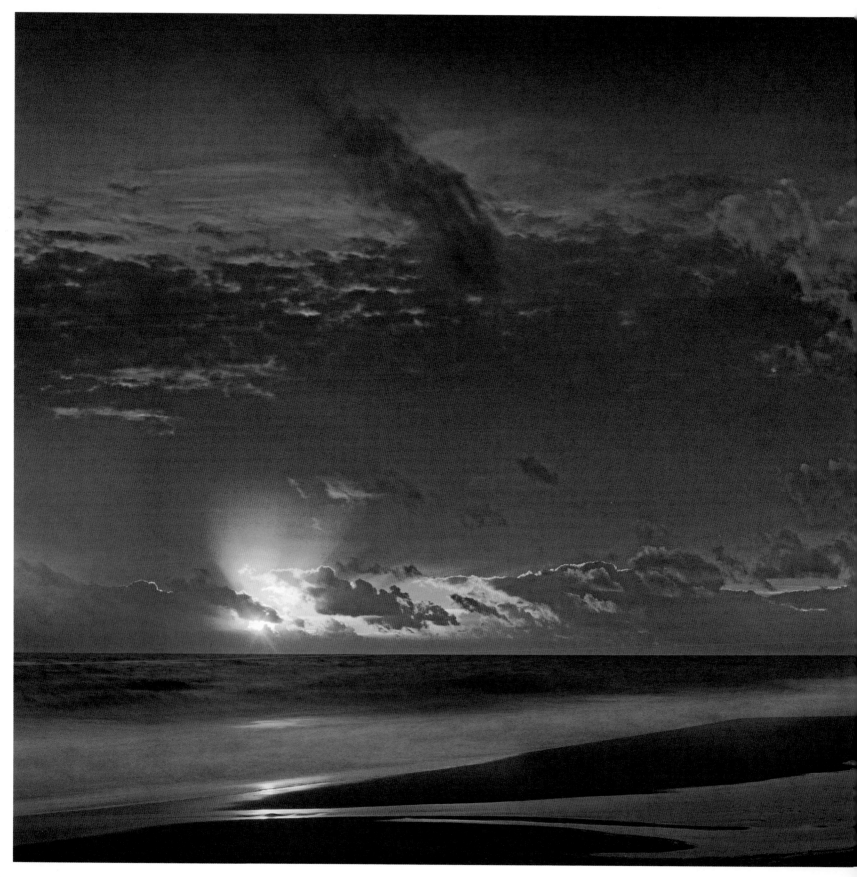

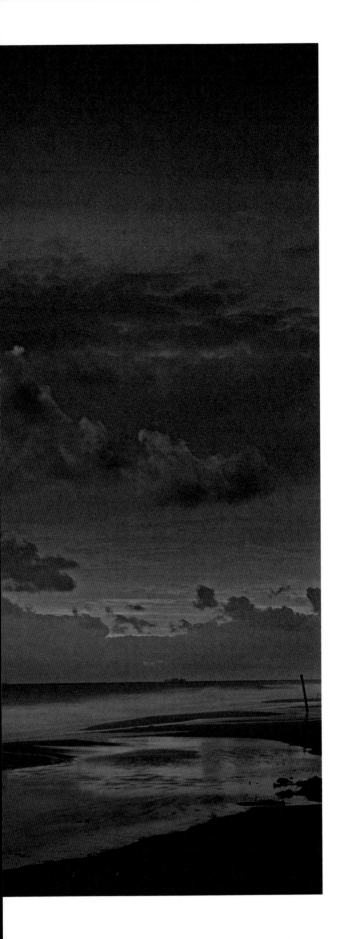

The sun rose
On the flawless
Brimming sea into
A sky all brazen

–HOMER

TIM FITZHARRIS | MACARTHUR BEACH, FLORIDA
Sunrise brightens clouds at MacArthur Beach. Located on an island off of Florida's southeastern coast, the beach helps protect the mainland from powerful Atlantic surf.

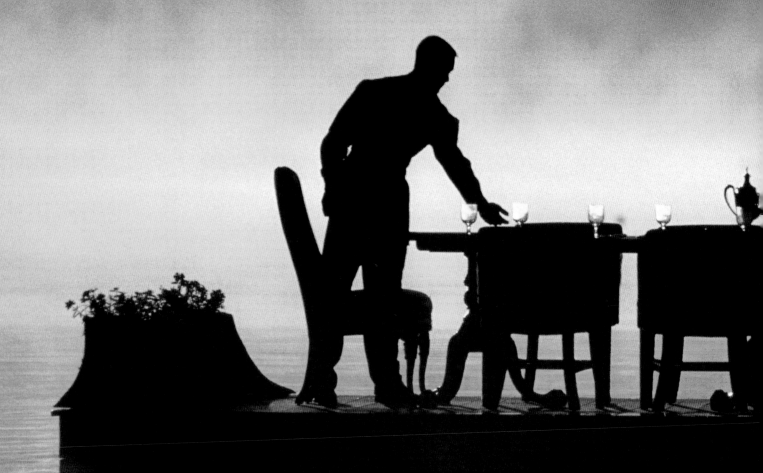

MICHAEL MELFORD | LAKE PLACID, NEW YORK
A silhouetted waiter sets a table on a floating dining room at the start of the day at Lake Placid in the heart of the Adirondacks.

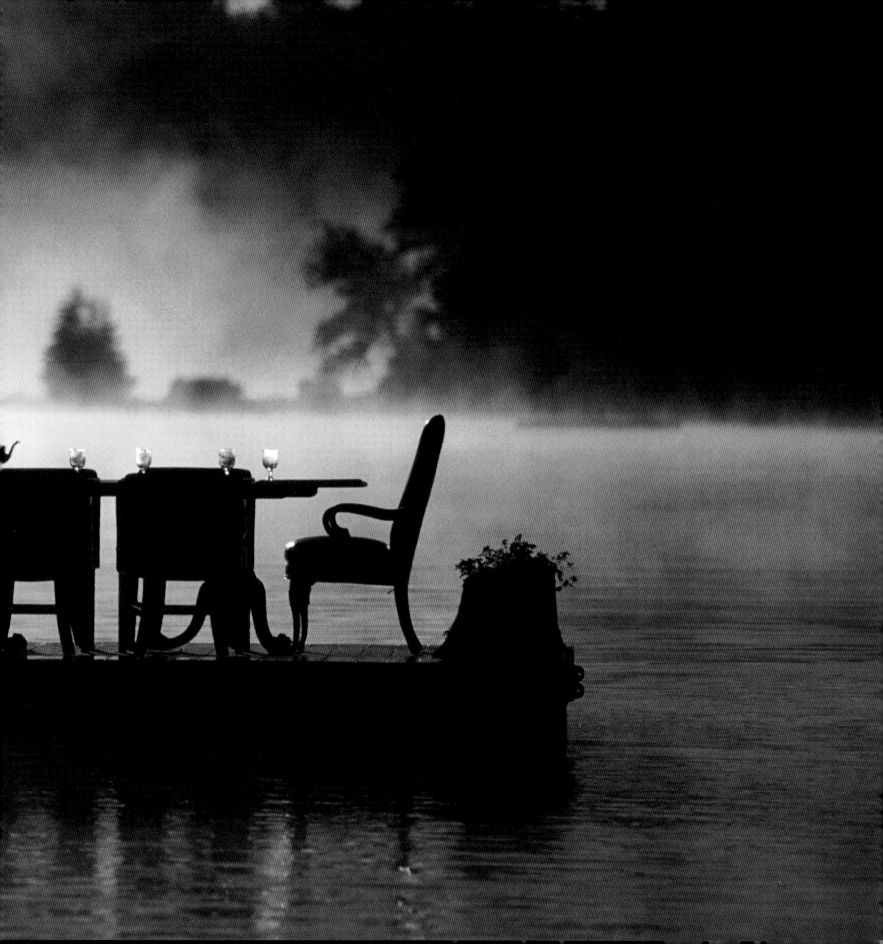

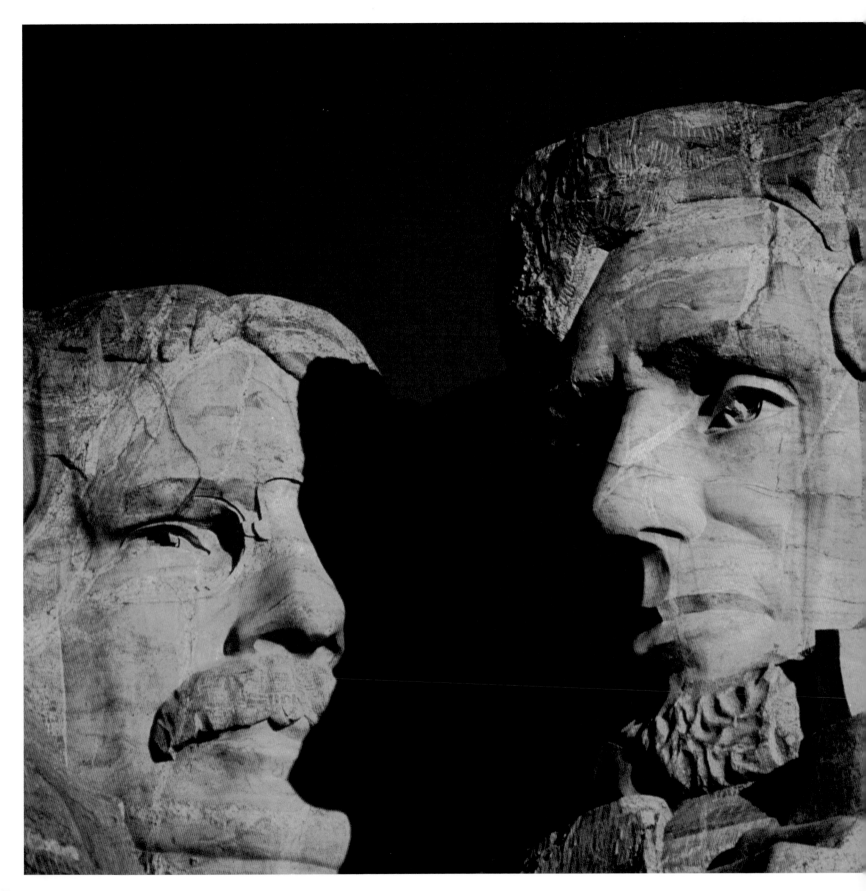

LONELY PLANET | MOUNT RUSHMORE, SOUTH DAKOTA
As they have for more than 70 years, Presidents Theodore Roosevelt and Abraham Lincoln greet the sunrise on Mount Rushmore in the Black Hills of South Dakota.

The flowers that sleep
by night, opened their
gentle eyes and turned
them to the day.
The light, creation's mind,
was everywhere, and all
things owned its power.

–CHARLES DICKENS

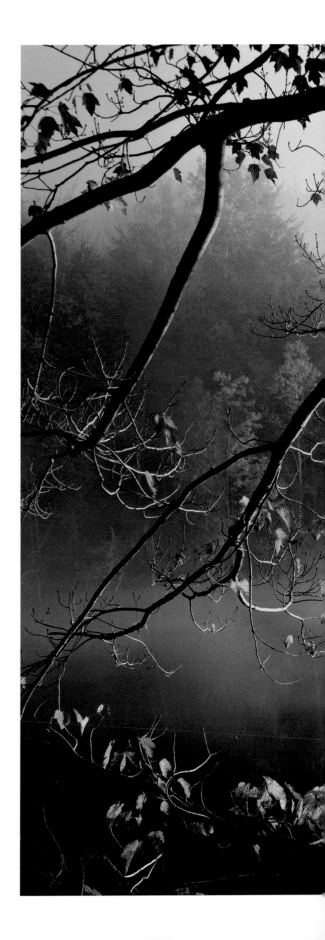

CARR CLIFTON | NEW YORK
*Fall foliage frames an early morning view of Heart Lake in New York's
Adirondack Park and Preserve.*

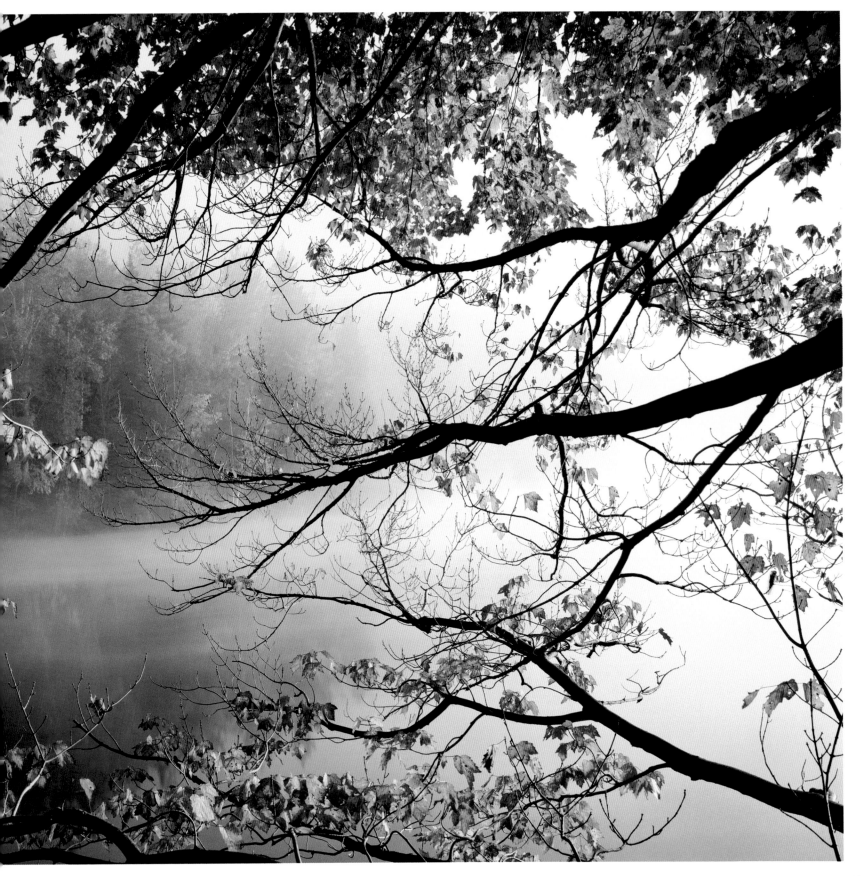

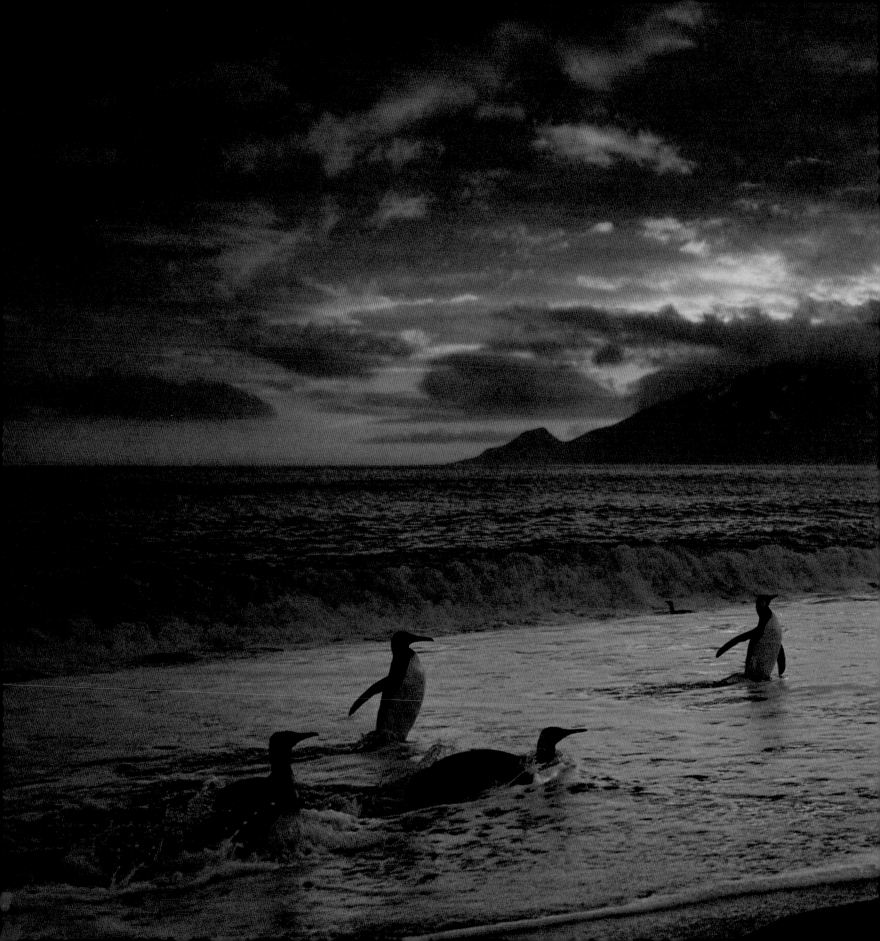

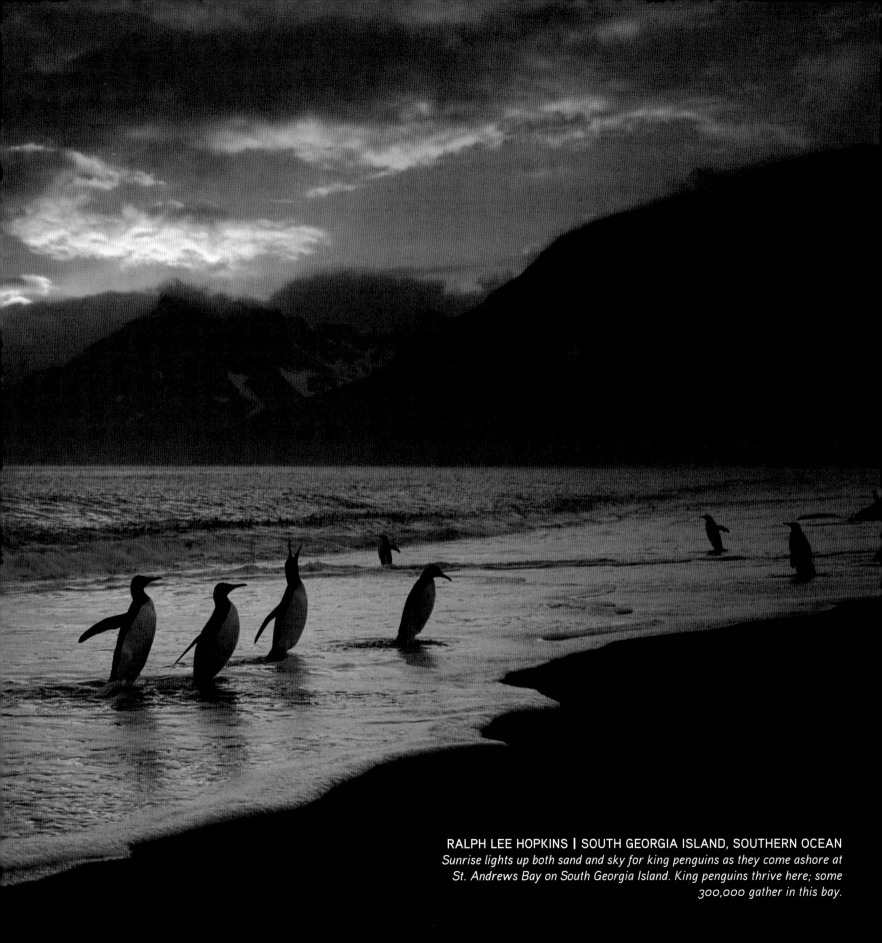

RALPH LEE HOPKINS | SOUTH GEORGIA ISLAND, SOUTHERN OCEAN
*Sunrise lights up both sand and sky for king penguins as they come ashore at
St. Andrews Bay on South Georgia Island. King penguins thrive here; some
300,000 gather in this bay.*

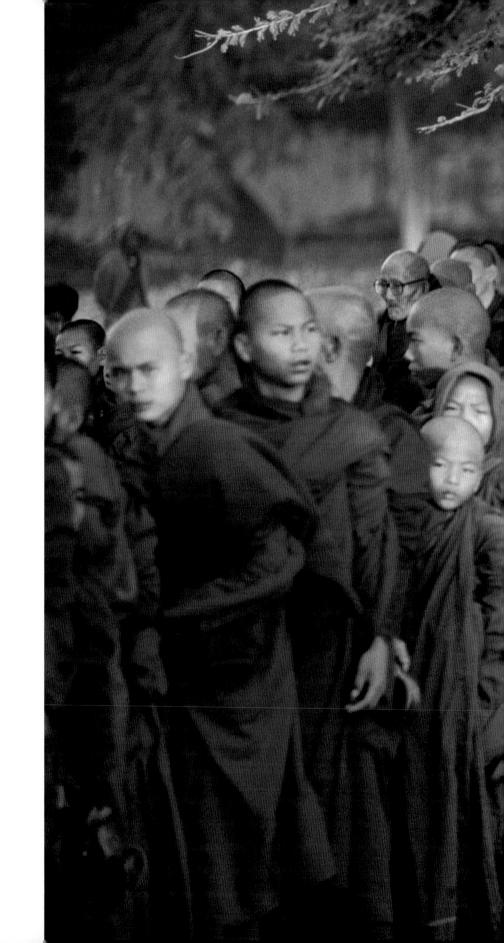

ANDERS BLOMQVIST | BAGAN, MYANMAR
Red-robed monks line up at sunrise during the Ananda Pagoda Festival in the ancient city of Bagan, Myanmar. The monks accept donations from pilgrims who travel to the festival in traditional ox carts.

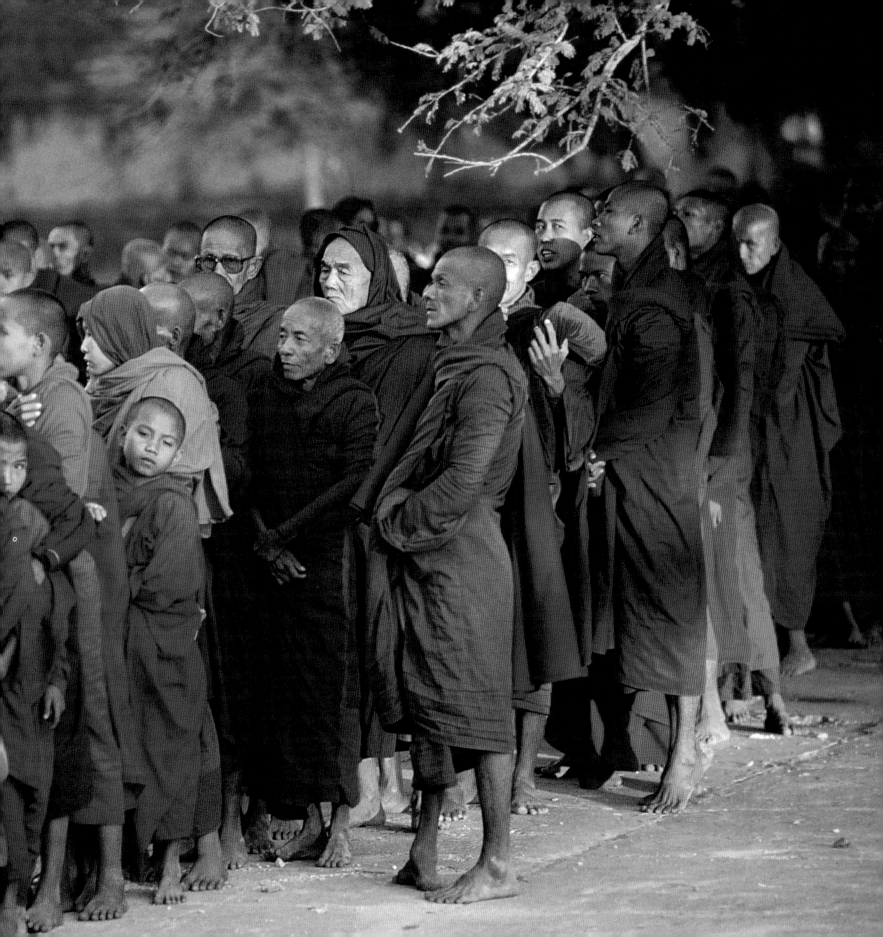

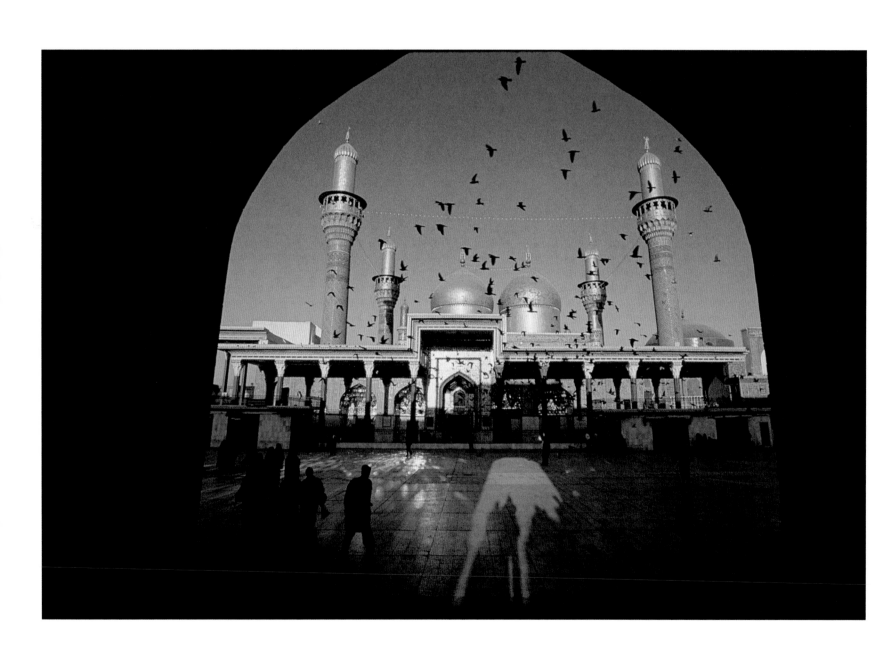

MICHAEL S. YAMASHITA | BAGHDAD, IRAQ
*Morning prayers call the faithful to the glittering domes and gold-coated minarets
of Baghdad's Kadhimain mosque in a neighborhood west of the Tigris River.*

JAMES L. STANFIELD | TELL MARDIKH, SYRIA
Sunrise casts long shadows from the 4,000-year-old city of Tell Mardikh, Syria.
The kingdom rivaled powerful Mesopotamia states in the third millennium B.C.

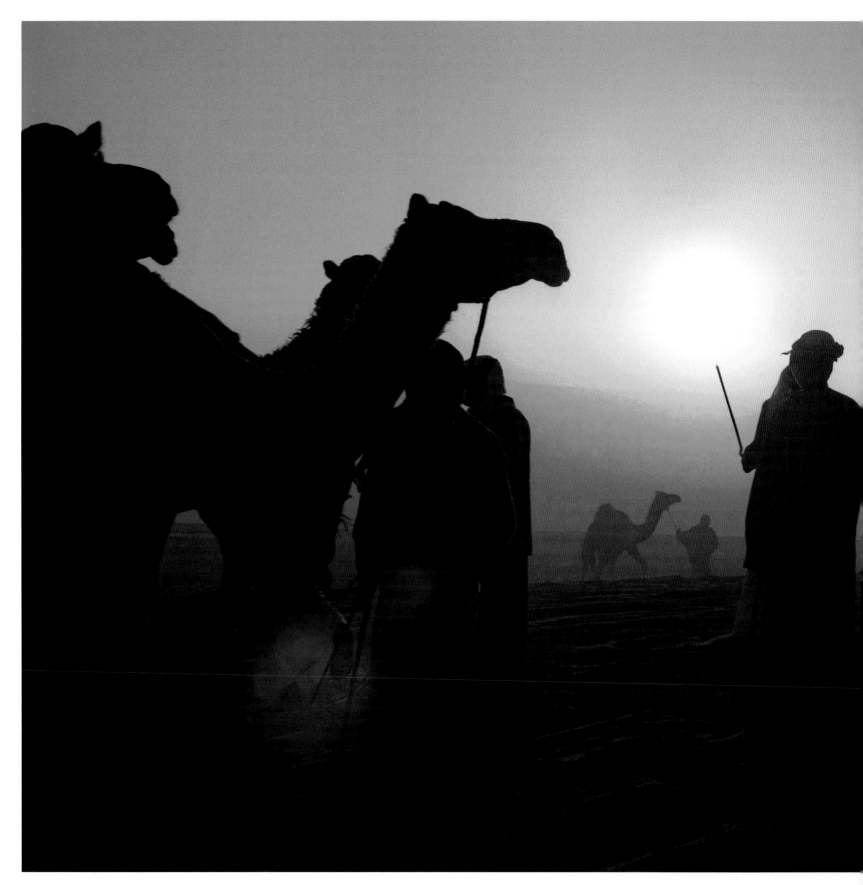

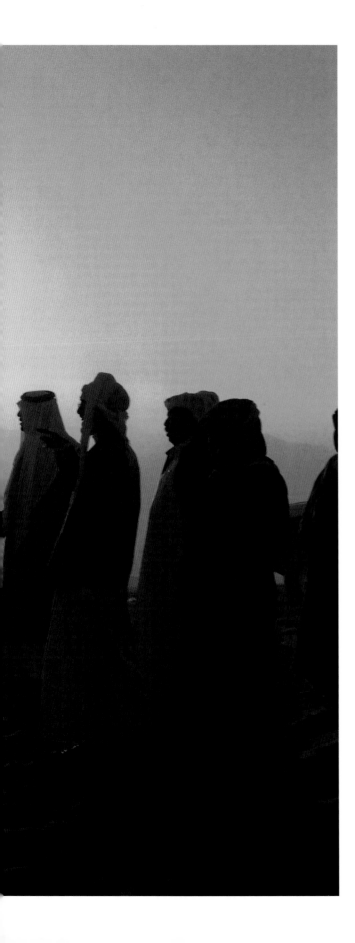

Five hours from Dubai and at the edge of the Empty Quarter—the largest continuous body of sand in the world—a small army of vehicles and camels from all over the Arab world converges for an annual camel beauty contest that includes more than 20,000 entrants. This beauty contest is more like a massive dog or horse show. Camels have lineages and pedigrees, and many are worth millions. Some have walked in with their owners or trainers, and others are trucked in when complicated border crossings are involved. Winning brings the family prestige and honor, which are valued above any of the many prizes. It's also a celebration of the tradition and importance of the camel in Arab culture. At the end of the day, groups gather in family tents or sit in the sand to tell stories by the campfire. Some look like just any simple Bedouin sitting beside a herd of camels. But any single one of those camels can be worth as much as $17 million.

RANDY OLSON
Madinat Zayid, United Arab Emirates
Camels wait for the beginning of a beauty contest.

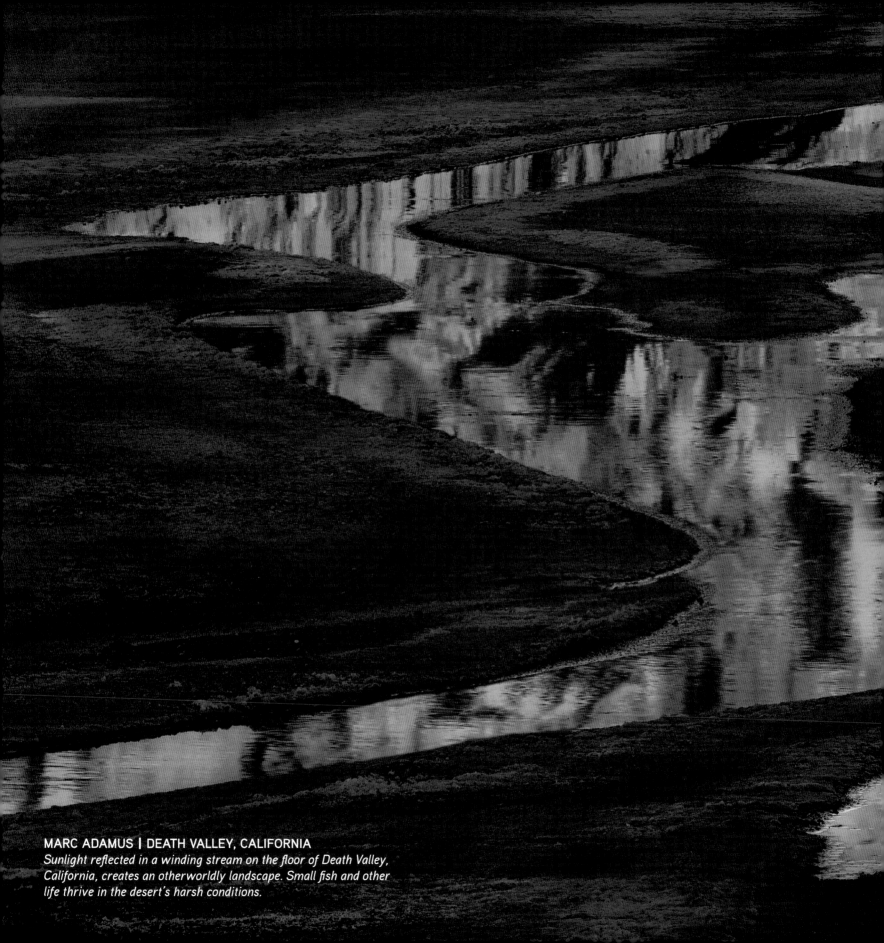

MARC ADAMUS | DEATH VALLEY, CALIFORNIA

*Sunlight reflected in a winding stream on the floor of Death Valley,
California, creates an otherworldly landscape. Small fish and other
life thrive in the desert's harsh conditions.*

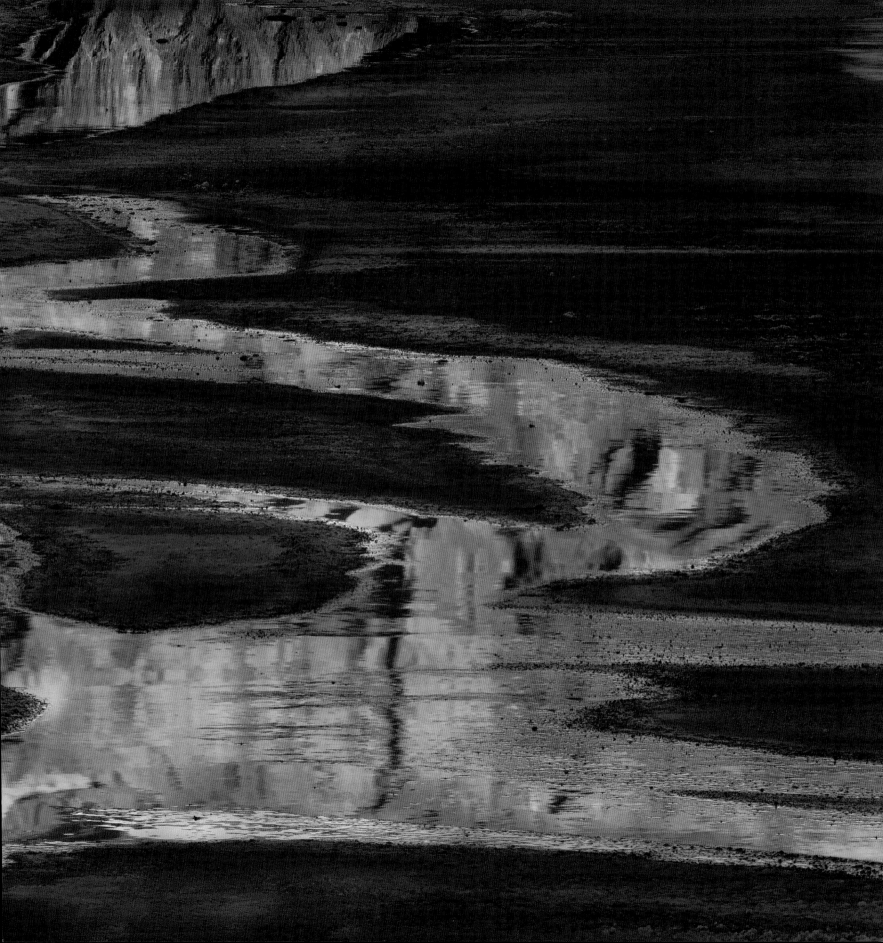

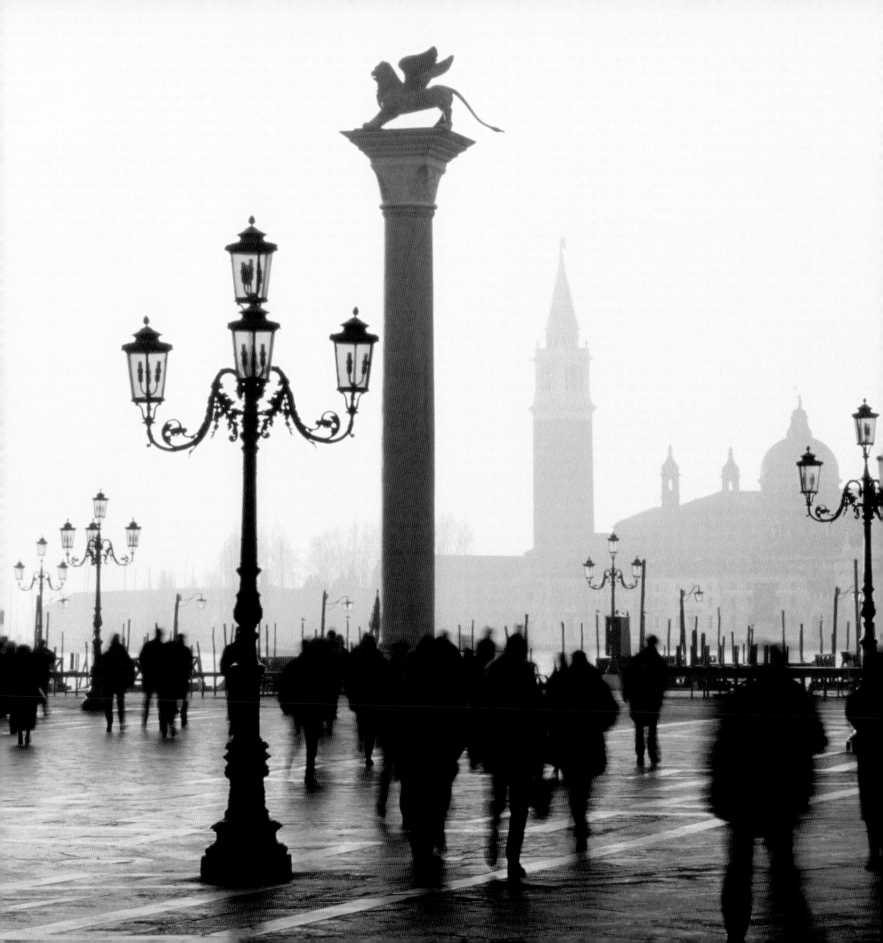

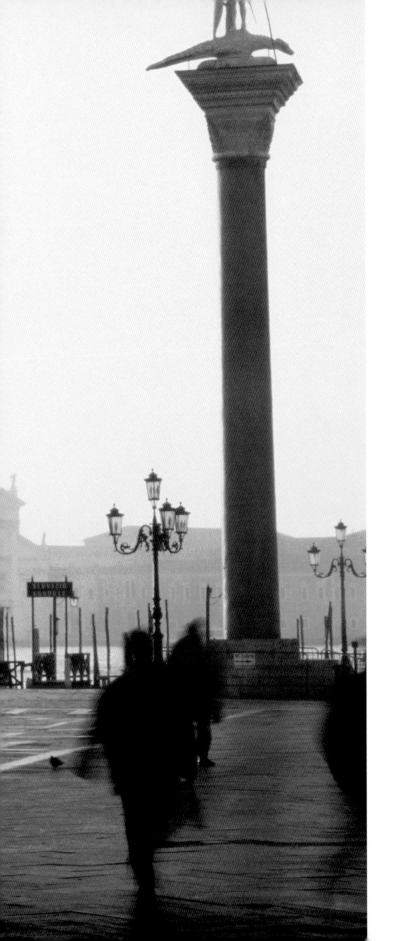

LEE FROST | VENICE, ITALY
Visitors to St. Mark's Square in Venice get an early start in the city known as La Serenissima, "the most serene one." San Giorgio Maggiore falls into shadow in the background.

FRANS LANTING | KENYA
*A fiery dawn silhouettes a lone wildebeest in the Masai Mara
National Reserve, Kenya. Some two million wildebeests migrate
annually between here and Tanzania's Serengeti National Park.*

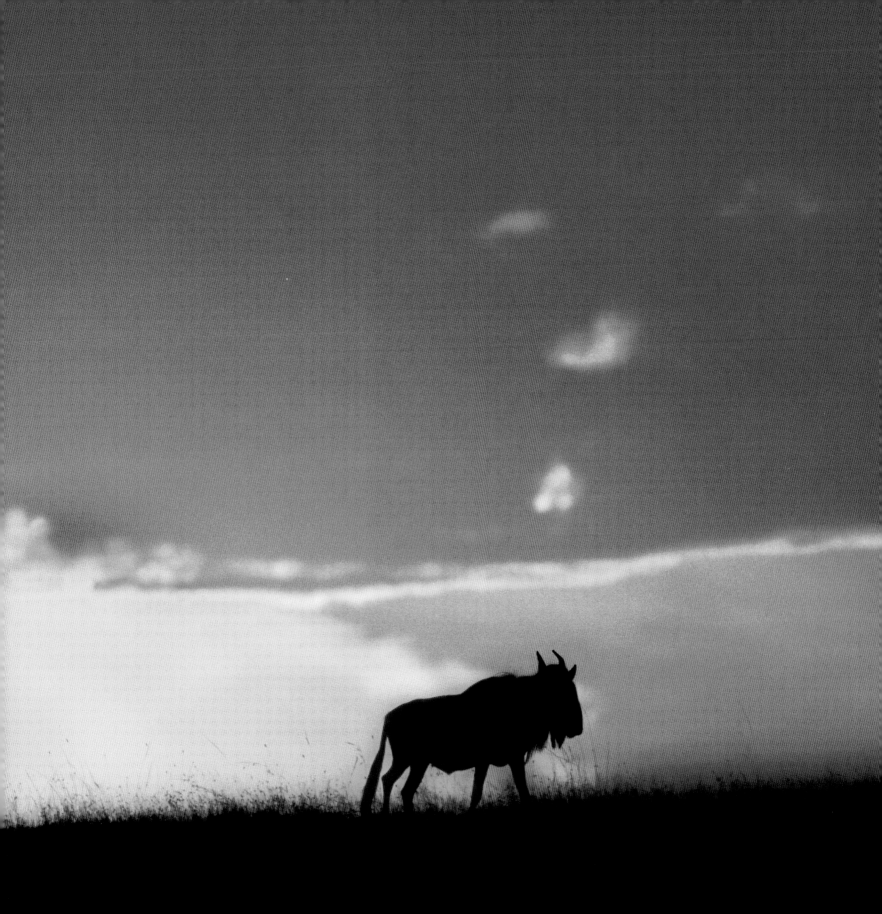

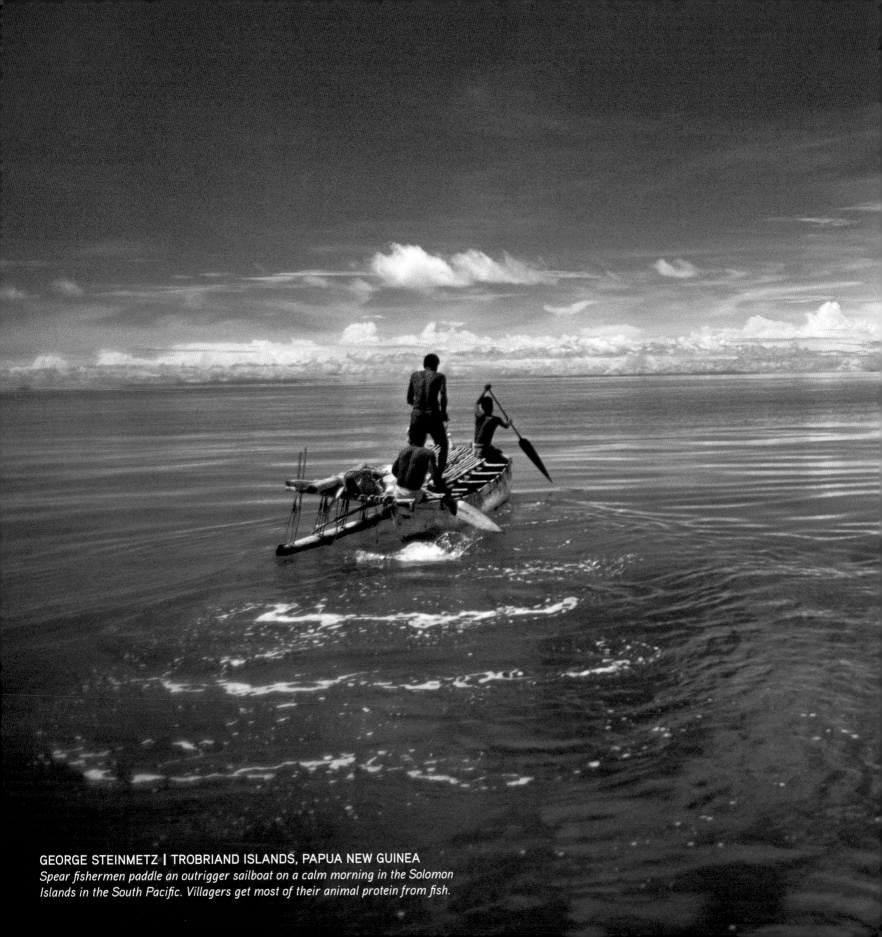

GEORGE STEINMETZ | TROBRIAND ISLANDS, PAPUA NEW GUINEA
Spear fishermen paddle an outrigger sailboat on a calm morning in the Solomon Islands in the South Pacific. Villagers get most of their animal protein from fish.

THE DAY GROWS ON

us. Morning light opens our eyes. The world is new, dew-washed, refreshed, and full of possibility. Now light serves to illuminate. We no longer are drawn to look at the sun, but instead our eyes survey the vast world on which it shines. Sly at first, casting cool shadows, light's angle lifts steadily above us, as if some great hand reached up to swivel the lamp to let us look more clearly at the way in which we live.

Morning is the springtime of the day, and morning light washes the world in living colors. Flower blossoms open and, in the early sunshine, dare to show their true colors. Birds add melody; they sing more in the morning. Light opens time and invites new life. "Morning has broken, like the first morning," sings a choir of children, their voices new and eager, their eyes looking up at the sky.

The first morning of creation, wrote the ancient Hebrews, was the very time that God first made the light: on Earth, darkness first. And then God said, "Let there be light." Light and morning were the first new beginnings, the first creations of all time. God and the Hebrews and all creation—every one of us, as we open into the full brilliance of each new day's light—can feel the warmth of the morning and know, or pray, or downright determine, that it is good.

JIM RICHARDSON | CHINA *A colorfully dressed farmer walks along a dirt path to harvest rice from terraced fields. Richardson says, "Energy is everywhere in the morning. People stride boldly, breezes bluster with freshness, the day pulses."*

JIM RICHARDSON | BRITTANY, FRANCE
The stone floor of a church in Brittany comes alive with color as morning sun filters through stained glass.

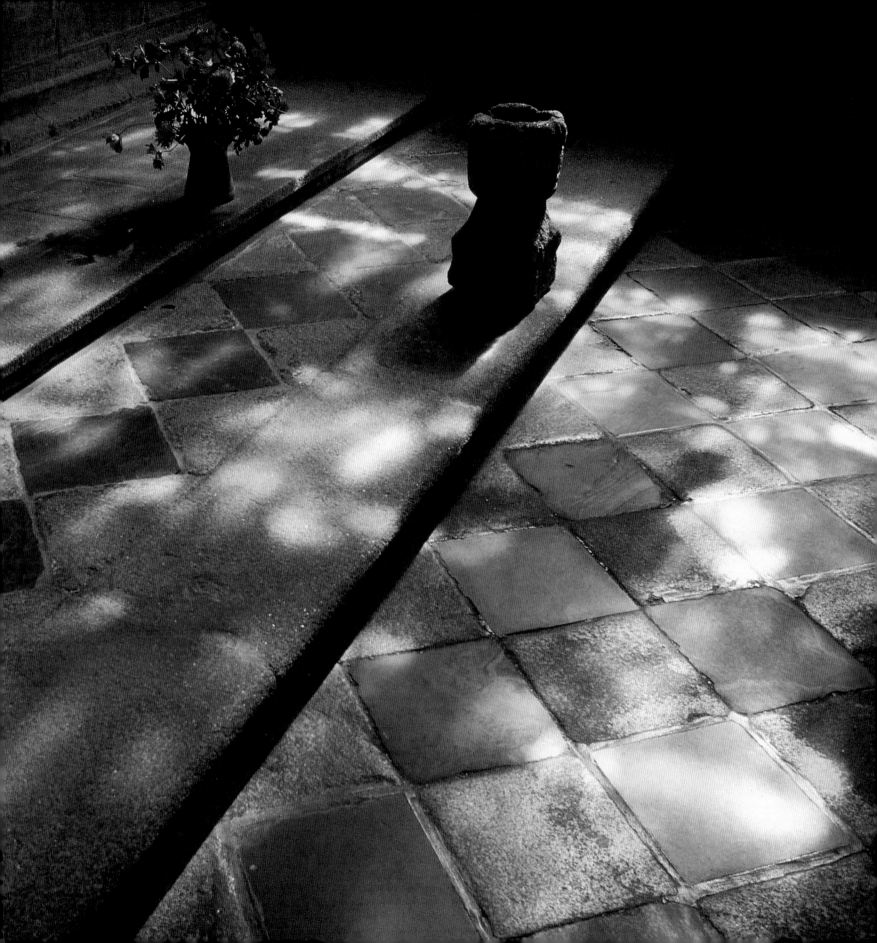

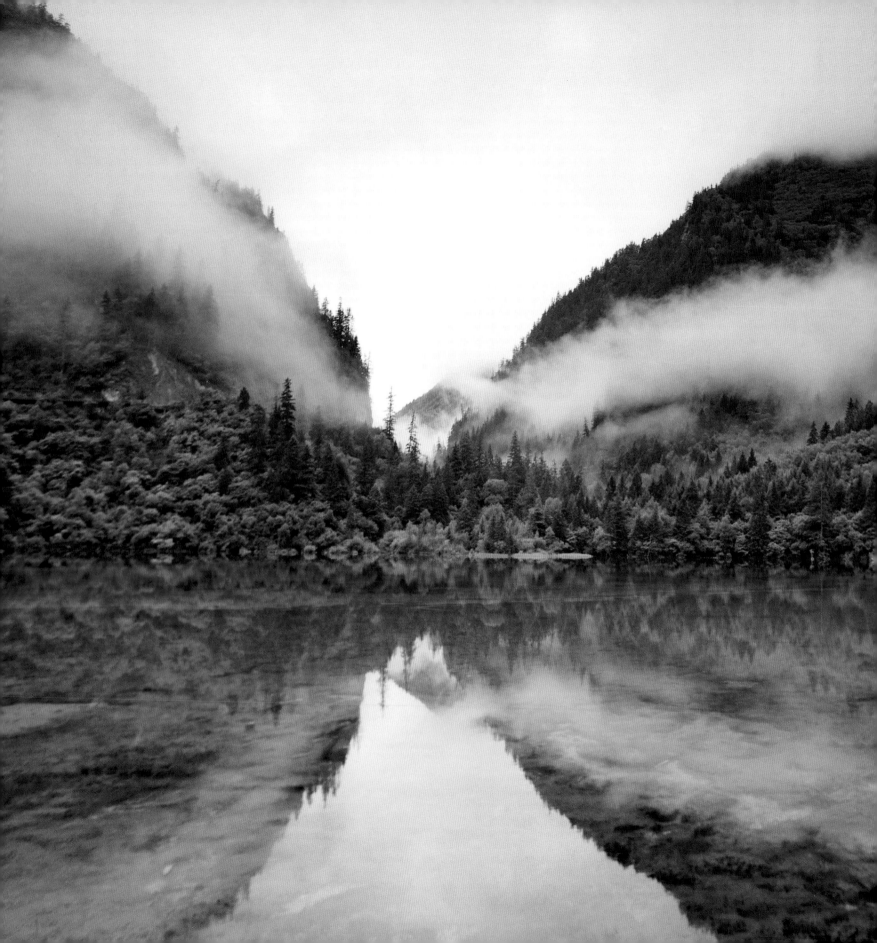

Full many a glorious
morn have I seen
Flatter the mountain-
tops with sovereign eye,
Kissing with golden face
the meadows green,
Gilding pale streams
with heavenly alchemy.

—WILLIAM SHAKESPEARE

MICHAEL S. YAMASHITA | JIUZHAIGOU, CHINA
*Crystal waters glisten below morning clouds over Five Colored Pond in
China's Jiuzhaigou Nature Reserve. Legend holds that a Tibetan goddess
dropped a mirror polished by clouds to form the reserve's 118 lakes.*

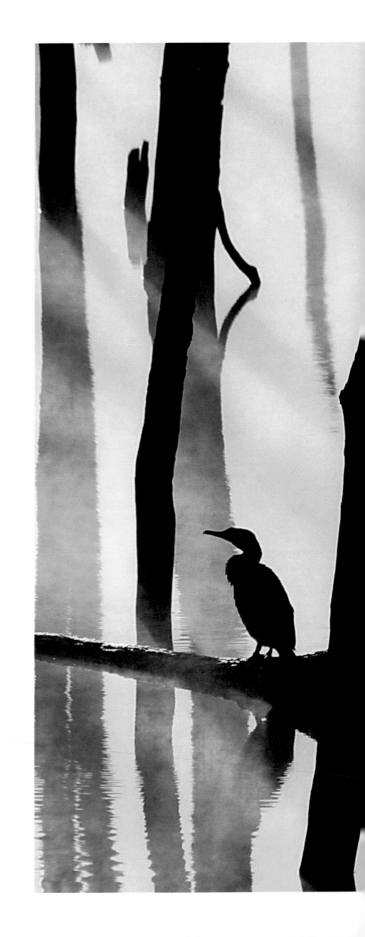

ROGER BECKER | HOWELL, NEW JERSEY
A pair of waterbirds sit on a log on a foggy morning at a
park in Howell, New Jersey.

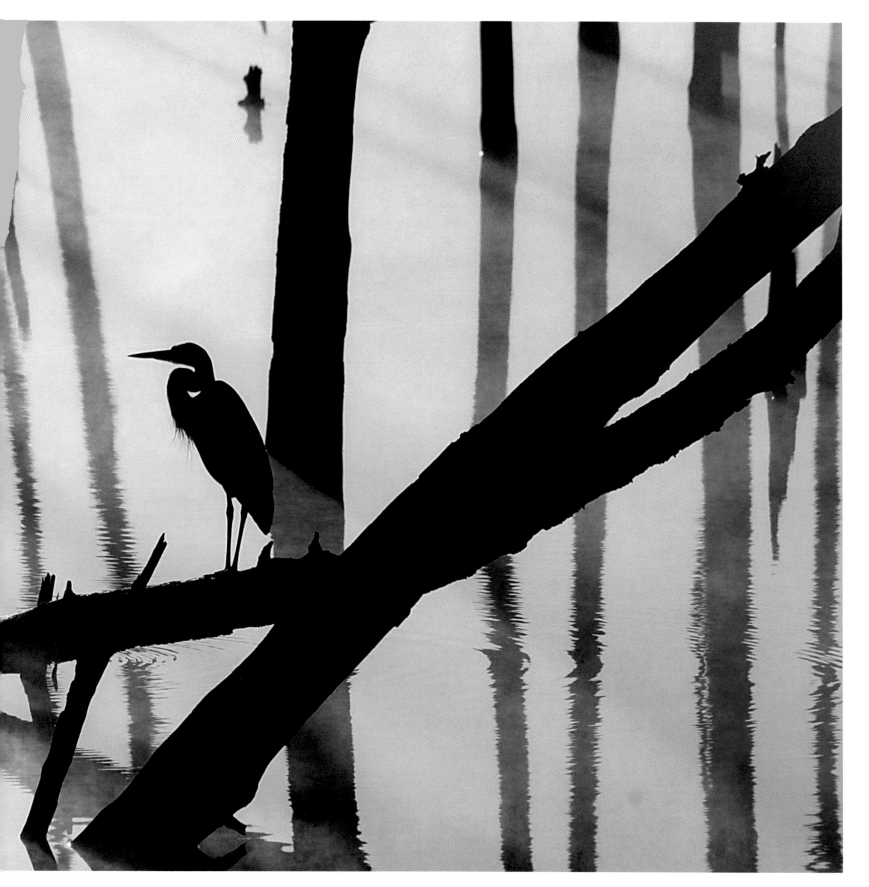

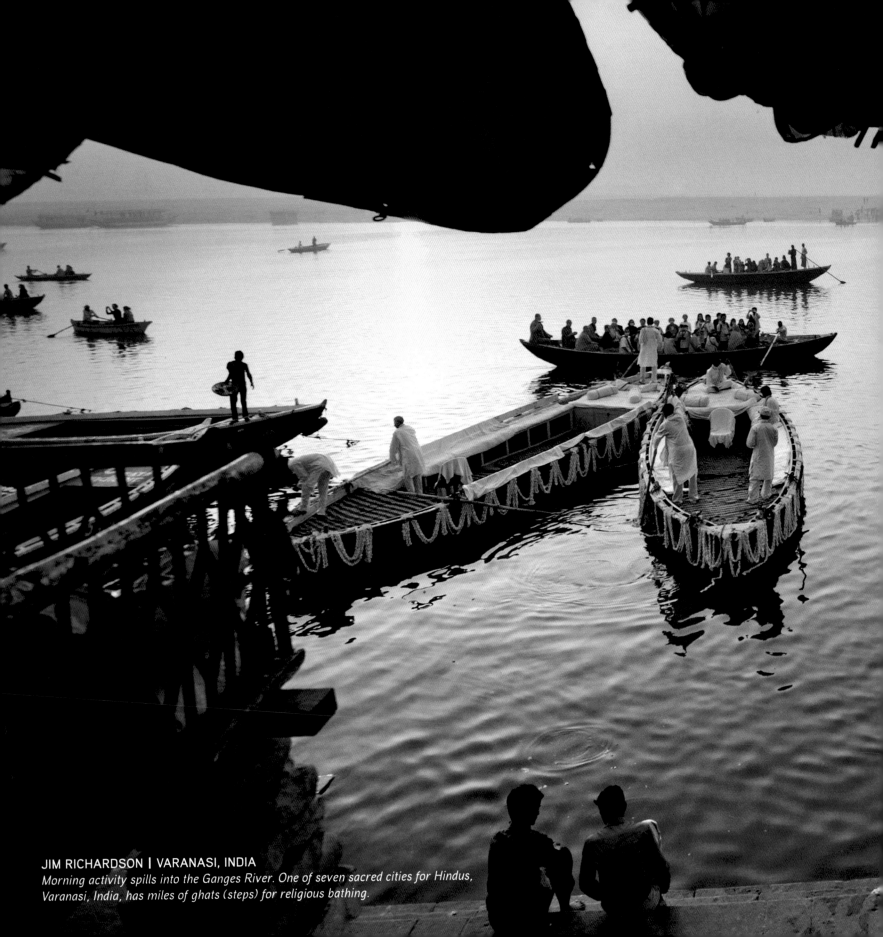

JIM RICHARDSON | VARANASI, INDIA

Morning activity spills into the Ganges River. One of seven sacred cities for Hindus,
Varanasi, India, has miles of ghats (steps) for religious bathing.

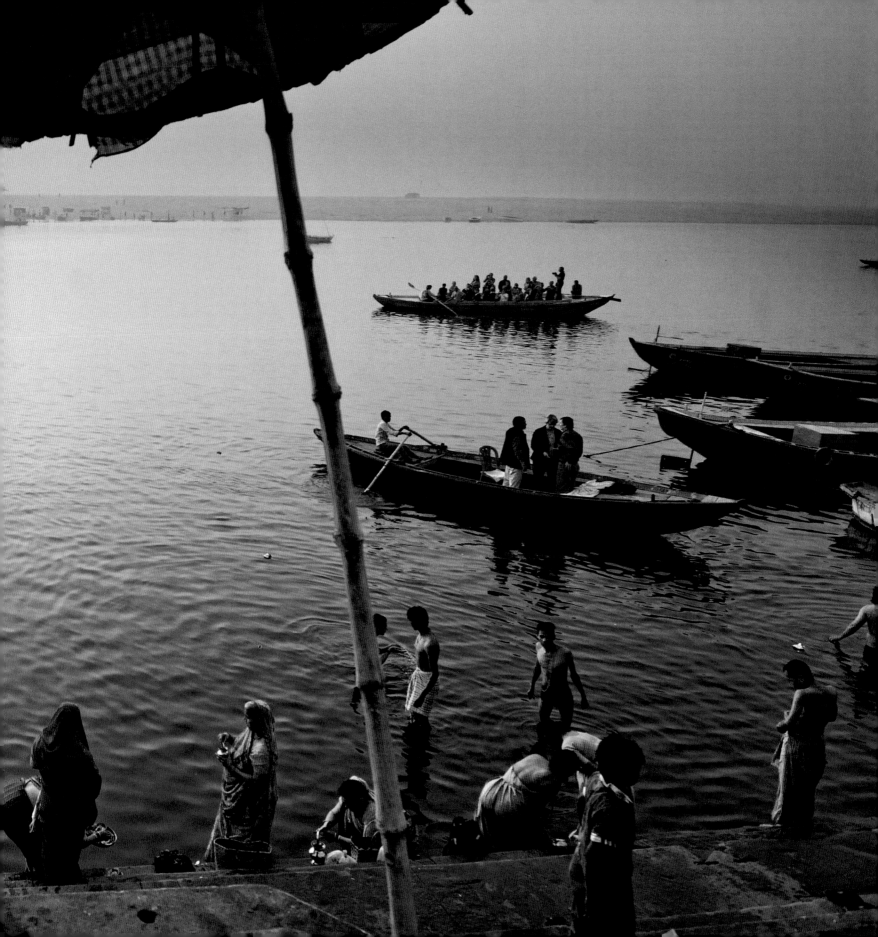

A few years ago, at New Zealand's

Poor Knights Islands, I was underwater, at the mouth of a cavern, surrounded by schools of fish. Spying a red pigfish darting repeatedly through the school of blue maomao, I adjusted my camera's settings in hopes of creating a dreamlike image. I experimented with the movement and mixing light, releasing the shutter at those fleeting moments when gesture and grace blended together. Back on the boat, I stared at the tiny images on my camera's LCD playback. Among the many misses was a single, perfect frame, the picture I had in my mind's eye before entering the water that day. It was the image of a once and future ocean; a sea of abundance that had been restored because of conservation—exactly what had happened to this nature reserve following 60 years of marine life protection.

BRIAN SKERRY

Poor Knights Islands, New Zealand
A red pigfish darts through a school of blue maomao.

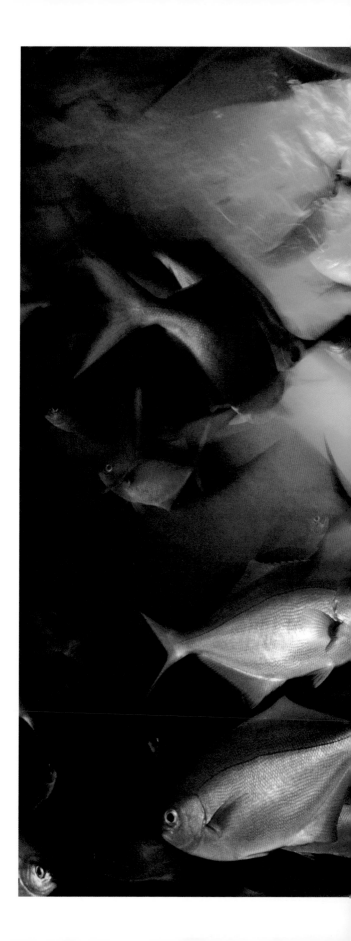

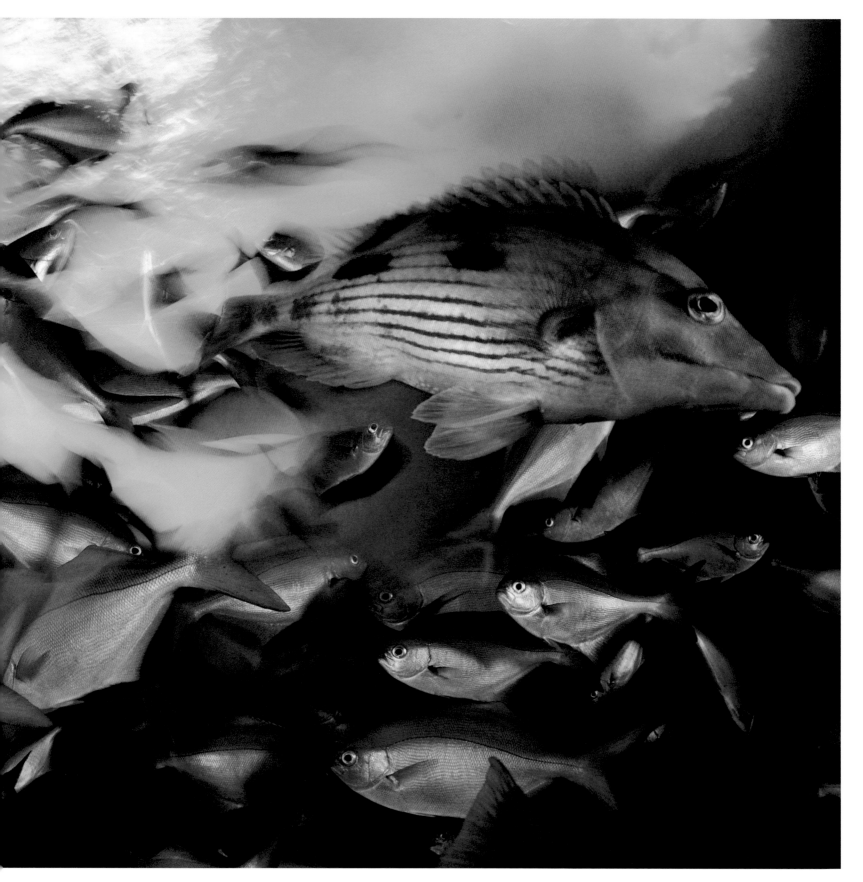

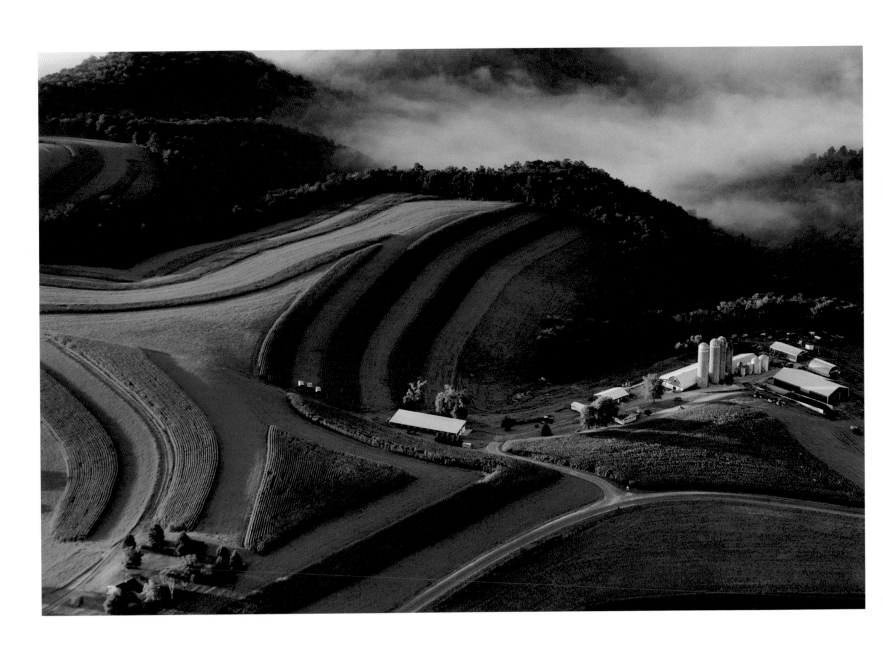

JIM RICHARDSON | SOUTHWEST WISCONSIN
*Carefully cultivated shapes create patterns on farmland in southwest Wisconsin
near the Mississippi River as low-hanging clouds fill in the ridges.*

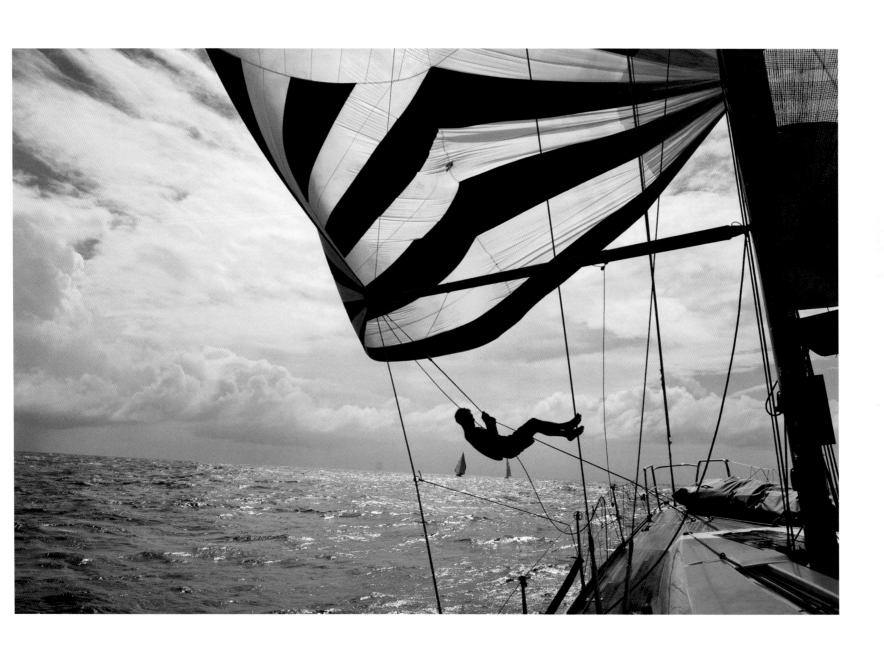

MATT PROPERT | GRENADA

Sun dapples the waves as a sailor hangs in the rigging during the Mount Gay Rum Round Barbados yacht race in the Caribbean, a tradition since 1936.

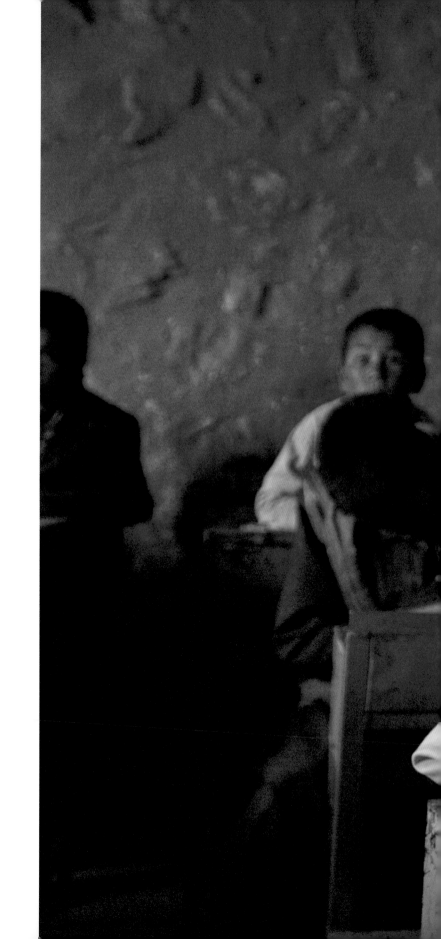

STEVE MCCURRY | BAMIAN, AFGHANISTAN
Afghan schoolboys pay close attention to their lessons in Bamian.
Many schoolchildren in the province learn in tents, but these boys
are lucky that their school has walls.

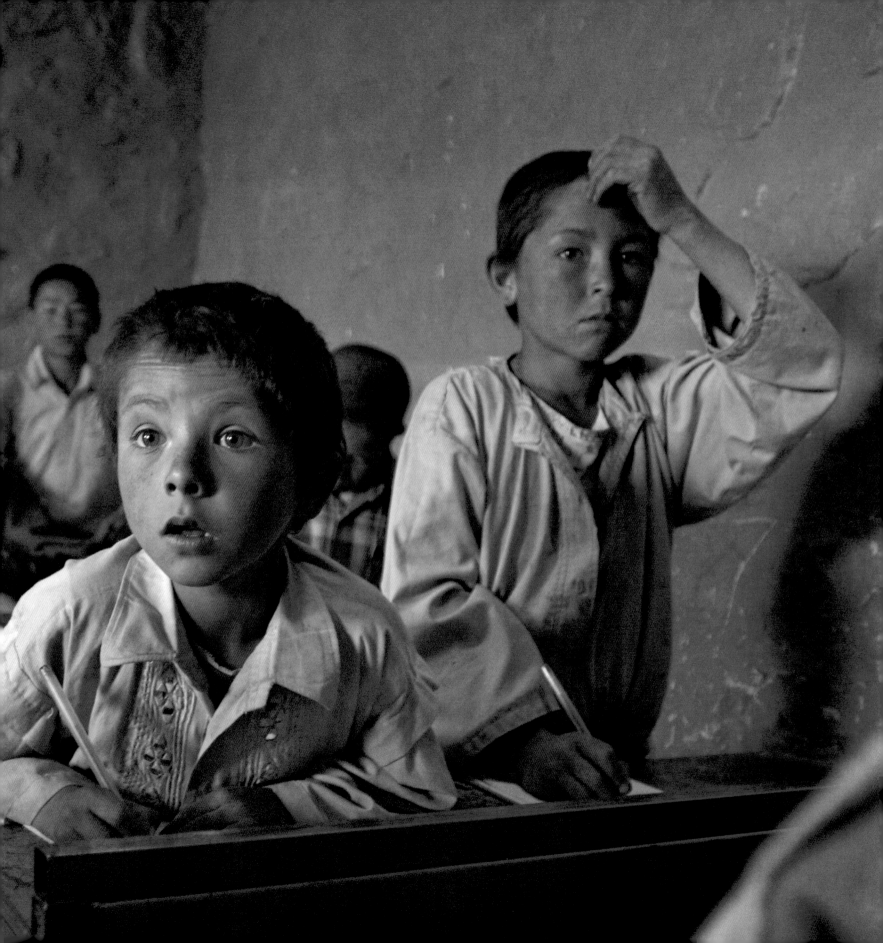

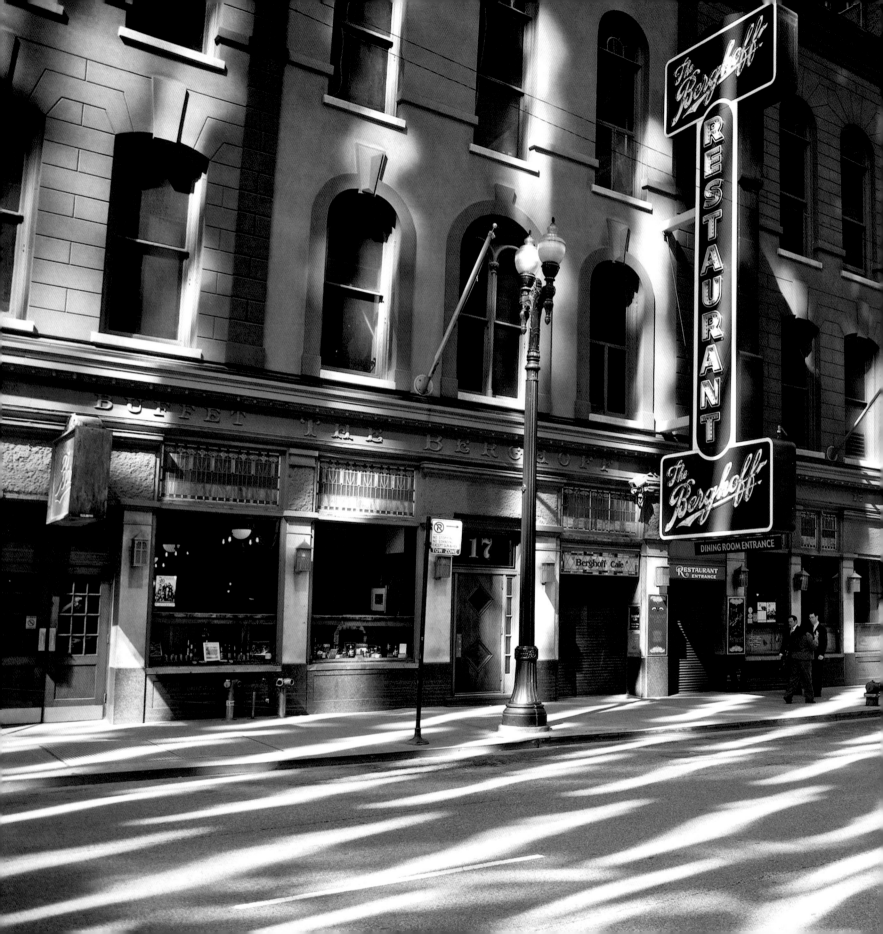

Light races across
the land in the morning.
It will not wait.

–JIM RICHARDSON

MELISSA FARLOW | CHICAGO, ILLINOIS
Morning sunlight dapples the sidewalk outside Berghoff
Restaurant in Chicago, Illinois. When it opened in 1898,
the café featured German-style beer and free sandwiches.

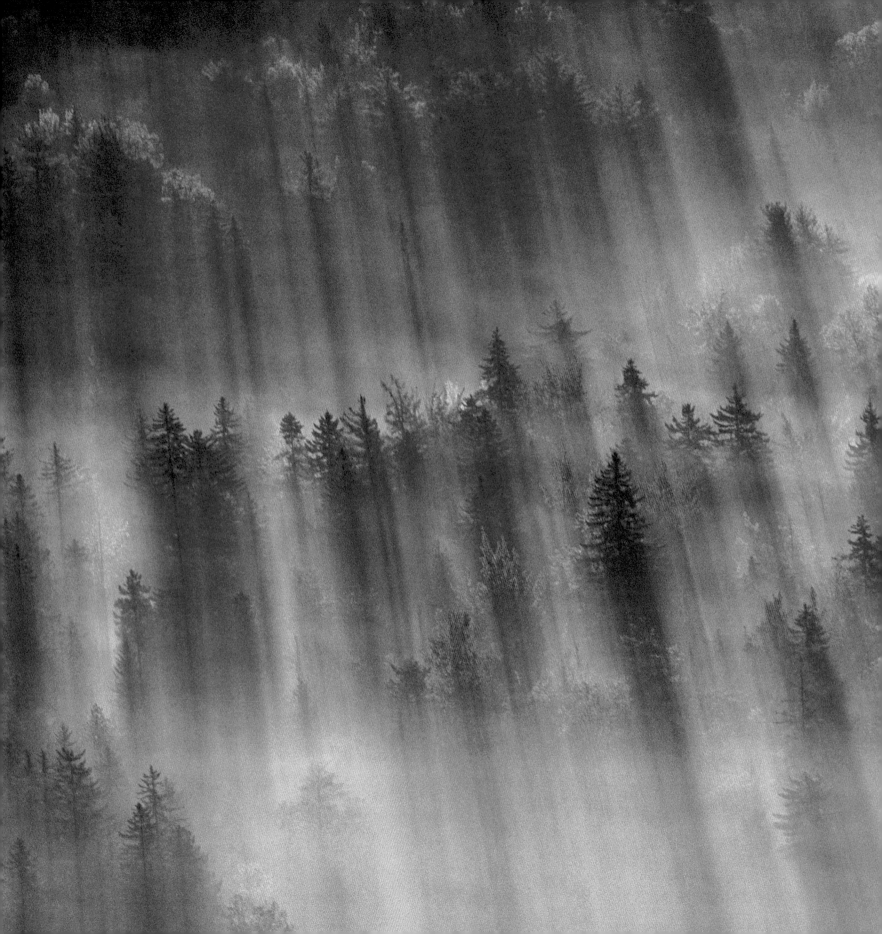

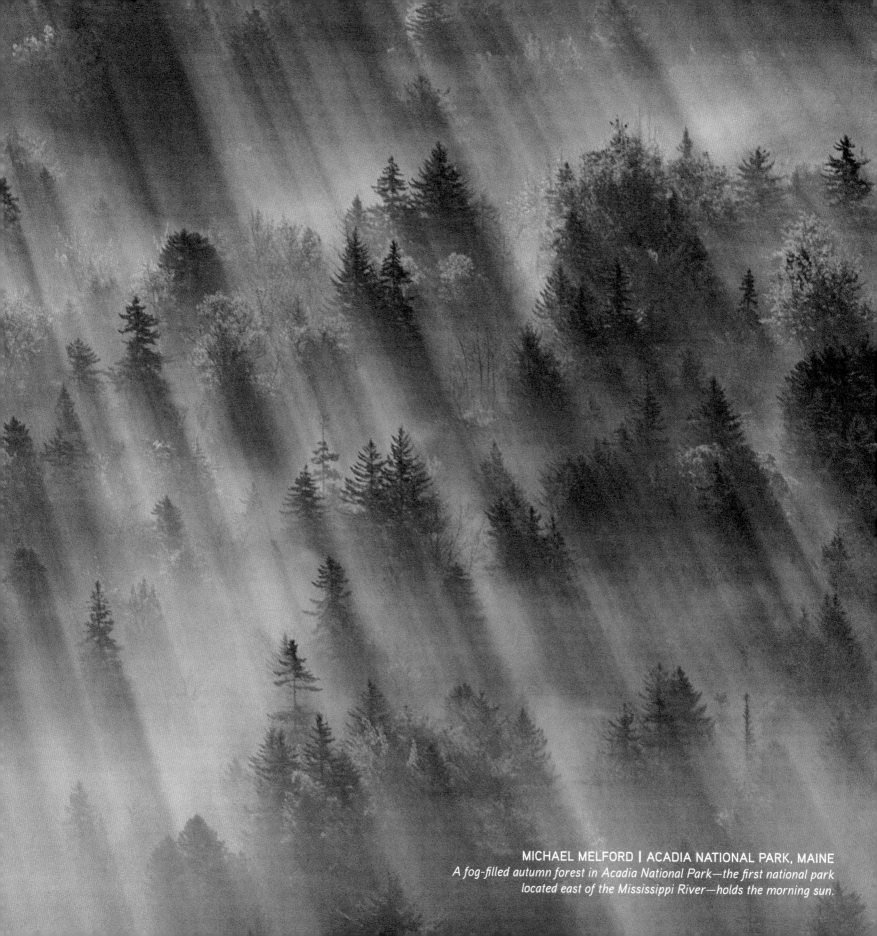

MICHAEL MELFORD | ACADIA NATIONAL PARK, MAINE
*A fog-filled autumn forest in Acadia National Park—the first national park
located east of the Mississippi River—holds the morning sun.*

CESARE NALDI | ANDAMAN ISLANDS, INDIA

A 60-year-old elephant named Rajan takes a morning dip in the warm waters of the Andaman Sea. Elephants here carried timber between islands in this sea off India's east coast.

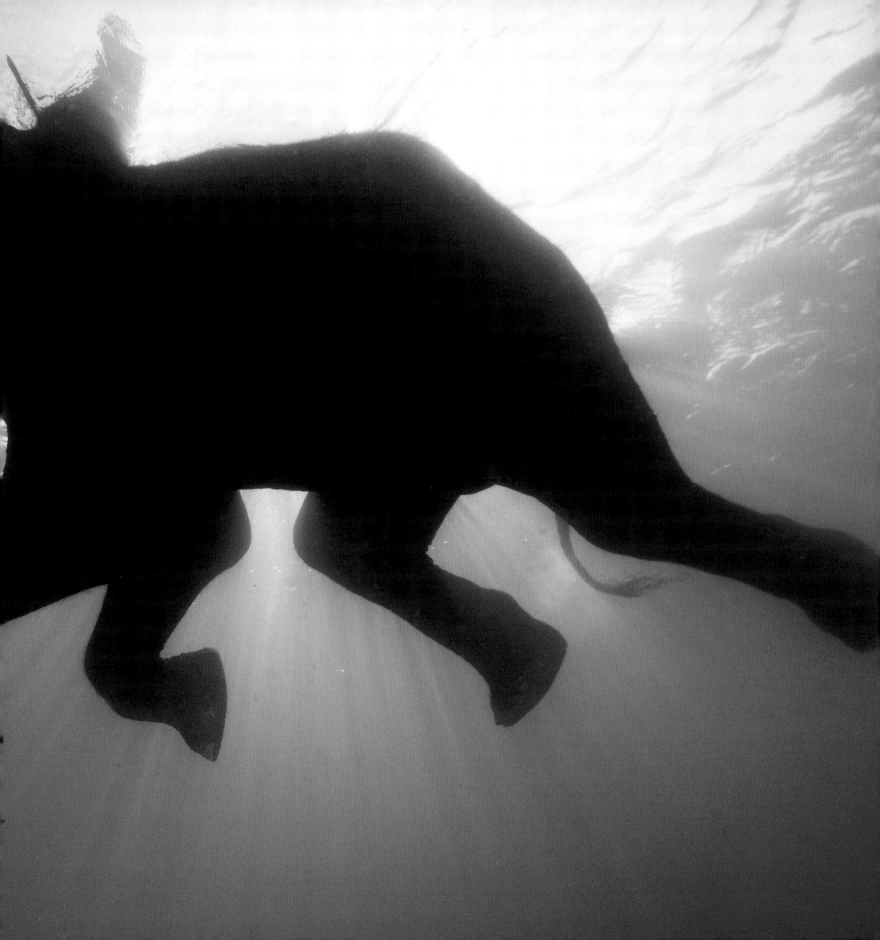

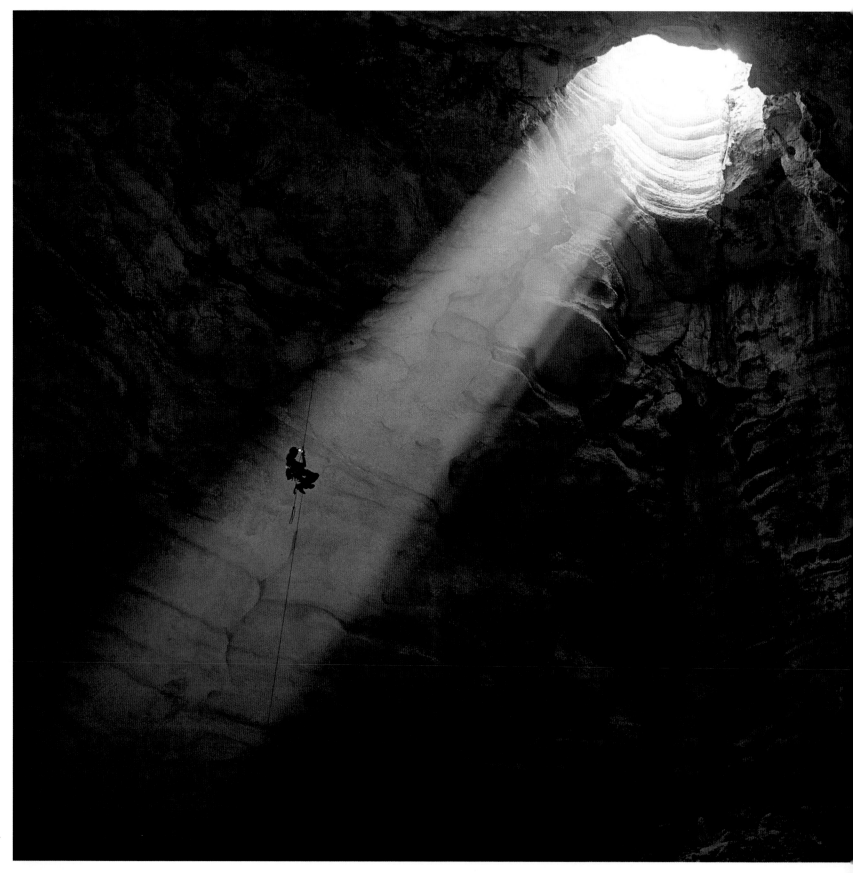

The window
of my soul I throw
Wide open
to the sun.

—JOHN GREENLEAF WHITTIER

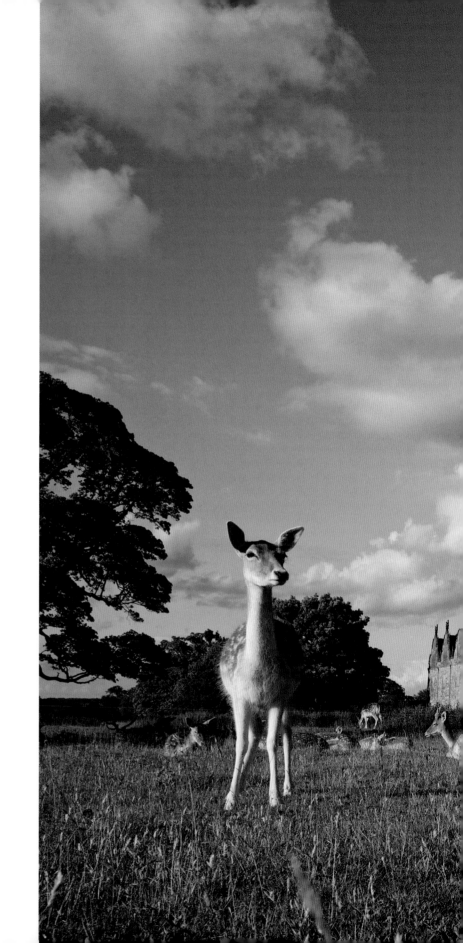

JIM RICHARDSON | SEVENOAKS, ENGLAND
Deer pepper the lawn of Knole House outside London. Both fallow and Japanese sika deer live in the 1,000-acre deer park surrounding the country house estate.

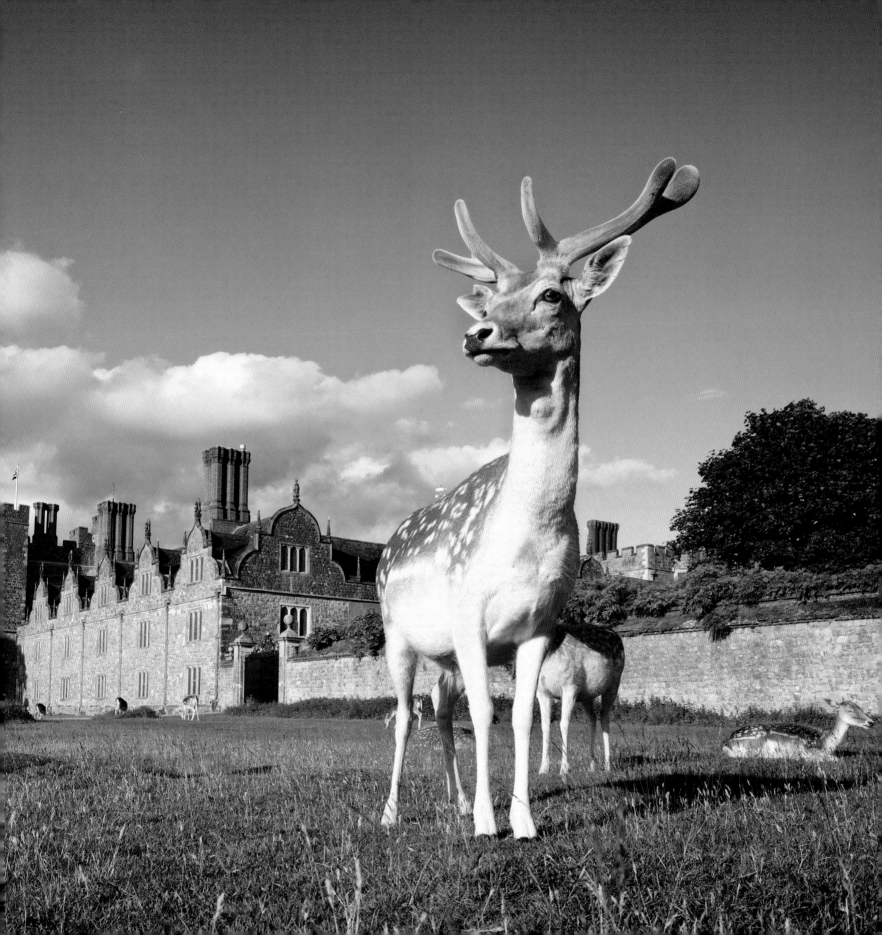

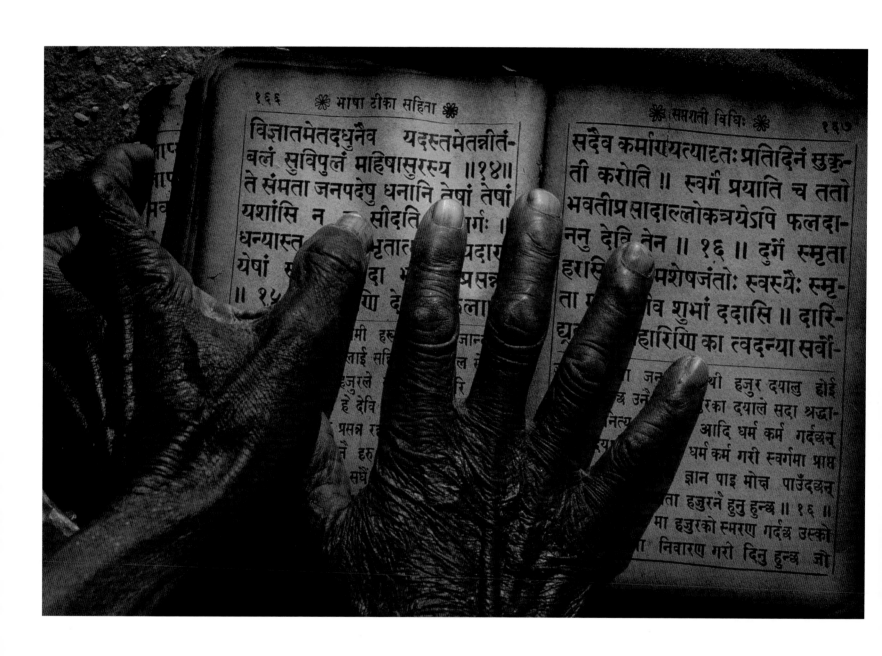

MAGGIE STEBER | DHADING, NEPAL

A man's hands move across the Ramayana, one of the two great Indian epic poems.
Morning prayers provide Hindus with a way to prepare for the day.

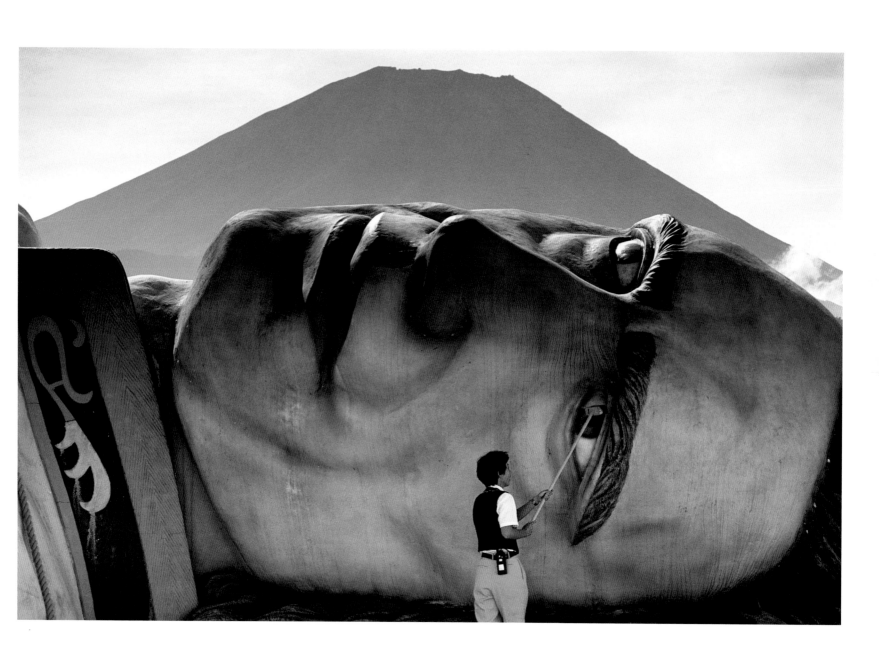

KAREN KASMAUSKI | MOUNT FUJI, JAPAN
A worker at the now demolished Gulliver's Kingdom amusement park in Japan gives the giant eye of Gulliver an early morning cleaning.

I was once nicknamed the Prince of Darkness, and my work often leans to the dark side of lighting. When I'm working on a project, I like to be out and shooting at first light, when there is that rich, warm light. When walking down a street, I will always be on the shady side of the road. This image was taken in the morning.

It's hard to believe the significant difference that digital has brought to low light shooting. You can do things handheld now that used to need a tripod. You can shoot in extremely low light levels and actually stop action, as opposed to being on a tripod at half a second. For me, the image is much more important than the process, and digital has allowed me to create images that never used to be possible.

STEVE MCCURRY

Rajasthan, India
Women cast morning shadows in Rajasthan.

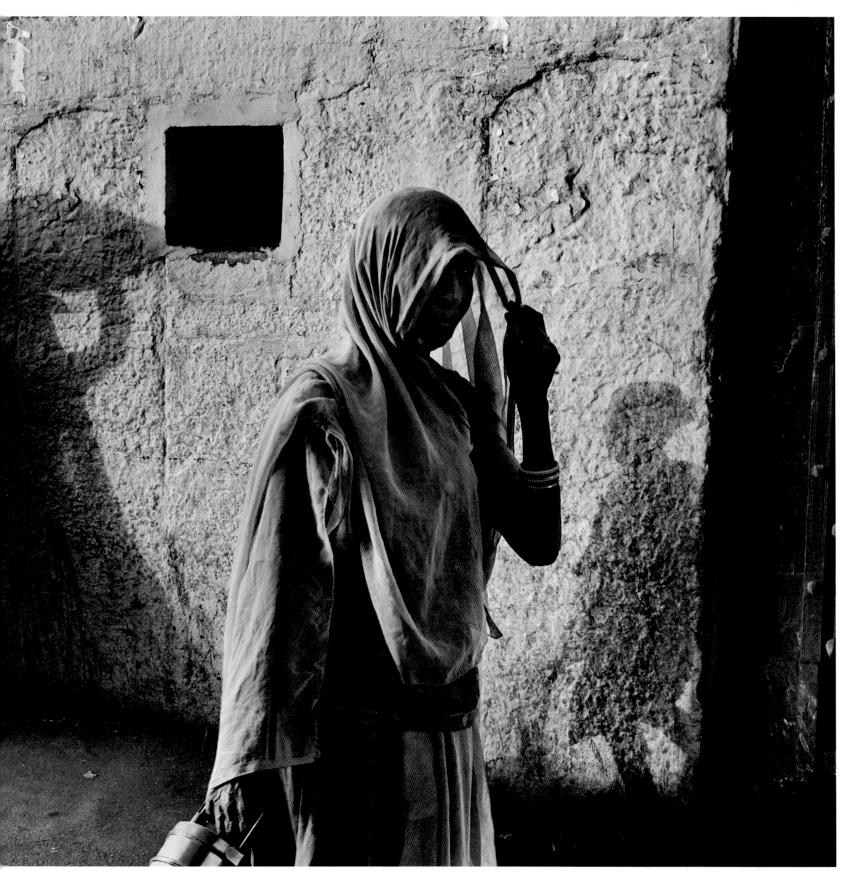

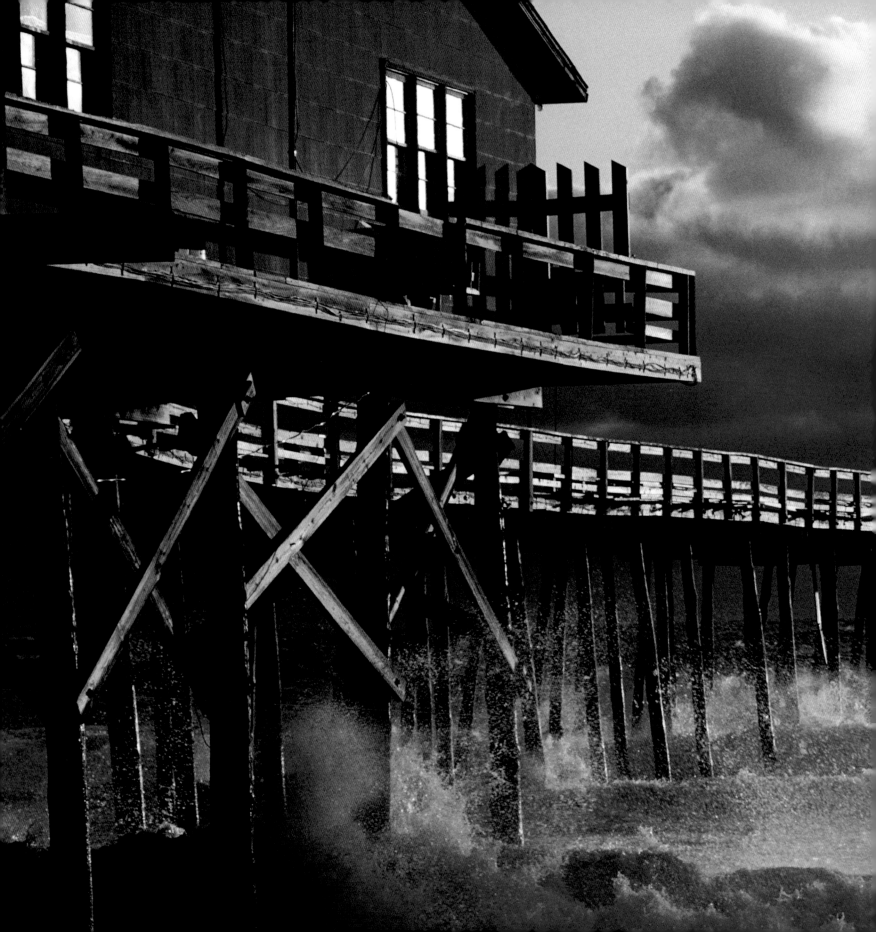

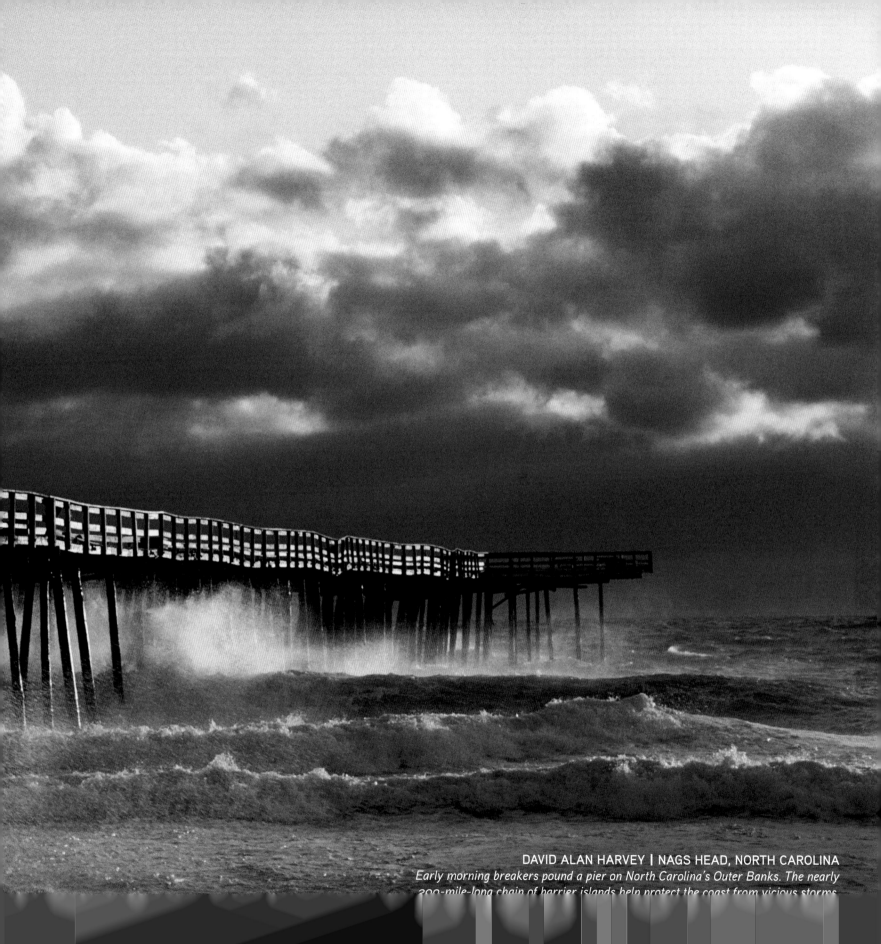

DAVID ALAN HARVEY | NAGS HEAD, NORTH CAROLINA
*Early morning breakers pound a pier on North Carolina's Outer Banks. The nearly
200-mile-long chain of barrier islands help protect the coast from vicious storms.*

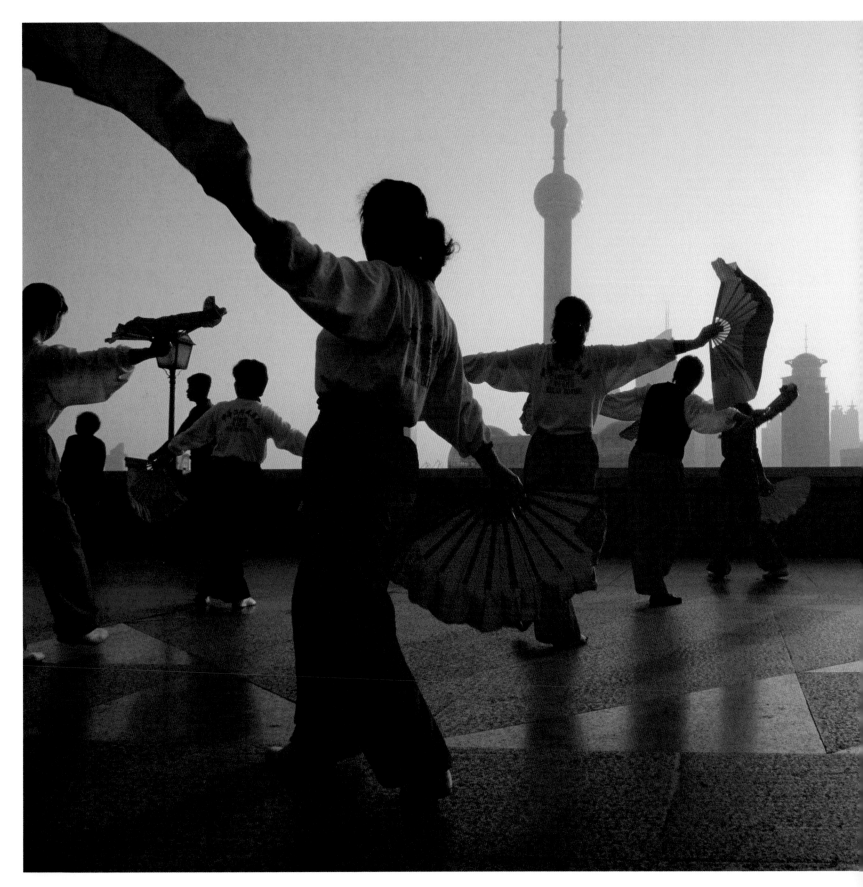

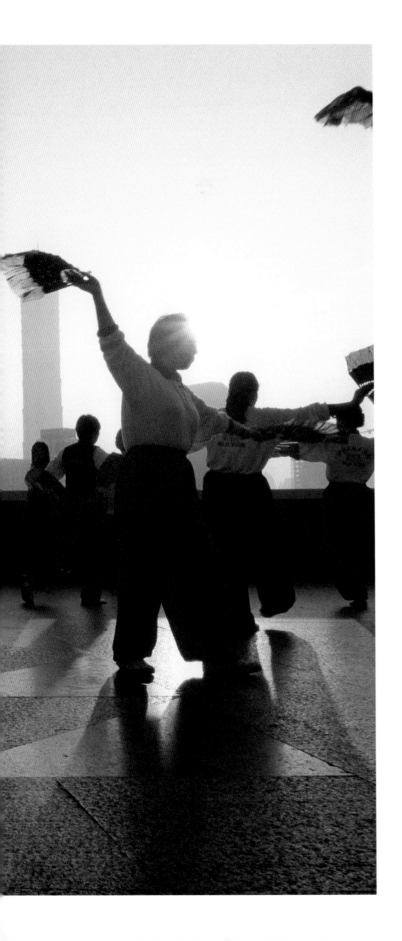

Sadness flies on
the wings of the
morning—and
out of the heart of
darkness comes
the light.

–JEAN GIRAUDOUX

JUSTIN GUARIGLIA | SHANGHAI, CHINA
*Women get their morning exercise along the Shanghai waterfront
by fan dancing. Some of the more than 4,000 skyscrapers of the
city dot the background.*

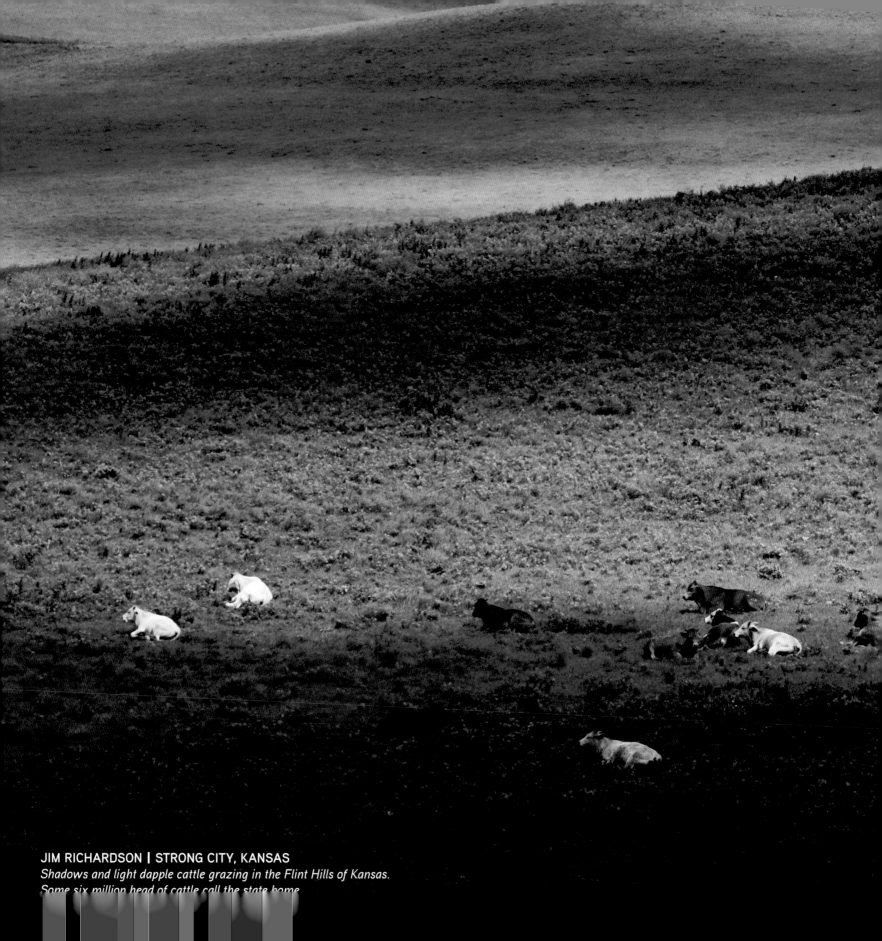

JIM RICHARDSON | STRONG CITY, KANSAS
Shadows and light dapple cattle grazing in the Flint Hills of Kansas.
Some six million head of cattle call the state home.

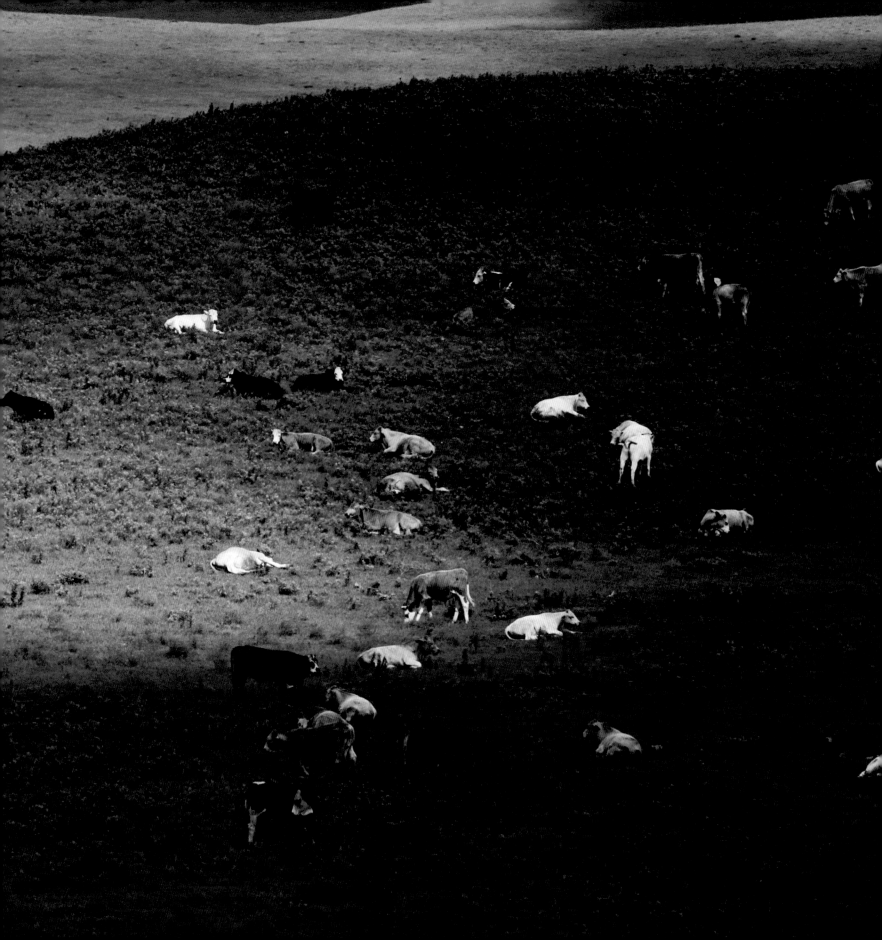

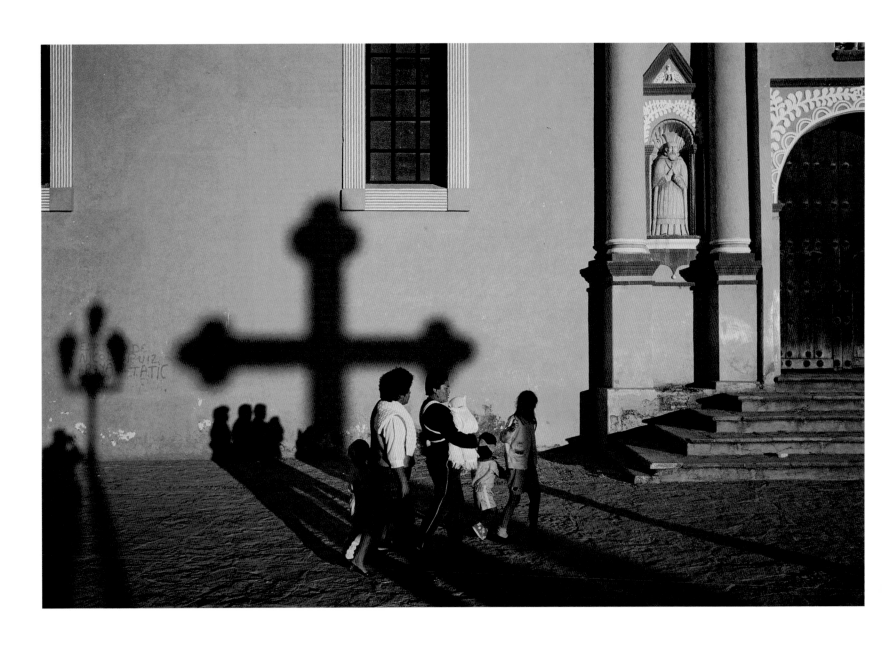

TOMASZ TOMASZEWSKI | SAN CRISTÓBAL DE LAS CASAS, MEXICO
A Mexican family comes to morning worship at the Cathedral of San Cristóbal de las Casas in Chiapas, Mexico. In 1544, the Dominican friar Bartolomé de las Casas became the first bishop of Chiapas.

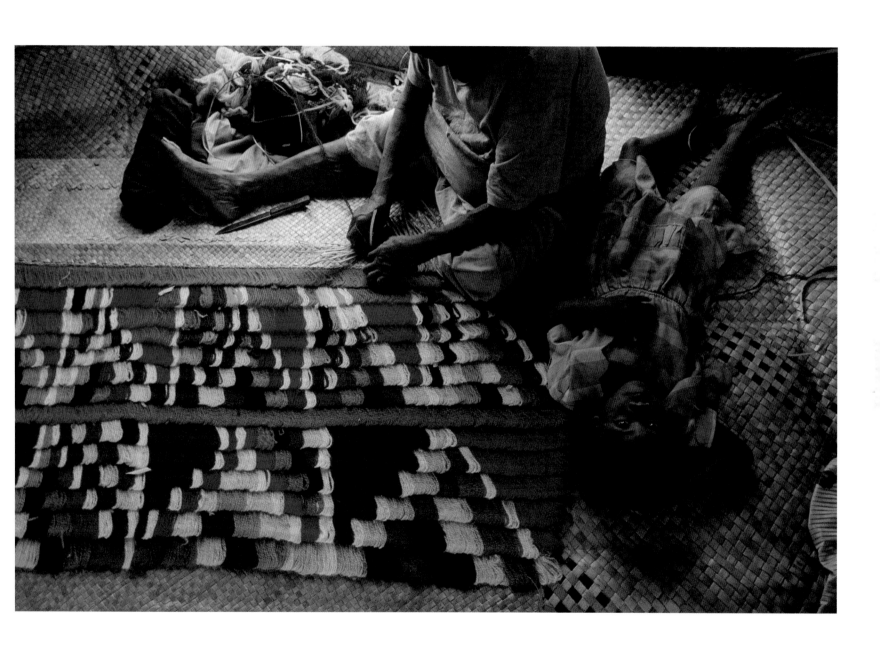

JAMES L. STANFIELD | YANDRANA, FIJI

A young girl stares at the ceiling as a woman weaves colorful yarn into a mat. Today yarn is used in place of colorful feathers.

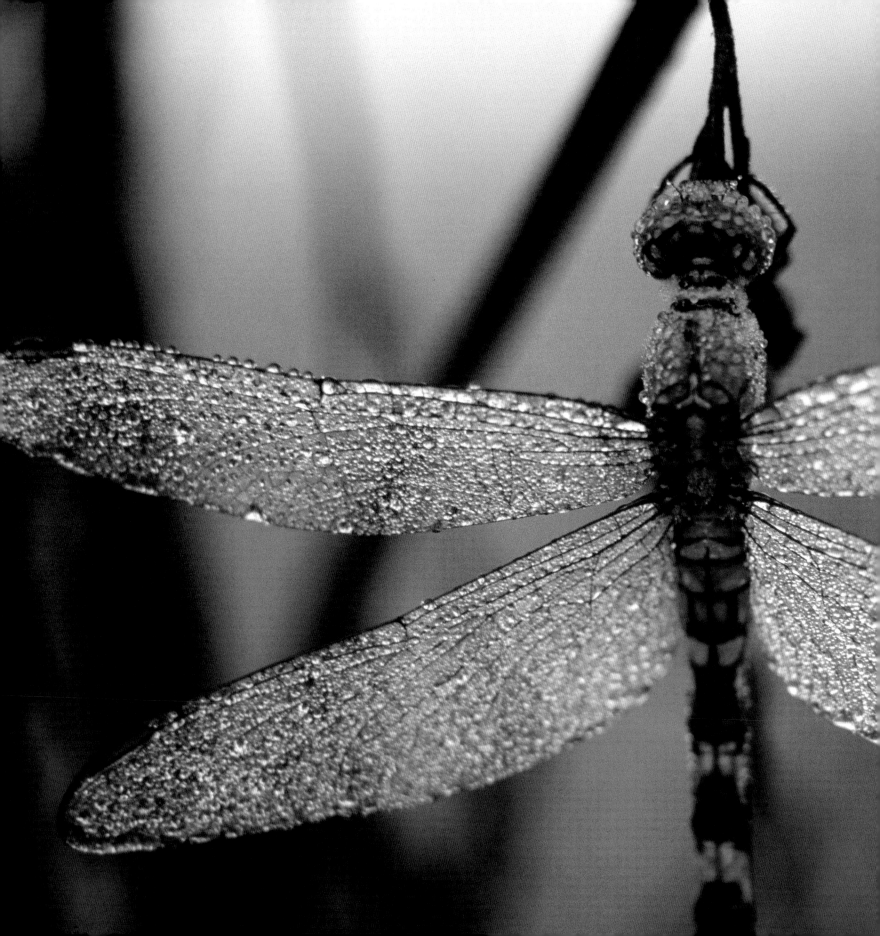

PHIL SCHERMEISTER | SPENCER, TENNESSEE
A dragonfly's wings catch early morning raindrops.
Dragonflies have been around for more than 300 million
years; a few raindrops won't bother them.

Finally breaking through fog and

thermal steam, the early morning sun reflected off a small hot spring in Yellowstone National Park. What just seconds before had been a drab, monochromatic landscape was suddenly transformed by the gift of light into an ethereal and wondrous winter dream—and the photograph I had wanted, with its low, soft backlighting. As with most successful images, it hadn't come easy, especially given Yellowstone's deep winter season. I accessed the park by snowmobile, with my gear and a month's supply of groceries loaded onto a sled behind me. Off I sped, over the park's frozen roads, filled with the thrill, excitement, and challenge of my wintry photographic adventure. That is until my sled swerved precariously and then flipped over, spilling all of my provisions into the snow. Such was the first of many Yellowstone-winter lessons, but eventually I became a part of the still, frozen environment and learned that the biggest inspirations can come from the smallest of moments. Like a sudden beam of light finding the chosen land where I stood, waiting.

RAYMOND GEHMAN

Yellowstone National Park
Steam rises from a hot spring on a winter morning.

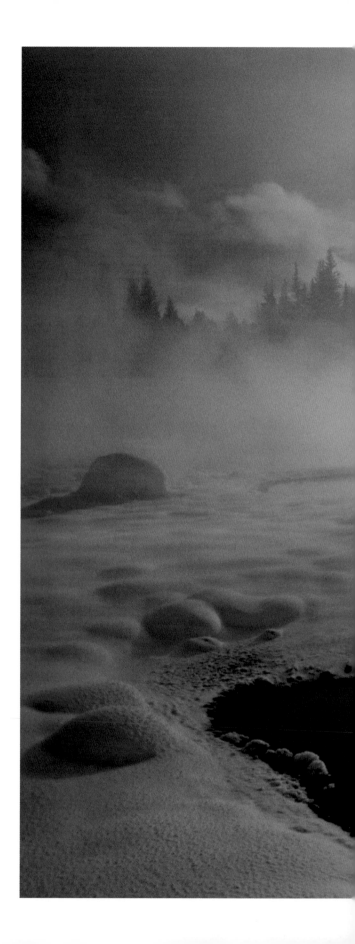

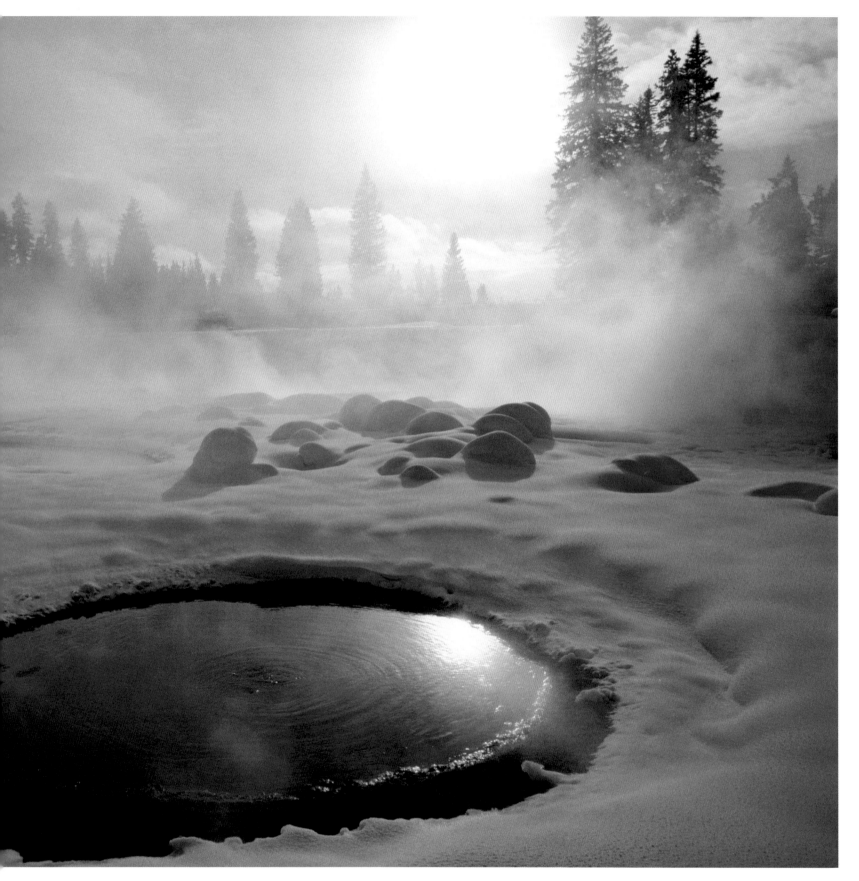

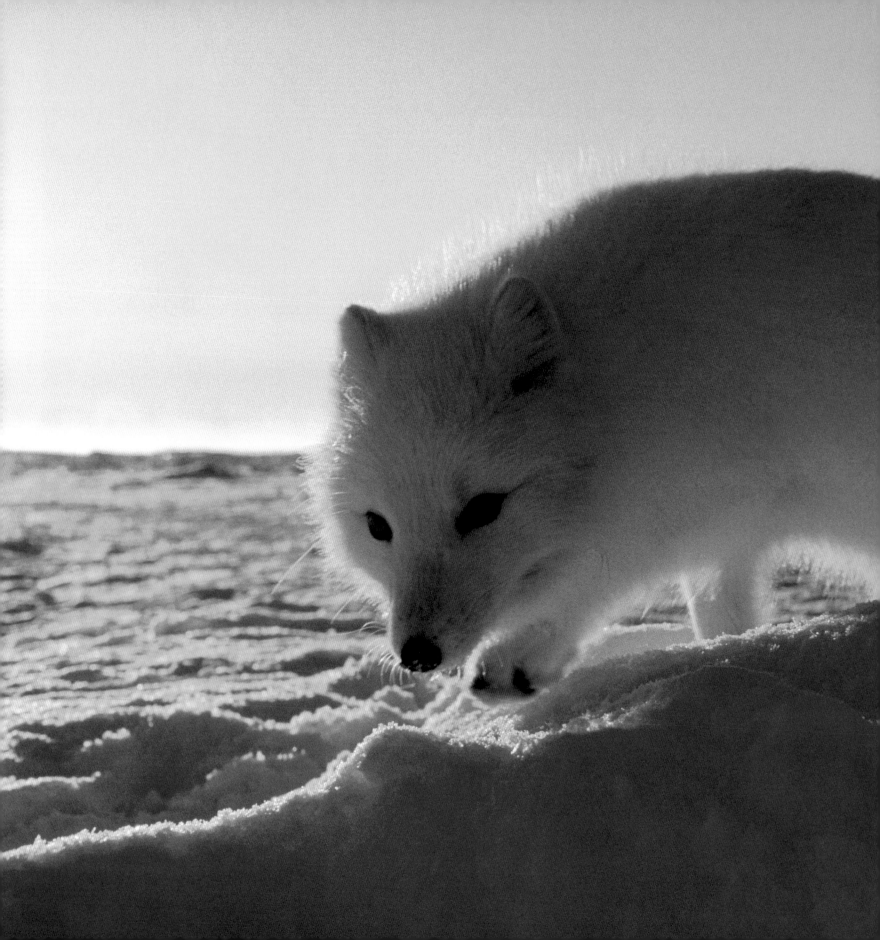

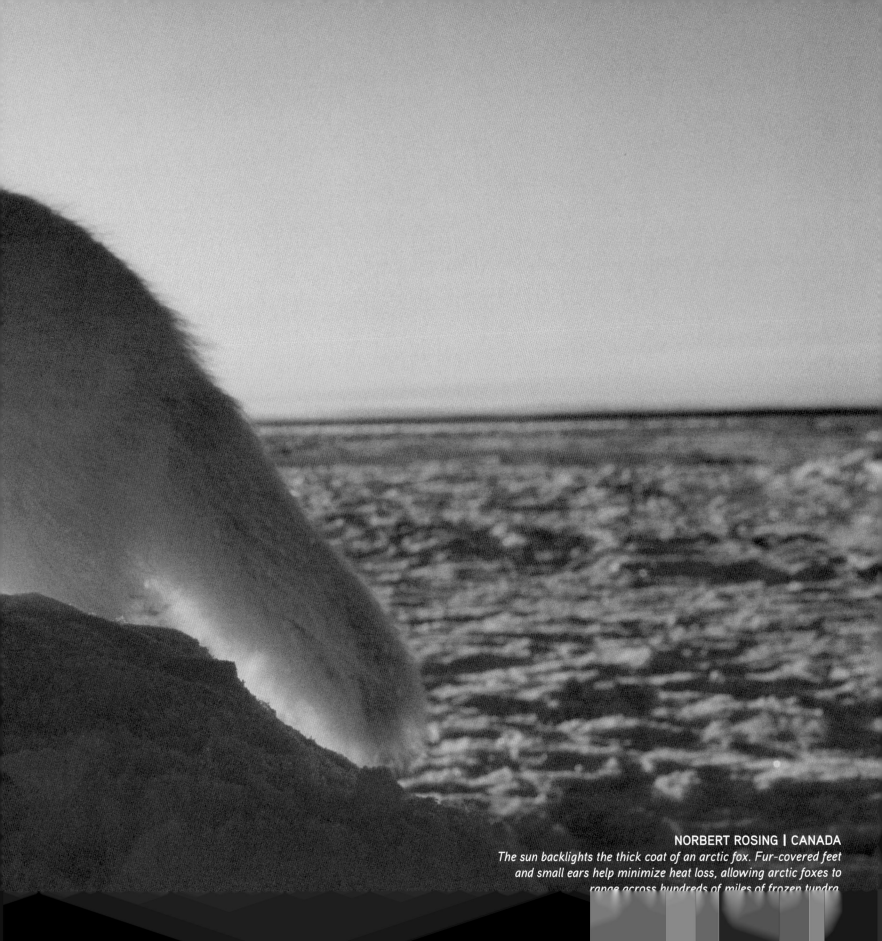

JIM RICHARDSON | BURKINA FASO, AFRICA
People on Yacouba Sawadogo's West African farm go about their day.
Yacouba has pioneered the use of small pits dug in the hard soil to help
plants take root as the region faces an advancing Sahara.

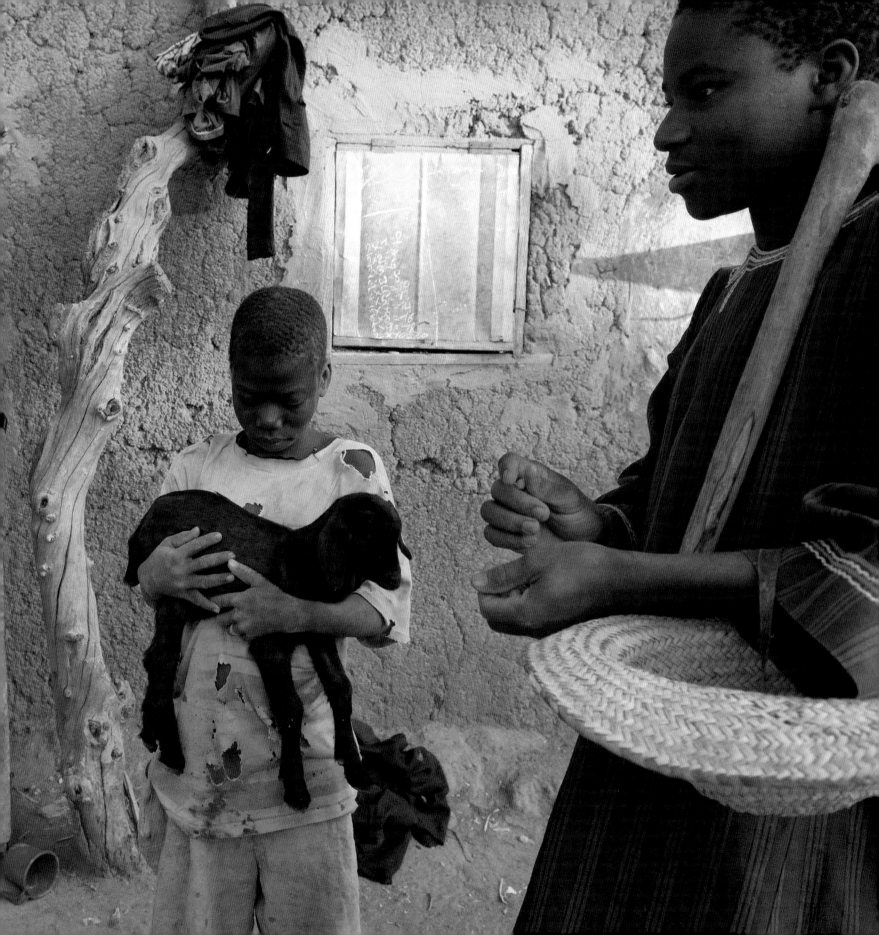

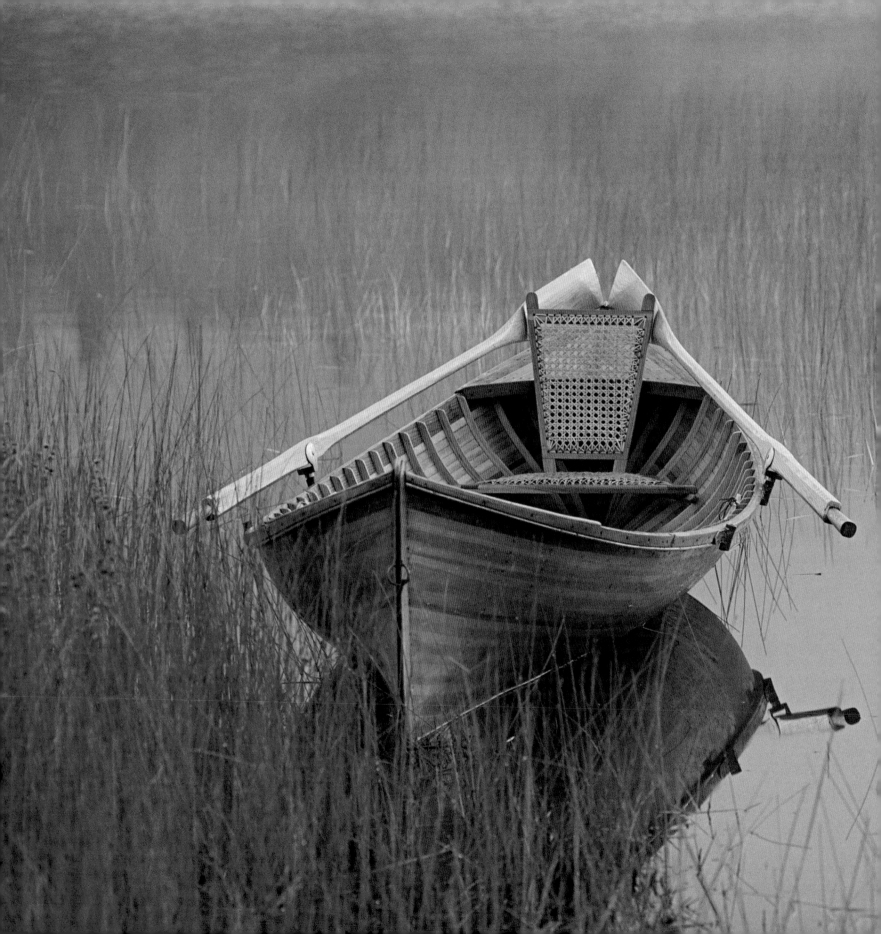

MICHAEL MELFORD | CONNERY POND, ADIRONDACKS, NEW YORK
An Adirondack guide canoe and a still morning wait for passengers on
Connery Pond, a glacial pond nestled in the high peaks.

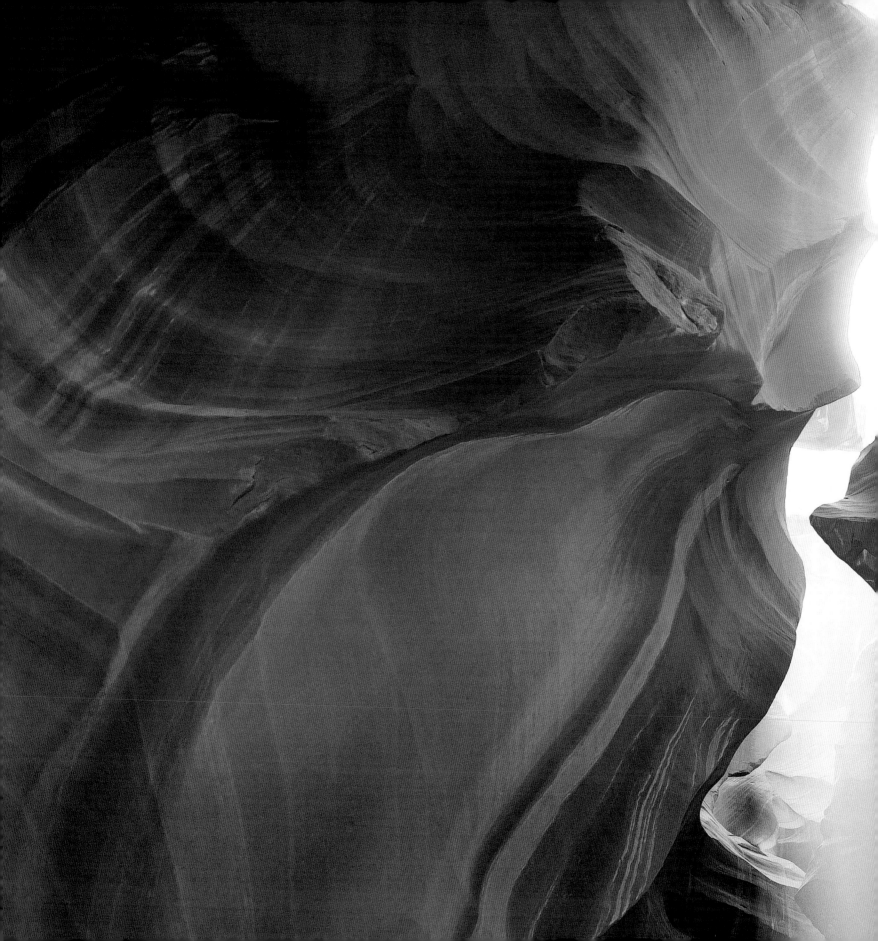

MIDDAY

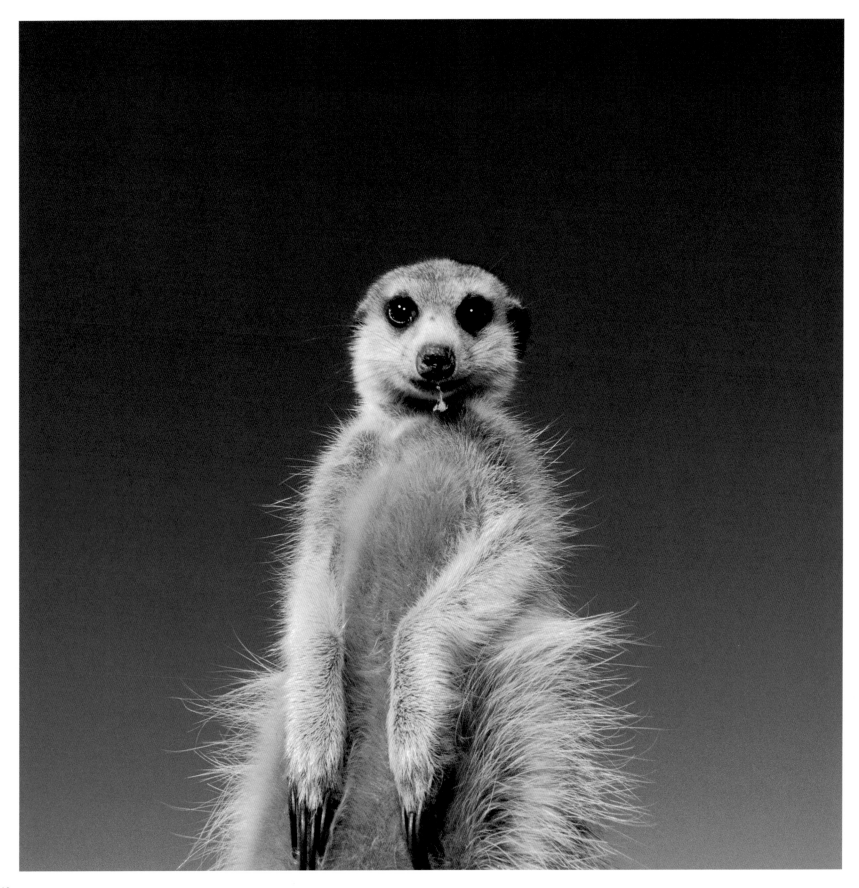

BRILLIANT, HOT, BRASH,

blinding: Midday exposes all blemishes. It makes clear what may once have been clouded. It strengthens line and solidifies object. It bounces off surfaces mercilessly, striking the eye almost as severely as it strikes the objects it illuminates. Noon's light can reveal; noon's light hurts. We squint, we sweat, we shield our eyes. We see more clearly, but we may have to look away. Noon light asserts once more the wildfire energy of the sun.

Can it be said that it is easier for our human eyes to gaze upon vague shapes, hazy phantoms, and the uncertainty of partial light? Plato would say we all live in the cave of shadows because we cannot stare straight into the light.

Some have suggested otherwise. Throughout the cultures of Eastern Europe roams a demon maiden named Lady Midday, Poludnika in her native lands. Known only to those who toil nonstop through the noontime hour, Poludnika skirts the fields, her white frock rippling as the sun hits its zenith. Those who see her fall victim to her madness.

Thirst, fever, backache, pain—the only escape is avoidance: a shade tree and a pause in one's labors.

Sit back and listen for the sounds that accompany this time of day with its surfeit light. Hear the drone of the locusts, the hum of the bumblebee: Hang back, harmonize with them to make sense of this noon time of day.

MATTIAS KLUM | KALAHARI DESERT, SOUTH AFRICA *A meerkat stands tall in the Kalahari Desert. Its long claws help it dig up insects; the remnant of an unlucky one hangs from its lips.*

CHRISTIAN ZIEGLER | PERTH, AUSTRALIA
Impersonating a pea-flower, a pansy orchid hopes that careless bees looking for nectar-loaded legumes will land on it by mistake.

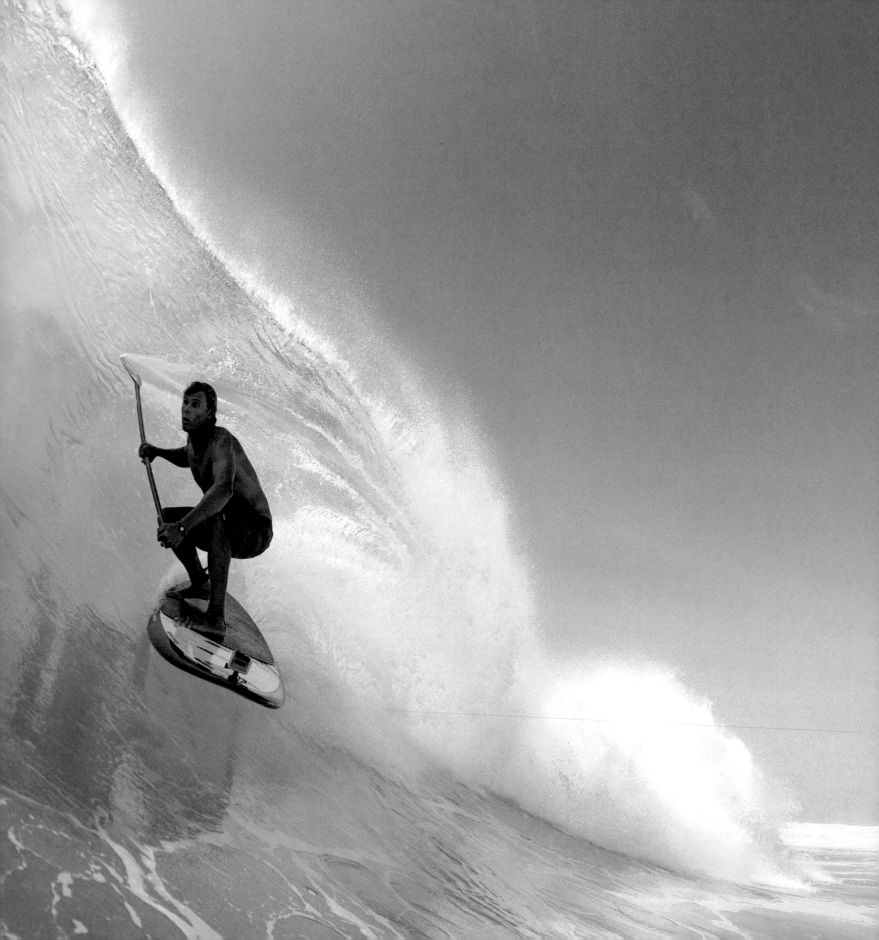

The day of the sun is
like the day of a king.
It is a promenade in
the morning, a sitting on
the throne at noon,
a pageant in
the evening.

—WALLACE STEVENS

JODY MACDONALD | THE MALDIVES
*A turquoise wave cradles Jamie Mitchell in Huvadhu atoll in
the Maldives. A champion ocean paddler and big-wave rider,
Mitchell is at home in epic swells.*

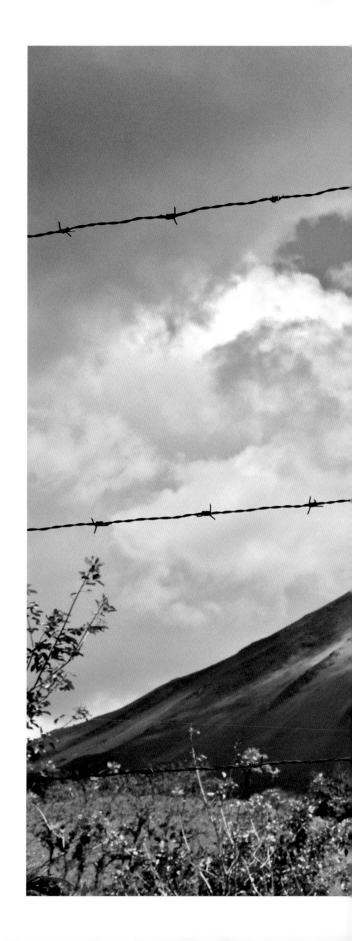

REBECCA PIETSCH | ARENAL VOLCANO, ALAJUELA, COSTA RICA
A cow drools, unperturbed by Costa Rica's Arenal Volcano. At 5,479 feet,
Costa Rica's youngest stratovolcano towers over the verdant hills.

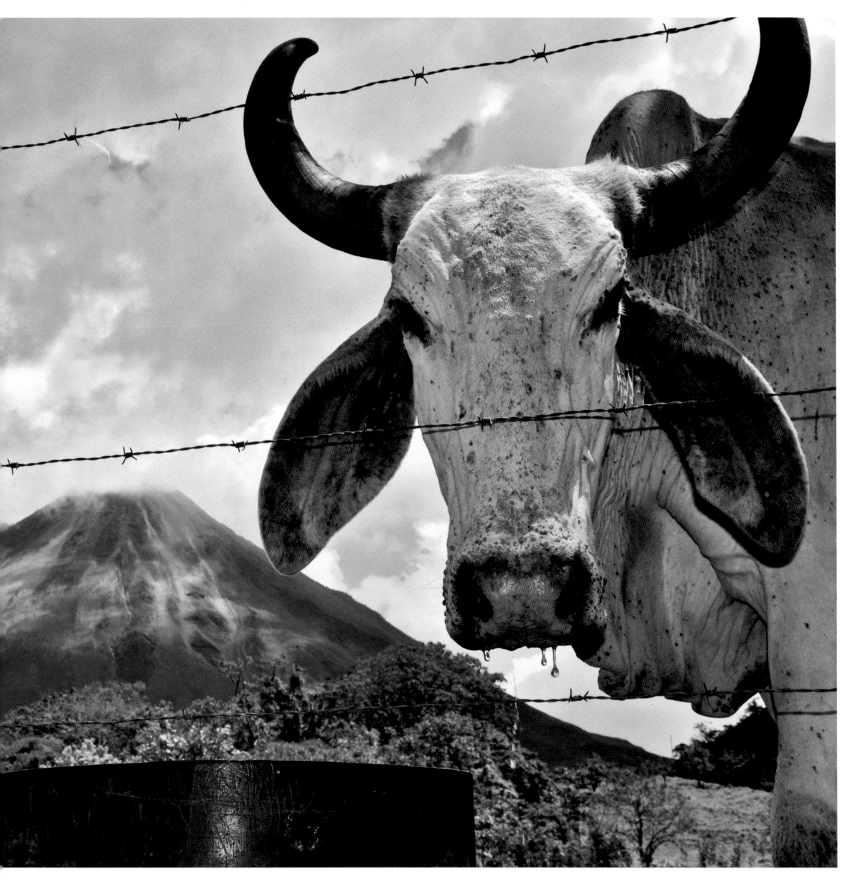

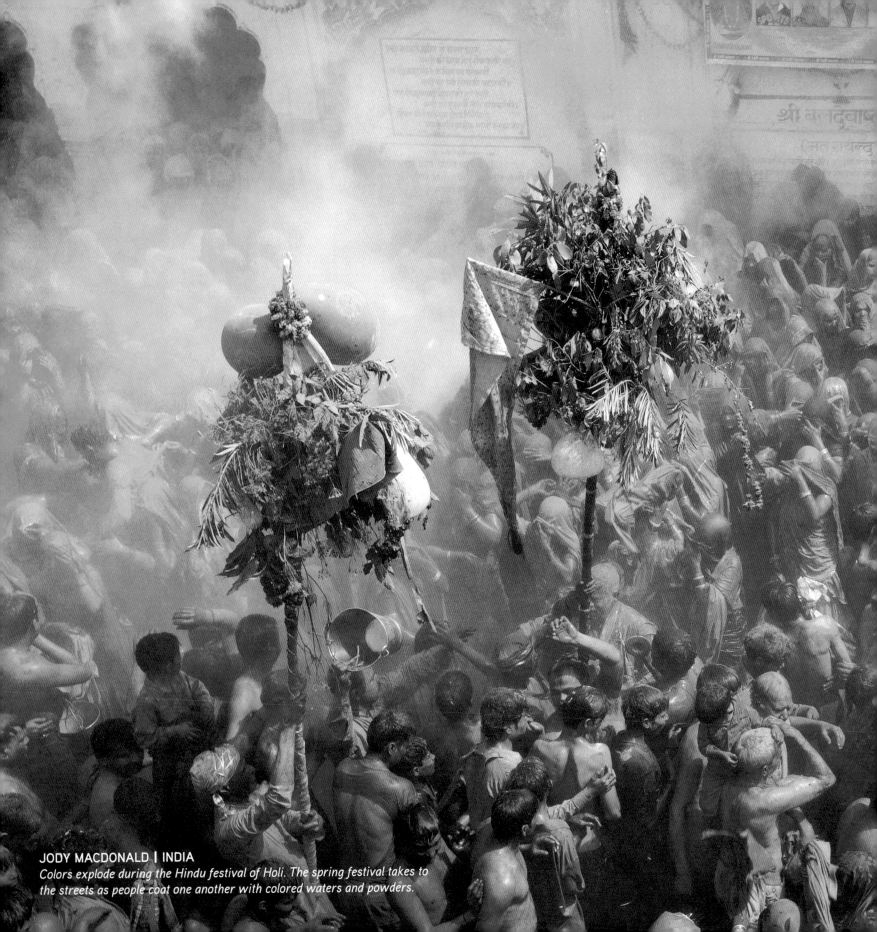

JODY MACDONALD | INDIA
Colors explode during the Hindu festival of Holi. The spring festival takes to the streets as people coat one another with colored waters and powders.

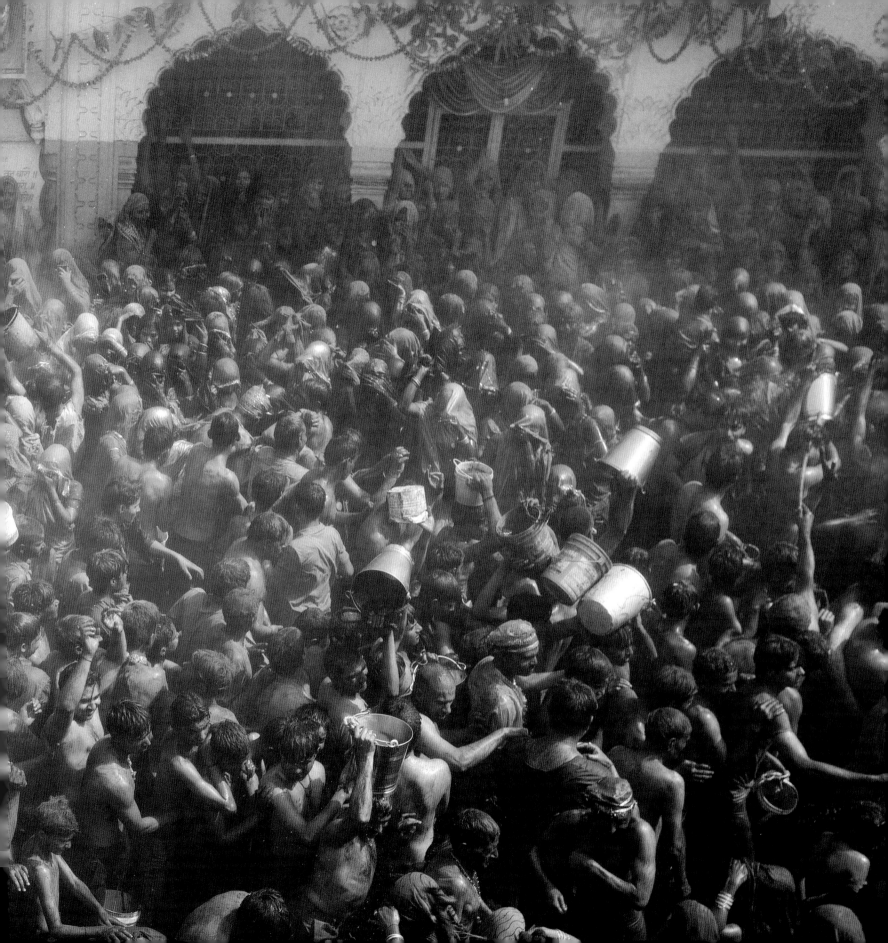

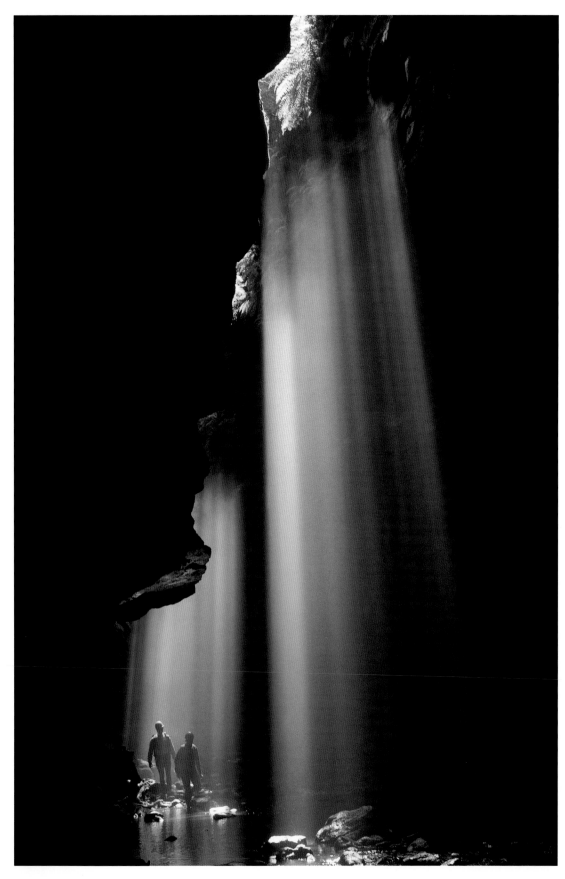

This photo was taken in 2011, when

Australia had record flooding. The weather was humid with constant drizzle and rain, but there were rare moments in the canyons when this humidity paid off.

I had always wanted to see when rays of light hit these microscopic water droplets. I knew it might be spectacular. In these small, tight, slot canyons there is only a short moment of light, depending on which part of the canyon you are in and the angle of the sun. I was mesmerized, but also a little afraid of the harsh contrasts in these incredibly dark recesses. Then, suddenly, I saw something exceptional. It was like a celestial moment and reminded me of old paintings I remember from childhood where God shines down through an angle in the clouds. The canyon became a cathedral, and you could look up to see these sunbeams.

CARSTEN PETER

New South Wales, Australia
Sun streams into a slot canyon in Rocky Creek Canyon.

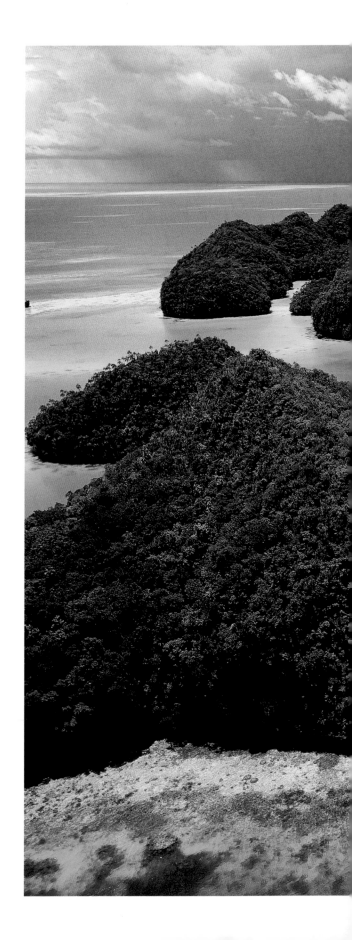

Tropical islands surpass themselves at midday, blue and turquoise harmonizing shamelessly in the sun.

–JIM RICHARDSON

JODY MACDONALD | PALAU
Forested islands pop up above the brilliant blue waters of the Republic of Palau in the western Pacific Ocean. This small group of islands hosts a wide range of sea life.

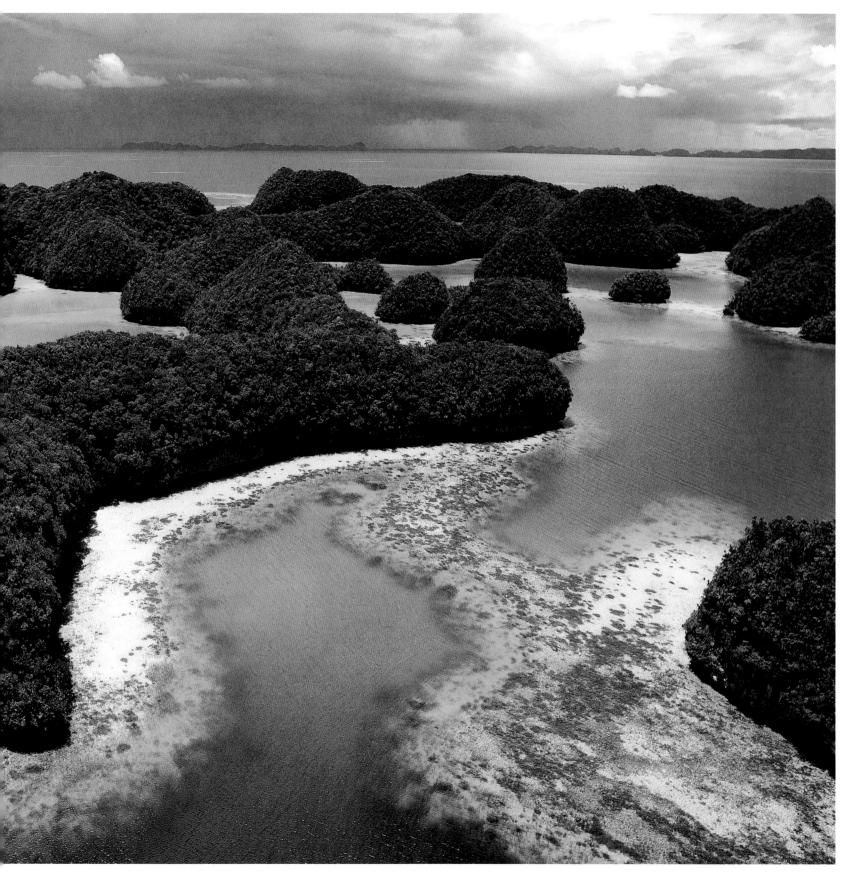

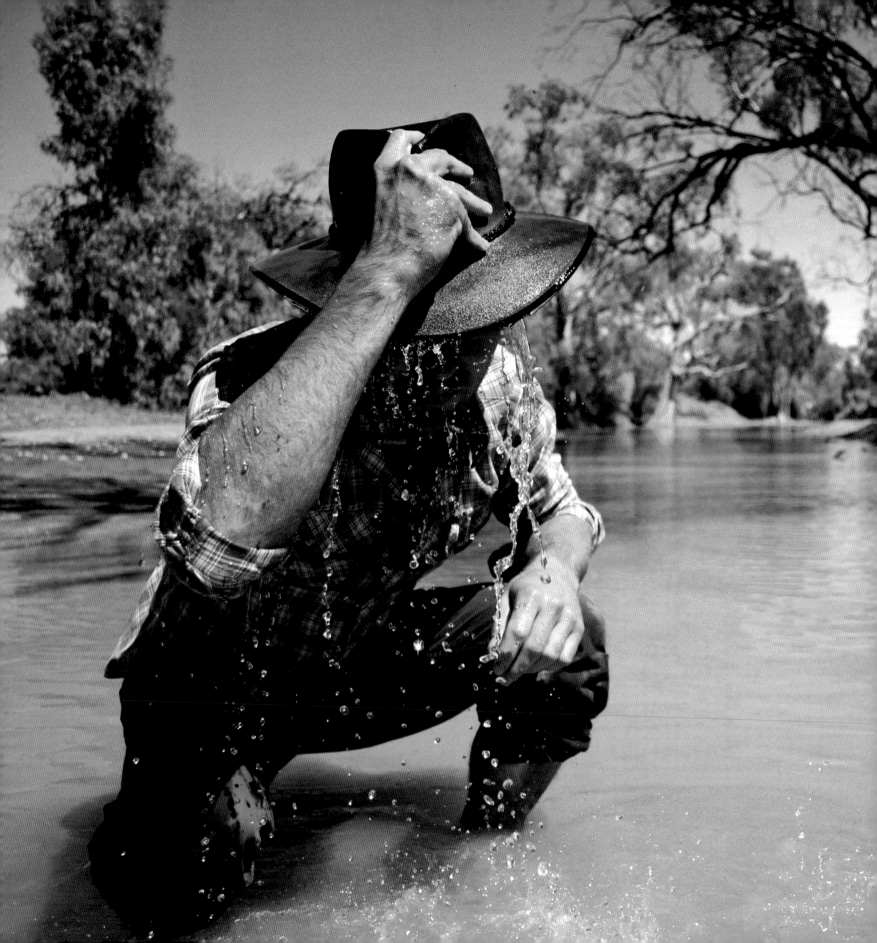

MILES ROWLAND | ADELAIDE, AUSTRALIA
*In the harsh Australian desert, a swollen creek refreshes a
traveler taking a break from the bright midday sun.*

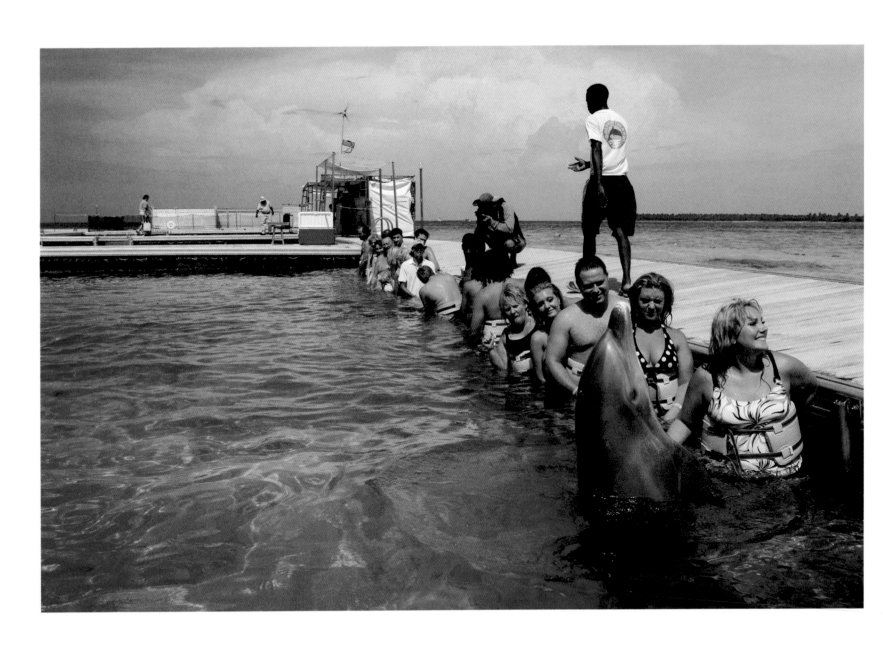

GILLES MINGASSON | DOLPHIN ISLAND, DOMINICAN REPUBLIC
Visitors from nearby resorts line the pier to mingle with dolphins in an enclosed pool dubbed Dolphin Island, just a few hundred yards from the Dominican coast.

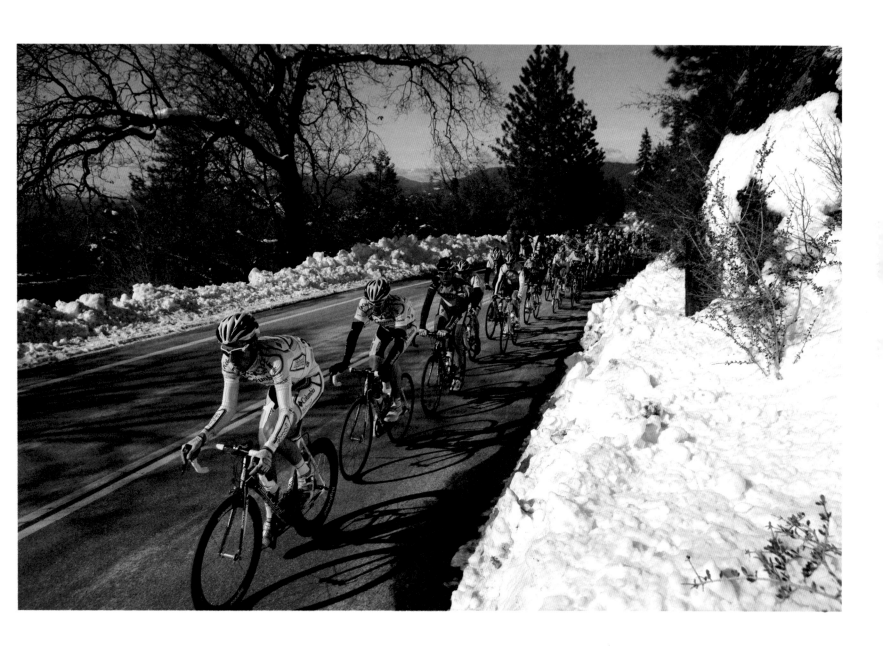

GILLES MINGASSON | SACRAMENTO, CALIFORNIA
Snow offers some mountain scenery during the 2009 Amgen Tour of California bike race as a pack of riders make their way through the last pass of the mountain stage.

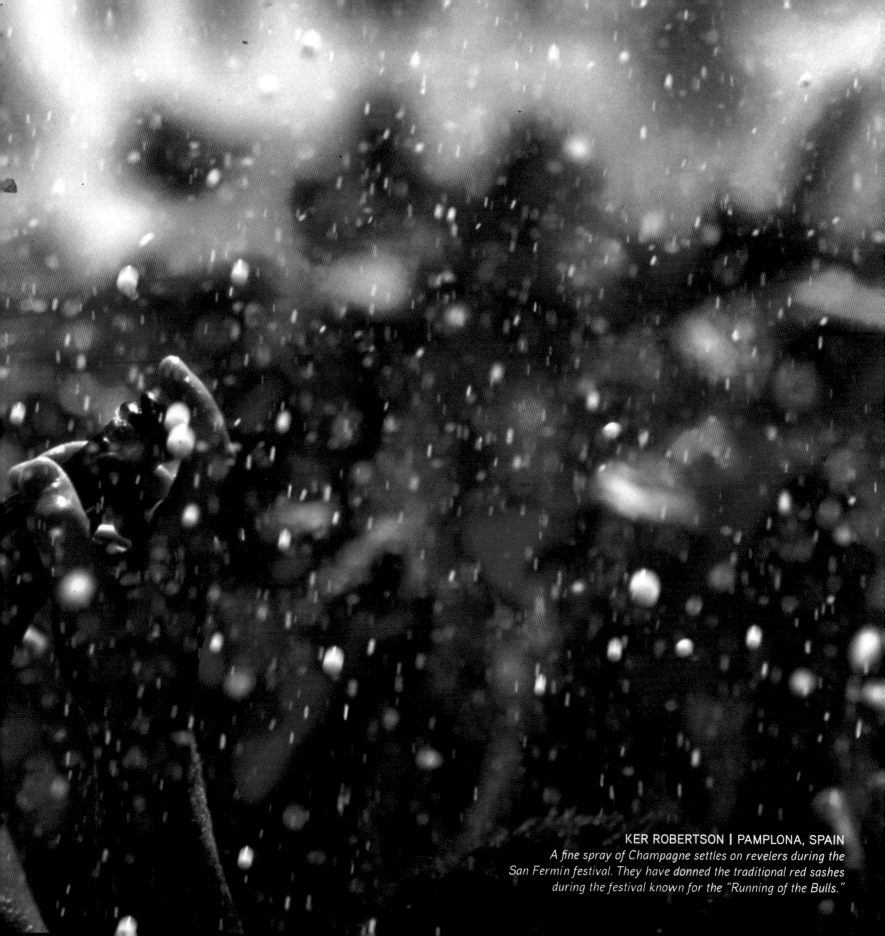

KER ROBERTSON | PAMPLONA, SPAIN
A fine spray of Champagne settles on revelers during the San Fermín festival. They have donned the traditional red sashes during the festival known for the "Running of the Bulls."

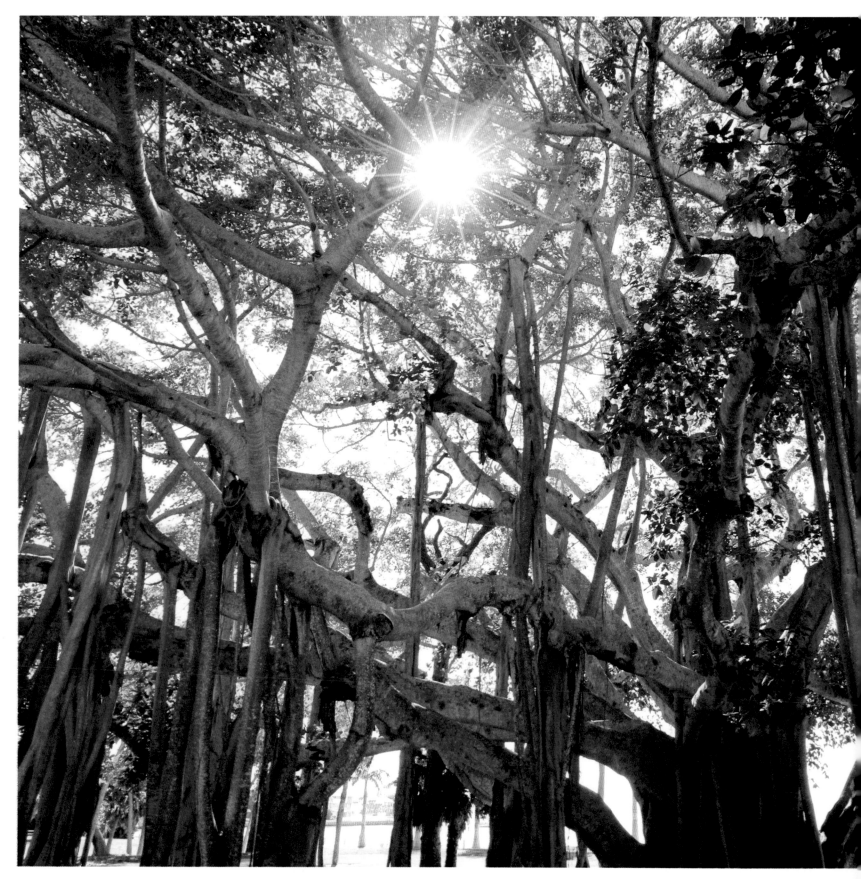

DAVID A. RIFFEL | SARASOTA, FLORIDA
*The sun shines through a banyan tree on the grounds
of the Ringling Circus Museum in Sarasota.*

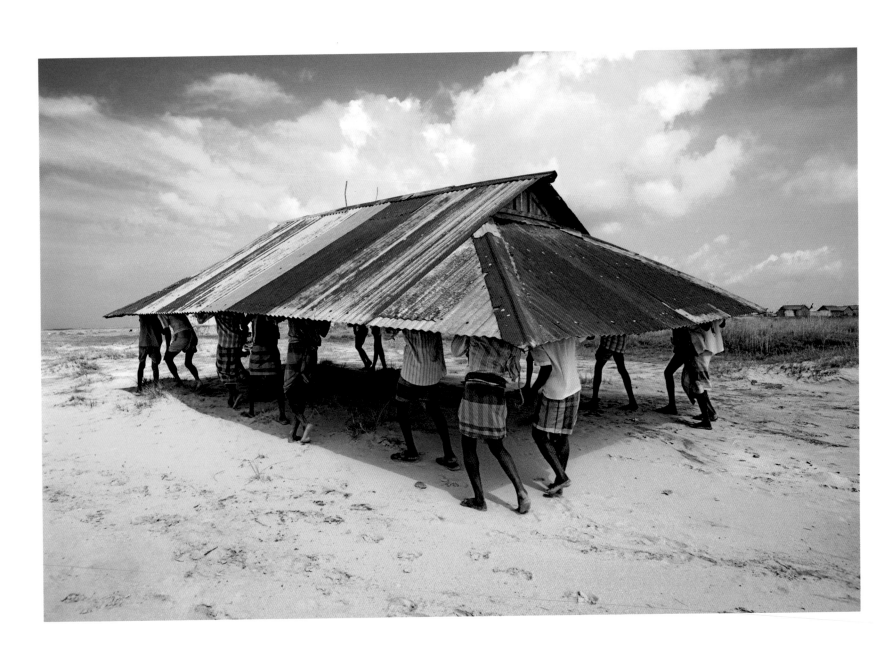

JONAS BENDIKSEN | KURIGRAM DISTRICT, RANGPUR DIVISION, BANGLADESH *When erosion threatened the local mosque, the locals used people power to move the structure.*

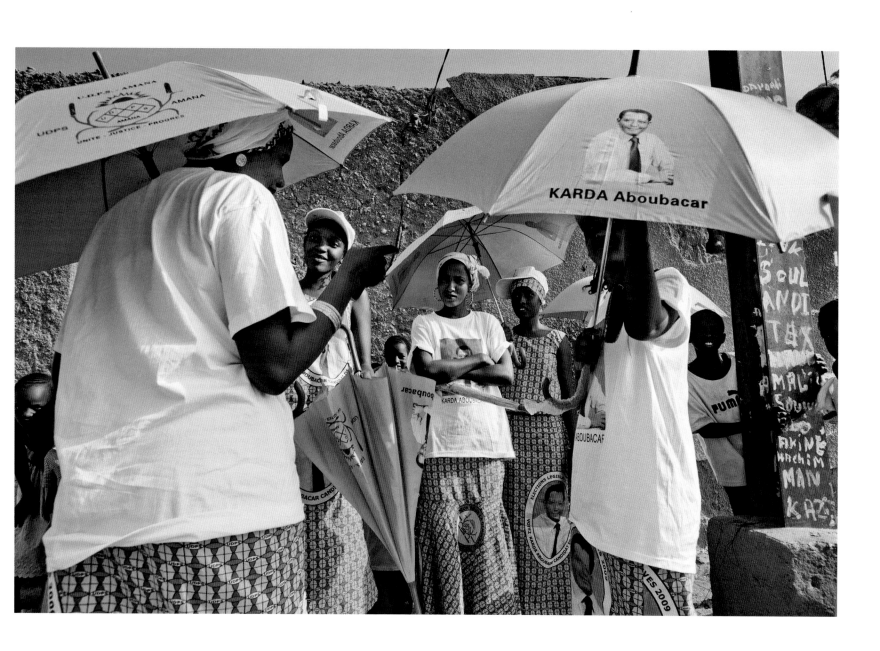

BRENT STIRTON | AGADEZ, NIGER
At a rally for a Tuareg candidate for office, the bright yellow of supporters seems to hold promise for the future. Many Tuareg have given up their nomadic lifestyle to settle in towns of North Africa.

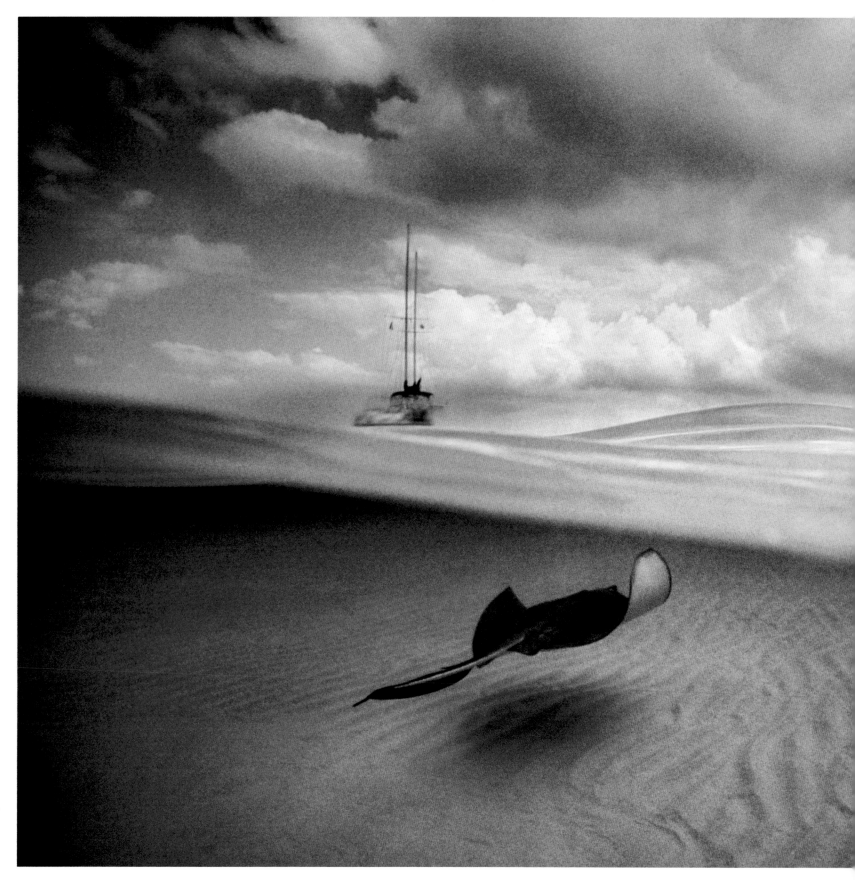

This picture captures North Sound

of Grand Cayman Island, where you have a brilliant white sand-bar behind a barrier reef, and the water flooding across the reef system. It's all about water and light. Waves have raked the sand like a Zen temple. The stingray is a performer, and on this simple stage the perspective of the bottom sand and the reflective surface come together, and the horizon disappears into a darker blue. What makes this picture work is motion. The heart of motion is gesture, and the stingray's wing is curving as it swims. It lifts its wing, and if you notice in this molecular thick edge of the water's surface, the curve of the wing mimics the curve of a wave. There was a liquidness to the whole day, which gives a languidness to the picture: a moment of stingray in clouds.

DAVID DOUBILET
Cayman Islands
Ocean meets air in the North Sound of Grand Cayman Island.

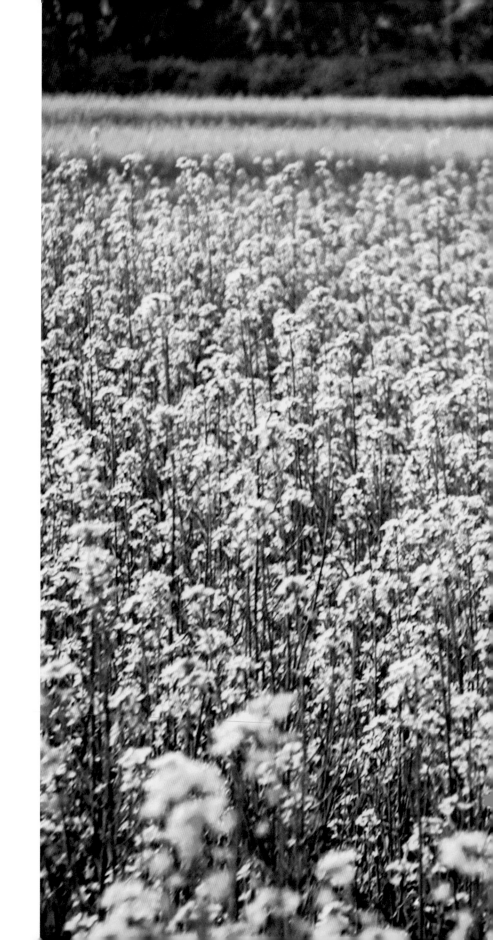

ATANU PAUL | BURDWAN DISTRICT, WEST BENGAL, INDIA
A field of golden rapeseed seems to inspire the young woman passing through it.

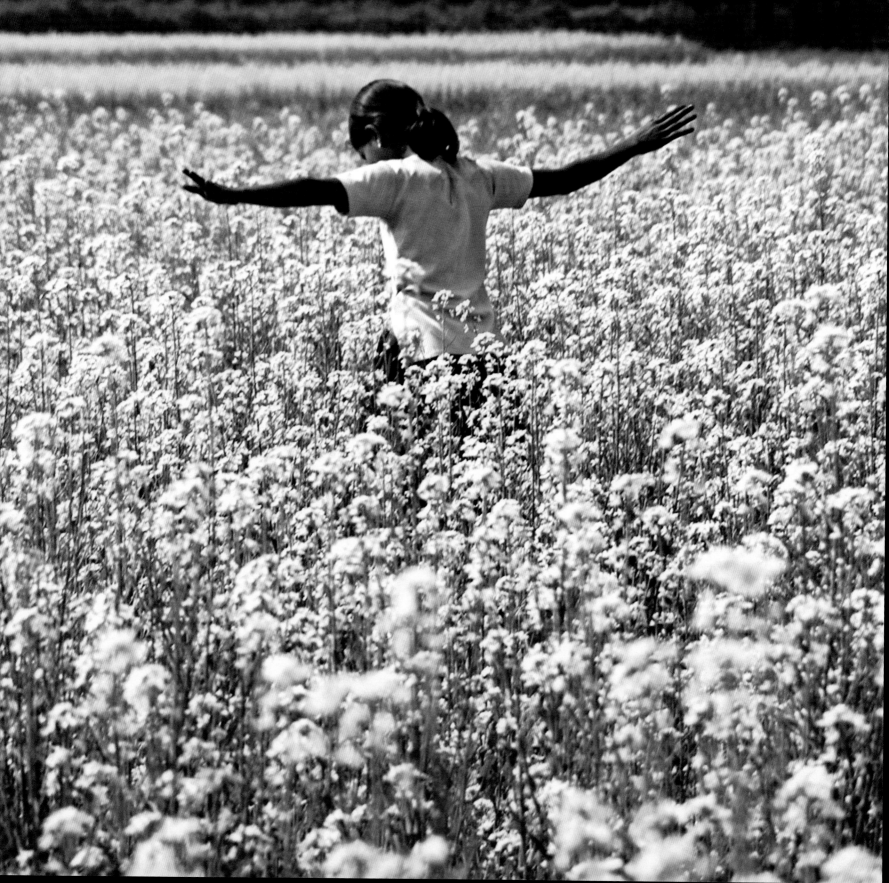

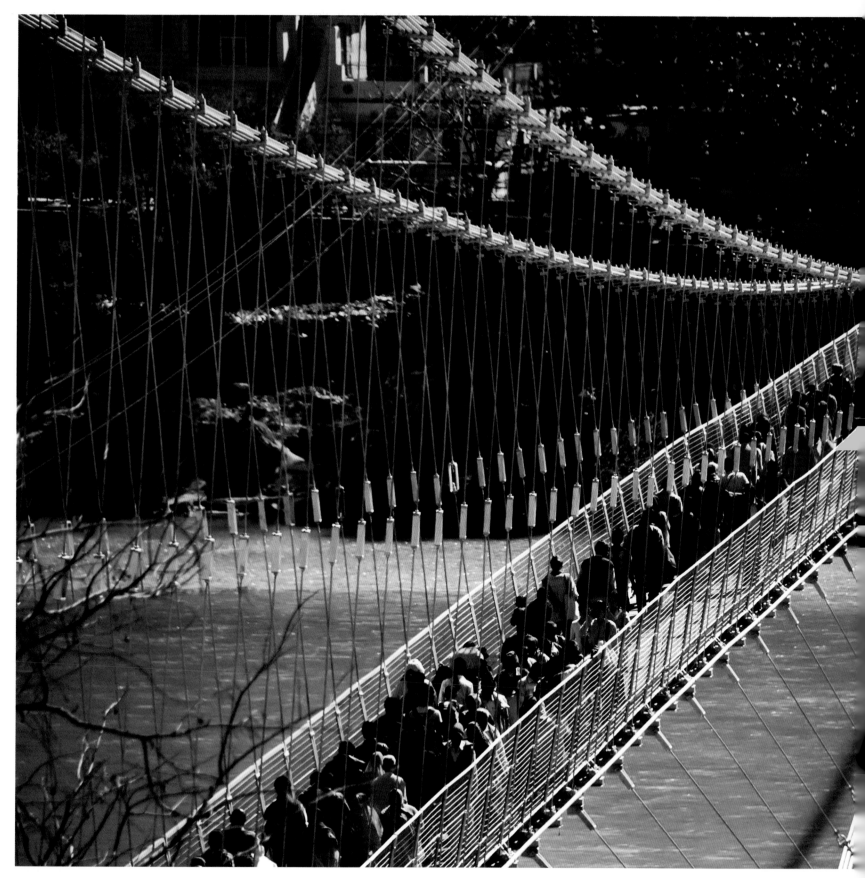

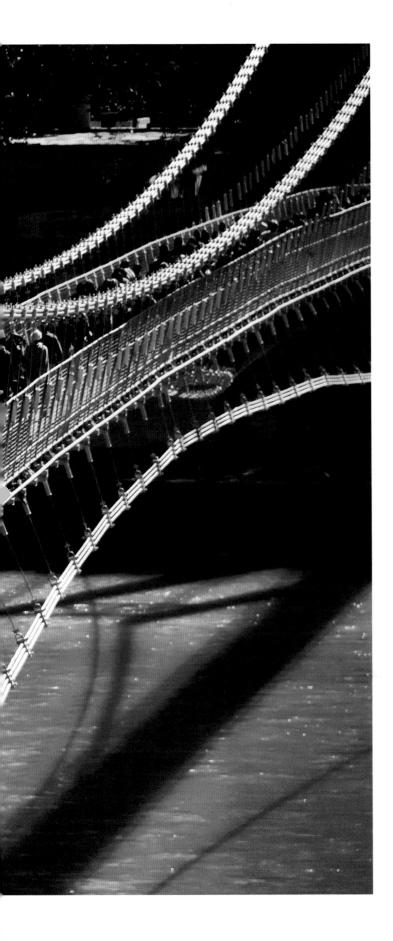

Think in the morning. Act in the noon. Eat in the evening. Sleep in the night.

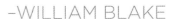

–WILLIAM BLAKE

ATANU PAUL | RISHIKESH, UTTARAKHAND, INDIA
The lines of the Lakshman Jhula suspension bridge hang over the Ganges in Rishikesh, India. The bridge offers a path between the holy sites of Badrinath and Kedarnath.

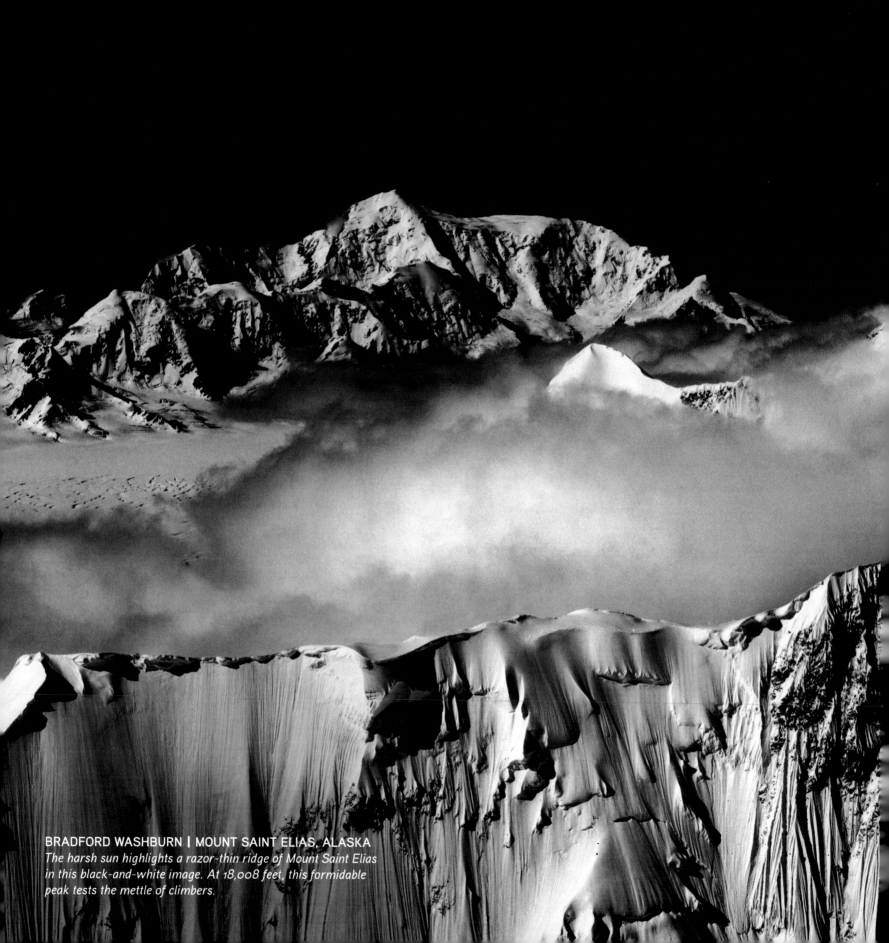

BRADFORD WASHBURN | MOUNT SAINT ELIAS, ALASKA
*The harsh sun highlights a razor-thin ridge of Mount Saint Elias
in this black-and-white image. At 18,008 feet, this formidable
peak tests the mettle of climbers.*

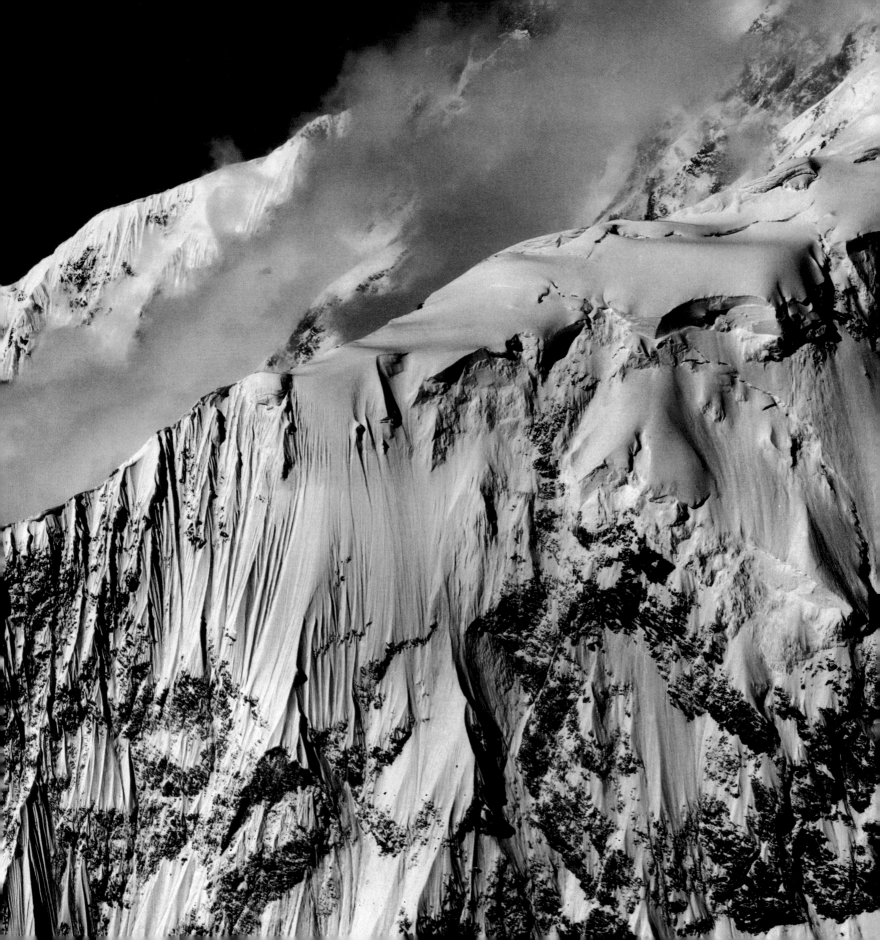

TOP PHOTO GROUP | YANGMING
MOUNTAIN, TAIWAN *Two carp with their
mouths agape seem to beckon to the viewer
to join them in the shimmering water.*

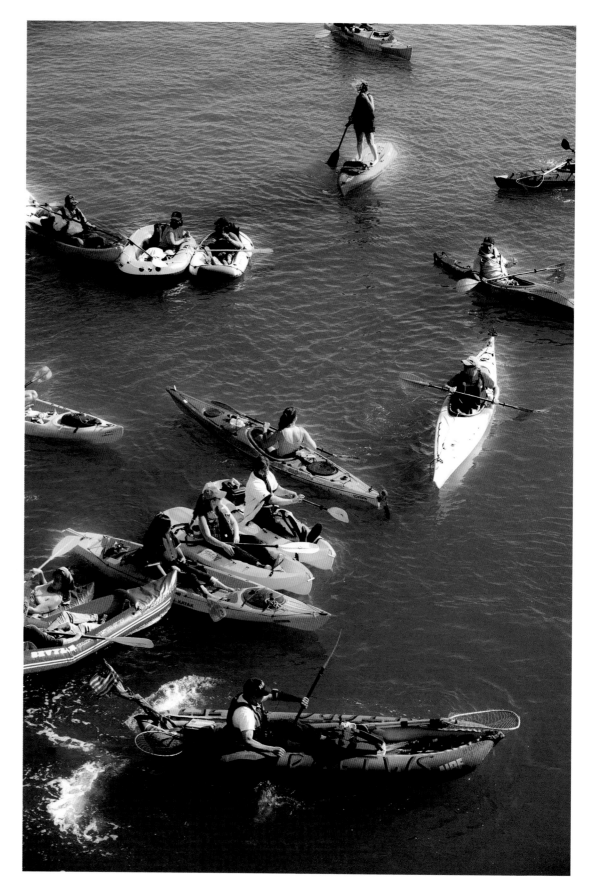

JAMES A. SUGAR | SAN FRANCISCO, CALIFORNIA *Kayaks in San Francisco's McCovey Cove jockey for the chance to catch a home run ball during the 2010 championship series between the Giants and the Phillies.*

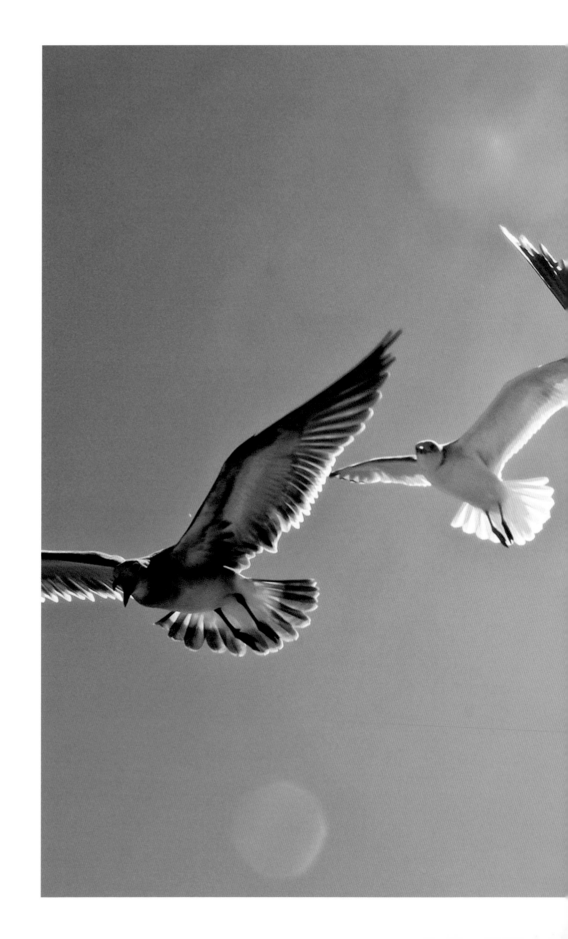

JIM MOORE | OCEAN CITY, MARYLAND
Ring-billed gulls and laughing gulls fly out of formation against a bright blue sky.

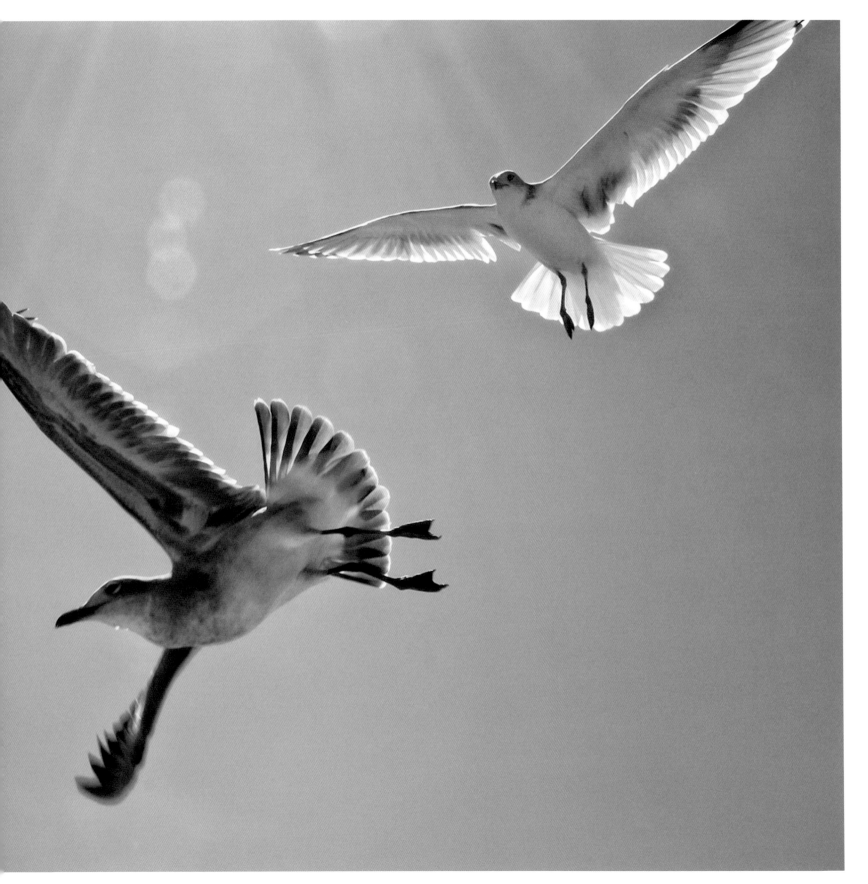

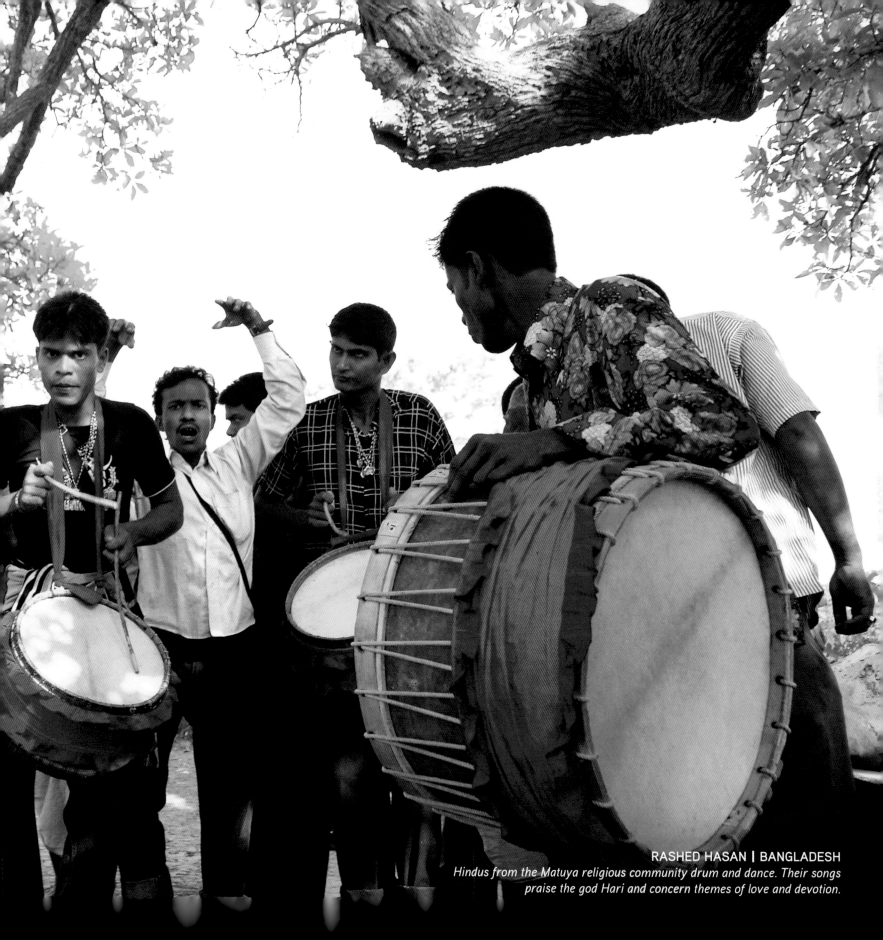

RASHED HASAN | BANGLADESH
Hindus from the Matuya religious community drum and dance. Their songs praise the god Hari and concern themes of love and devotion.

This image of Yva's feet in her old

hiking boots against the backdrop of the Colorado Plateau's petrified sand dunes reflects our contemplation of this ancient landscape and the humans who have experienced it. Here are magical forms of sandstone shaped by millennia of erosion and the intruding human who walks those golden bones of the Earth. Is she, the hiker, cherishing the beauty of the place, or rudely breaking the fragile fins of the lovely sedimentary rock she came to see?

Perhaps this picture whispers to you: Stop, rest, and admire, but go no farther, and if you must go on, at least shed your boots and tread gently, for now you are responsible for these thin fins and flowing layers. And perhaps, walking, you will feel the granular texture of the warm rock touching your bare feet and sense that your presence is fleeting, and light, and good.

YVA MOMATIUK AND JOHN EASTCOTT

Arizona
Sandstone buttes in the Paria Wilderness Area

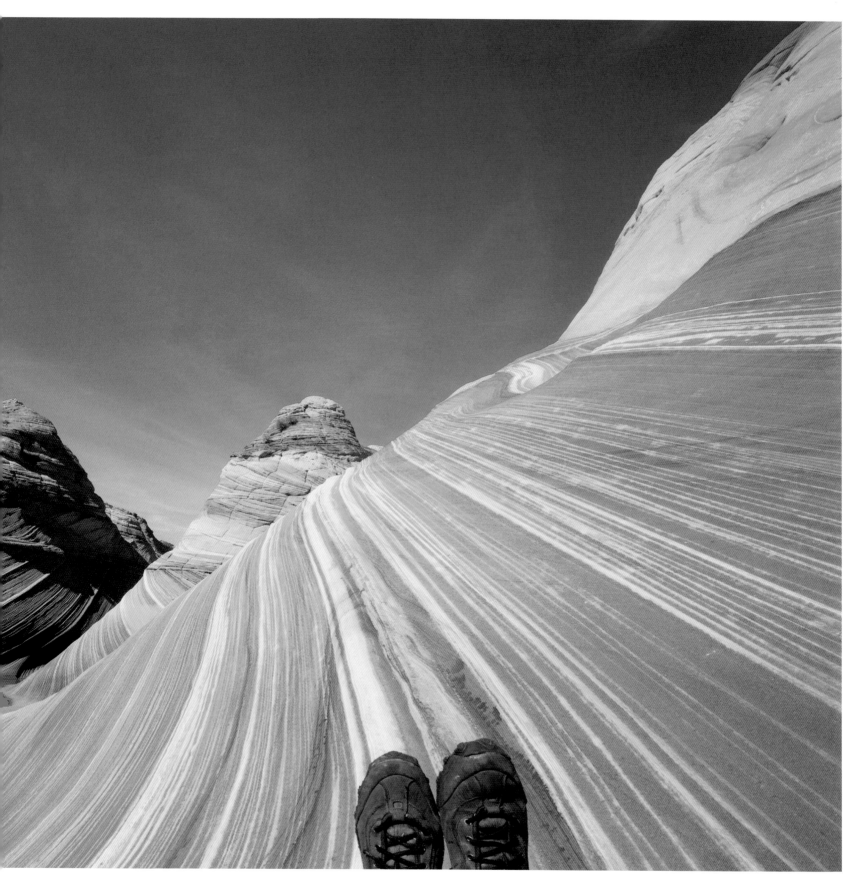

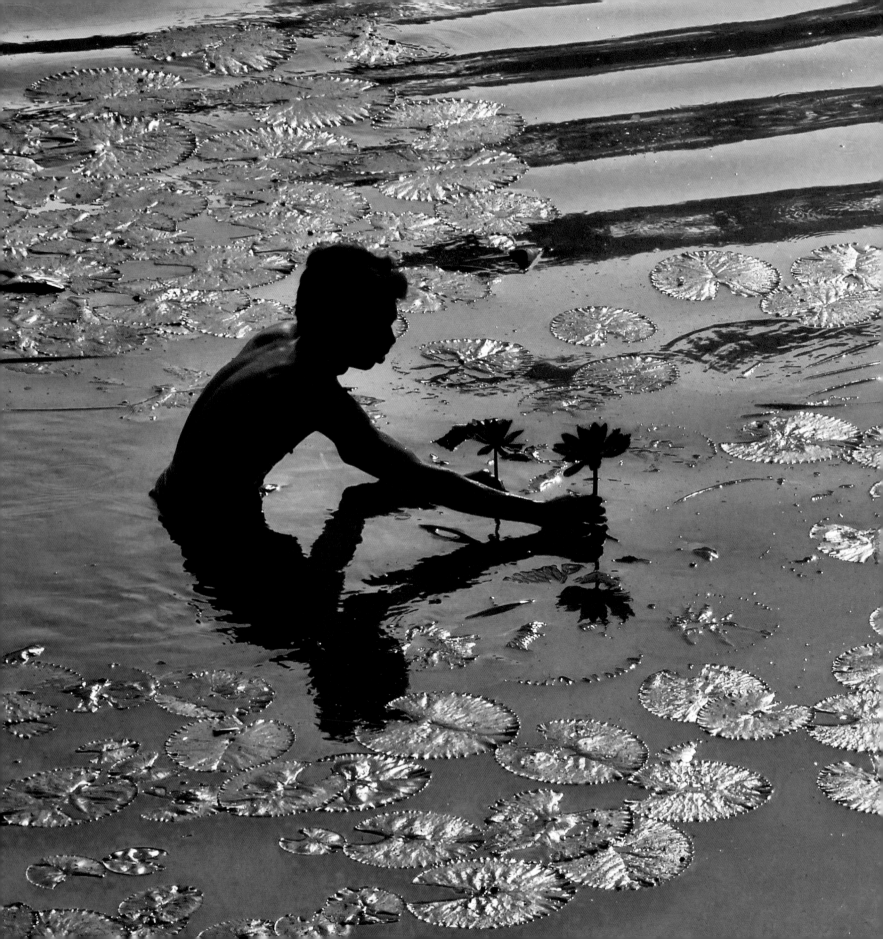

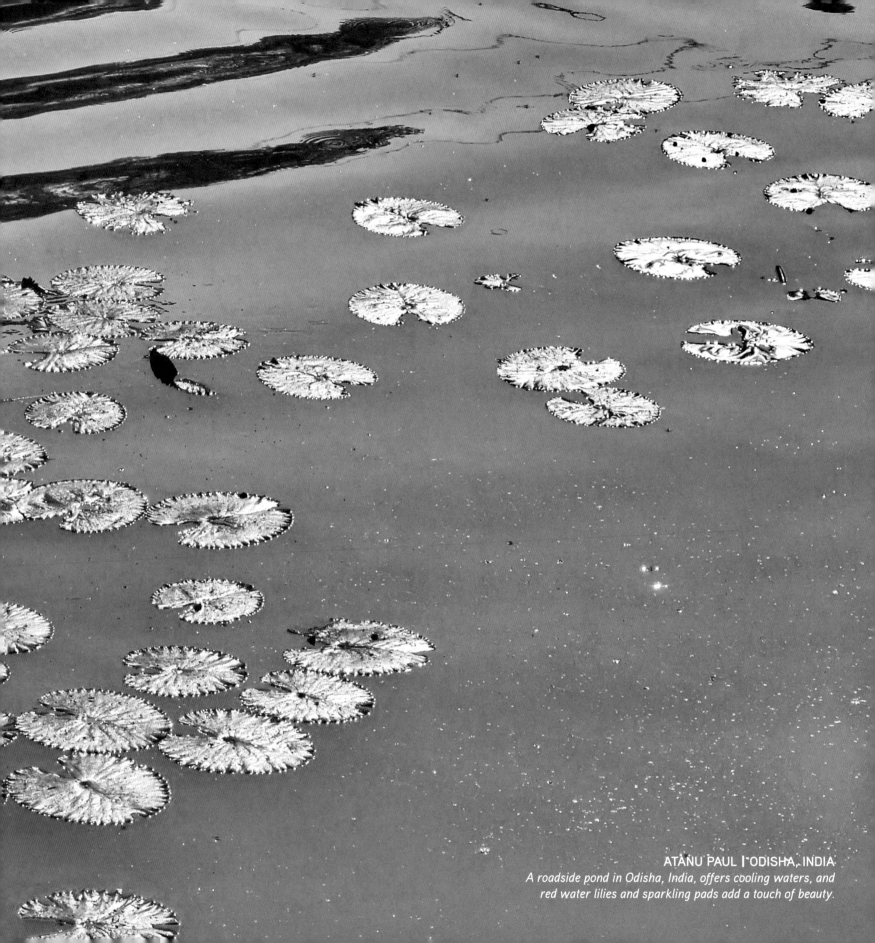

ATANU PAUL | ODISHA, INDIA
A roadside pond in Odisha, India, offers cooling waters, and
red water lilies and sparkling pads add a touch of beauty.

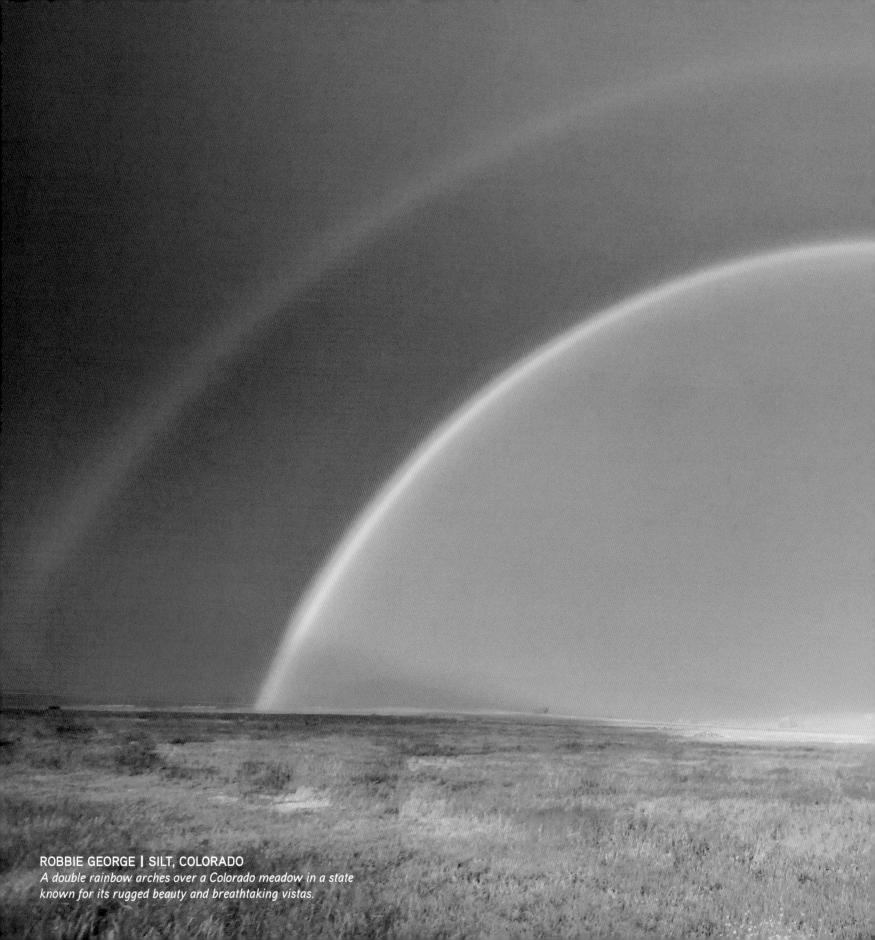

ROBBIE GEORGE | SILT, COLORADO
A double rainbow arches over a Colorado meadow in a state known for its rugged beauty and breathtaking vistas.

AFTERNOON

WE CAN BREATHE A

sigh as midday recedes. Slant light, afternoon rays respect their object, caress and forgive. Our eyes open wider again, more trusting of what we feel and see. This is the time of reflection, recalibration, or perhaps resignation. Light is ample, revealing, and generous, and yet now we find ourselves closer to night than to morning, closer to an end than to a beginning. The day has declared its shape; now it is time to find its meaning.

Few cultures have deified the afternoon light—its shine feels so approachable and human. Afternoons are even-tempered, providing a fine time for power inside and energy outside to balance and meet. "The day becomes more solemn and serene / When noon is past," writes the poet Percy Bysshe Shelley. The fading day becomes us.

Bright sun's respite invites a small rebirth in the world of nature. Flower blossoms that curled in on themselves to save their nectar now dare to bloom again, fragrancing the air as daytime lingers. Birds that sang an early morning chorus return and toss sweet notes into afternoon breezes. They dip and swing, their flight songs mirroring those of morning.

Like continued exertion once muscles have been pushed and tested, afternoons delight. Still at work, we feel ourselves gliding toward rest.

RICHARD NOWITZ | WASHINGTON, D.C. *Tranquil afternoon light showcases the finer details of the U.S. Capitol. The neoclassical landmark took just more than ten years to complete.*

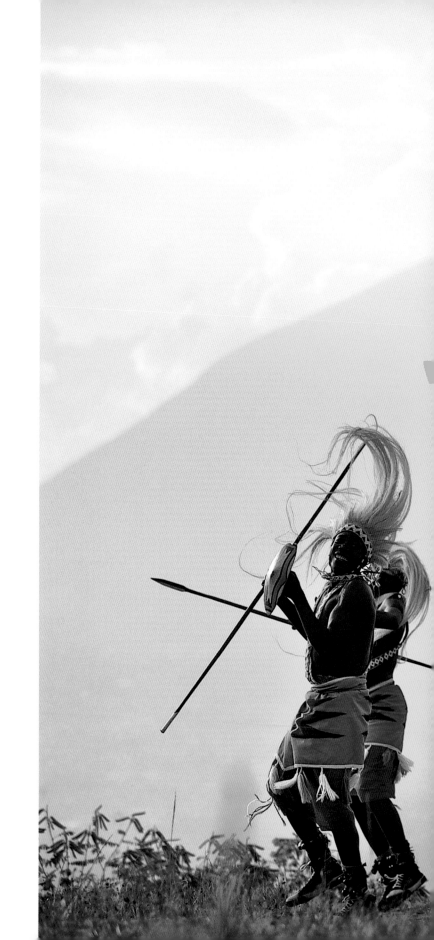

JIM RICHARDSON | PARC NATIONAL DES VOLCANS, RWANDA
A volcano creates a stunning backdrop for Intore dancers as they perform at the Virunga Safari Lodge. The Intore were court dancers for the Tutsi monarchy.

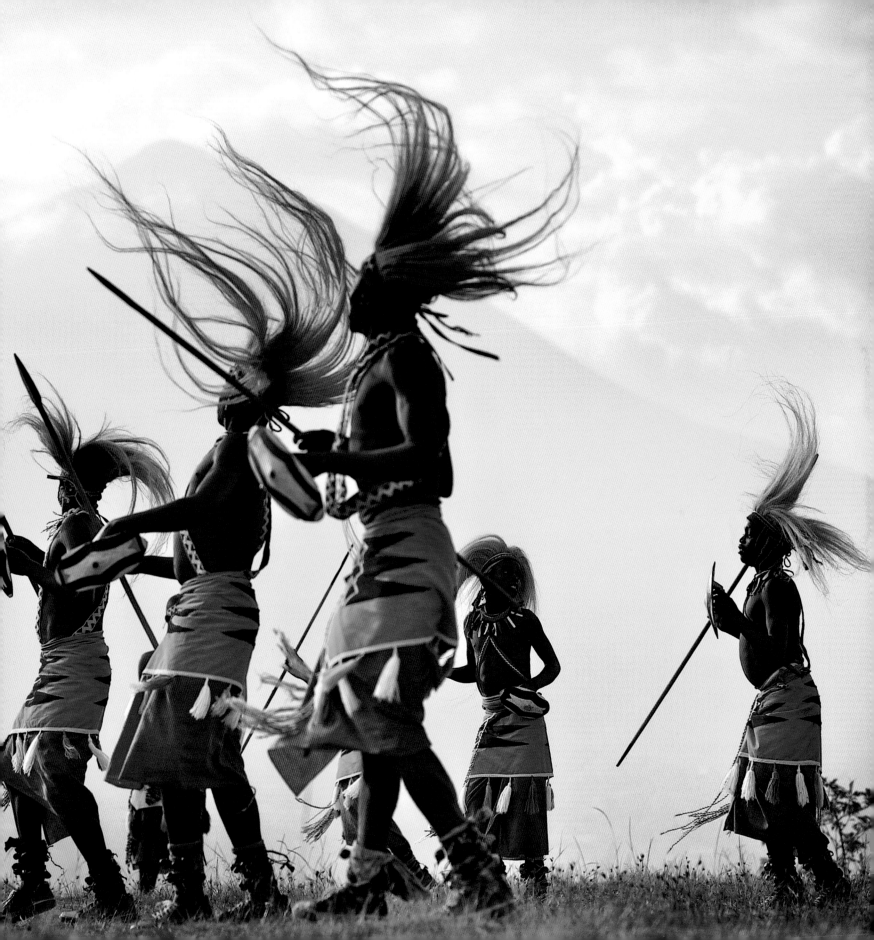

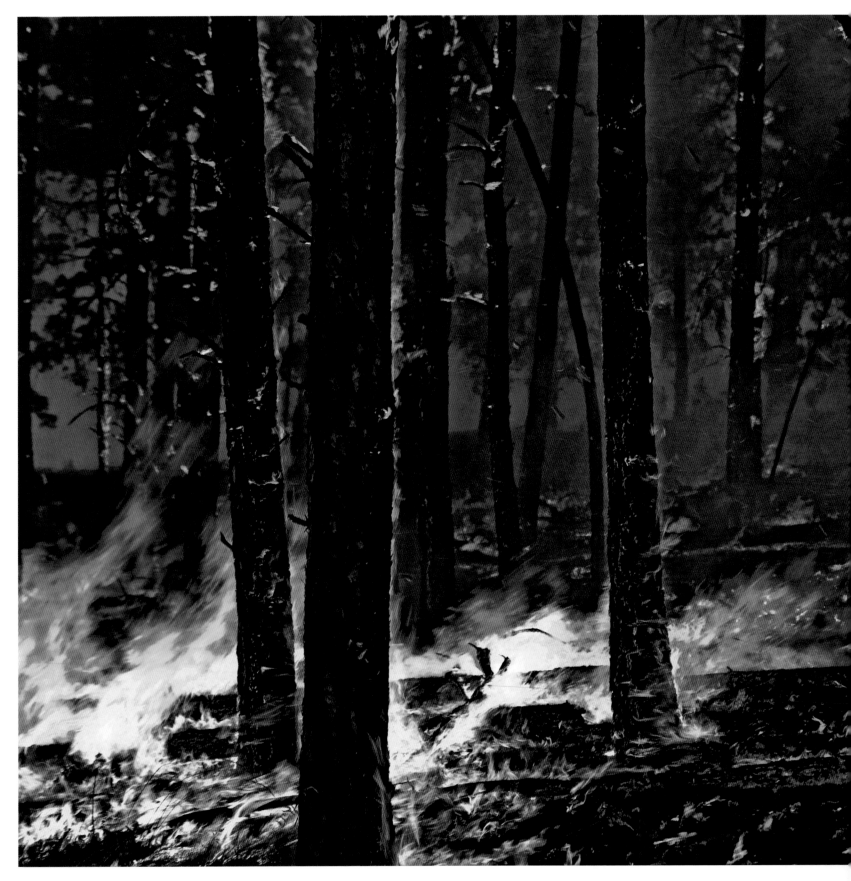

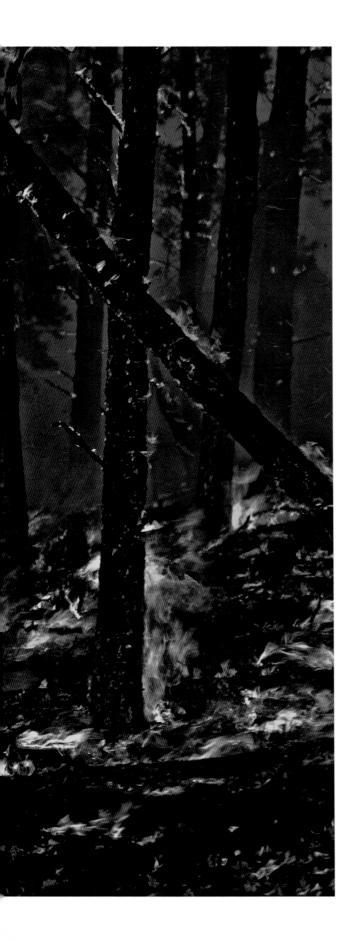

This is a healthy fire. It's a low-intensity ground fire that kills competing saplings and turns the underbrush into fertilizer. All the larger trees will survive this fire and become healthier for the scorching. Their scarred bark will secrete a resin that will help them withstand fiercer fires in the future. Even without the dangers inherent in photographing wild-fires, capturing extraordinary photographs can be a challenge. With fires, smoke often obscures the scene's "sweet spot"; then, for a brief second a gust of wind blows it away only to bring it back with the next rush of air. Thick, black smoke also billows high into the trees, blocking out the sun and making high noon seem like night. The intensely bright flames can be the dominant light source, providing me with an otherworldly fire landscape.

MARK THIESSEN

South Dakota
Fire whips through trees in Custer State Park, South Dakota.

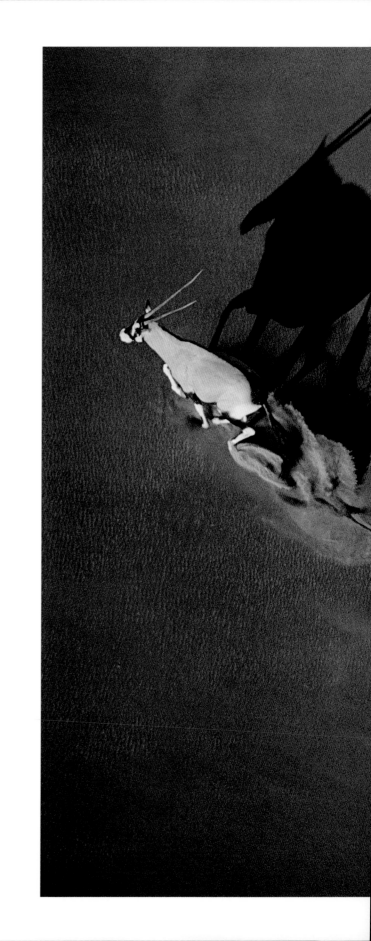

ROBERT B. HAAS | NAMIB DESERT, NAMIBIA
Gemsbok cast late afternoon shadows and leave winding tracks in Namibian sands. High dunes are not a hurdle for these arid-adapted ungulates.

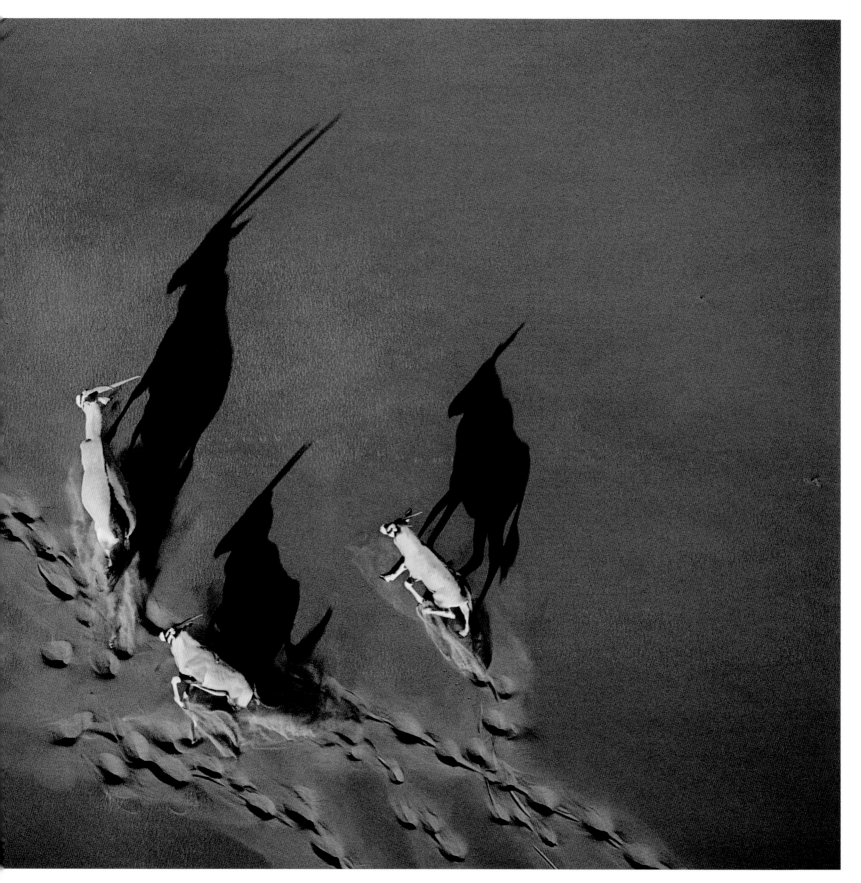

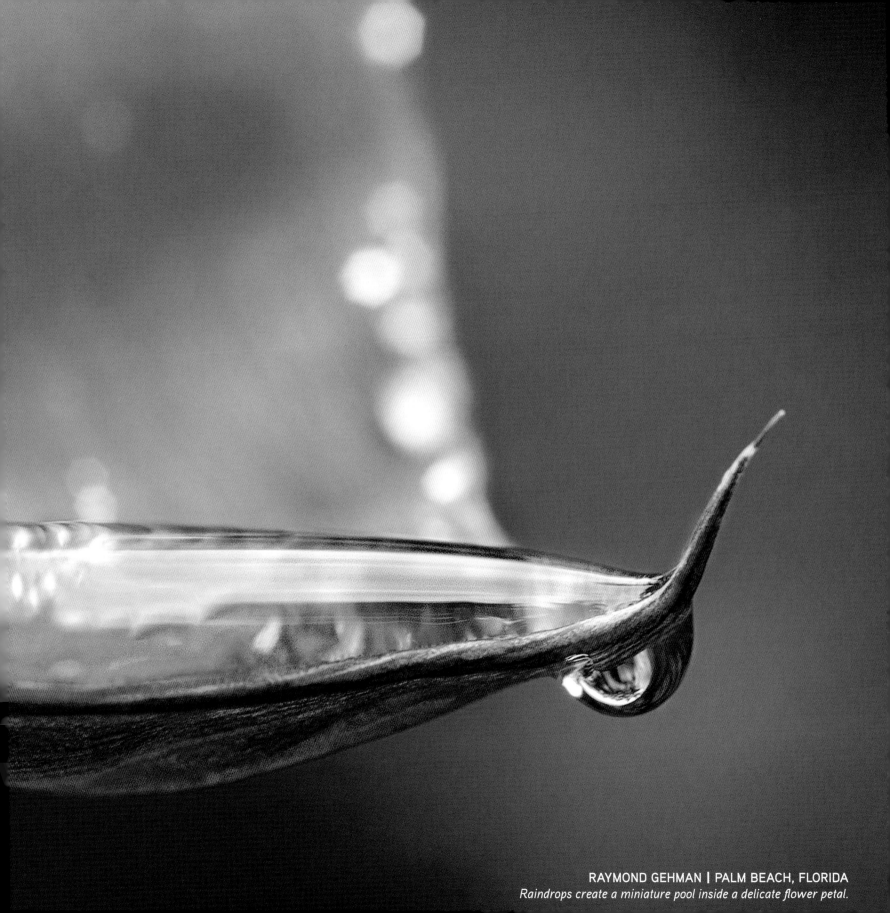

RAYMOND GEHMAN | PALM BEACH, FLORIDA
Raindrops create a miniature pool inside a delicate flower petal.

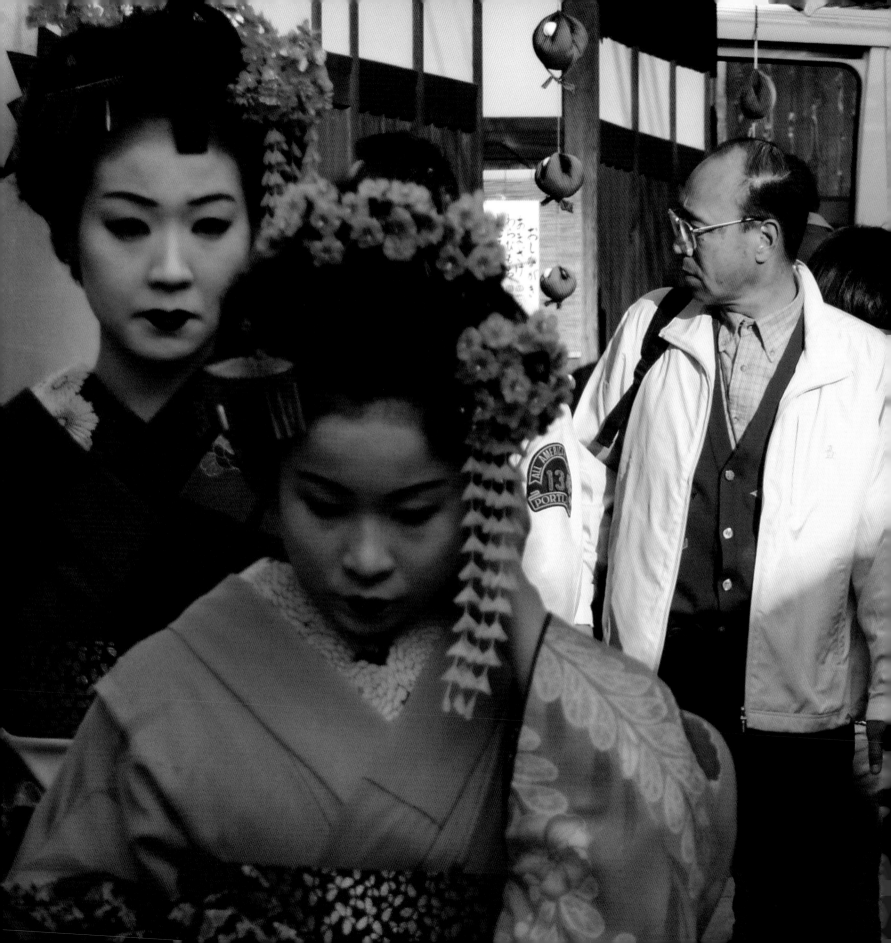

Turn your face
to the sun and
the shadows fall
behind you.

∽

—MAORI PROVERB

ANTHONY AUSTIN | NEW YORK CITY, NEW YORK
*A man makes his way among geisha on a sunny Brooklyn street. The geisha
were crossing through the neighborhood after coming from a temple.*

223

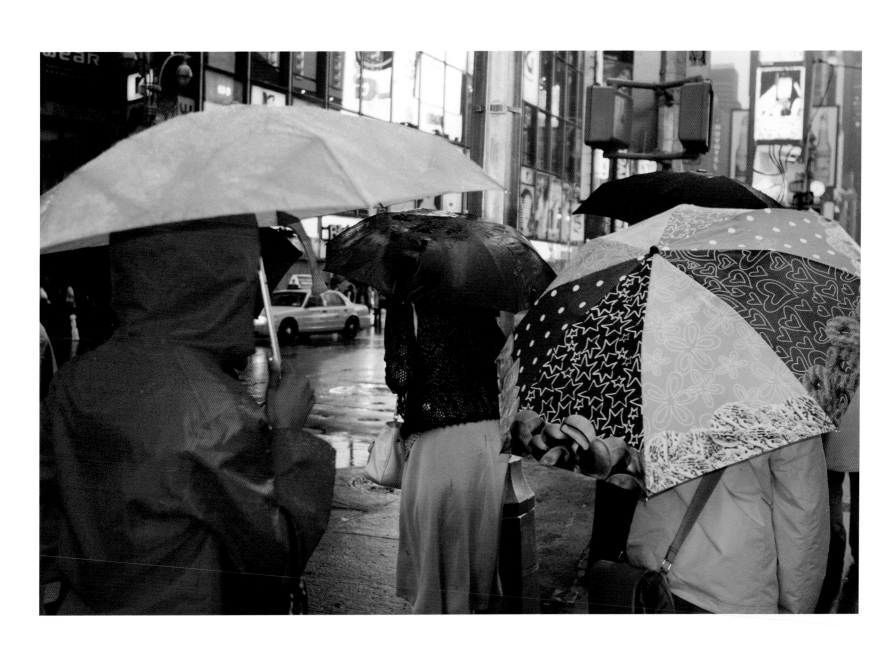

IRA BLOCK | NEW YORK CITY, NEW YORK
Colorful umbrellas come out to guard against a midday rain shower
in New York's Times Square.

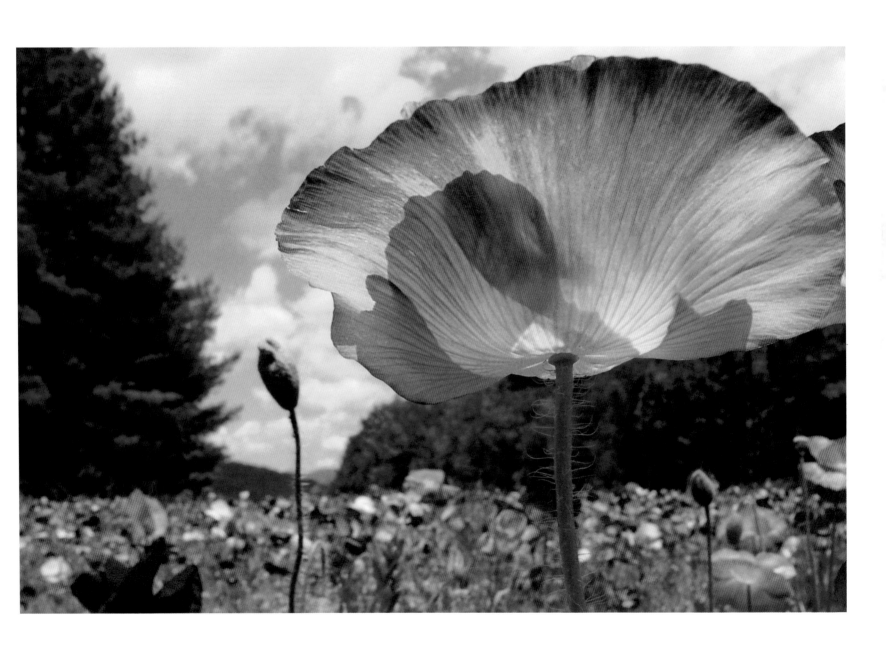

AMY WHITE AND AL PETTEWAY | ASHEVILLE, NORTH CAROLINA
*A red-tinged poppy flower seems to rise above its companions
in a field drenched by the afternoon sun.*

Lingering seems most at home in the late afternoon. Other words belong to other times. But lingering (like dawdling and dallying) works best when the day is slipping away, and we don't care.

–JIM RICHARDSON

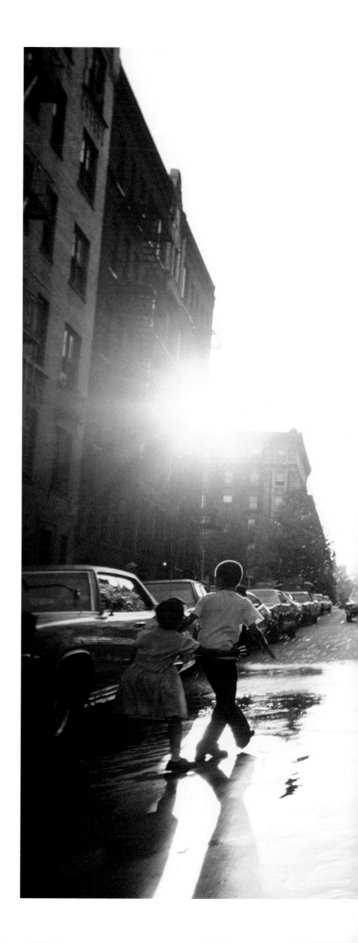

LEROY H. WOODSON | NEW YORK CITY, NEW YORK
The sun begins its descent behind a building as young kids in 1970s Harlem find an open fire hydrant and enjoy some cool relief.

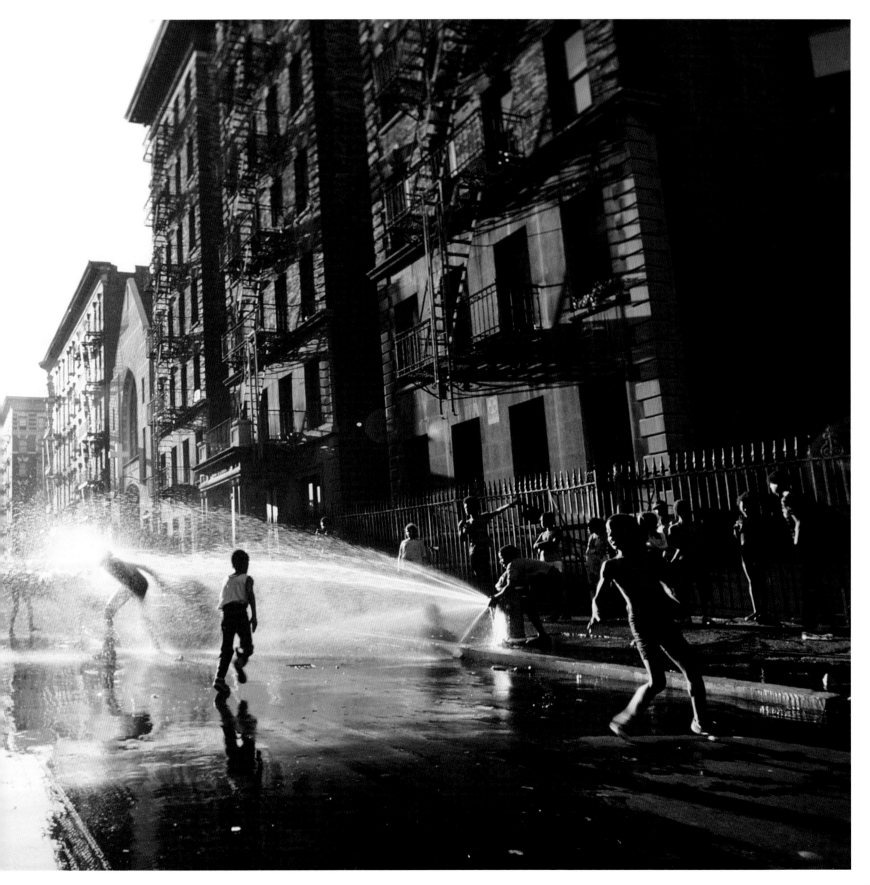

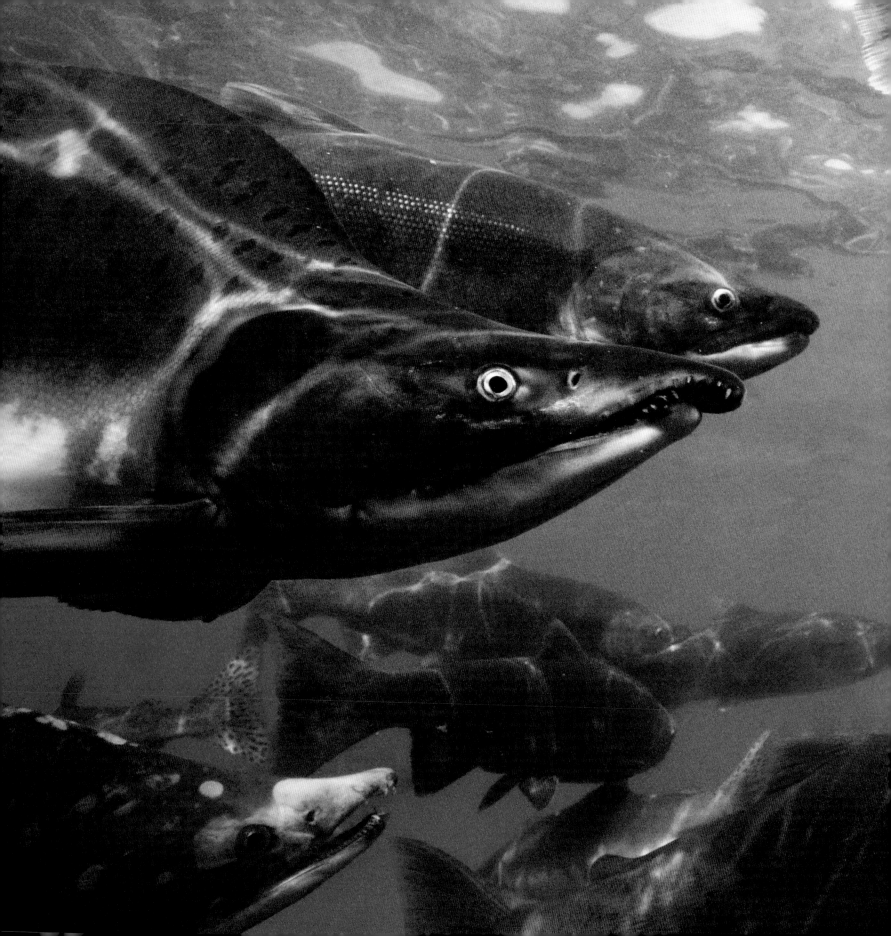

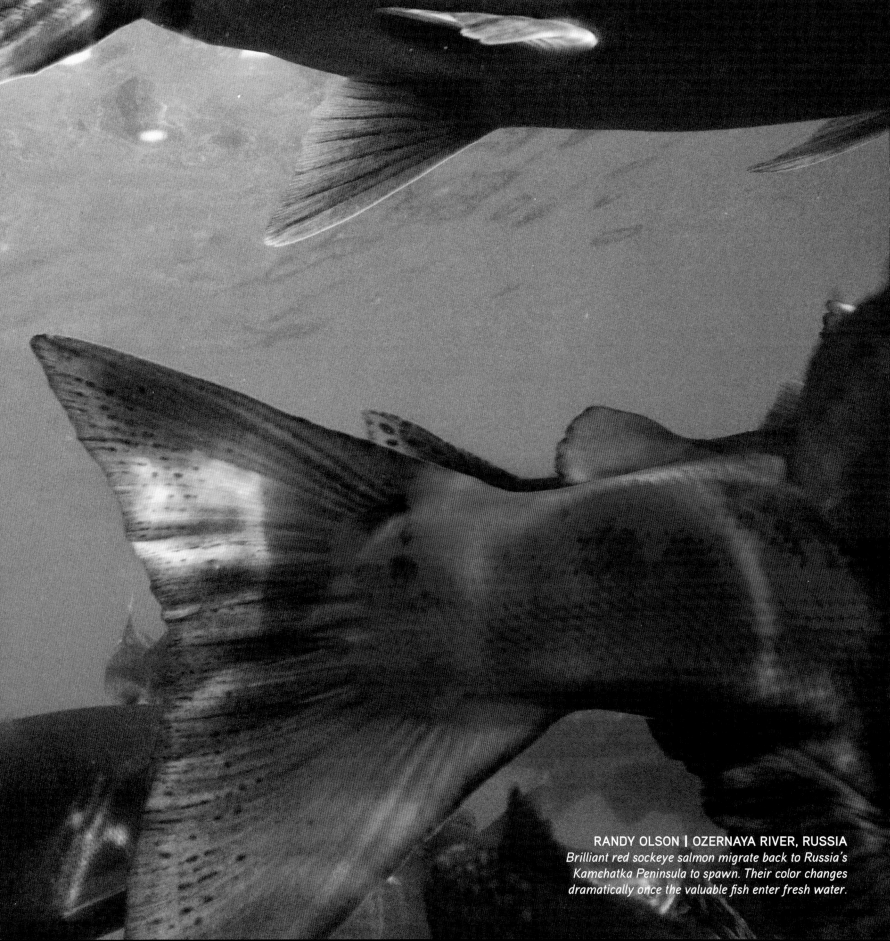

RANDY OLSON | OZERNAYA RIVER, RUSSIA
Brilliant red sockeye salmon migrate back to Russia's Kamchatka Peninsula to spawn. Their color changes dramatically once the valuable fish enter fresh water.

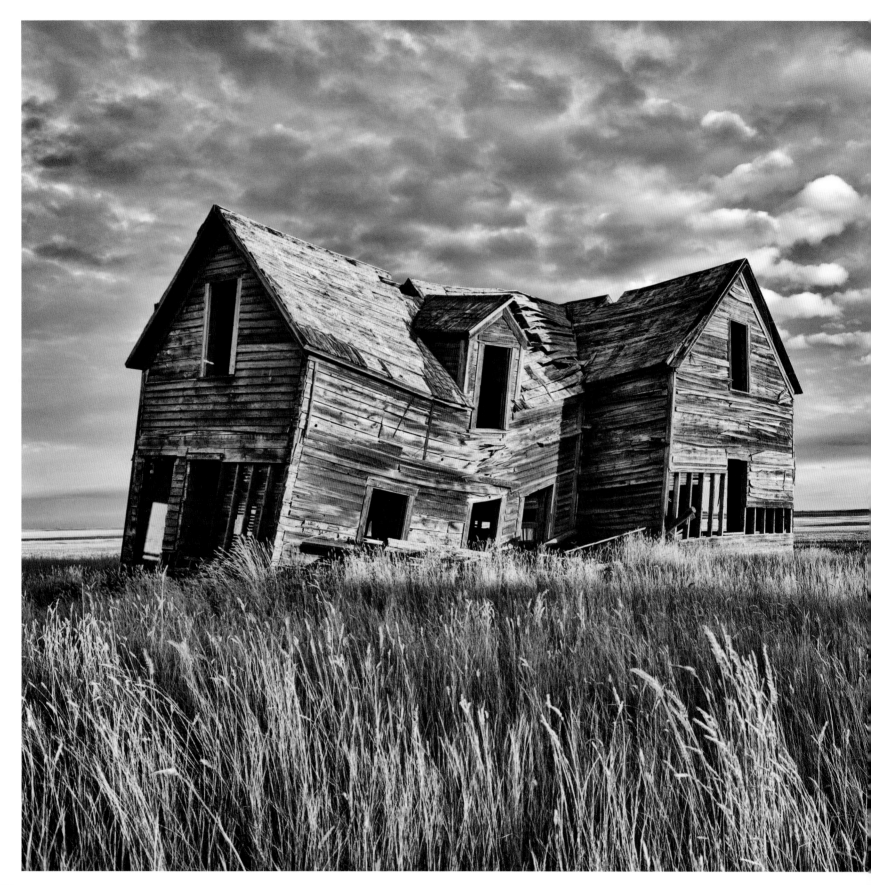

Into my heart's night
Along a narrow way
I groped; and lo!
the light,
An infinite land
of day.

–RUMI

PETE RYAN | ALBERTA, CANADA
Gentle afternoon sunshine and shadows create a vibrant display on the Alberta prairie, which seems poised to overtake an old farmhouse.

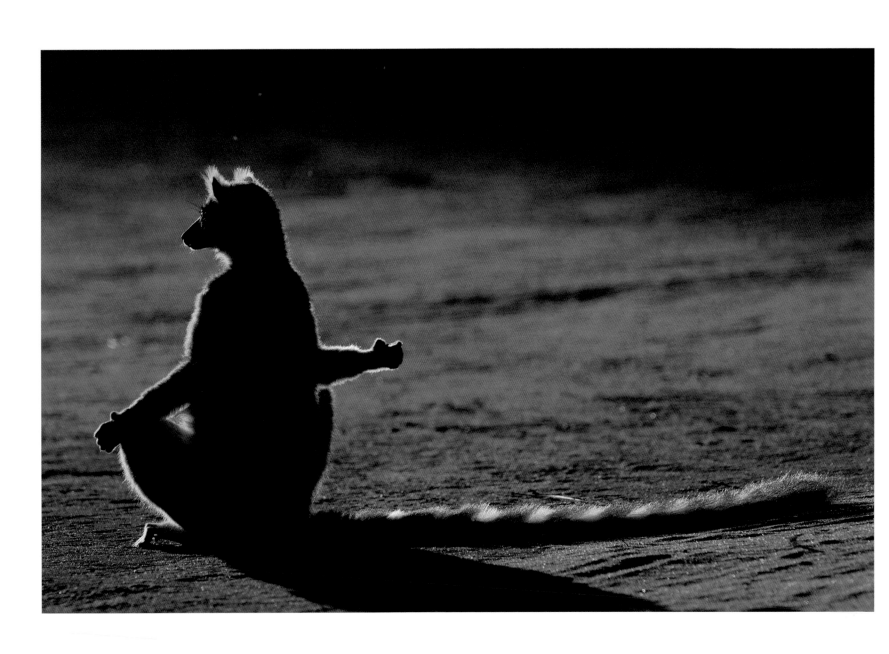

PETE OXFORD | BERENTY RESERVE, MADAGASCAR
Say "om." A ring-tailed lemur seems to adopt a contemplative pose
as it suns itself. The species makes its home in forests, rocky canyons,
the bush, and on the savanna.

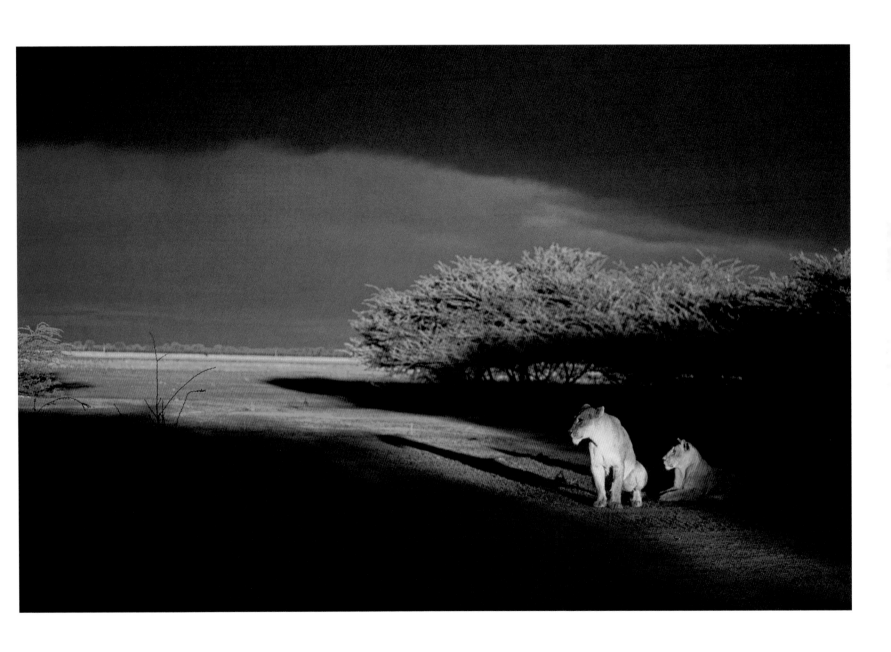

BEVERLY JOUBERT | SAVUTI CAMP, BOTSWANA
The late afternoon sun places two African lionesses in the spotlight as they rest in the arid grasslands of Botswana's Chobe National Park.

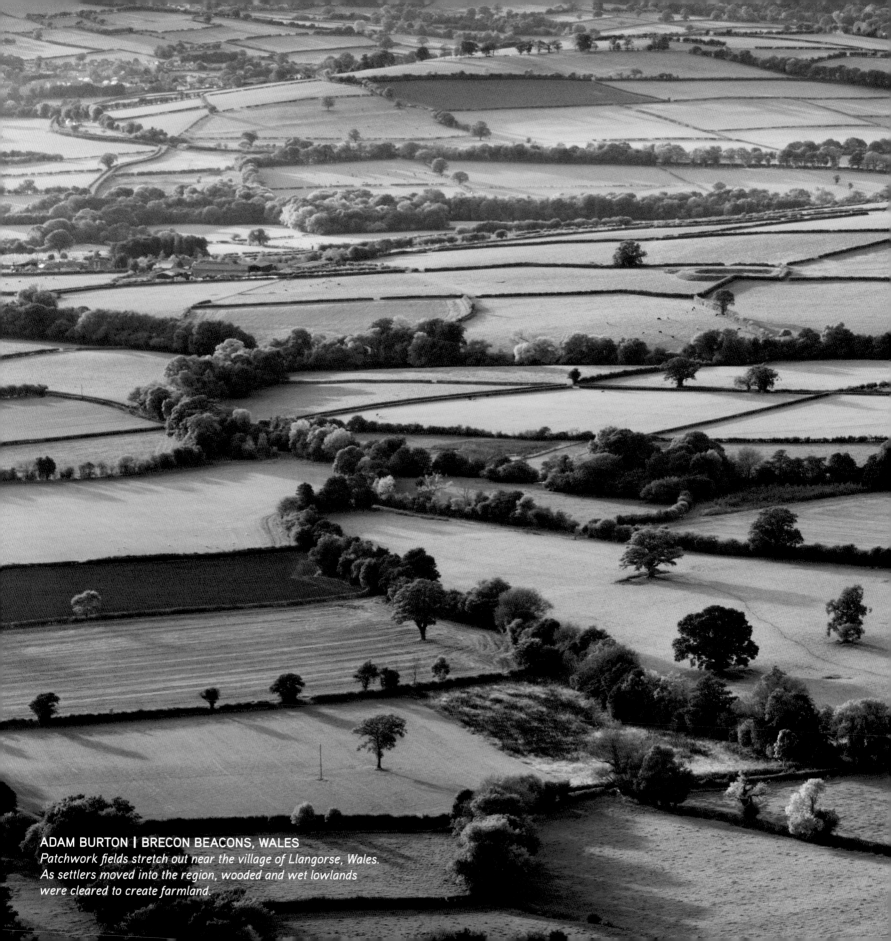

ADAM BURTON | BRECON BEACONS, WALES
Patchwork fields stretch out near the village of Llangorse, Wales.
As settlers moved into the region, wooded and wet lowlands
were cleared to create farmland.

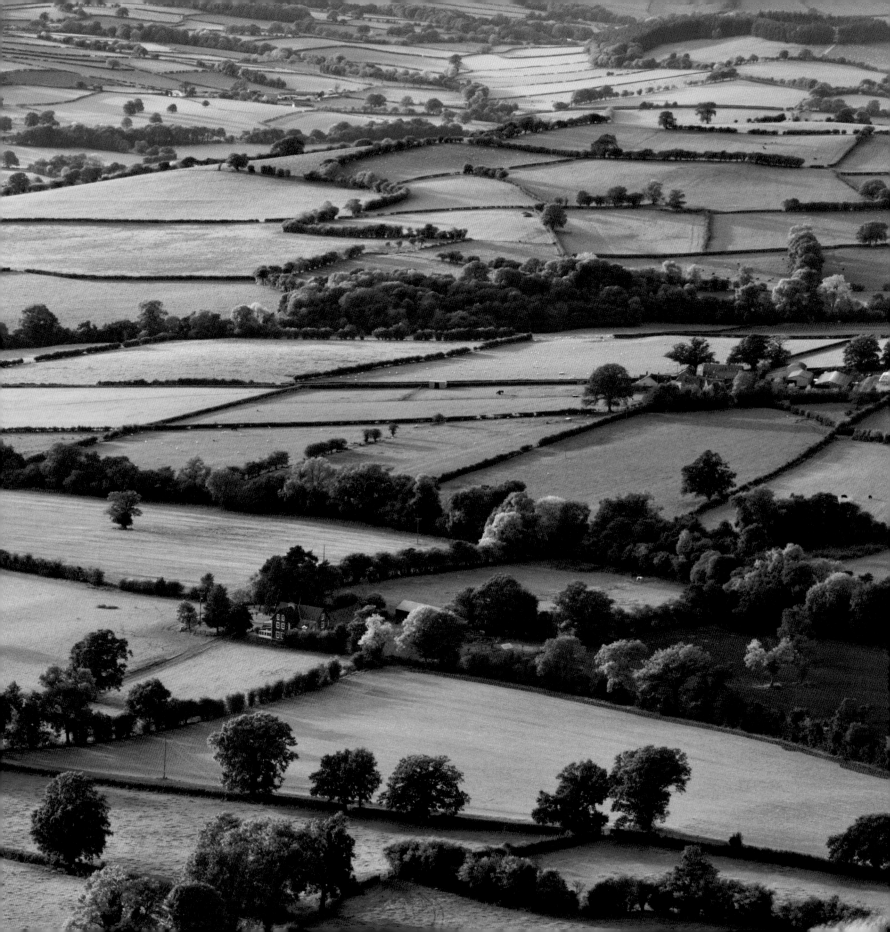

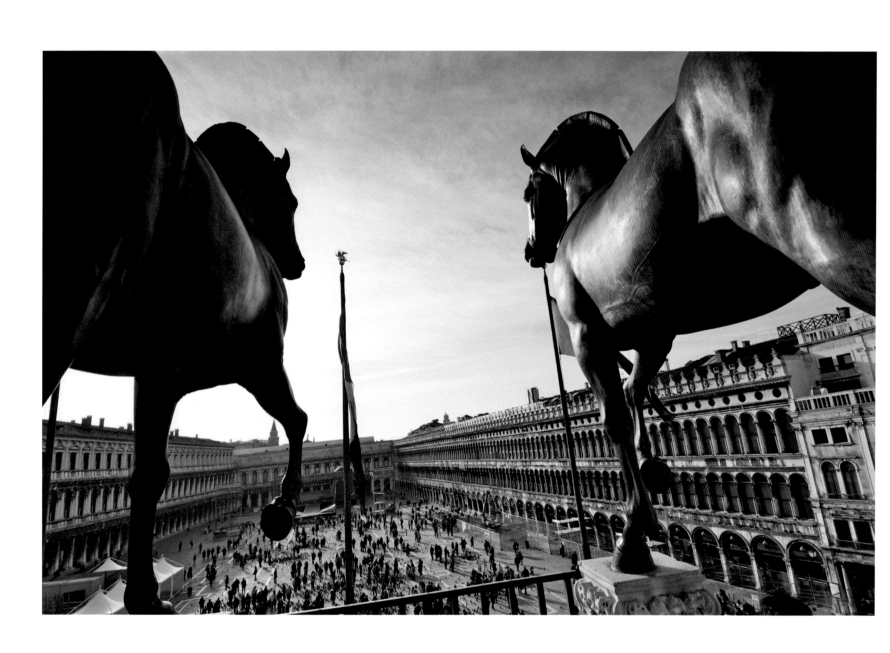

JIM RICHARDSON | VENICE, ITALY
Horses on the steps of San Marco Basilica look out over Venice's Piazza San Marco. Tourists throng the cafés and shops on what Napoleon termed Europe's finest drawing room.

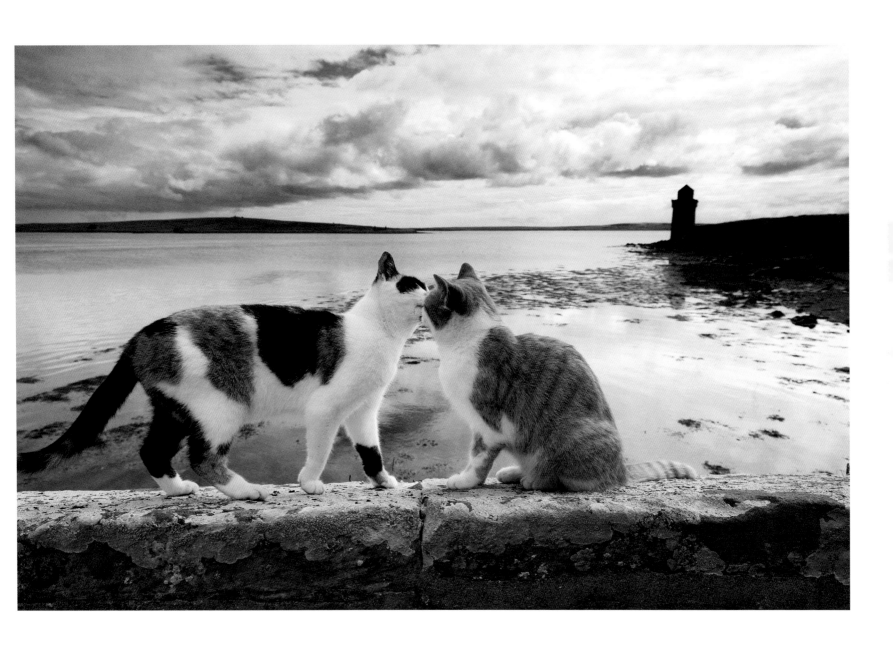

JIM RICHARDSON | SHAPINSAY, SCOTLAND
*Two cats share a nuzzle in Shapinsay in Scotland's
Orkney Islands. The islands, some 20 miles north of the
mainland, have been occupied since the Neolithic.*

The afternoon hour before sunset

is my favorite time to work. I love the vibrancy of colors that turn into deeply muted tones just as dark takes over. But unlike sunrise, in late afternoon's light, the hustle and bustle of life is everywhere. In this photo, the sun angled into a school bus full of high school cheerleaders anticipating the night ahead. We were on our way to one of the final football games of the season. I was drawn to the red, red lips and the all-American feel of this young Texan woman at this moment, but most of all to her expression. It's a quiet hustle and bustle, but it speaks to a rich inner world, a personal space only she can inhabit. That space cannot be accessed in the photo itself, and I think that's what sparks our curiosity. I like looking for quiet, pensive moments because I think they give dignity to our inner lives.

KITRA CAHANA

Austin, Texas

Cheerleaders ride to a varsity football game.

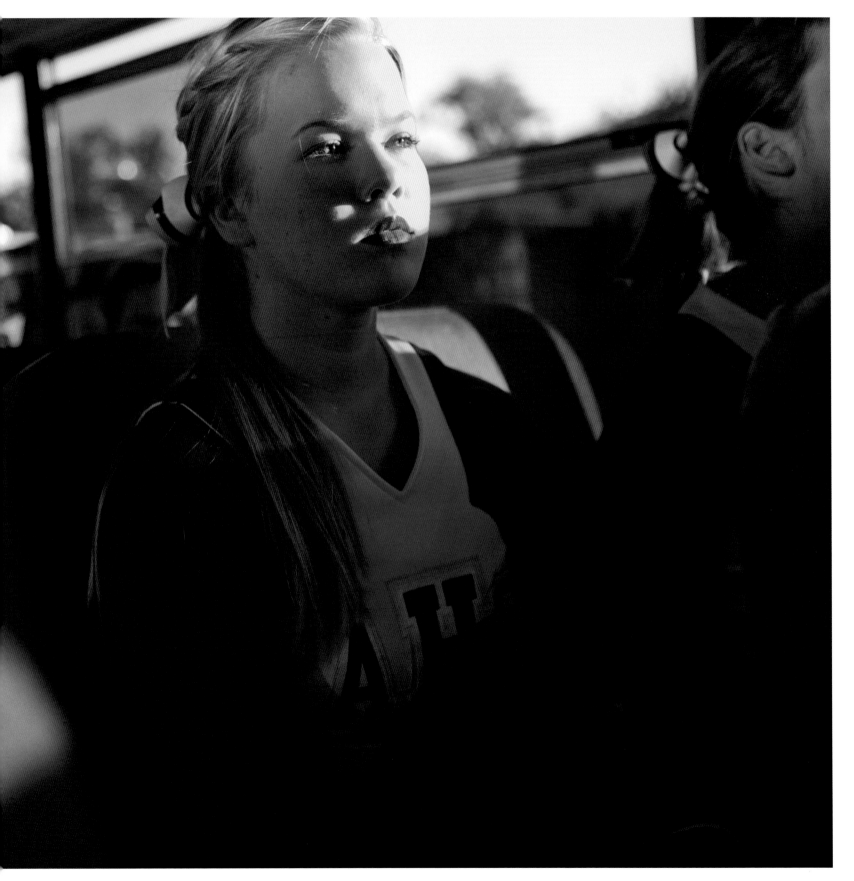

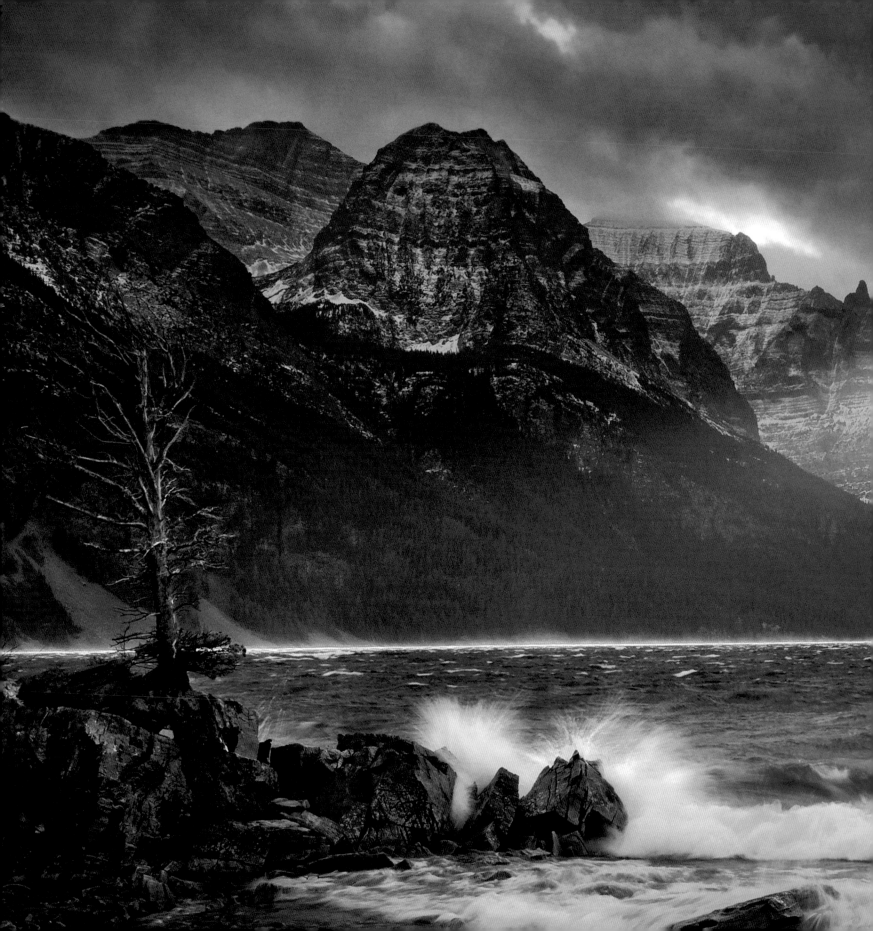

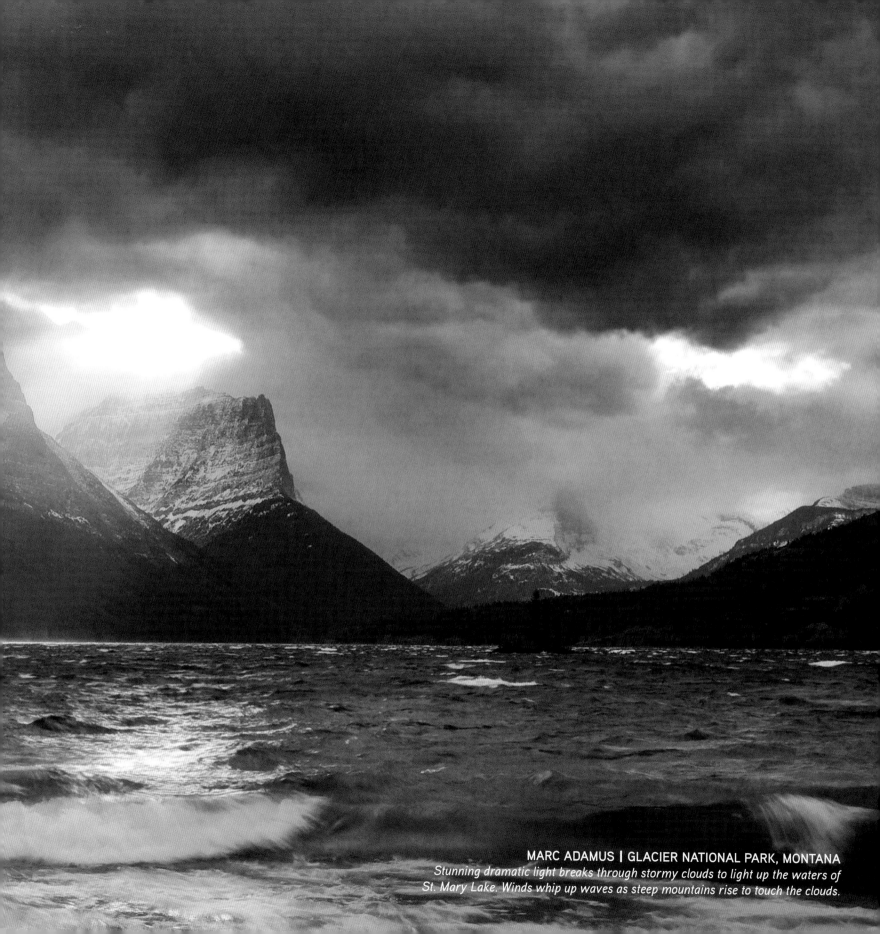

MARC ADAMUS | GLACIER NATIONAL PARK, MONTANA
*Stunning dramatic light breaks through stormy clouds to light up the waters of
St. Mary Lake. Winds whip up waves as steep mountains rise to touch the clouds.*

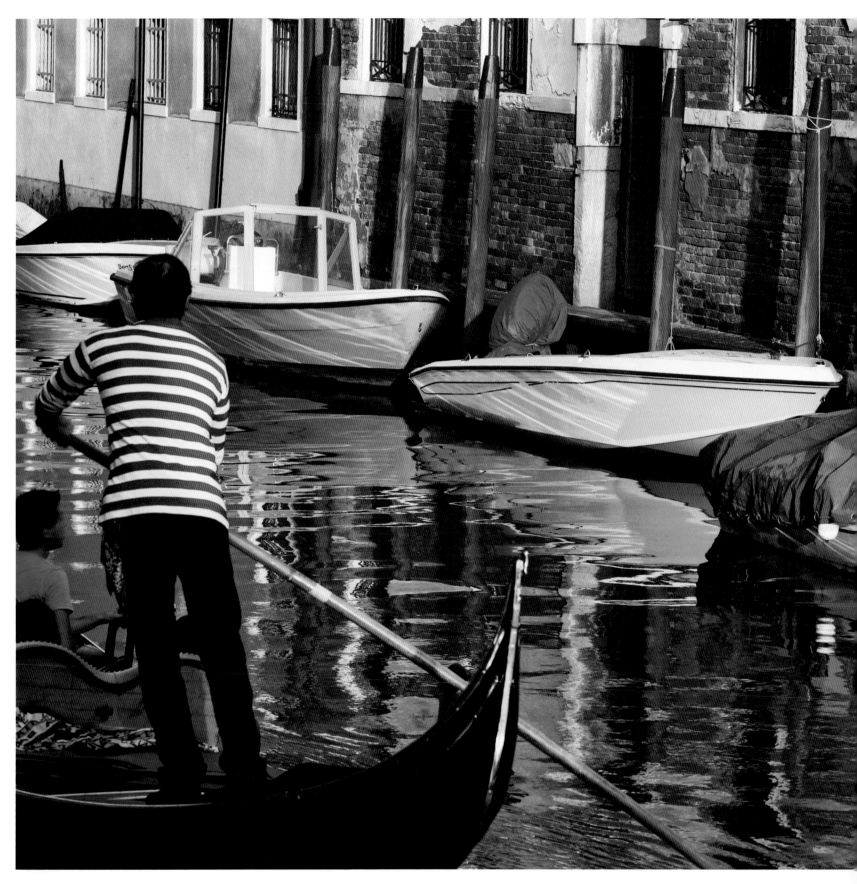

FOTOSEARCH | VENICE, ITALY

A gondolier in the traditional red-and-white striped shirt
passes moored boats. Gondoliers don't pole their boats
through the deep canals but row "Venetian-style."

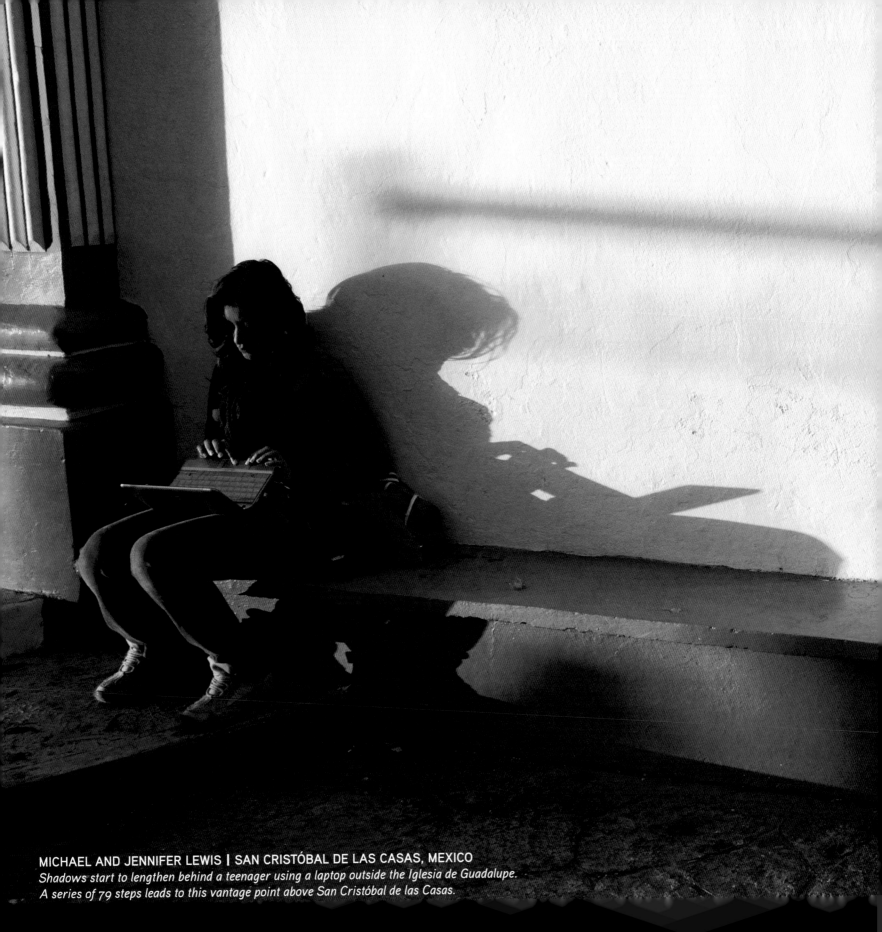

MICHAEL AND JENNIFER LEWIS | SAN CRISTÓBAL DE LAS CASAS, MEXICO
Shadows start to lengthen behind a teenager using a laptop outside the Iglesia de Guadalupe.
A series of 79 steps leads to this vantage point above San Cristóbal de las Casas.

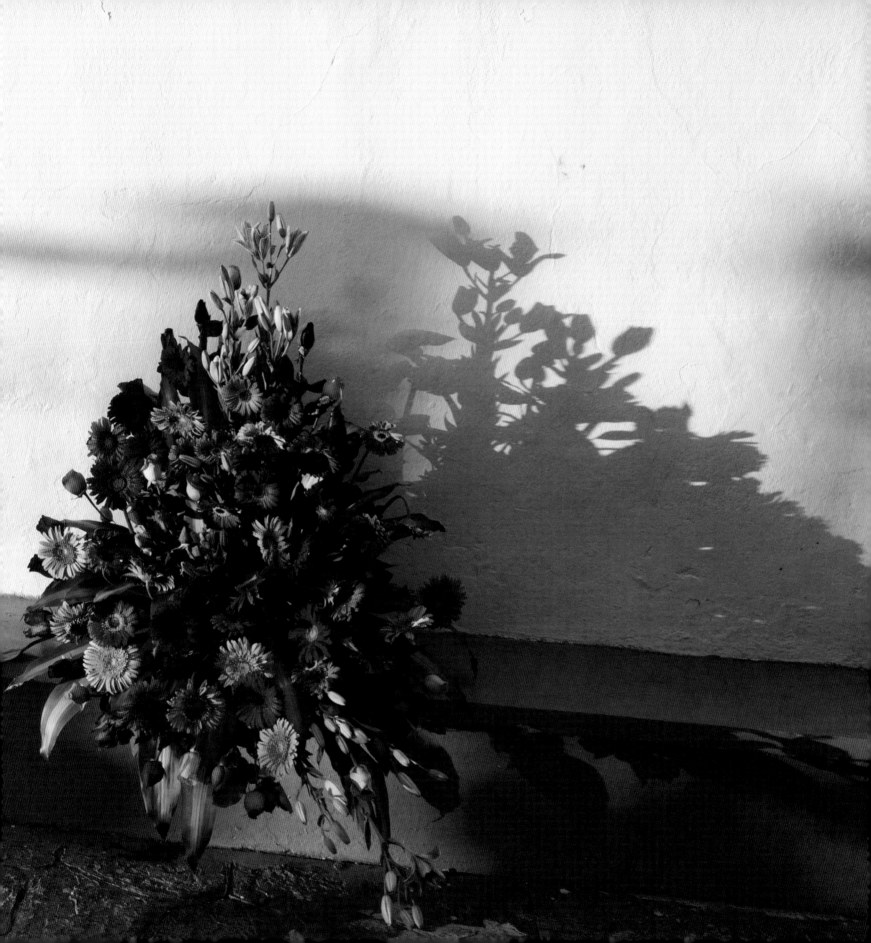

During four years of travel for my story "Journey of Faith," I followed Abraham's journey according to the three monotheistic religions: Judaism, Christianity, and Islam. The gate that the Palestinians call "Abraham friend of God" is an important gate in the walls of Jerusalem—and an important landmark for my story too. It was late in the day, and the winter sun put all its energy into this beautiful, crisp, yellow-orange light. The scene, the architecture, the penetrating rays of sun, all presented a perfect scene, but something was missing. Then, a sudden movement, and I saw him firmly holding his hat and running through the gate. Perfect moment! Perfect lighting! Click before he disappeared. I had made the opening picture of the story.

REZA

Jerusalem
A Jewish man casts a long shadow as he walks toward a doorway.

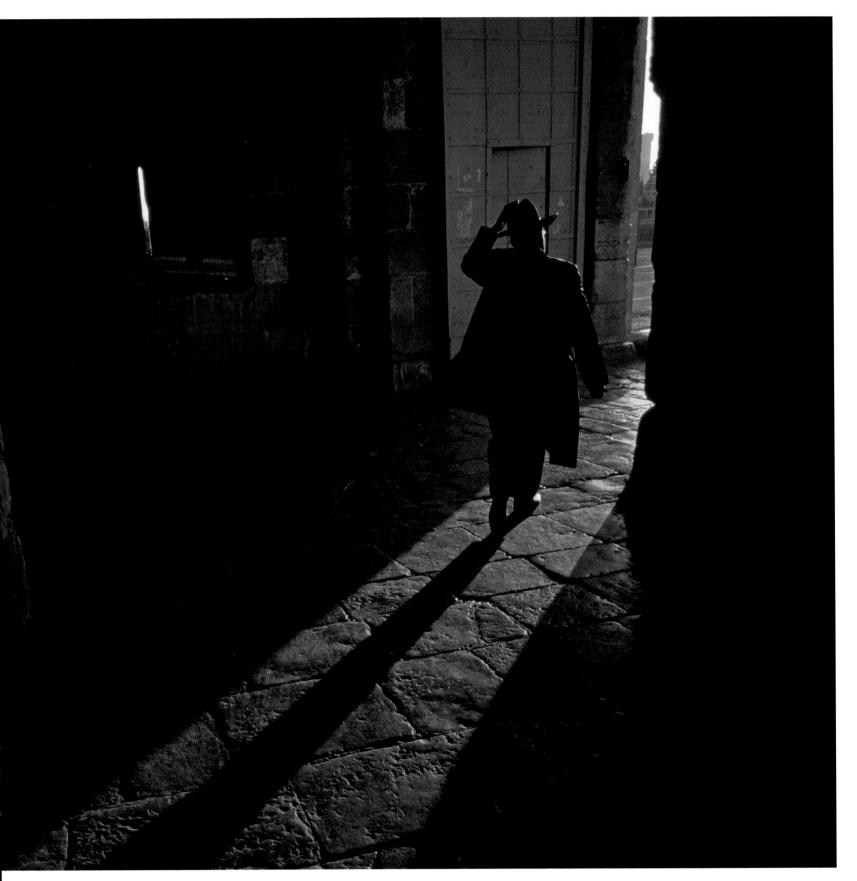

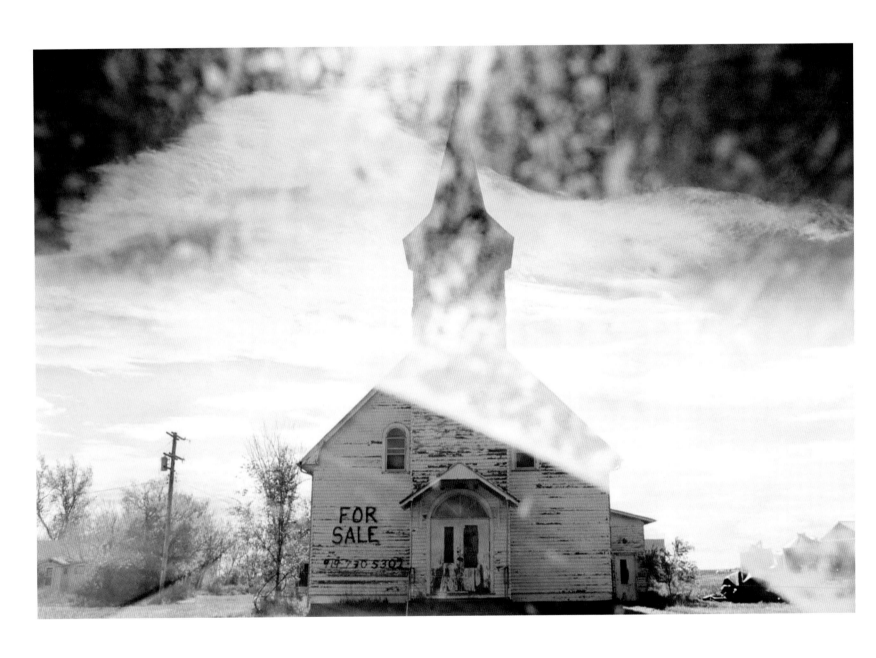

EUGENE RICHARDS | BALFOUR, NORTH DAKOTA
St. Joseph's Catholic Church sits abandoned and for sale. Late afternoon clouds move across the frame, taken through the front windshield of an SUV.

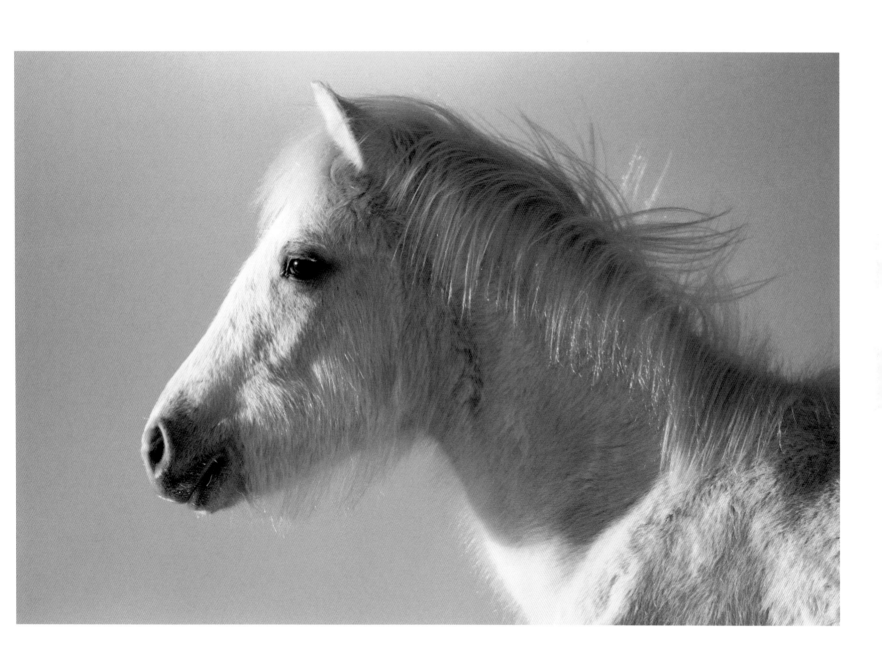

YVA MOMATIUK AND JOHN EASTCOTT | WYOMING
Gentle winter light lands on the soft coat of a wild Mustang foal.
Mustangs have lived in Wyoming's rugged lands for nearly 200 years.

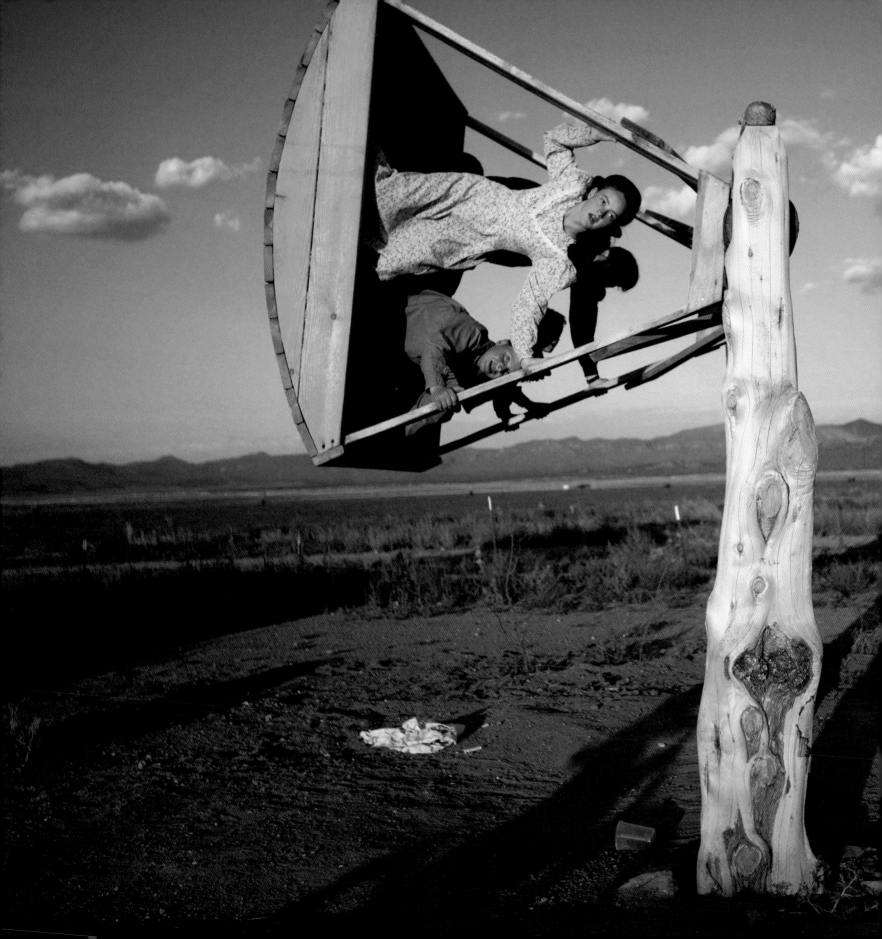

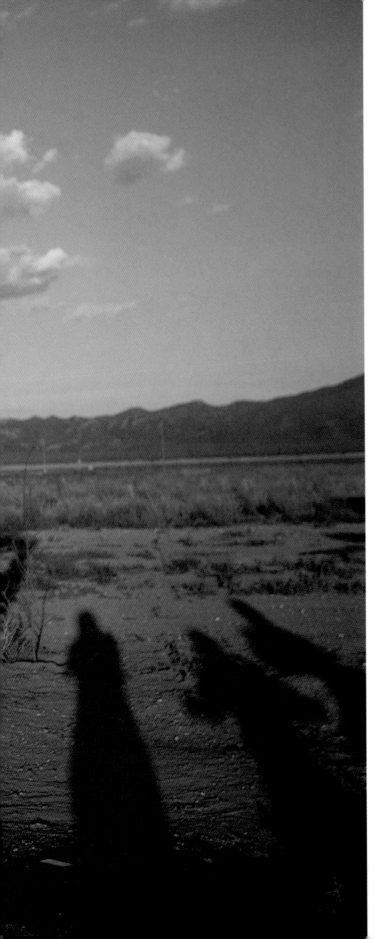

Do not anticipate trouble or worry about what may never happen. Keep in the sunlight.

–BENJAMIN FRANKLIN

STEPHANIE SINCLAIR | PONY SPRINGS, NEVADA
After helping to bring in the hay harvest, friends soar on a homemade swing at a 4,000-acre ranch of the Fundamentalist Church of Jesus Christ of Latter-Day Saints.

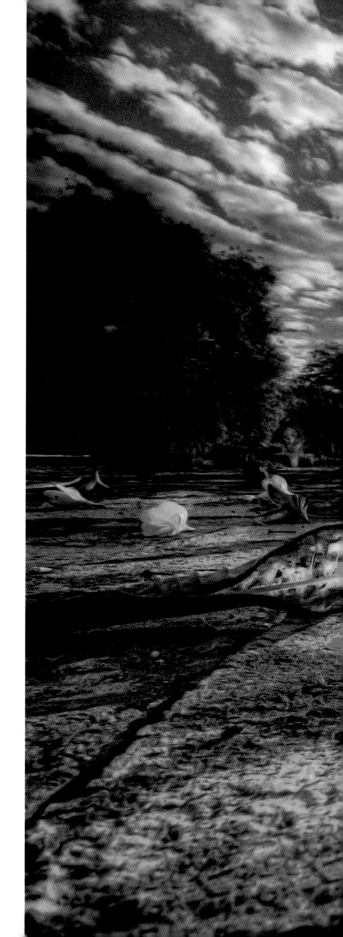

LAURENT HUNZIKER | THAILAND
Late afternoon sunlight brightens a flower at a temple site near Chiang Mai, Thailand. More than 300 temples can be found in this area, some 400 miles northwest of Bangkok.

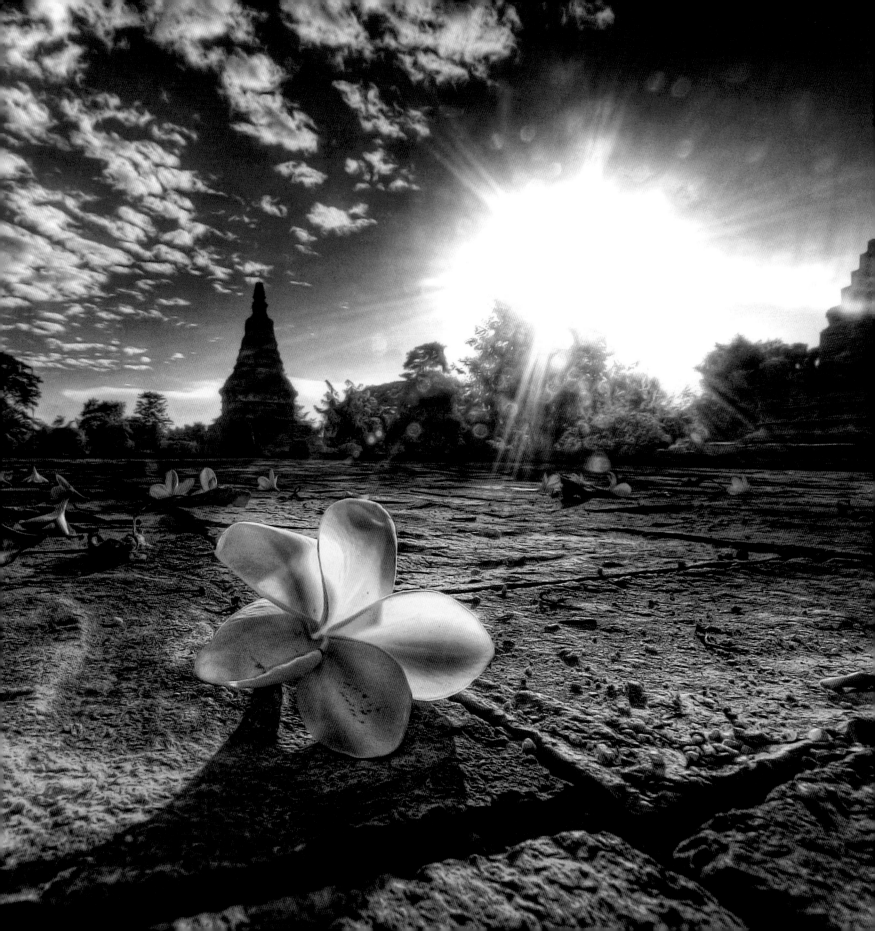

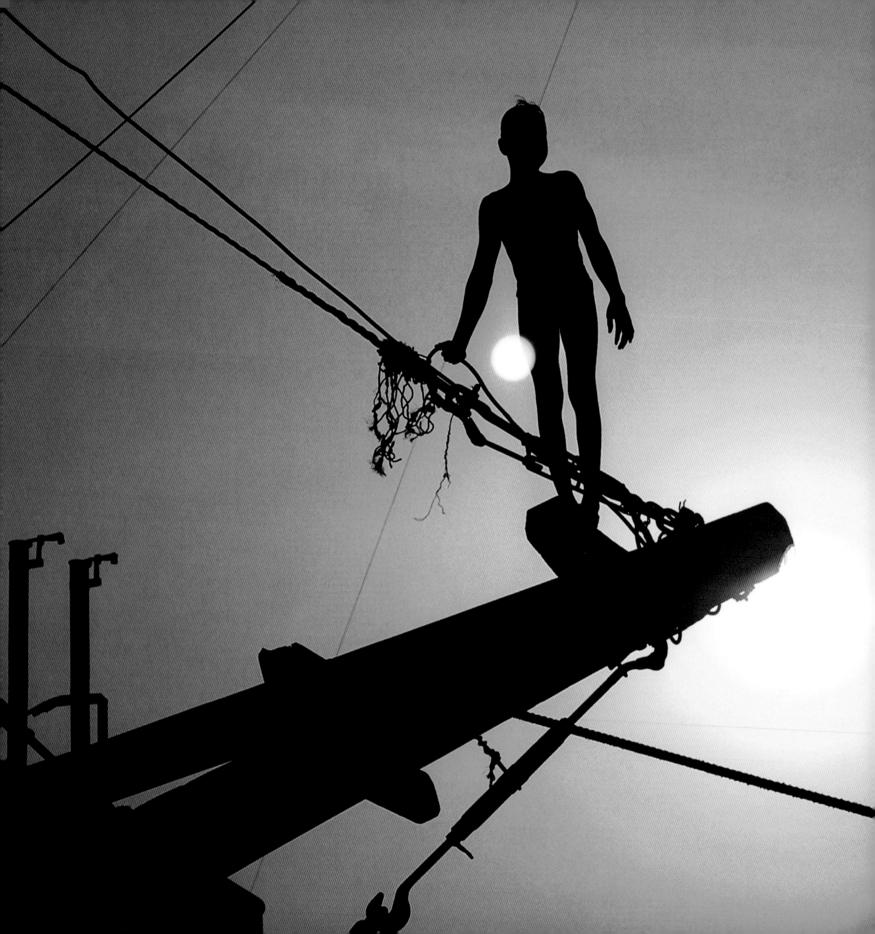

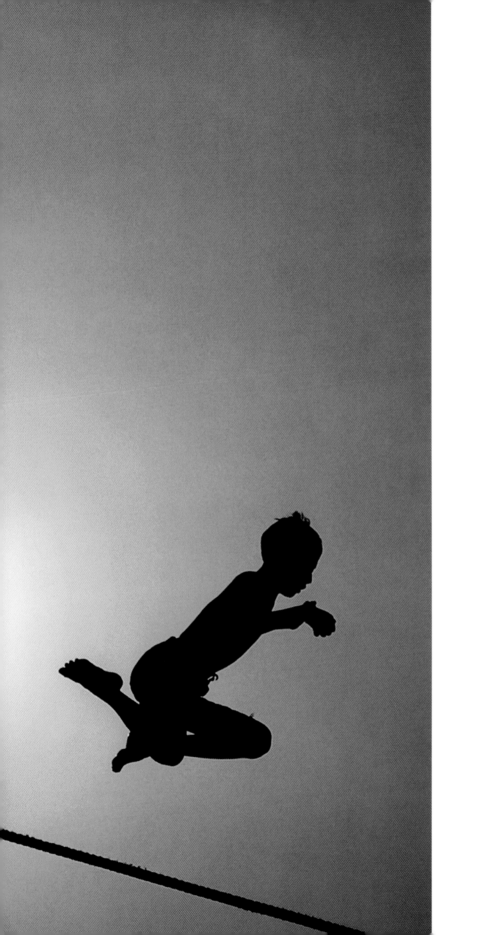

NORMAN SETIAWAN | JAKARTA, INDONESIA
*Ahoy there! Set against an orange sky, children jump
from a ship in the Sunda Kelapa Harbor in Jakarta.
European traders first arrived here in the 16th century.*

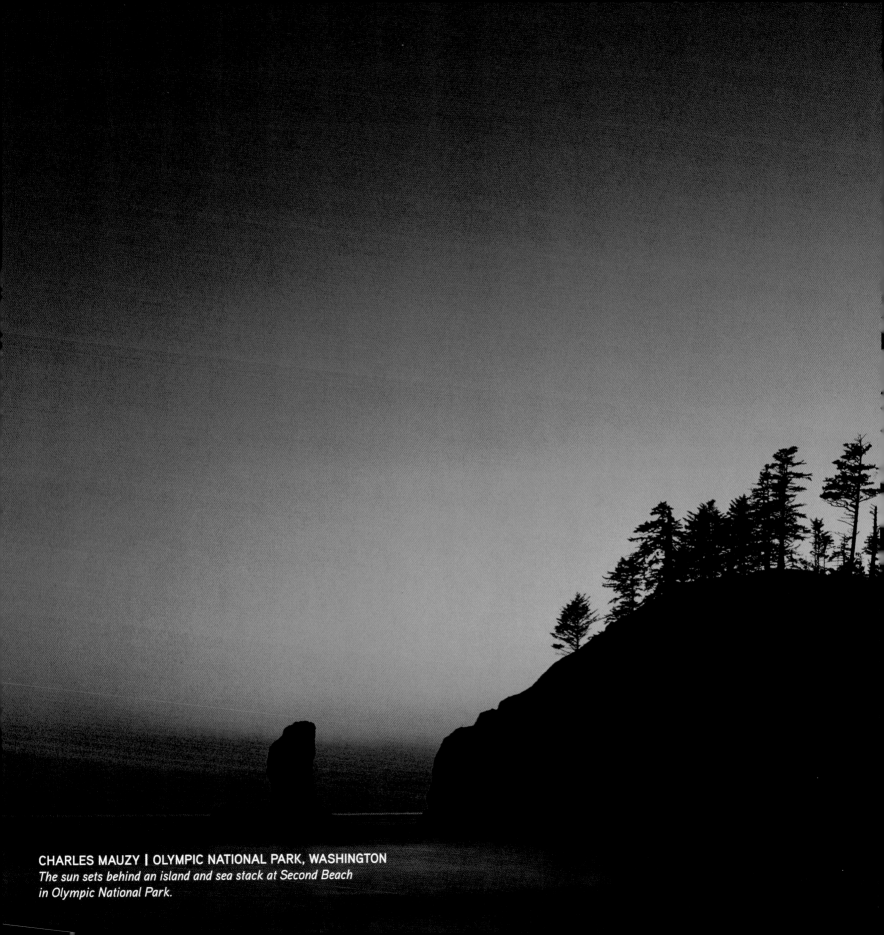

CHARLES MAUZY | OLYMPIC NATIONAL PARK, WASHINGTON
*The sun sets behind an island and sea stack at Second Beach
in Olympic National Park.*

SUNSET

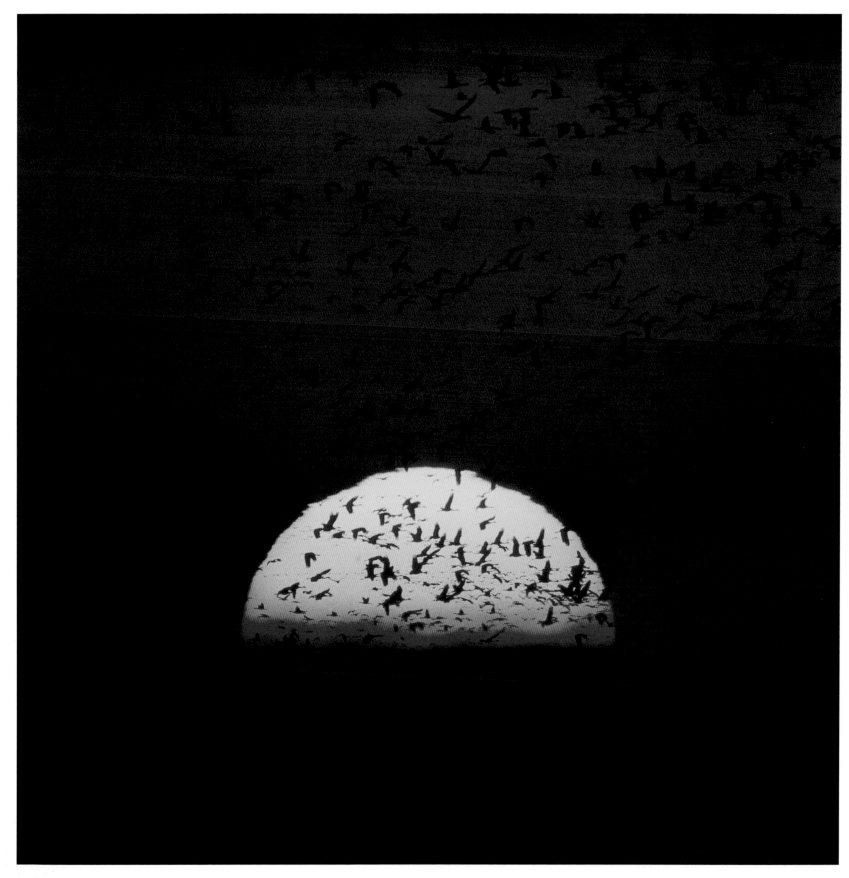

PAUSE AND SALUTE

the light at sunset, the day's last chance to commune with the sun. In morning we are just opening our eyes; at noon we seek to shield them; in afternoon we grow complacent, sight becomes so easy and ordinary. Now, suddenly, sunset blazes out at us, demanding we watch the shifting light paint combinations of color so amazing, ever different—swatches that set the standard for what we call beautiful.

What is the secret of sunset? It is the time when light meets land, when fire touches earth and sets off an exquisite explosion, a divine display. This gift of light and color is so ample and opulent, the ancient Greeks embodied it as the Hesperides, three graceful maidens in filmy robes who tended an orchard ever ripe with golden apples. Daughters of Night, these nymphs were charged with keeping their valuable harvest out of the hands of gods and mortals, but that did not keep them from tossing the apples up into the sky, thus splashing a golden glow upon the world below.

Sunset's drama never lasts long enough. We watch as the colors collect themselves and intensify. We hope for yet cannot imagine shades more beautiful than these—and then the sun dips down below the horizon, sometimes a whisper, sometimes a flash, leaving only ripples behind.

JOEL SARTORE | PLATTE RIVER, GIBBON, NEBRASKA *Sandhill cranes by the thousand cross in front of a setting sun. The cranes return to the Platte River in central Nebraska during their spring migration north.*

GEORGE GRALL | SMYRNA, DELAWARE
*Great egrets, dowitchers, and American avocets hunt
in the water at sunset—a perfect time to watch wading birds.*

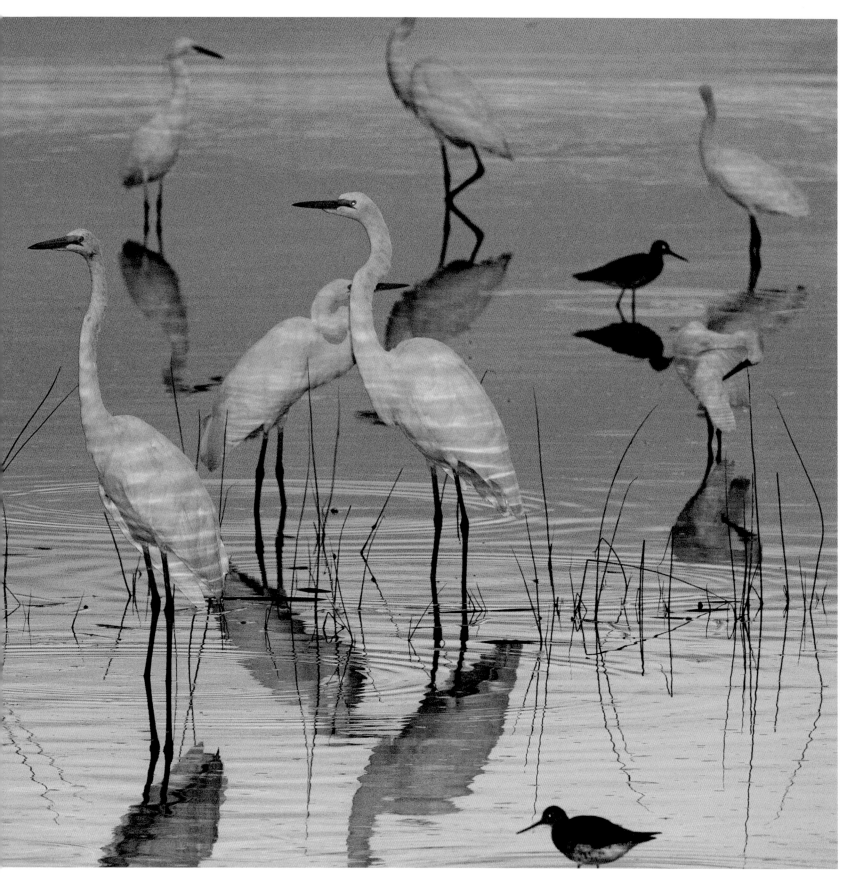

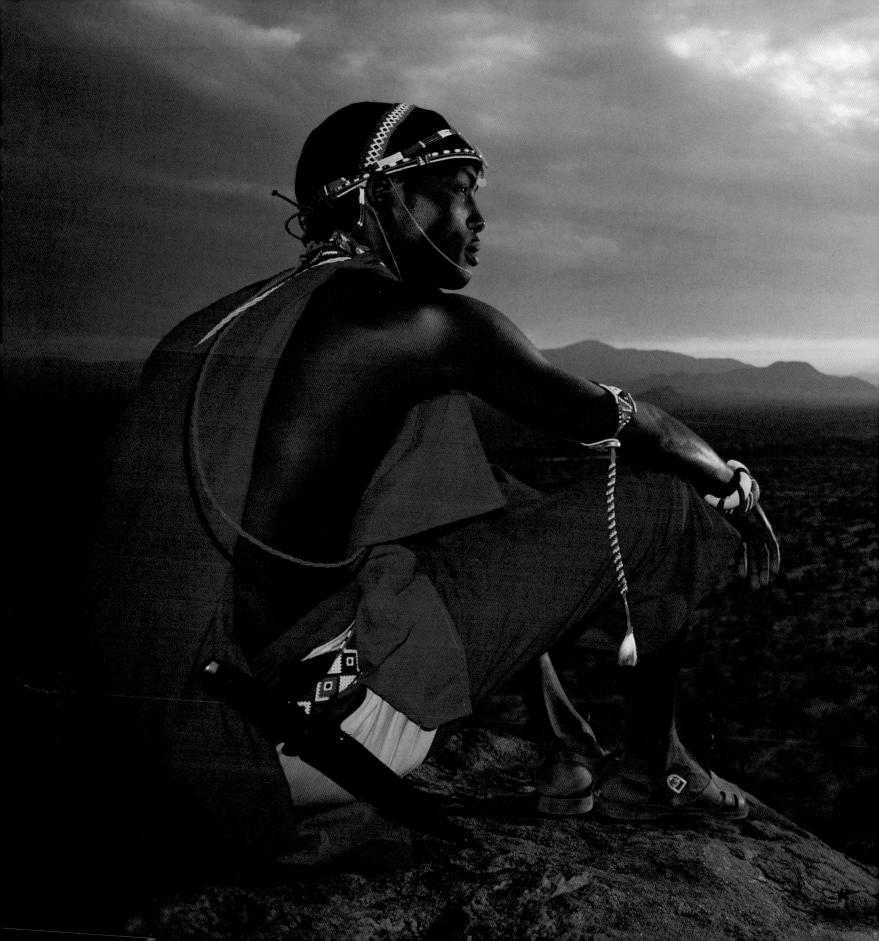

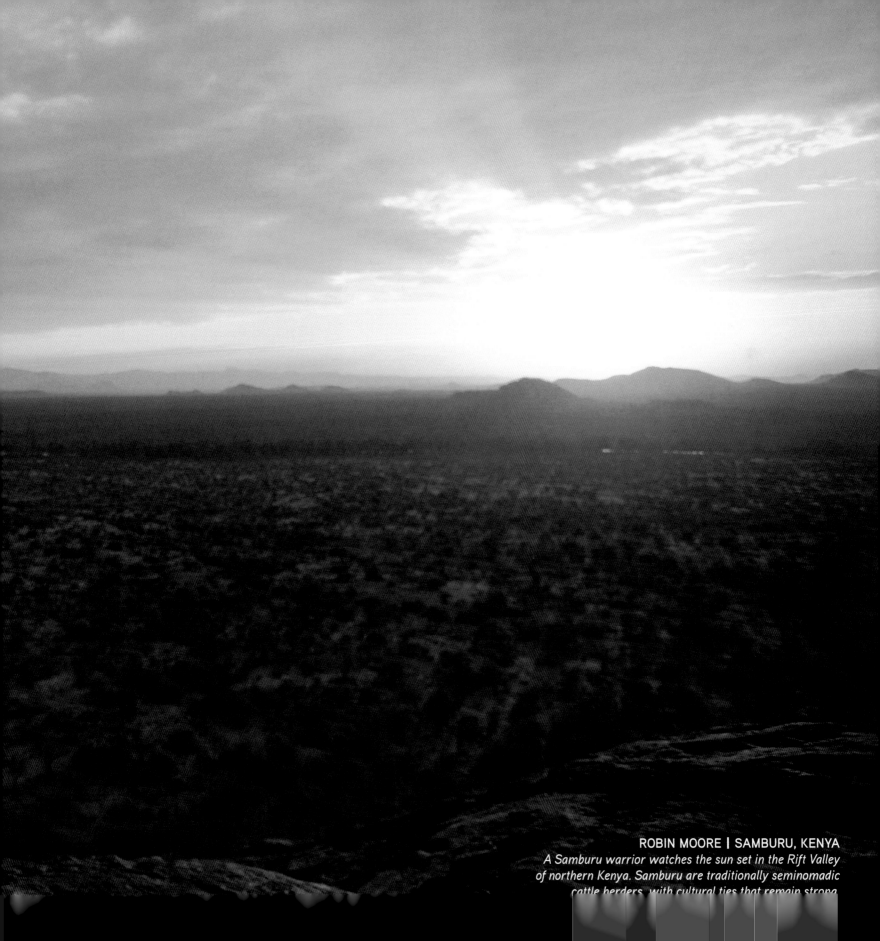

ROBIN MOORE | SAMBURU, KENYA
*A Samburu warrior watches the sun set in the Rift Valley
of northern Kenya. Samburu are traditionally seminomadic
cattle herders, with cultural ties that remain strong*

Nature is painting for us, day after day, pictures of infinite beauty.

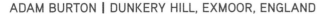

-JOHN RUSKIN

ADAM BURTON | DUNKERY HILL, EXMOOR, ENGLAND
The fading sun turns wispy clouds and rare, sagging mammatus clouds a deep and blotchy pink. The soft light also bathes the flowering heather and open moorland.

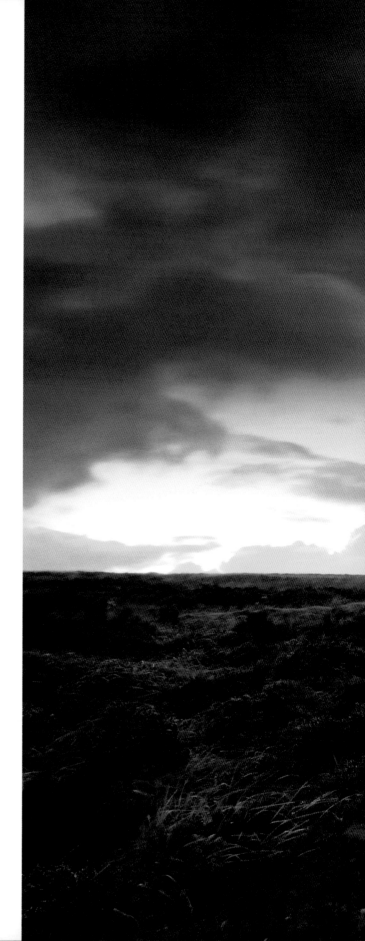

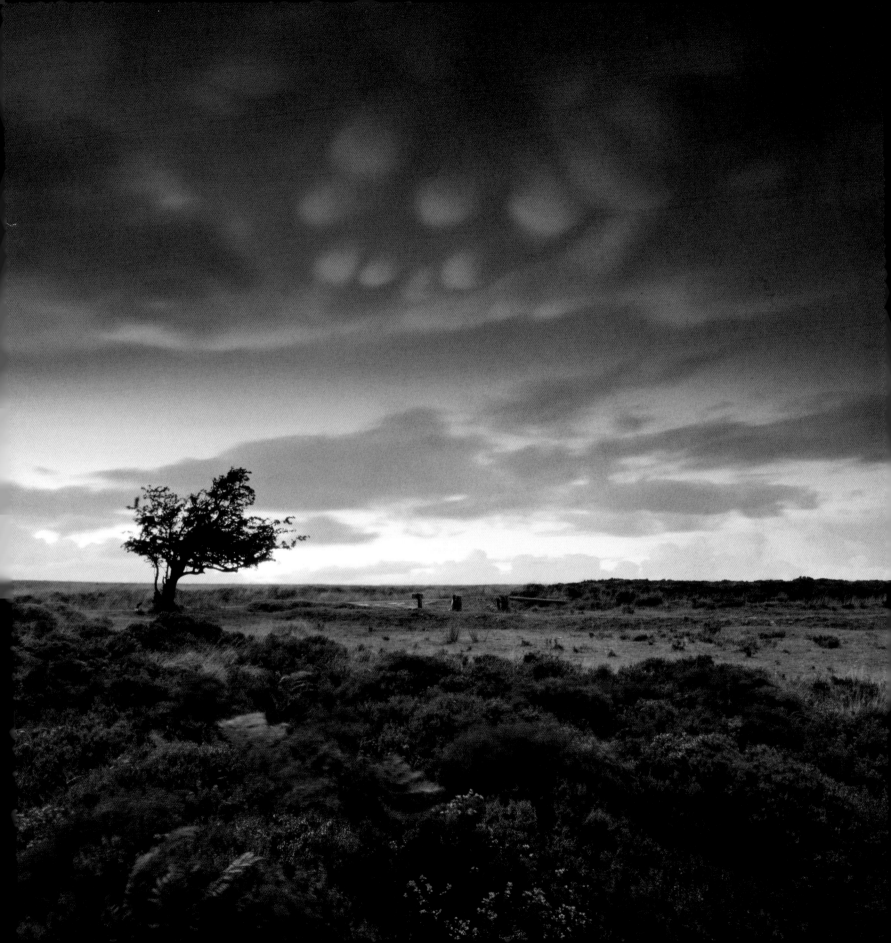

SETH RESNICK | TAMPA, FLORIDA
Silhouetted riders take in the setting sun as they swing from
a rotating ride at the Florida State Fair in Tampa, Florida.

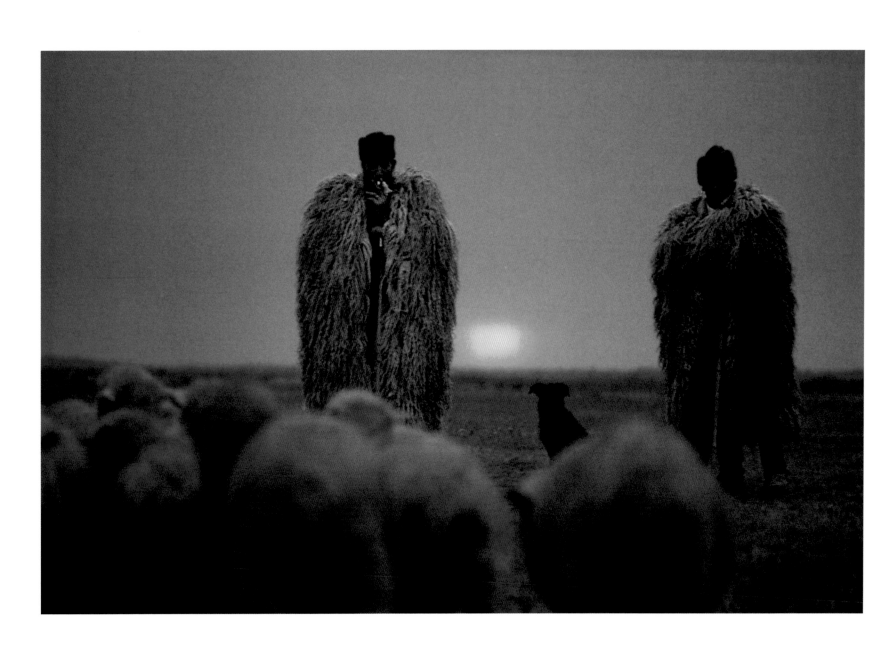

ALBERT MOLDVAY | HORTOBÁGY PLAIN, HUNGARY
Shepherds in eastern Hungary wear the traditional suba, *a sheepskin coat,*
to protect against an autumn chill.

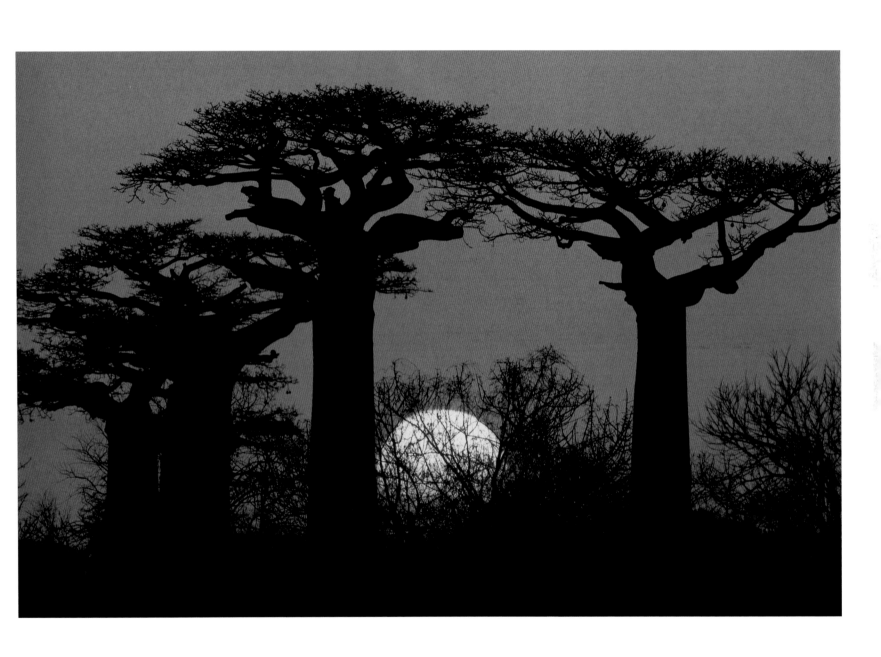

FRANS LANTING | NEAR MORONDAVA, MADAGASCAR
The setting sun casts magnificent baobab trees in silhouette in a dry forest.
Their unique shape led to their being called the "upside-down tree."

Each day I asked Hmoudi, my guide in Petra, to take me some place new. One evening we climbed to the top of a cliff, which turned out to be Dayr el-Bahari, the famous complex of temples and tombs. I had seen the Northern Monastery from the ground many times but never from this perspective. It was late in the day, the sun was setting, the color in the desert was warm, and it was so beautiful. Hmoudi had been there a thousand times, climbing up just to see the sunset. He had arrived before me and was sitting on the dome—his perch since childhood. When I took this picture it was possibly the only time in my career that I thought, "This could be a *National Geographic* magazine cover." It doesn't happen often that you come upon something and it takes your breath away, but it happened that day.

ANNIE GRIFFITHS

Petra, Jordan
A Bedouin surveys the view from the rooftop of Al Deir, the Monastery.

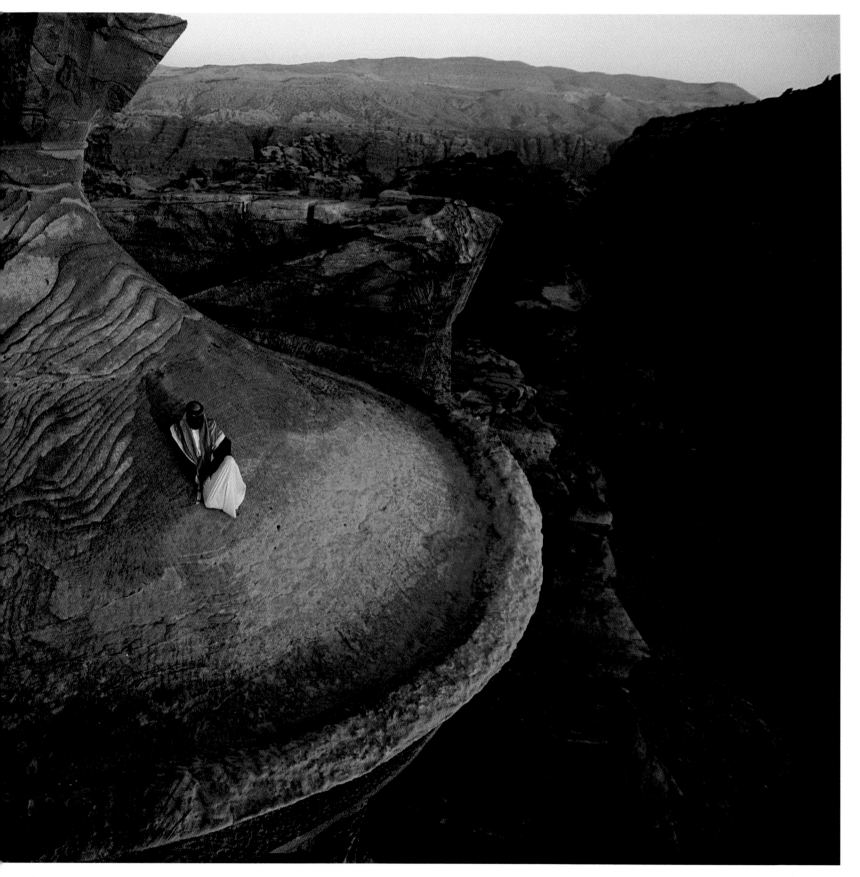

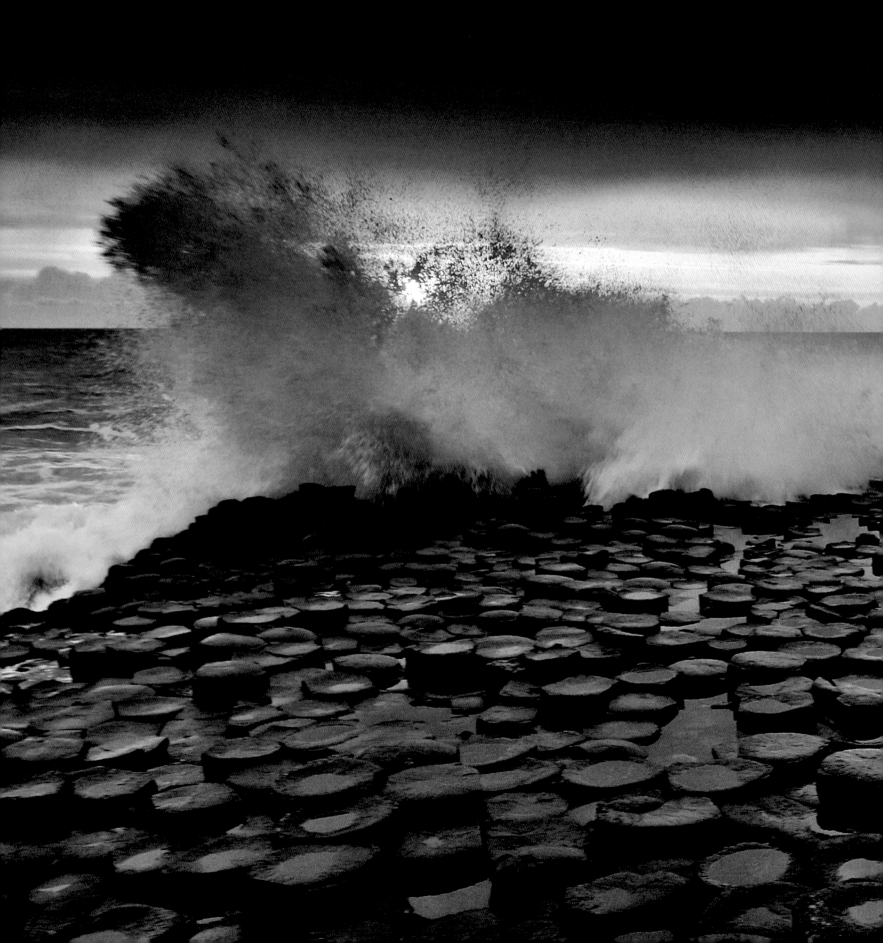

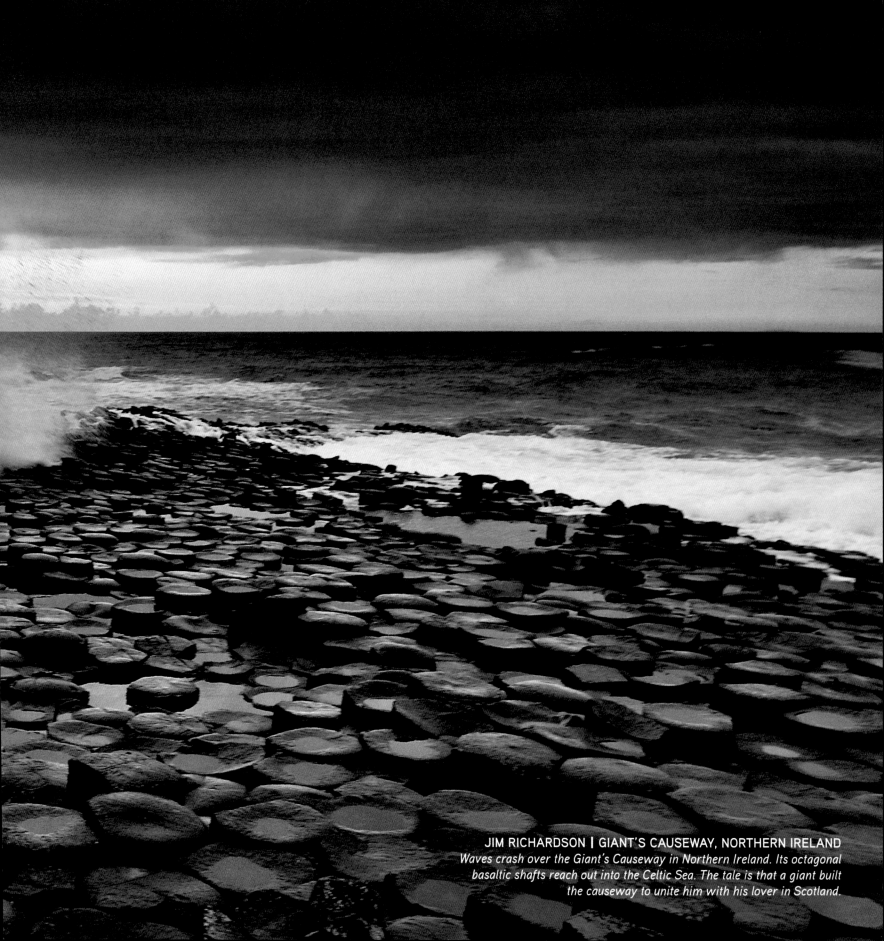

JIM RICHARDSON | GIANT'S CAUSEWAY, NORTHERN IRELAND
Waves crash over the Giant's Causeway in Northern Ireland. Its octagonal basaltic shafts reach out into the Celtic Sea. The tale is that a giant built the causeway to unite him with his lover in Scotland.

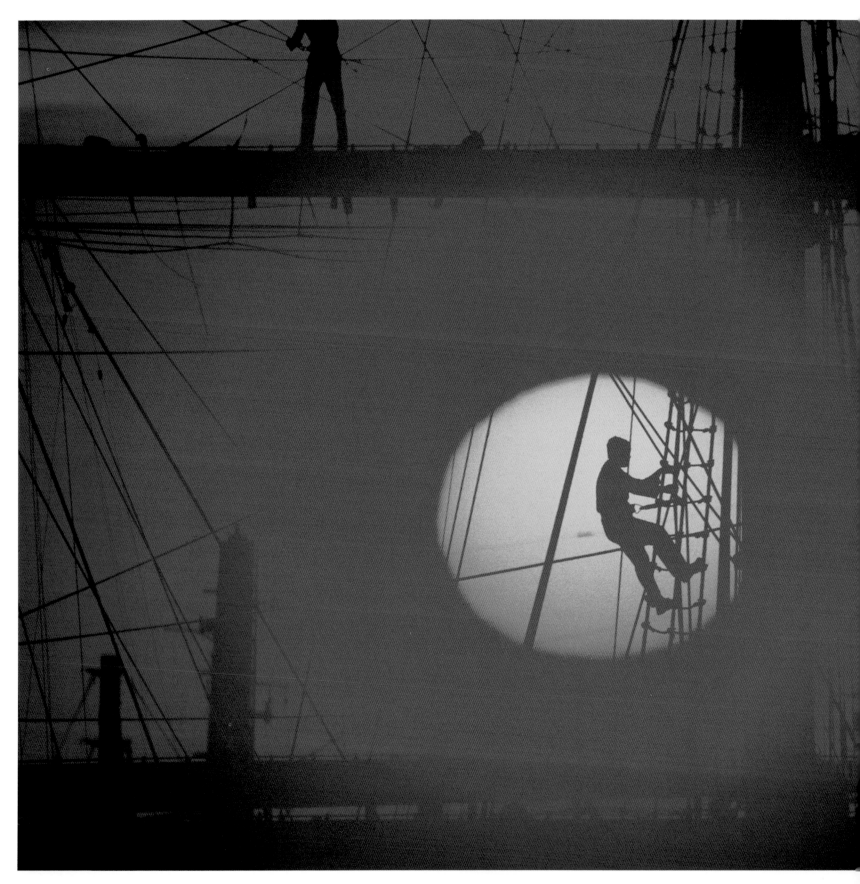

O setting sun! though
the time has come,
I still warble under you,
if none else does,
unmitigated adoration.

—WALT WHITMAN

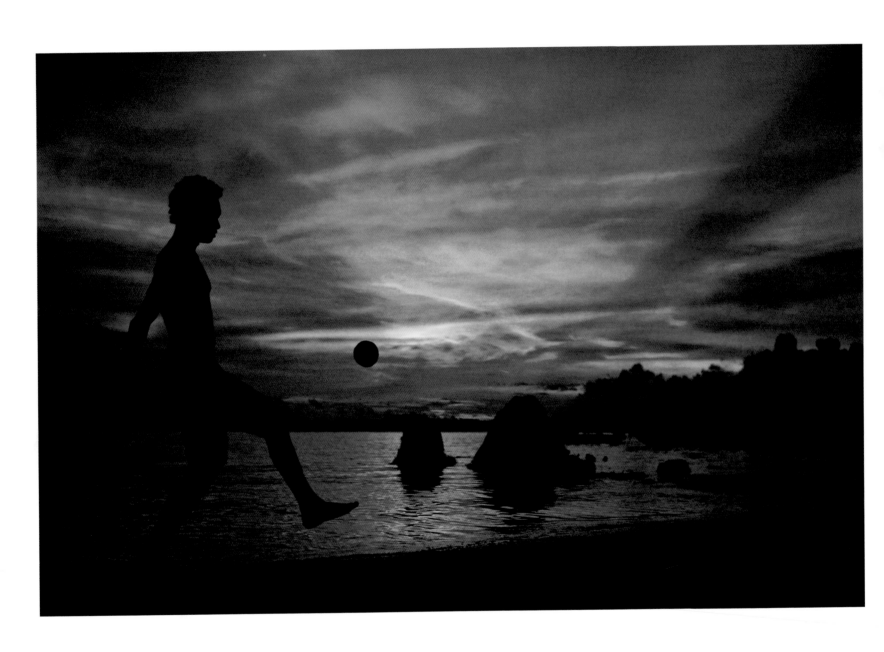

ROBIN MOORE | TETEPARE, SOLOMON ISLANDS
*A Solomon Islander finds the stunning sunset irresistible
for kicking a ball. Locals protected the island from logging,
helping to make the island an ecotourism haven.*

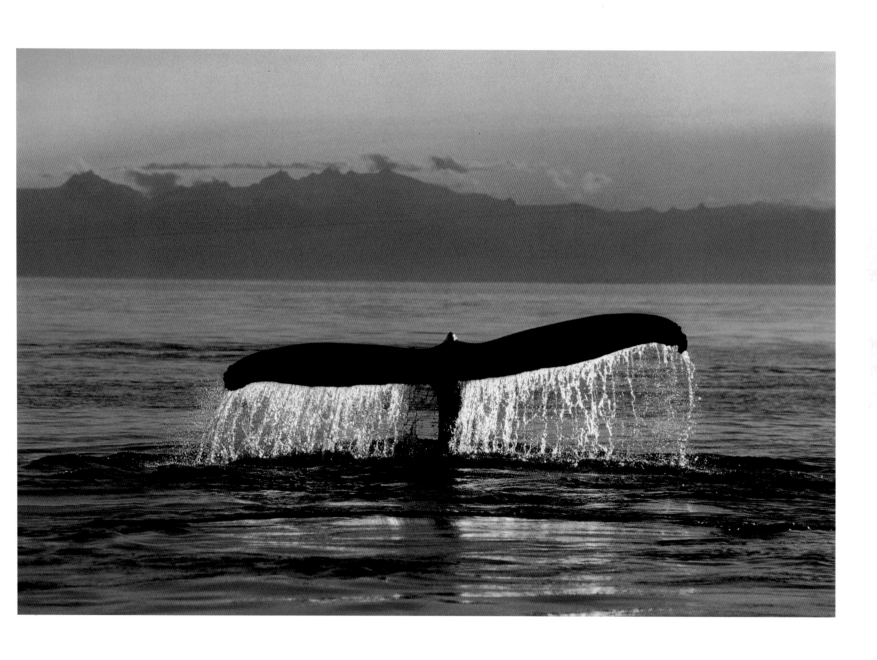

JOHN HYDE | INSIDE PASSAGE, ALASKA
Water cascades off a humpback whale's fluke as it dives against the evening sky. Each whale has an individualized fluke with a unique shape and coloring.

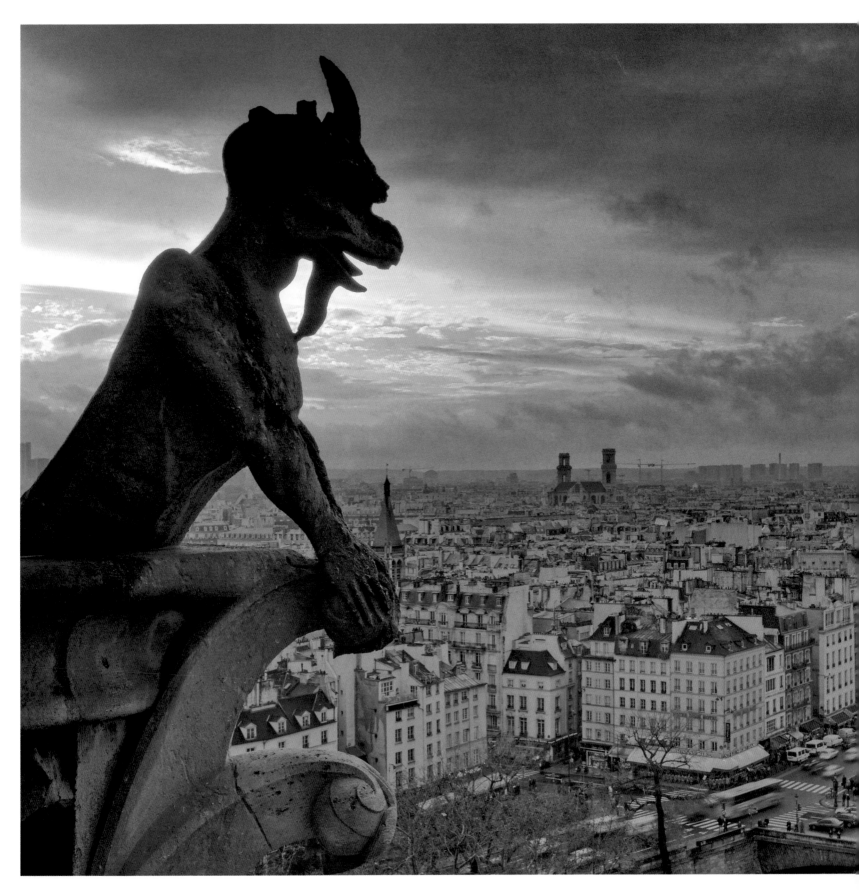

Gargoyles must be fond of sunset. Perhaps their stony hearts beat a little faster when the sun goes down.

–JIM RICHARDSON

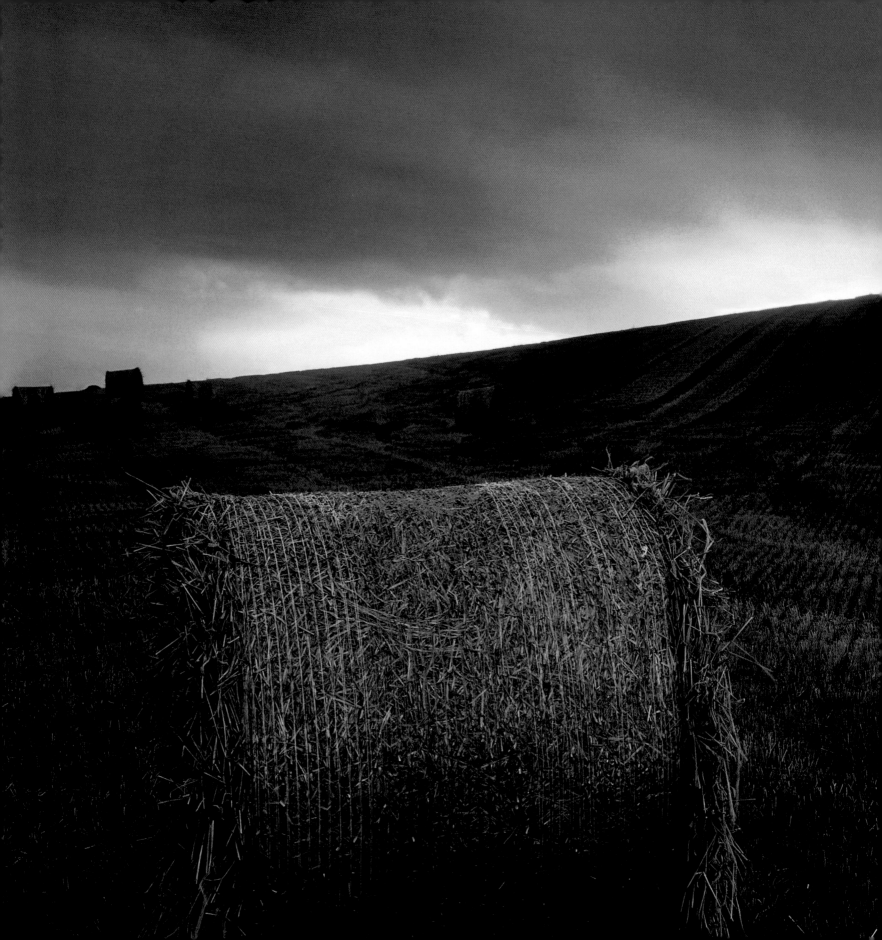

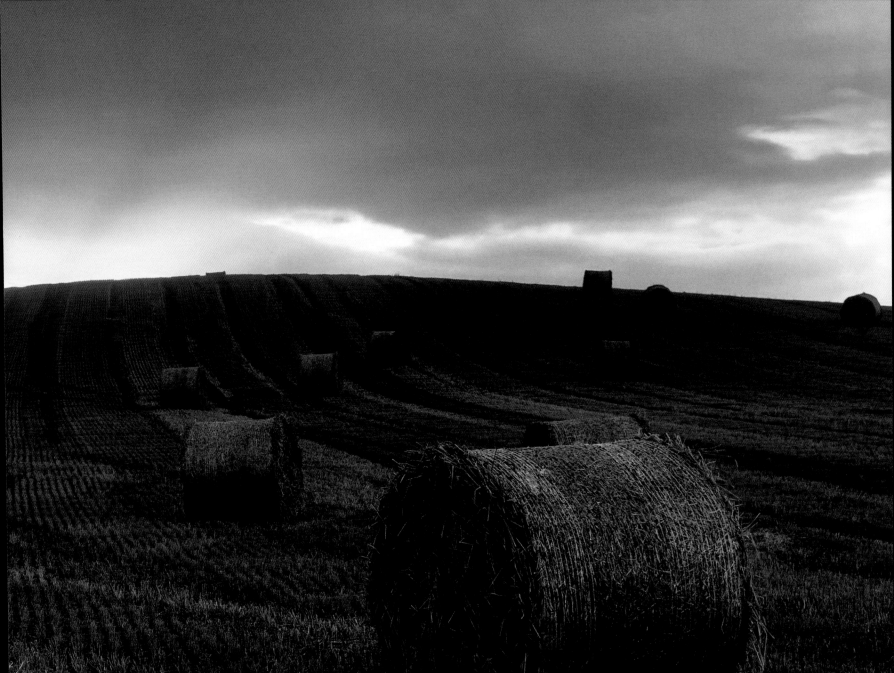

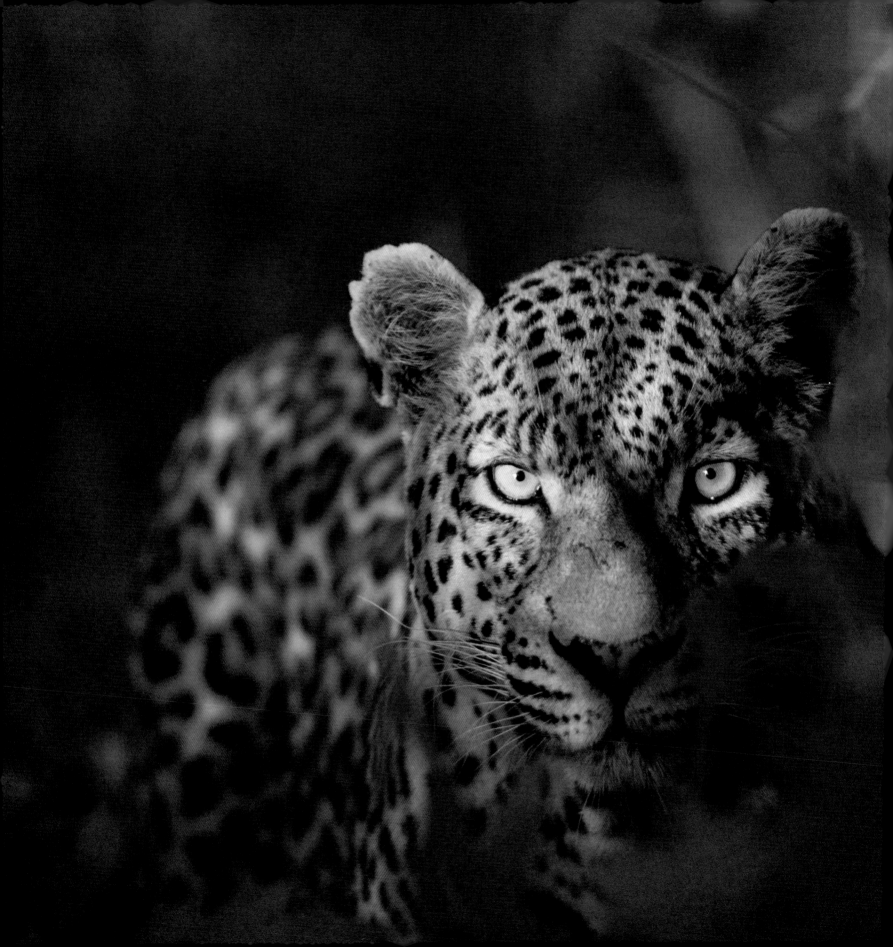

BEVERLY JOUBERT | OKAVANGO DELTA, BOTSWANA
*Hunting at twilight, a leopard with yellow eyes stares out
from tall grasses.*

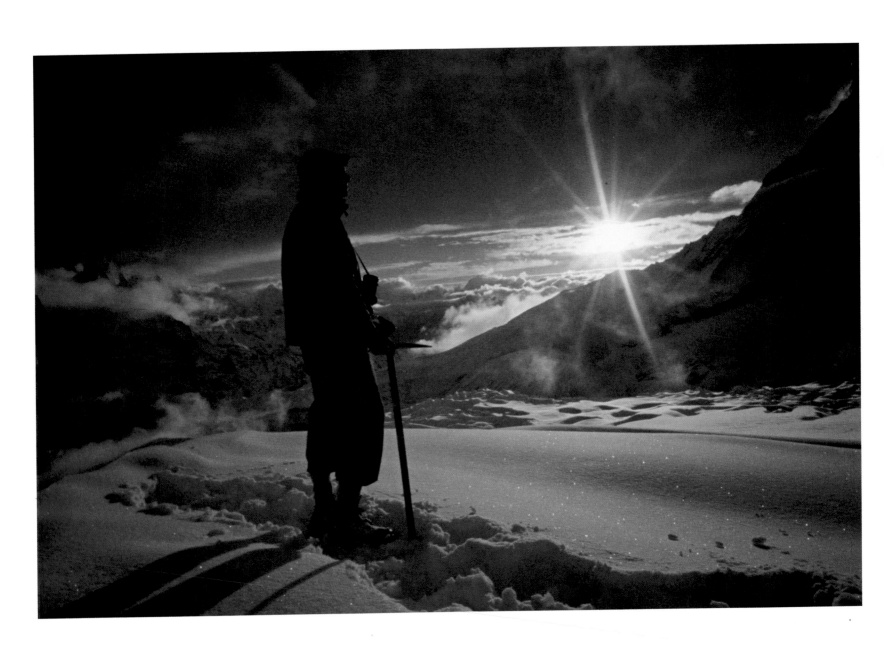

BARRY BISHOP | AMA DABLAM, NEPAL
Sunset hits the snow on the top of a glacier glittering in the rarefied air of the Himalaya. In 1961, Bishop and his team became the first to summit Ama Dablam.

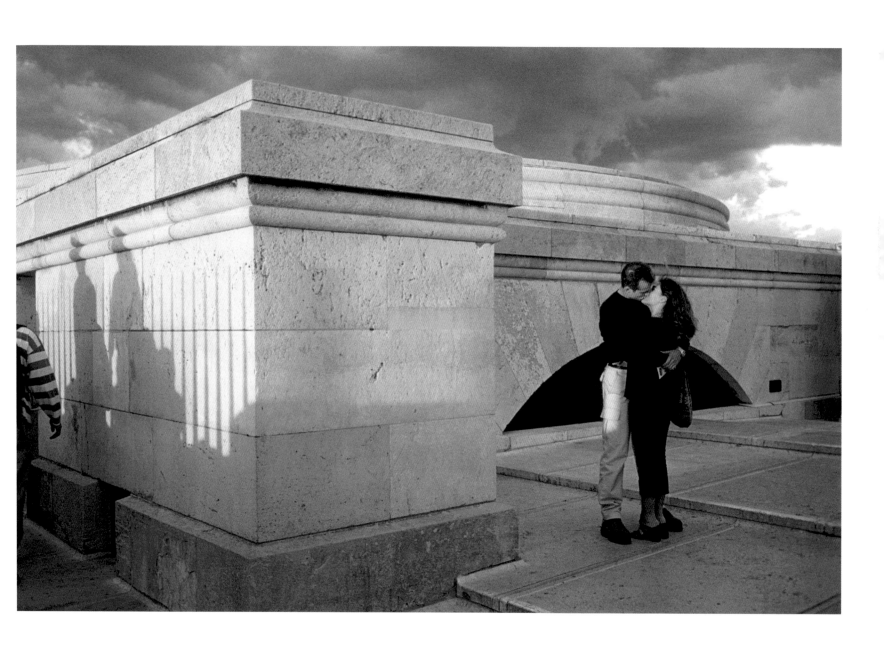

CHRIS STEELE-PERKINS | PARIS, FRANCE
A couple shares a late afternoon embrace from the platform roof of the Arc de Triomphe. The 19th-century monument took 30 years to build.

Thanks to Buffalo Bill Cody's Wild

West show, Nebraska is thought to be the birthplace of rodeo; it's also my home state. In the late 1990s, I covered a story on the annual Big Rodeo in Burwell, in the heart of the Sandhills, where old-time events like the dinner-bell derby and wild horse races take place. My photo captures the audience of a chuck-wagon race, while a thunderstorm threatens to break.

Just as the shadows of sunset crept in over the arena, the sun lit the top of the anvil-shaped cloud and created the backdrop. Often when the great light happens, I grope for what to put in the foreground. Luckily that night people were standing on the bleachers and high enough up for me to fit them within that cloud. The cross section of people—farmers, ranchers, regular citizens—sums up our state nicely as well.

JOEL SARTORE

Burwell, Nebraska
Rodeo attendees watch a chuck-wagon race.

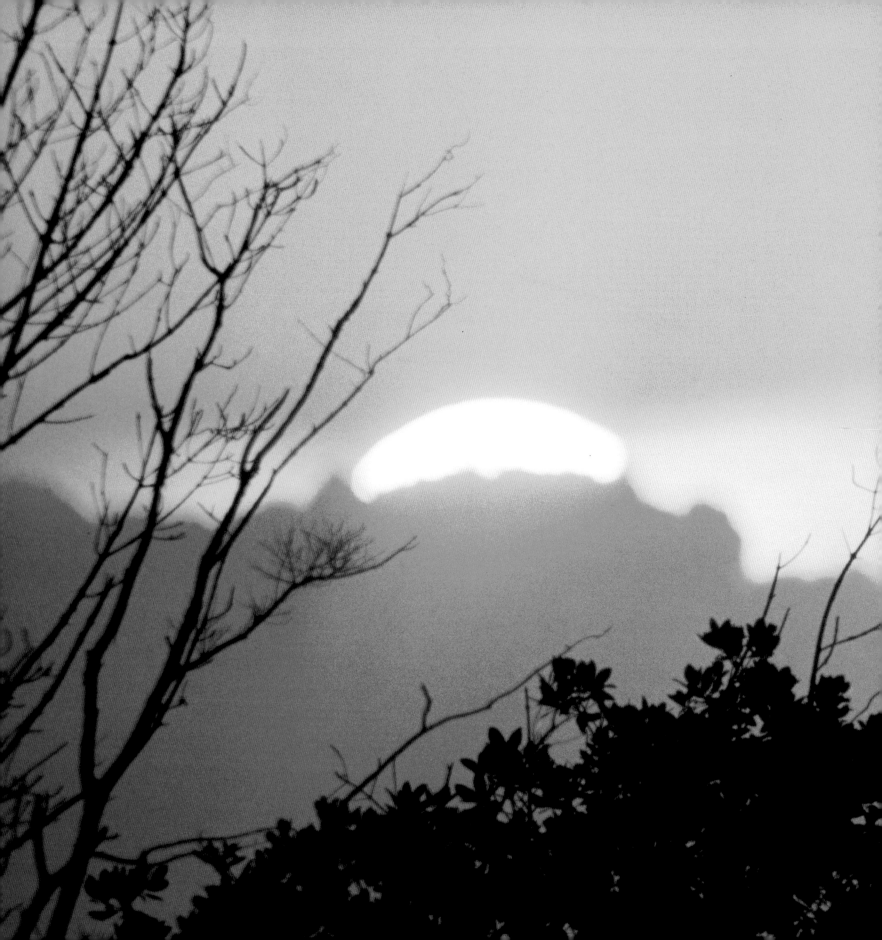

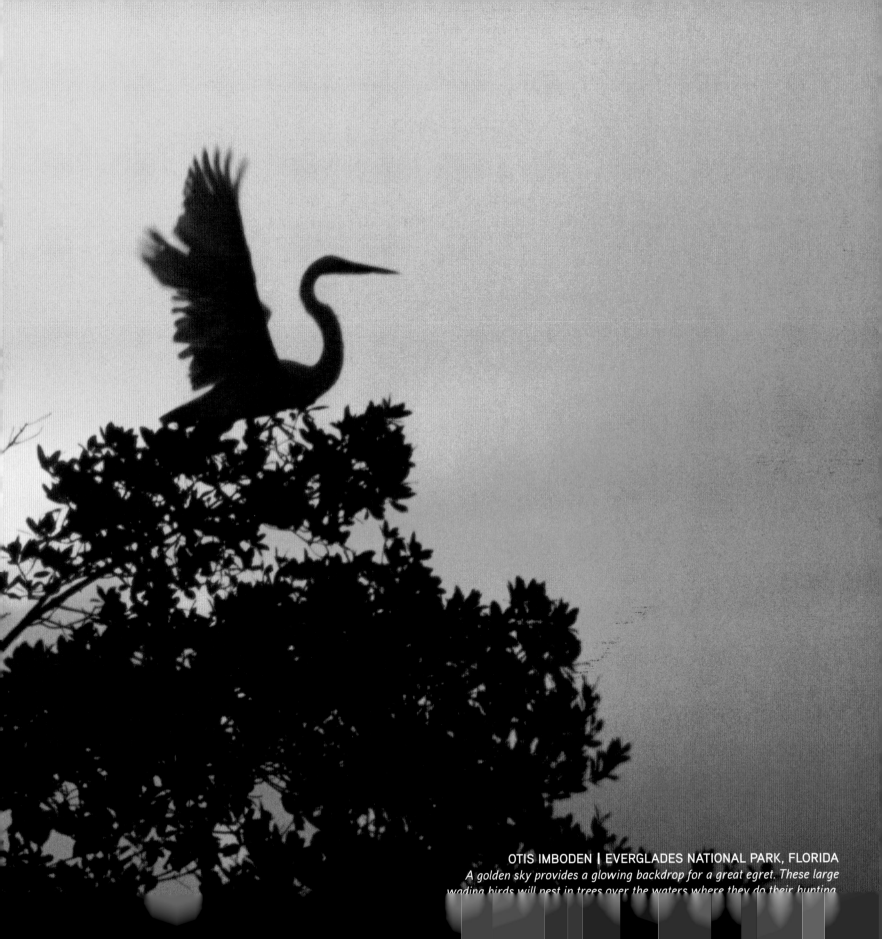

OTIS IMBODEN | EVERGLADES NATIONAL PARK, FLORIDA
A golden sky provides a glowing backdrop for a great egret. These large
wading birds will nest in trees over the waters where they do their hunting.

We sleep, but the loom
of life never stops and
the pattern which was
weaving when the sun
went down is weaving
when it comes up
to-morrow.

–HENRY WARD BEECHER

JOEL SARTORE | LINCOLN, NEBRASKA
Evening sun filters in on a sweet moment between a father and
his two-year-old daughter in their home in Lincoln, Nebraska.

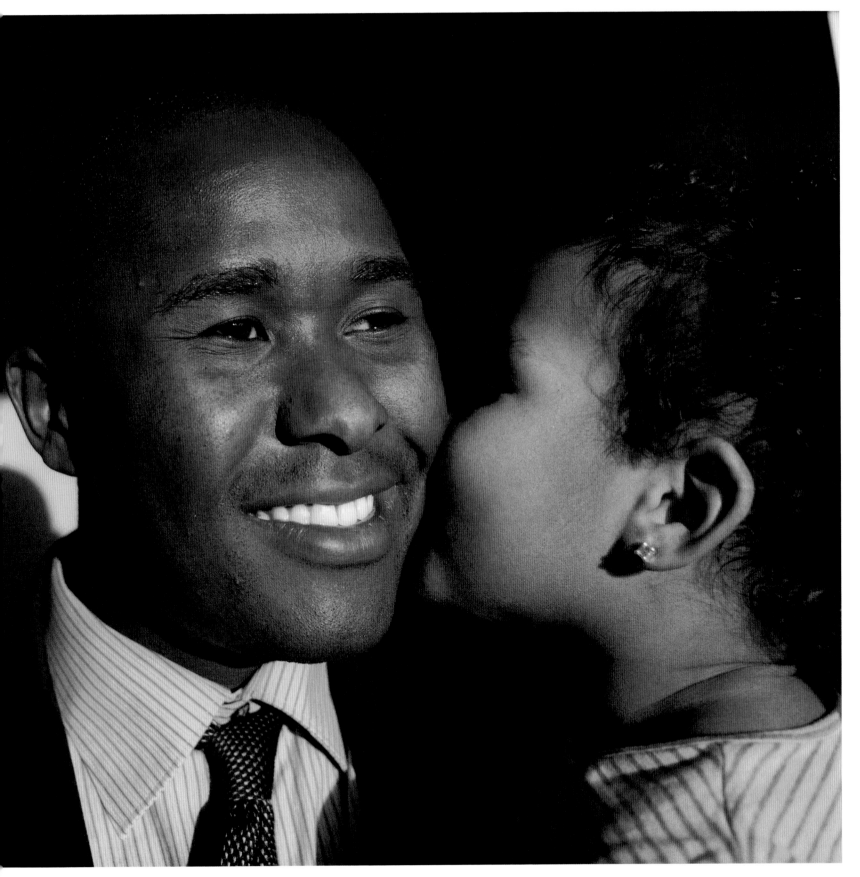

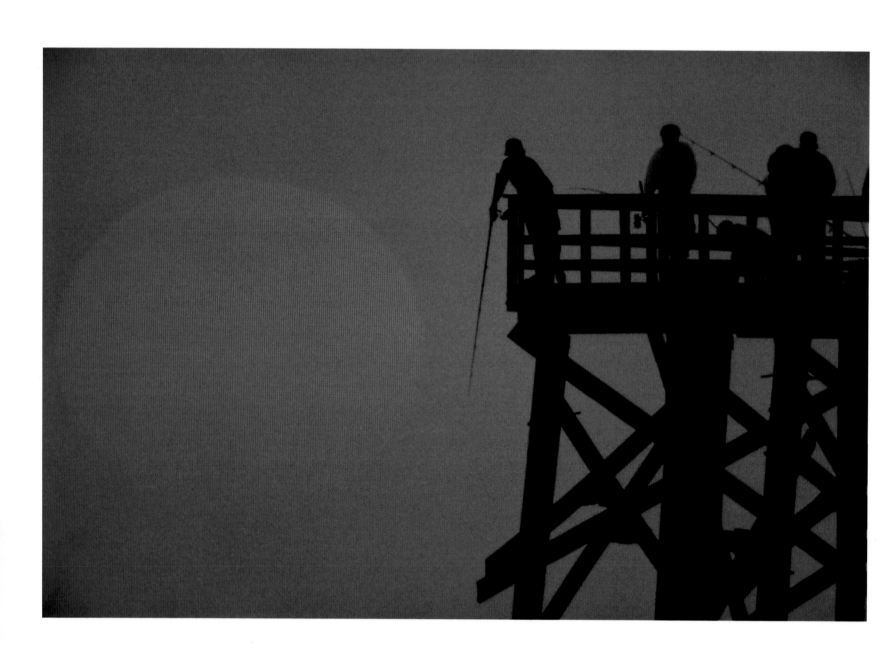

JOEL SARTORE | VENICE BEACH, CALIFORNIA
*A harvest moon—the full moon closest to the autumn equinox—fills the sky
behind fishermen trying their luck on a pier in Venice Beach, California.*

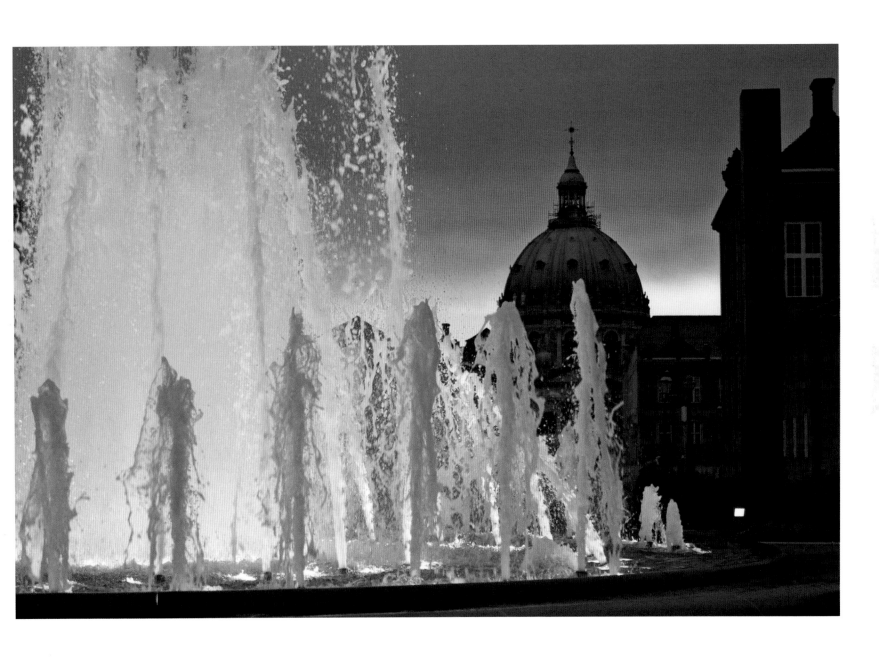

SISSE BRIMBERG AND COTTON COULSON | COPENHAGEN, DENMARK
Evening arrives as the fountains of Amaliehaven cascade into a pool. The garden and fountains offer an urban oasis in the center of Copenhagen.

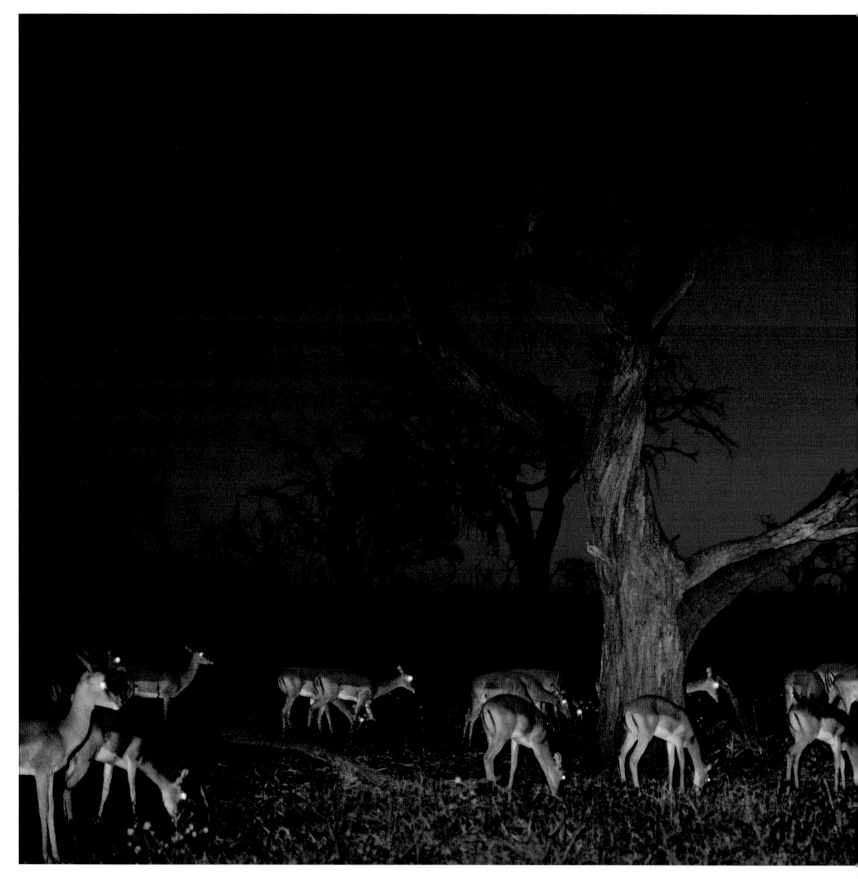

I took this photograph in Chobe

National Park in 1989 when on assignment for an article on wilderness and wildlife in Botswana. I wanted to extend my coverage into the African night. Since working at night poses technical difficulties, the African night had not been covered nearly as much as the day.

I captured the intense glow of a fading sun and illuminated the impalas by a powerful strobe. The light bounced back from their retinas, an effect that used to be considered something to avoid. I began using it for creative effect and found it enhanced the feeling of spookiness—a real feature of the African night because you are not really sure what is going to happen. For these impalas, twilight is a time of increasing fear because they become more vulnerable to lions, leopards, and hyenas.

Twilight and sunset presented interesting opportunities to combine ambient light and a flash, a radical concept in wildlife photography at the time.

FRANS LANTING

Chobe National Park, Botswana
Impalas graze under a night sky lit by the setting sun.

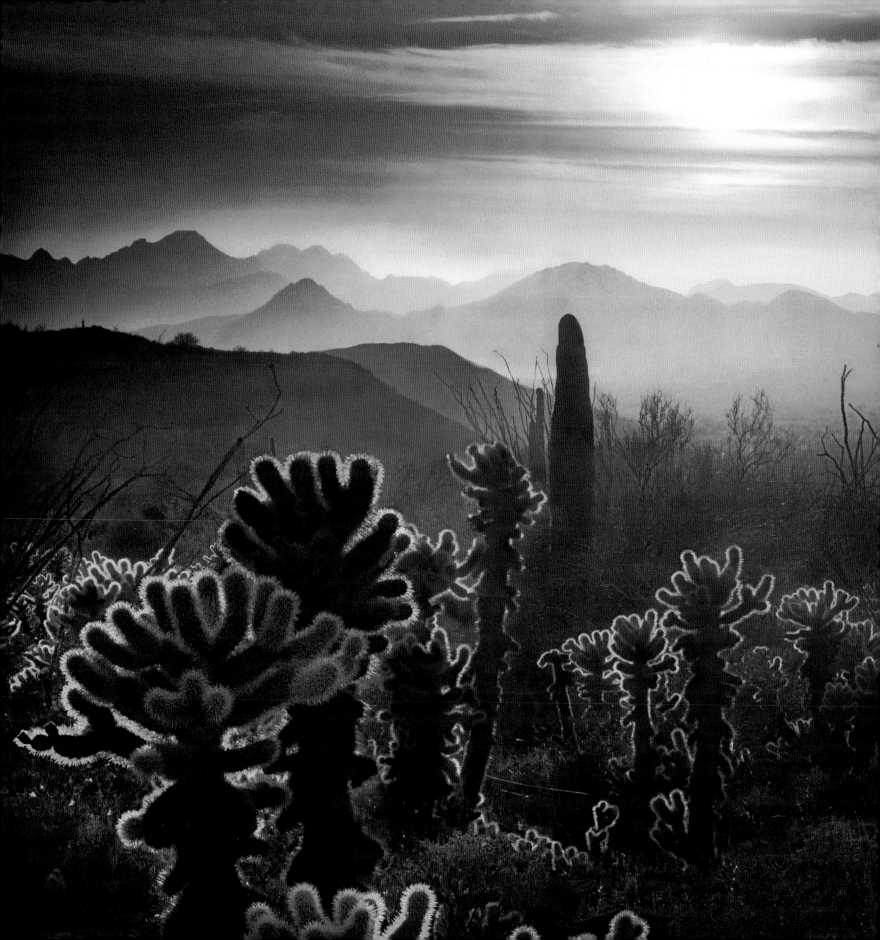

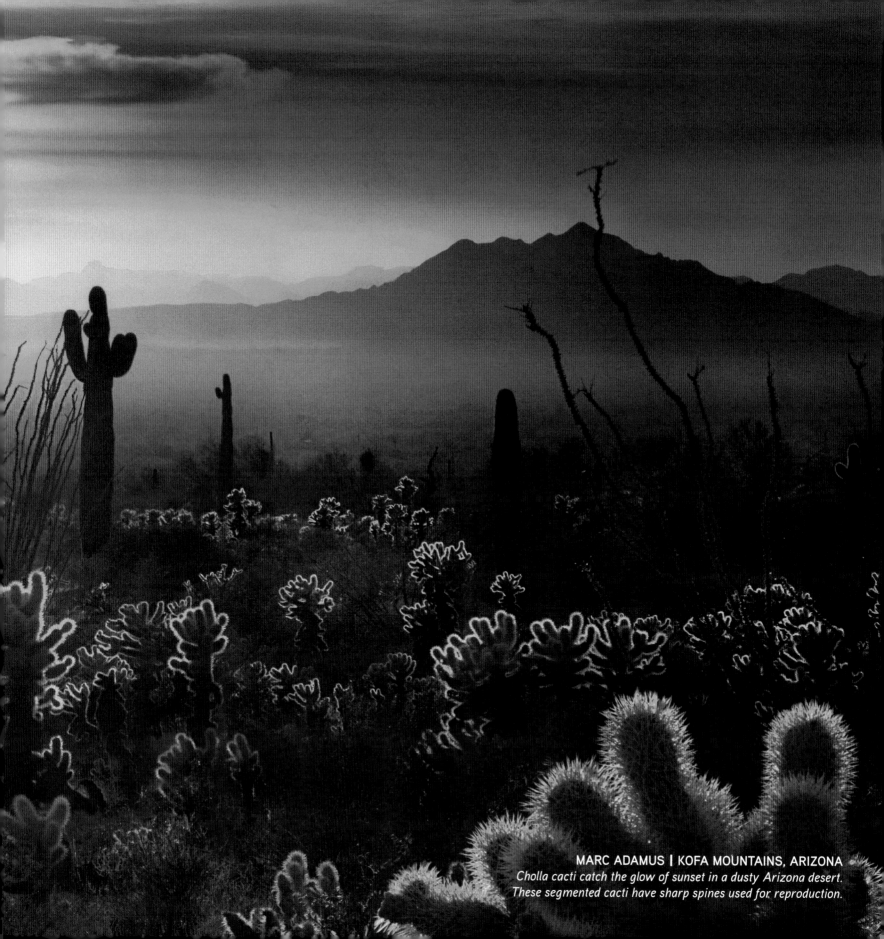

MARC ADAMUS | KOFA MOUNTAINS, ARIZONA
Cholla cacti catch the glow of sunset in a dusty Arizona desert.
These segmented cacti have sharp spines used for reproduction.

COLLEEN PINSKI | ALBUQUERQUE, NEW MEXICO
A hillside offers a perfect vantage point for an annular solar eclipse,
when the moon crosses in front of the center of the sun but leaves a
glowing ring, called an annulus.

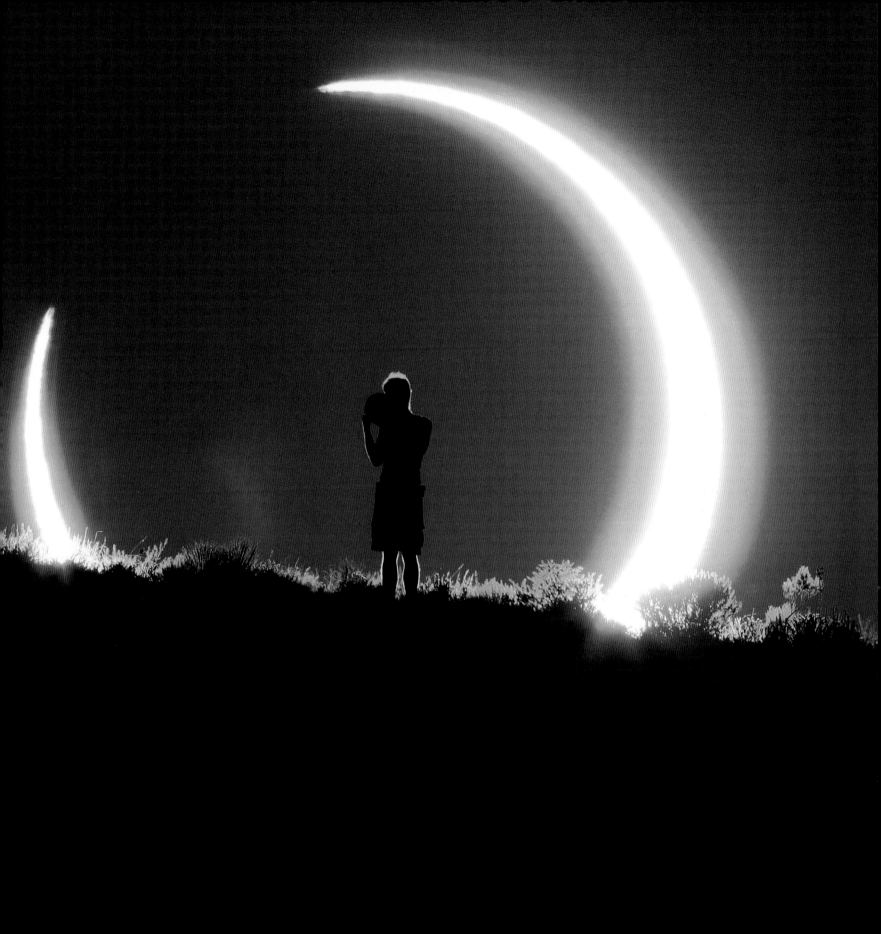

TWILIGHT

IAN CAMERON | HOPEMAN, SCOTLAND

As the horizon turns dark blue, the setting sun shines a warm spotlight on a sandstone formation that almost appears to become a pirate ship.

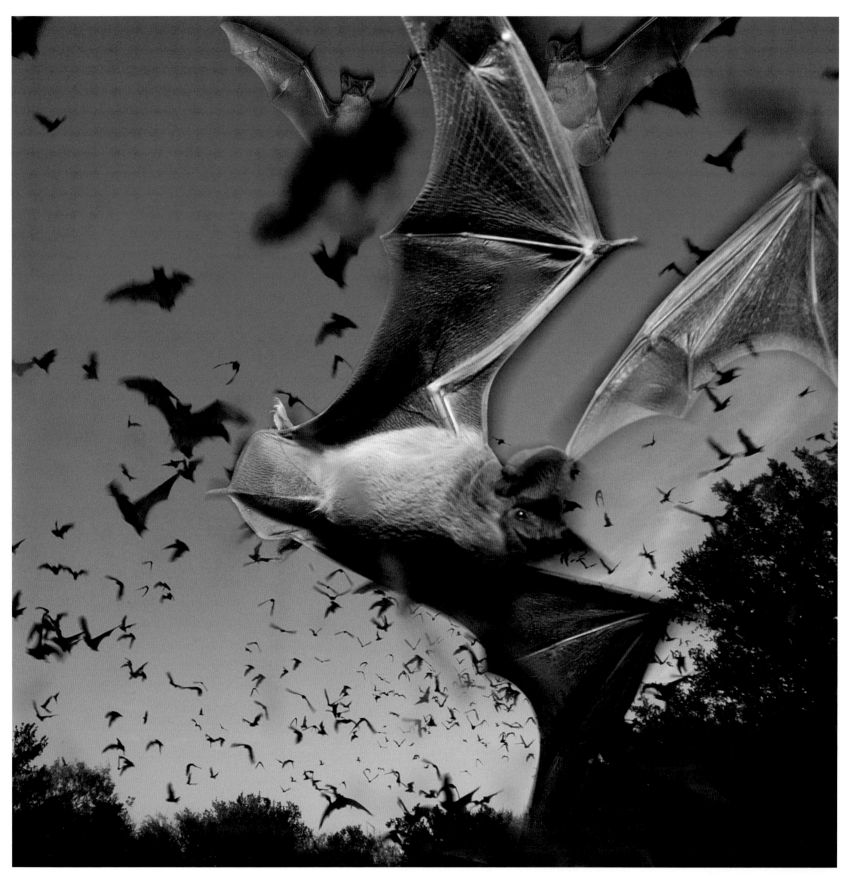

THE SUN HAS SET AND

yet sight remains in this precious sliver of time we call twilight. Half-light, between-light, the dimming that carries us into night. If there is any more work to be done, now is the time. Look well, act fast, seize this last lingering light, for soon the dark will be upon you.

At twilight shapes assume their softer, pastel forms. Things that were hard and definite again become soft, transient, and sublime. The sky retains the memory of sunset. Light scatters. For a precious moment, all Earth glows. And then, in a moment just as precious, all sights disappear.

Through the ages, myths have given names, shapes, and characters to the light and times of day. Modern science quantifies them, distinguishing, for example, three distinct twilights. It's not just compulsive calculation. Naval law, military strategy, and navigational wisdom depend on these differences. In the first wedge of time—the first 6 degrees, the first 24 minutes after the sun slips out of view—shapes are still visible and sight can still be trusted. In the second—the next 6 degrees, up to 48 minutes—the view may be deceiving, a time for stealth and final preparations. By the third twilight—up to an hour or more past sundown—even the scattered light is gone, and returning darkness brings distant stars back into view.

Civil dusk, nautical dusk, astronomical dusk: twilights going, going, gone.

JOEL SARTORE | ECKERT JAMES RIVER BAT CAVE PRESERVE, TEXAS *Millions of Mexican free-tailed bats pour from the mouth of a cave to begin hunting the insects that sustain them.*

BOBBY MODEL | SAHARA, LIBYA
A Tuareg tribesman prays at twilight. Many Tuareg follow Islamic beliefs,
but their culture predates Islam's entrance into northern Africa.

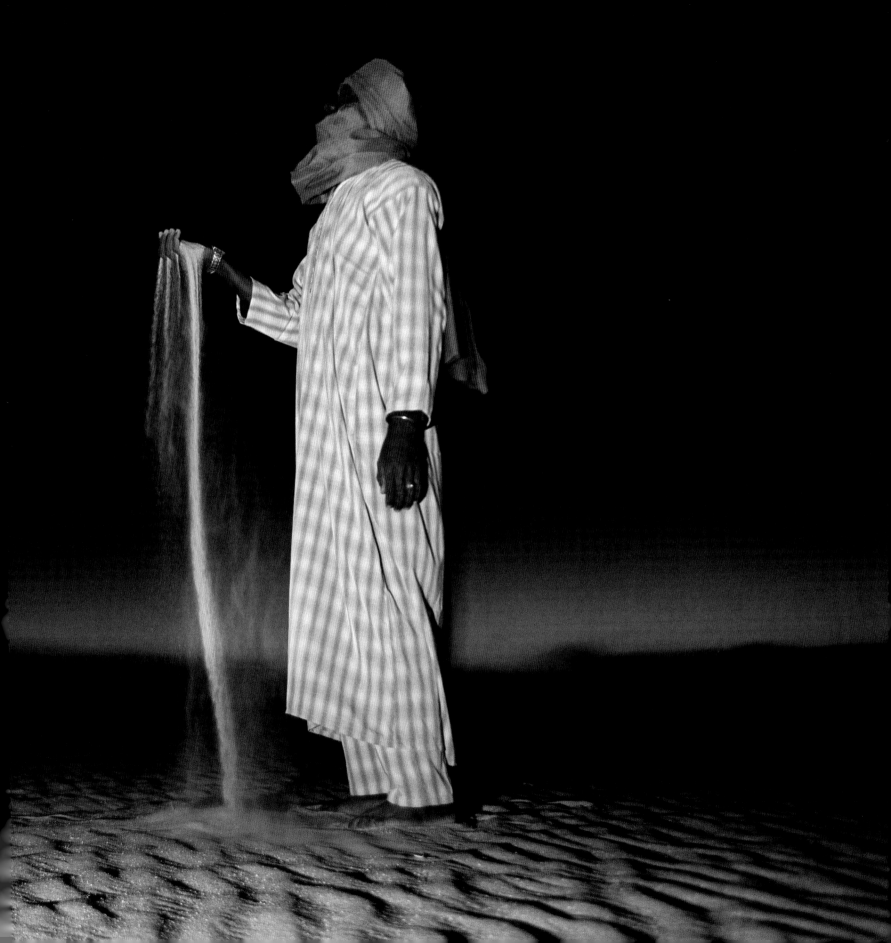

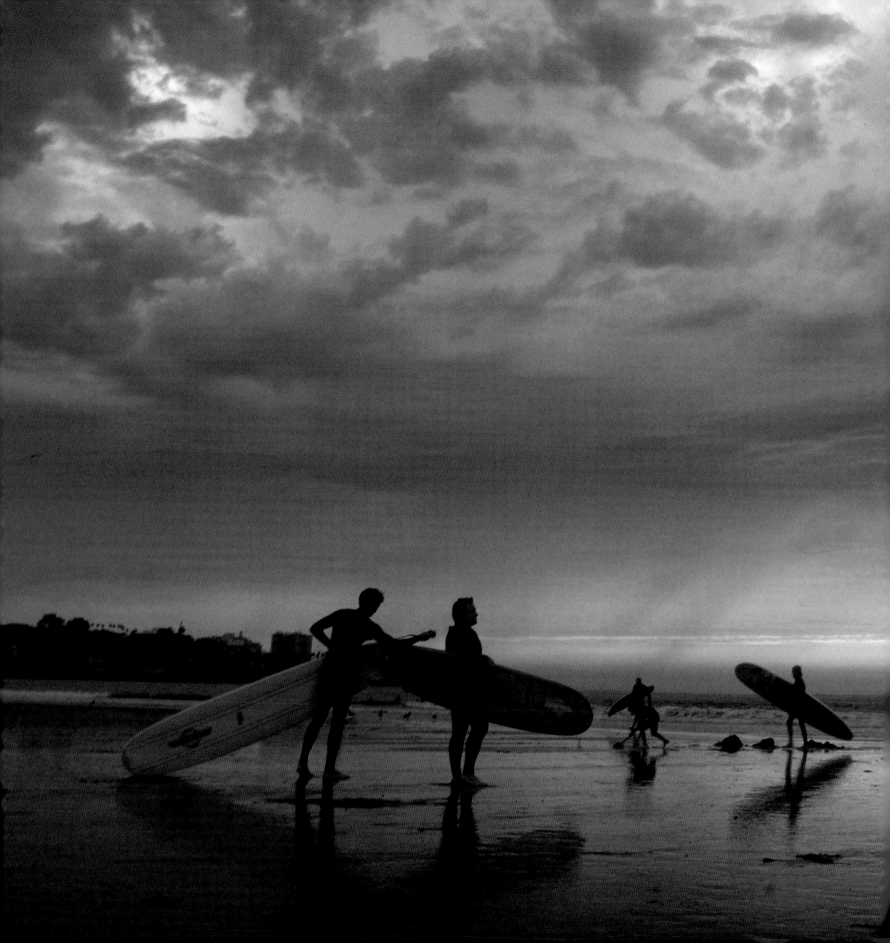

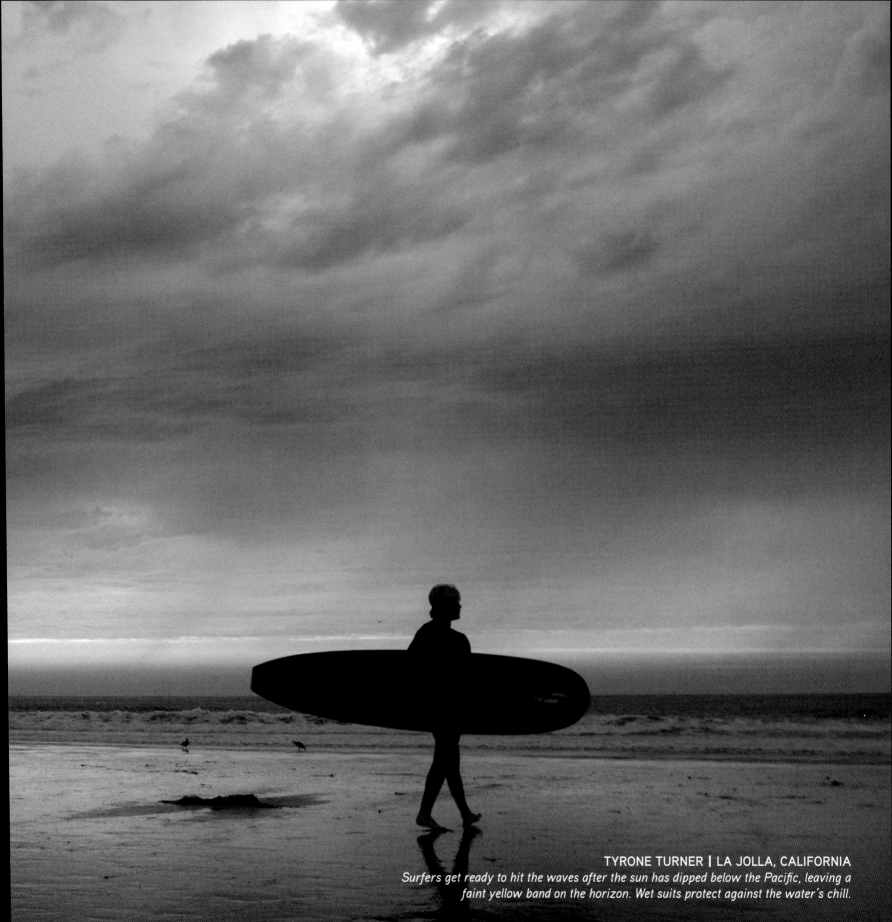

TYRONE TURNER | LA JOLLA, CALIFORNIA
*Surfers get ready to hit the waves after the sun has dipped below the Pacific, leaving a
faint yellow band on the horizon. Wet suits protect against the water's chill.*

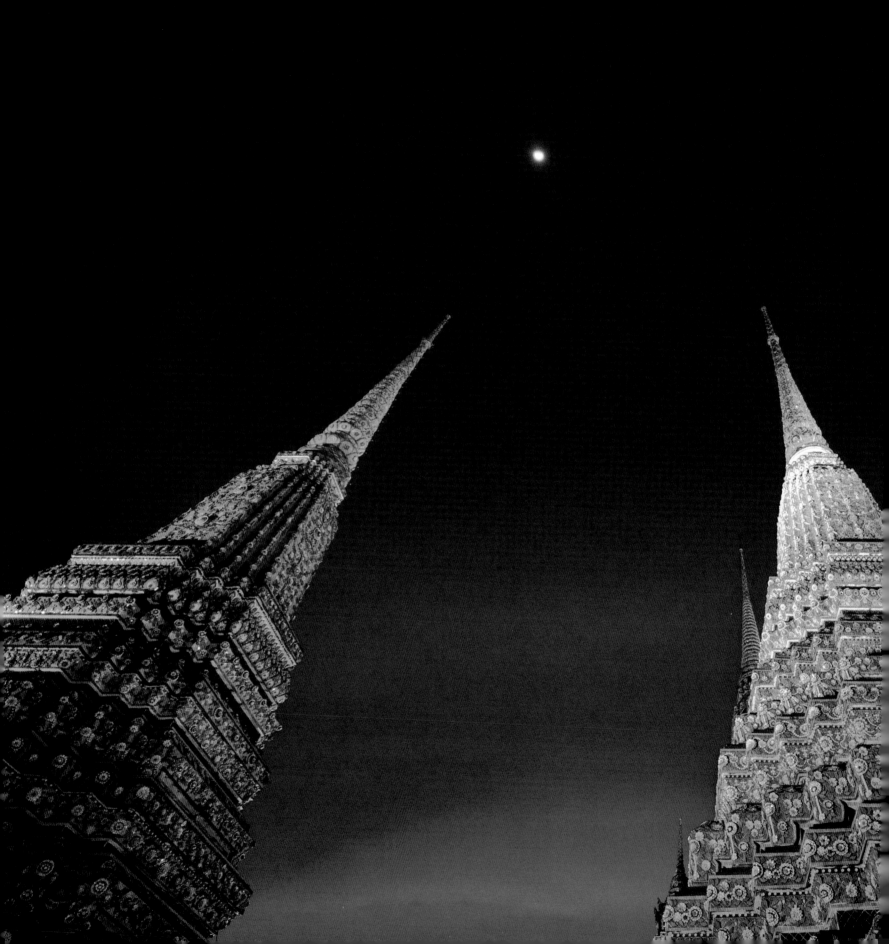

Twilight drops
her curtain down,
and pins it
with a star.

—LUCY MAUD MONTGOMERY

JASON EDWARDS | BANGKOK, THAILAND
The moon has risen to a bright point in a dark sky over the prangs *(spires)*
of Wat Pho, part of the Grand Palace complex in Bangkok.

MICHAEL MELFORD | THÍRA, GREECE
A couple and a swimmer take in twilight's fading colors over the Aegean Sea. They are on the southernmost isle of the Greek Cyclades, known as "most beautiful" in antiquity.

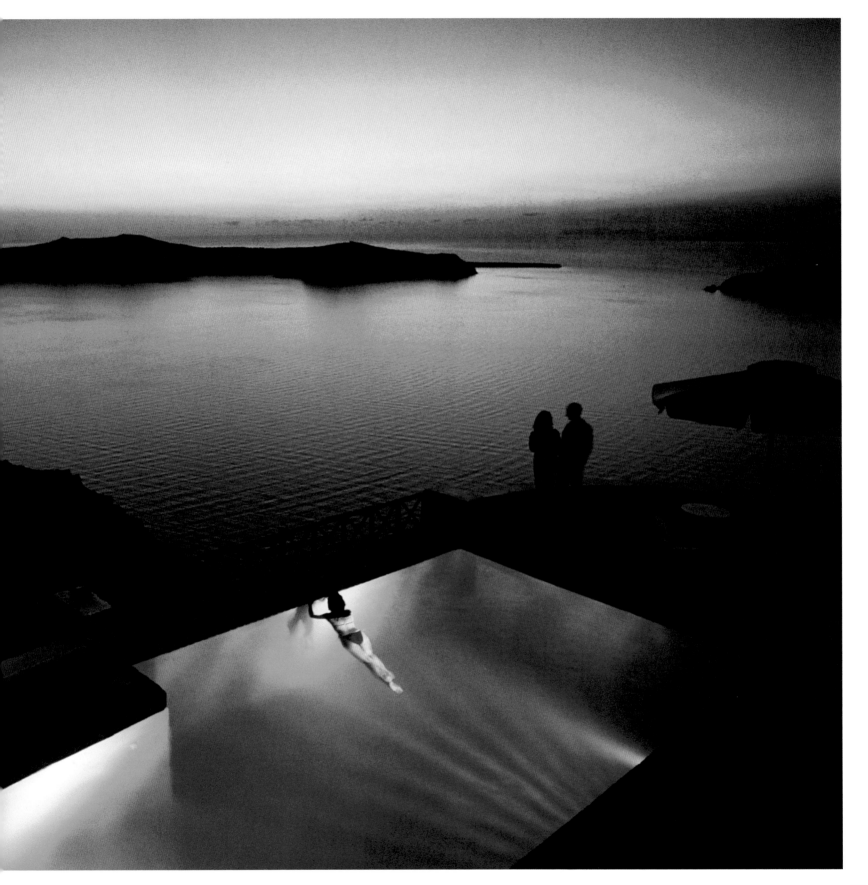

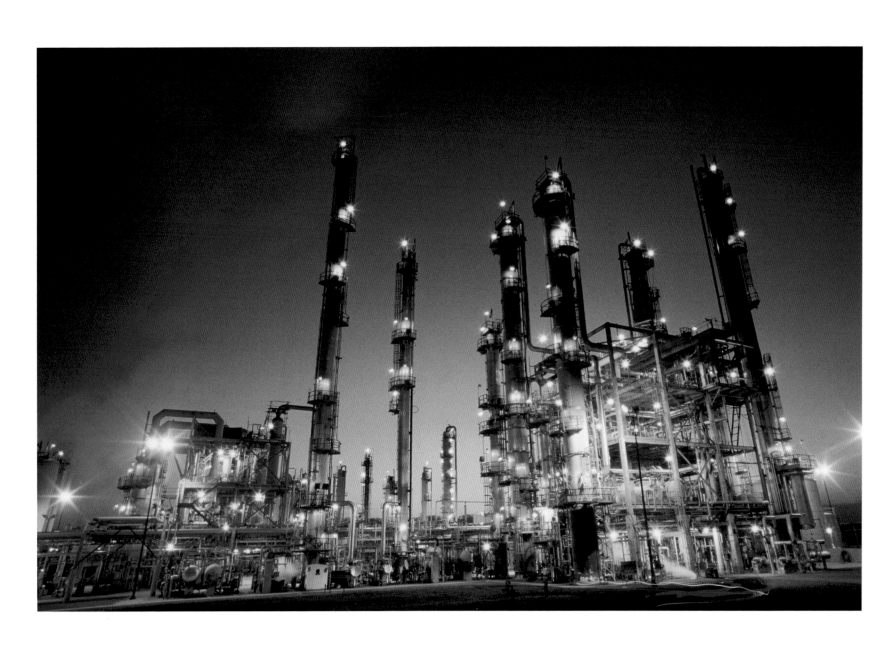

LYNN JOHNSON | HOUSTON, TEXAS
The lights of an oil refinery compete with a darkening sky in Houston, Texas. Petrochemical industries dominate the landscape in this city, dubbed the world's energy capital.

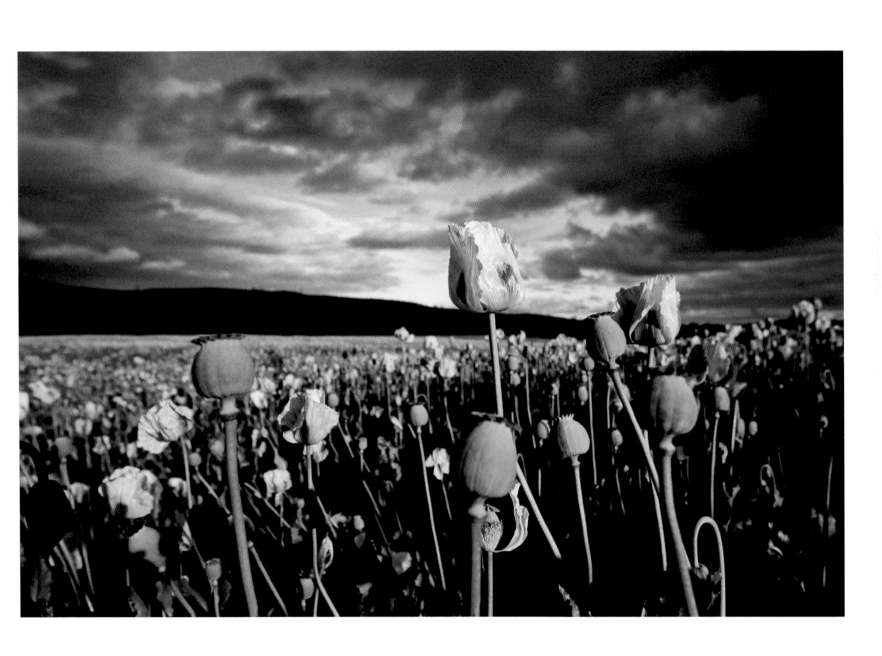

GERD LUDWIG | NEAR RICHMOND, TASMANIA
Dusk casts its soft light over a field of opium poppies.
These colorful flowers last only a few days as the petals
emerge crumpled, then expand, and then fall off.

Milan is not "beautiful" Florence,

Venice, or Rome—thus this image speaks to the best-known industry of the town. Armani advertised with this billboard in a location that lined up well with the city's traffic. And since you don't see Claudia Schiffer at the bus stop, I went to this spot around dusk to capture the street traffic during the so-called magic hour—the hour when ambient and city light balance. It is really more a point in time, like the moment when a soufflé becomes perfectly cooked. Standing in a pedestrian island in the street, I used a long lens to shoot rolls and rolls of film to catch this moment. Photographers try to get close to things, but sometimes we are better off doing the opposite. Sometimes you should run away from your subject and look back.

GEORGE STEINMETZ

Milan, Italy
An Armani billboard towers above a busy street.

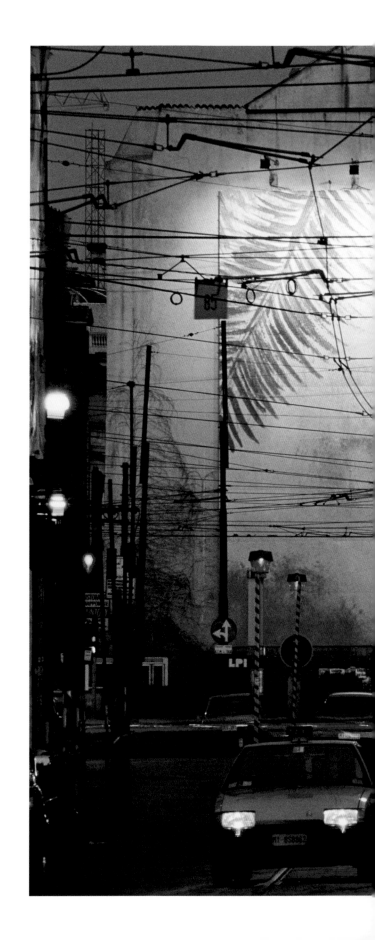

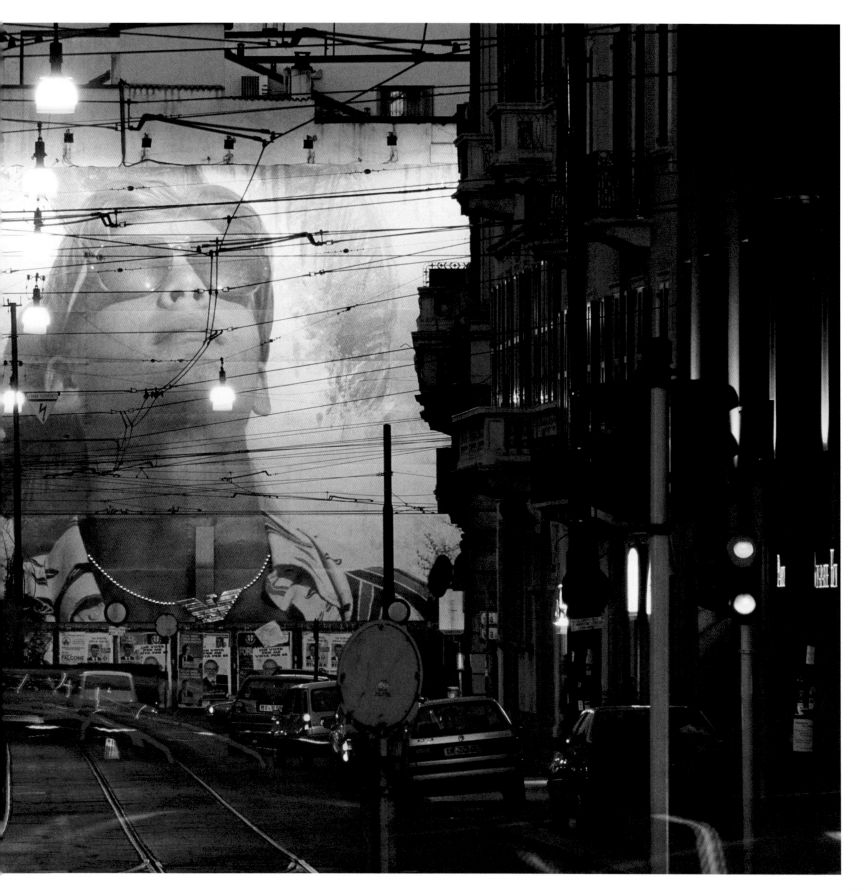

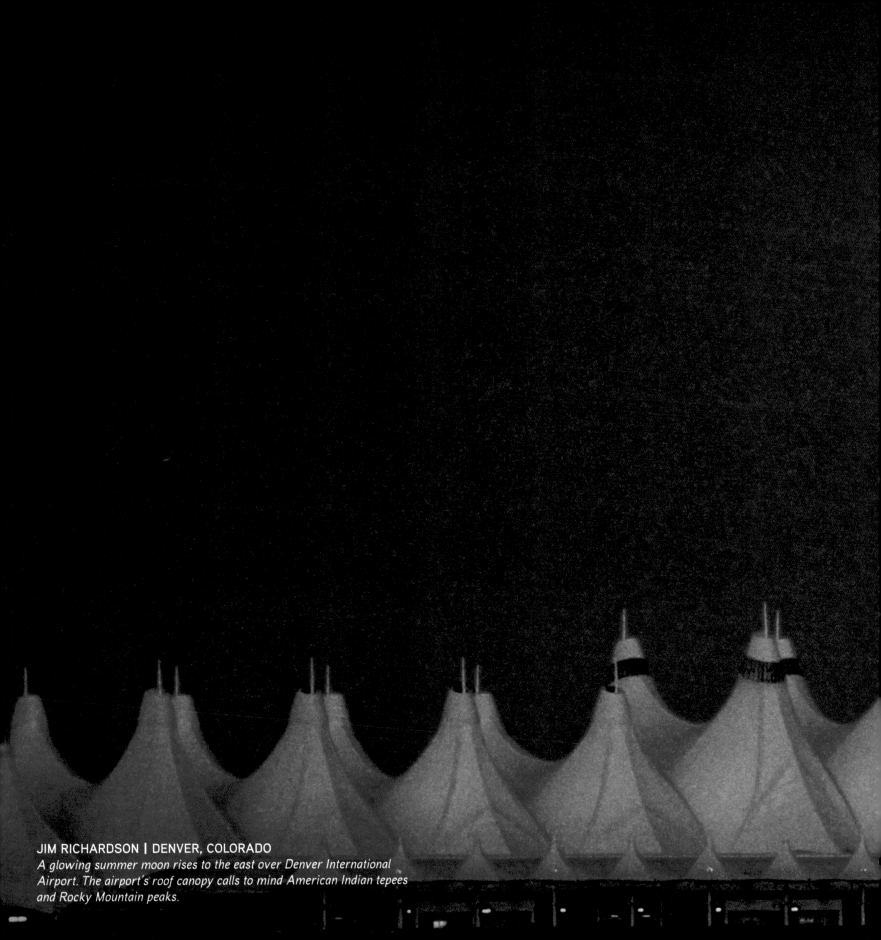

JIM RICHARDSON | DENVER, COLORADO
A glowing summer moon rises to the east over Denver International Airport. The airport's roof canopy calls to mind American Indian tepees and Rocky Mountain peaks.

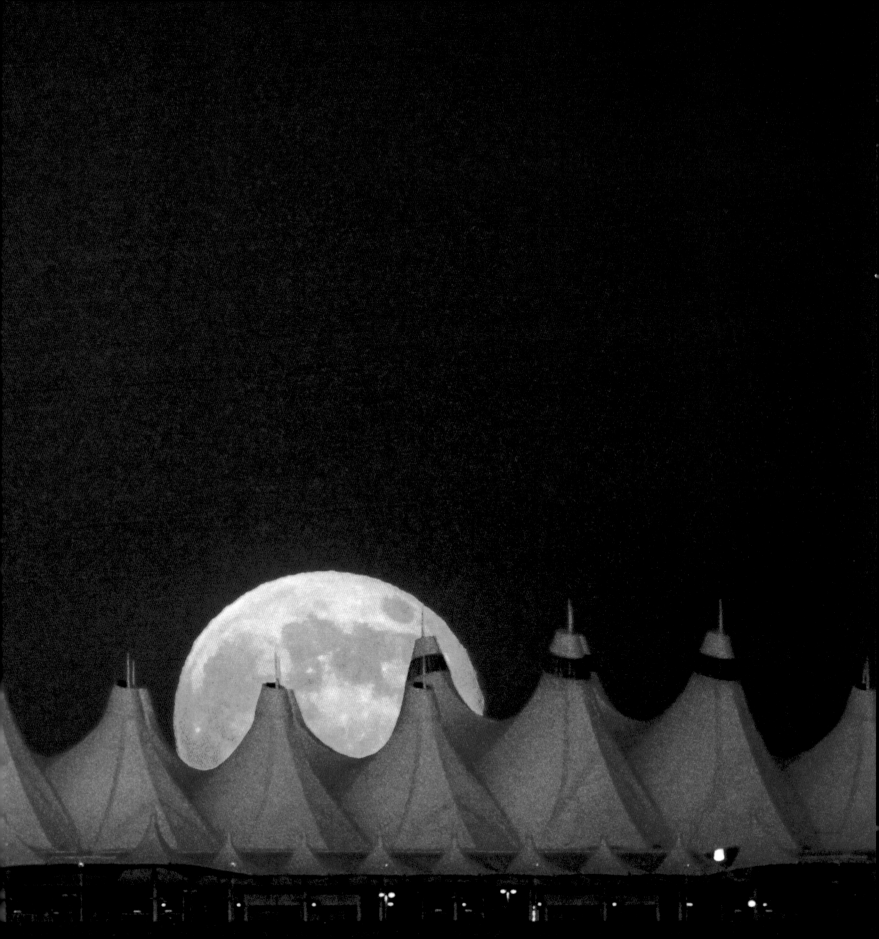

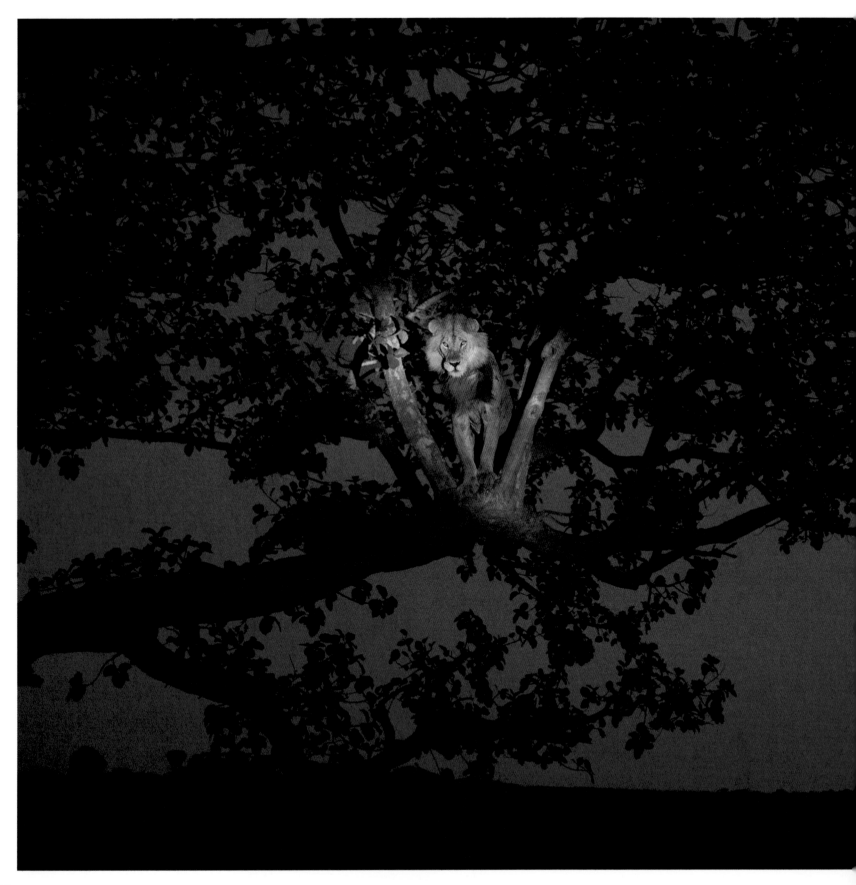

Never fear shadows.
They simply mean
there's light shining
somewhere nearby.

∽

–RUTH RENKEL

JOEL SARTORE | QUEEN ELIZABETH NATIONAL PARK, UGANDA
An African lion finds a perch for the night. The Ishasha area of Uganda's Queen
Elizabeth National Park is one of only two places where lions climb trees.

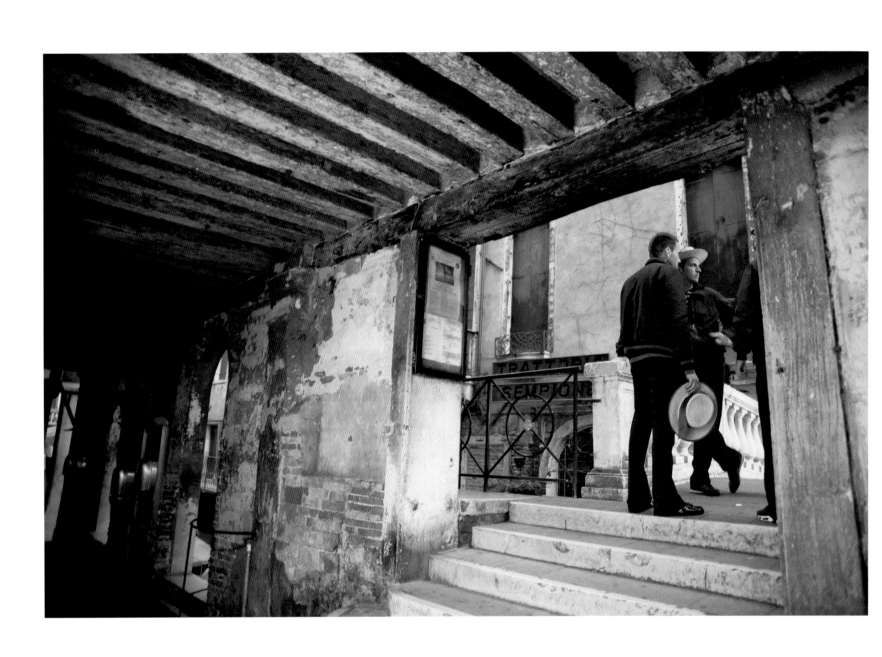

JODI COBB | VENICE, ITALY
Gondoliers wait for customers as night falls on Venice.
Tourists bring a force to Venetian waterways, but tourism
has also led to a decline in local residents.

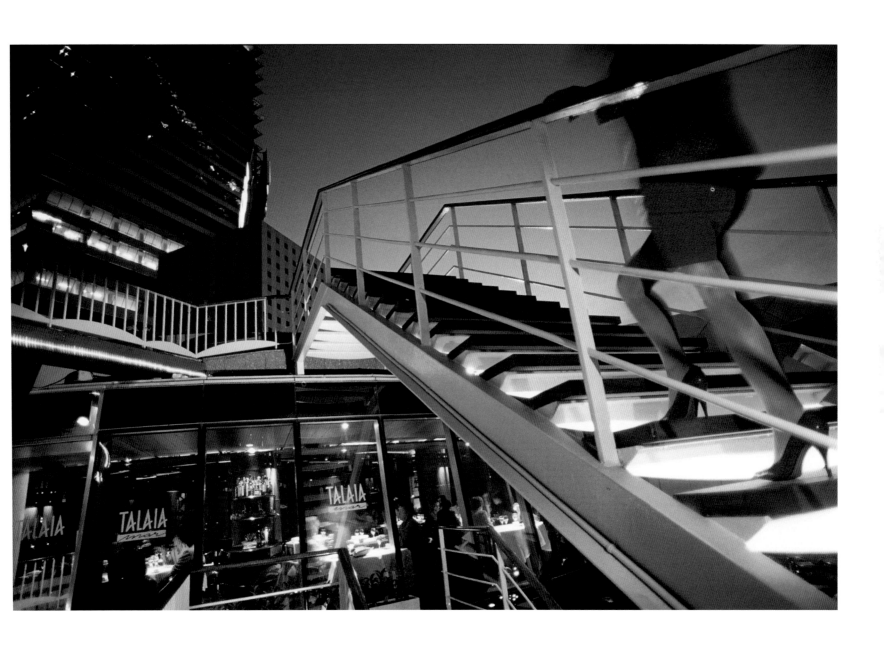

TINO SORIANO | BARCELONA, SPAIN
A woman in red heels and a red dress adds a fashionable
splash to Barcelona's Port Olímpic. The city revitalized the
area for the 1992 Summer Olympics.

By twilight all things
not yet settled will have
to wait another day.

–JIM RICHARDSON

ANNIE GRIFFITHS | ZAMBEZI RIVER, ZAMBIA
The lights come on as the sun goes down on the Zambezi River.
Visitors enjoy a drink on the "great river," the meaning of Zambezi
for the Tonga people.

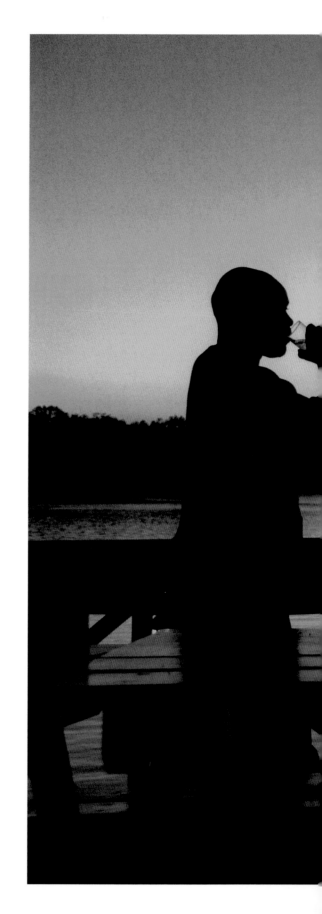

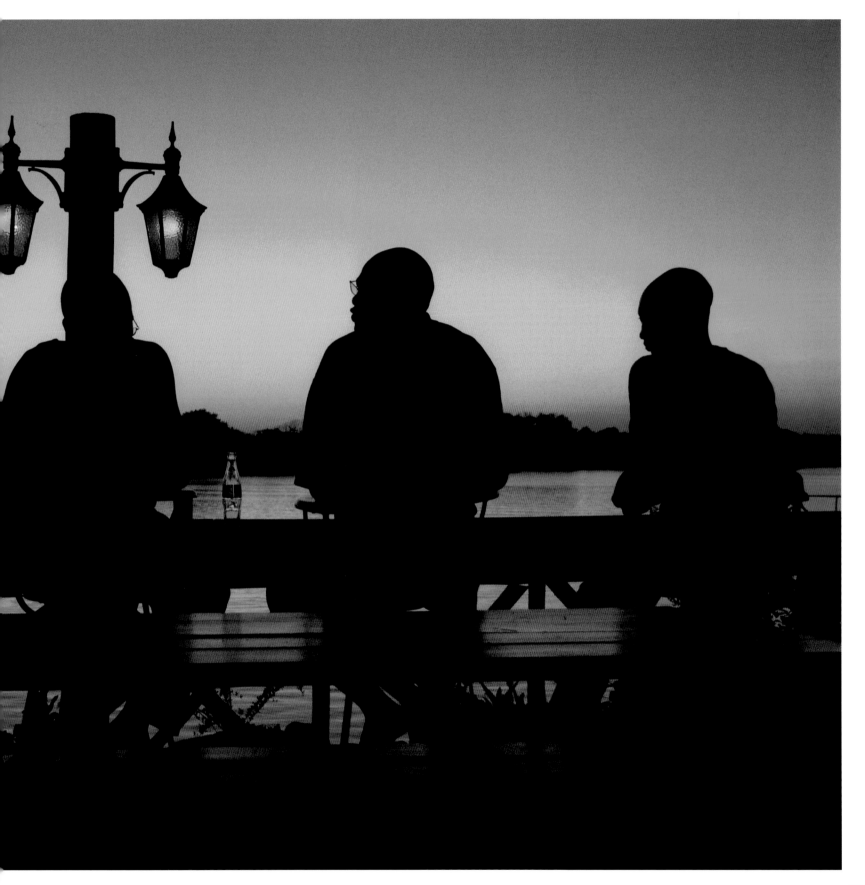

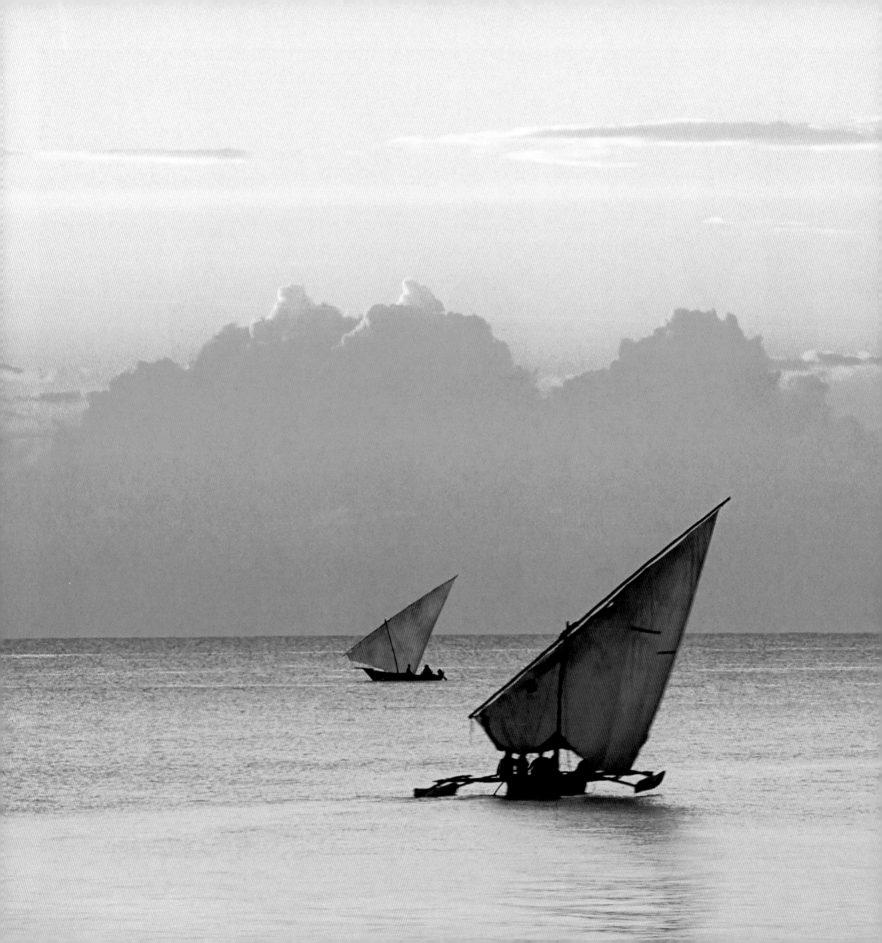

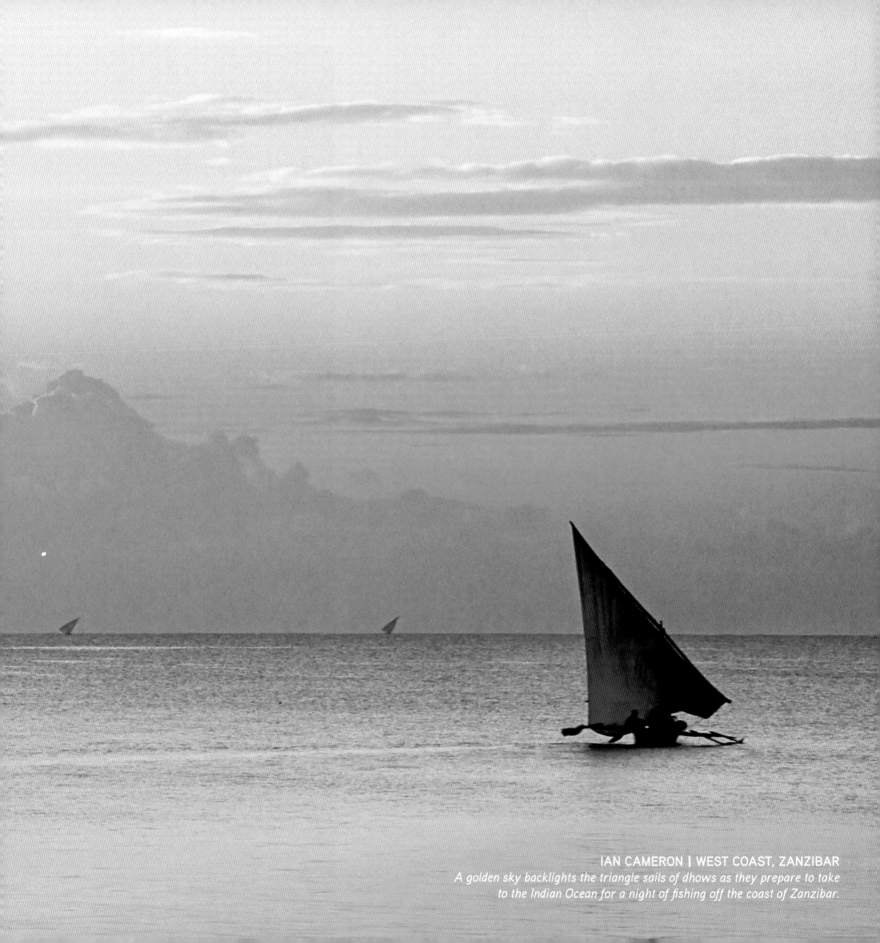

IAN CAMERON | WEST COAST, ZANZIBAR
A golden sky backlights the triangle sails of dhows as they prepare to take to the Indian Ocean for a night of fishing off the coast of Zanzibar.

When photographing on assignment,

I constantly observe my surroundings for pictures, but I also search for clues that may lead me to an unseen photograph, one that is yet to happen. This picture was made inside a tent where local monks had gathered for the Kathentean Ceremony, which marks the end of the rainy season in Cambodia. I knew the twilight hour would bring a brilliant blue that would make the scene, with the umbrellas illuminated by candles, a rainbow of color. When the sky was getting close to the correct brightness to balance with the candlelight, I crawled inside the tent and took a seat. I paused a few minutes for people to forget about me. As quietly as possible, I squeezed off frames each time hands were raised and heads bowed. The central figure, the monk with bowed head, is illuminated by a low-wattage fluorescent light. I composed him for that reason, and also for his exposed shoulder and contrasting white sash.

FRITZ HOFFMANN

Siem Reap, Cambodia
Monks observe the end of the rainy season.

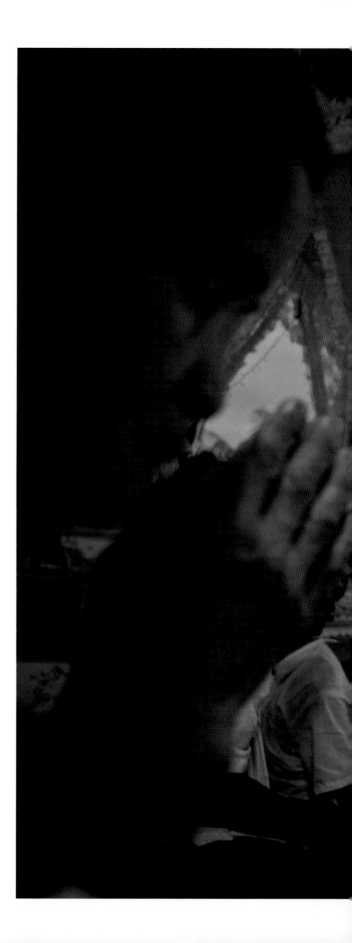

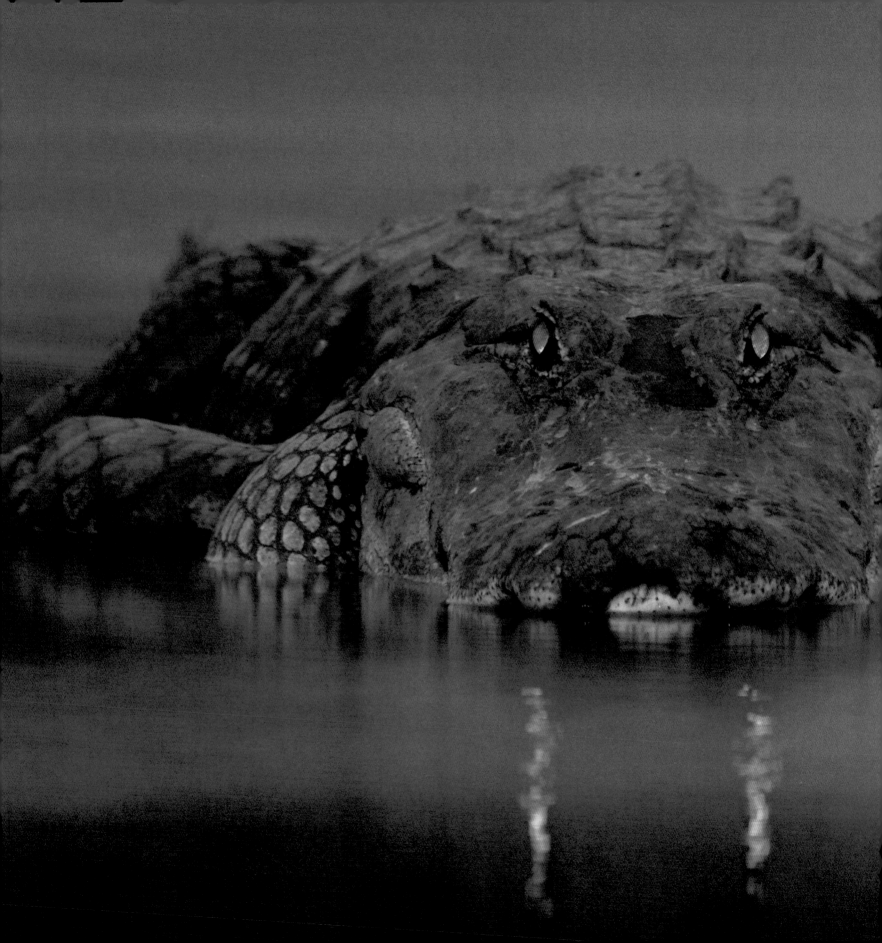

LARRY LYNCH | MYAKKA RIVER STATE PARK, FLORIDA
An alligator, stuffed full of fish, stares at the photographer.
Lynch used a small flash to catch the alligator's red eye shine.

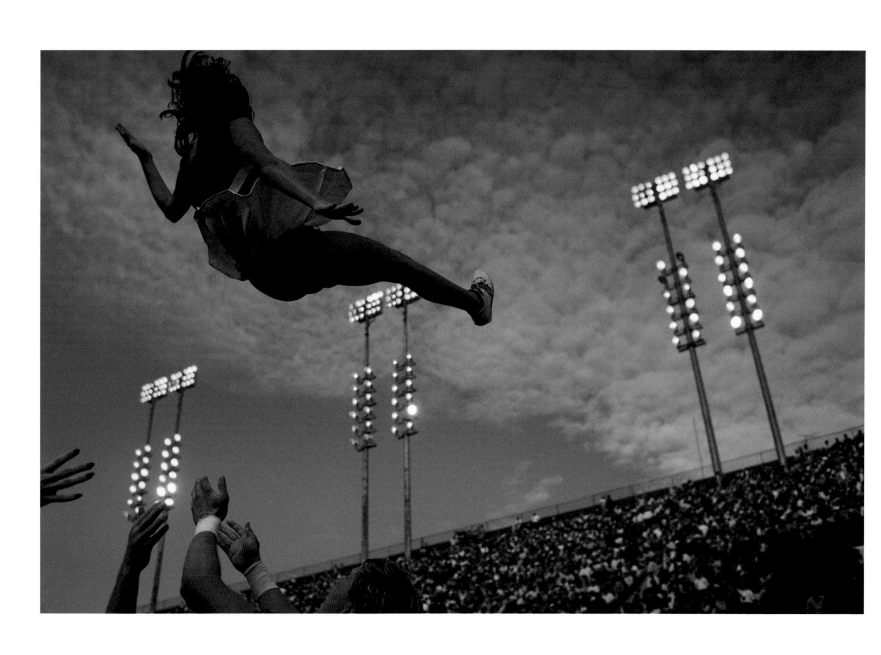

WILLIAM ALBERT ALLARD | TIGER STADIUM, BATON ROUGE, LOUISIANA
*A cheerleader catches some air under the bright lights of Tiger Stadium, home of the
Louisiana State Fighting Tigers. Nearly 100,000 spectators can watch games here.*

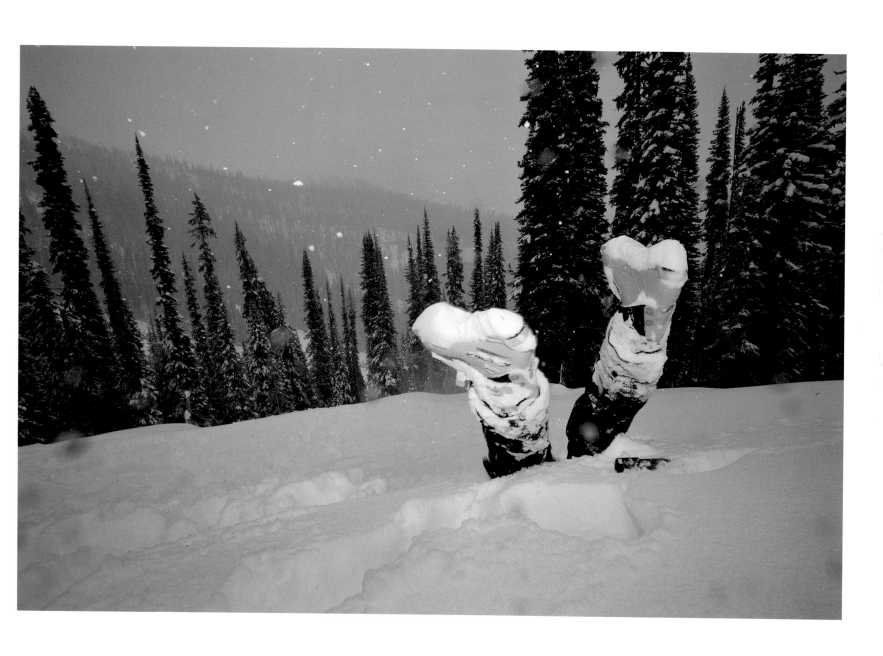

DAWN KISH | ICEFALL LODGE, BRITISH COLUMBIA, CANADA
Deep powder cradles a young skier who fell headfirst into a snow bank. This back-country lodge in the Canadian Rockies comes with 50,000 acres of pristine terrain.

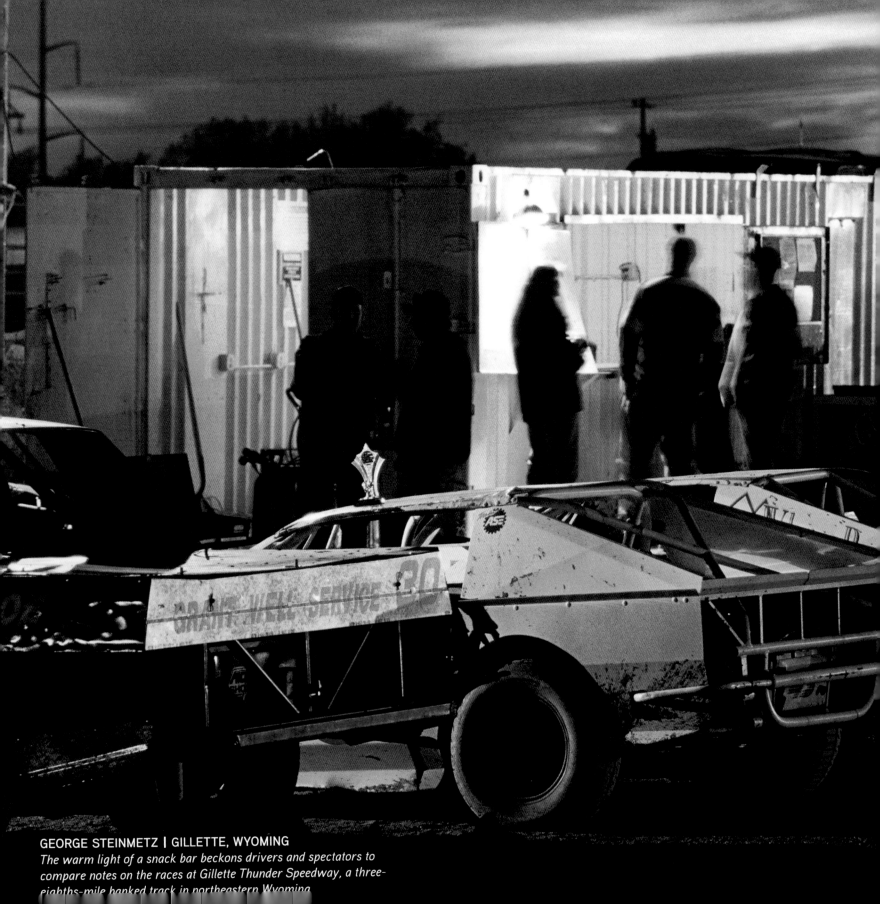

GEORGE STEINMETZ | GILLETTE, WYOMING

The warm light of a snack bar beckons drivers and spectators to compare notes on the races at Gillette Thunder Speedway, a three-eighths-mile banked track in northeastern Wyoming.

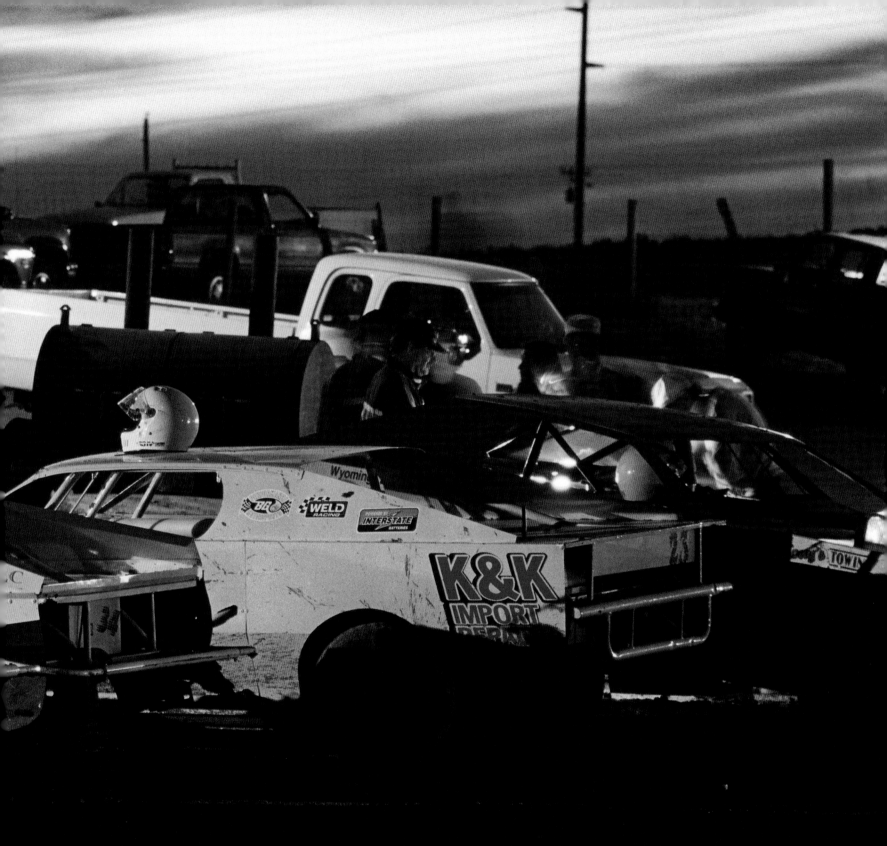

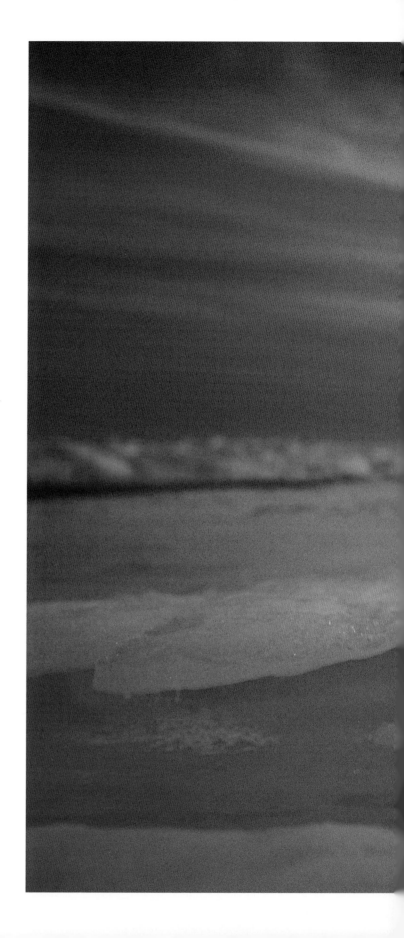

Light can be gentle, dangerous, dream-like, bare, living, dead, misty, clear, hot, dark, violet, springlike, fall-ing, straight, sensual, limited, poisonous, calm and soft.

–SVEN NYKVIST

BRIAN SKERRY | GULF OF ST. LAWRENCE, CANADA
A whitecoat pup rests on ice under a pastel sky. Harp seals migrate some 2,000 miles to reach their breeding grounds on the Gulf of St. Lawrence.

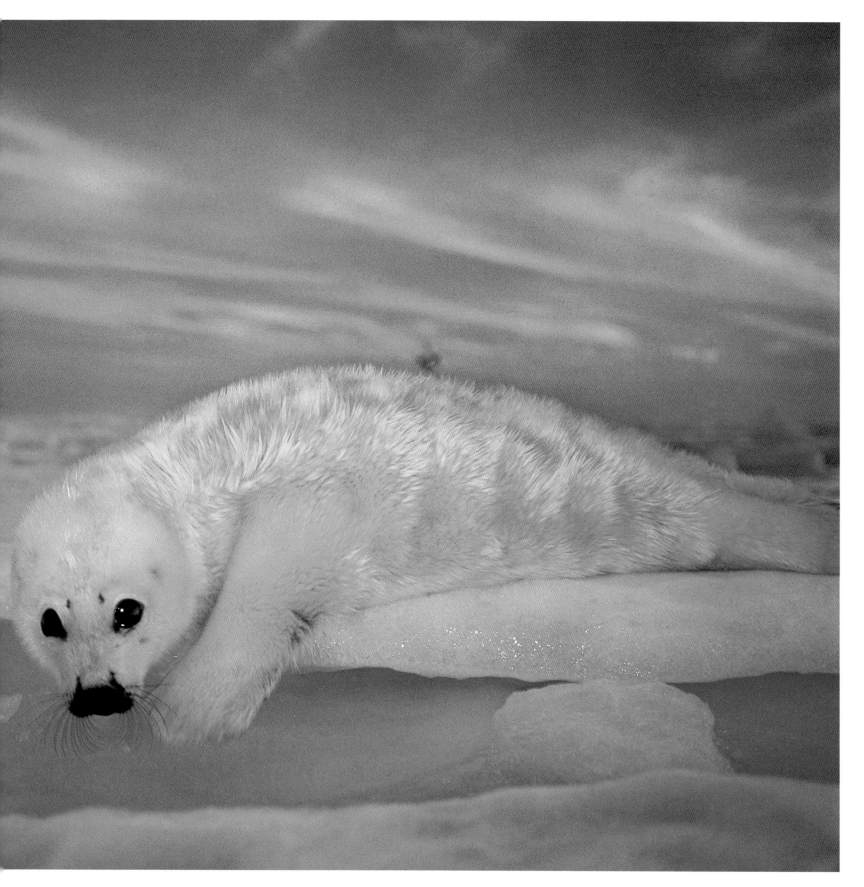

O. LOUIS MAZZATENTA | CARTAGENA, COLOMBIA

Dusk darkens a block near the white-trimmed cathedral in the heart of Cartagena. The Spanish conquistador Pedro de Heredia founded this city on the Caribbean in 1533.

RAUL TOUZON | LAKE PLACID, NEW YORK
An ice-skater zooms past Christmas trees during a dusk-time workout in
Lake Placid. The town hosted the Winter Olympics in 1932 and again in 1980.

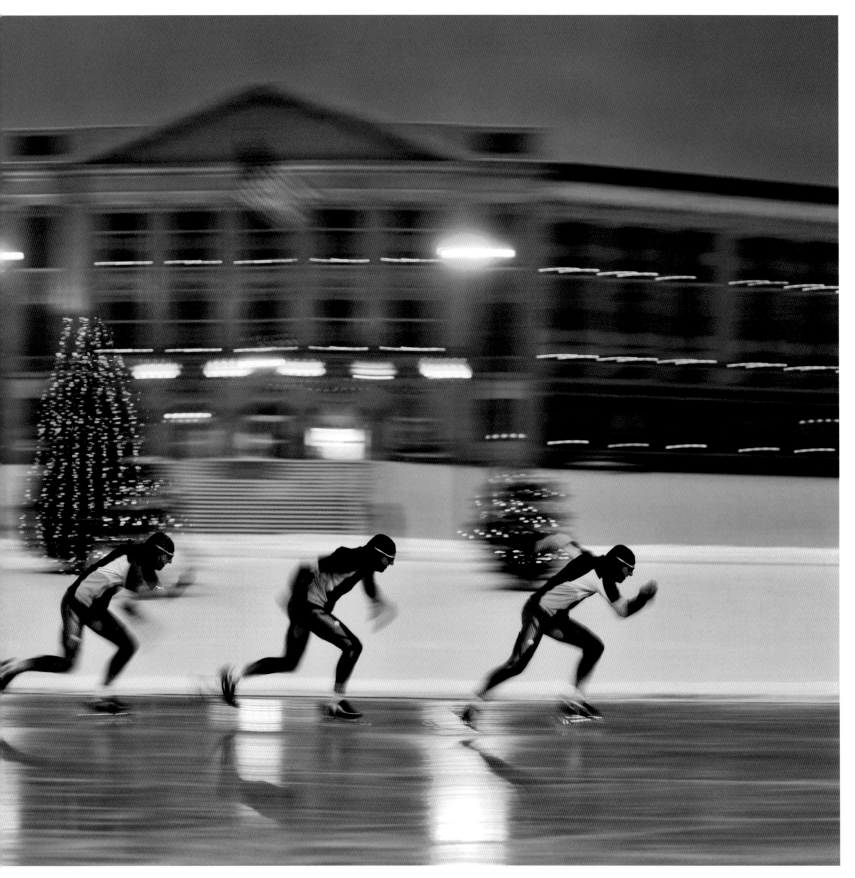

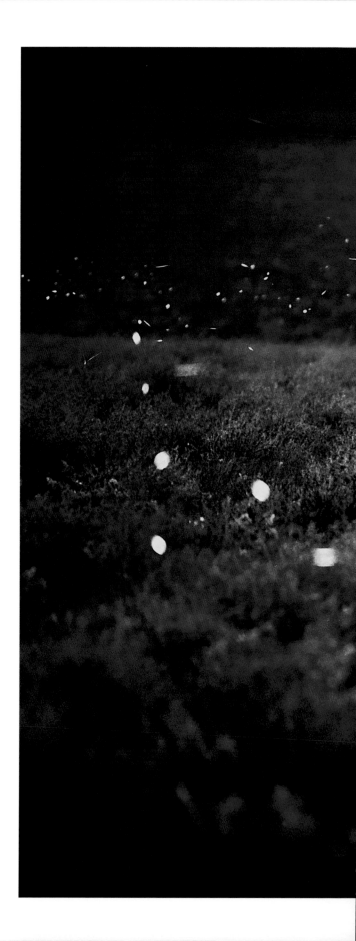

It was a beautiful scene that night

out in the Flint Hills of Kansas, darkness settling in shades of indigo over the wild alfalfa. This photograph was a desperate attempt to capture the mating rituals of the fireflies, it was a "stab in the gloaming," a primordial Scots word for that time when darkness takes away the last of the light. Looking through my camera's viewfinder was hopeless. I pointed by instinct and rotated the focus to some hoped-for miracle setting. The first shots were wildly out of focus. I adjusted, tweaked the exposure, repointed the camera. Finally I got one—one firefly flew toward me, flashing his way through the night for all 76 seconds of my exposure, leaving a trail of light across the frame as if he were an artist. I'll forever be thankful to that one firefly, and to all the adolescent fireflies who let me share that night with them out there on the silent plains.

JIM RICHARDSON

Flint Hills, Kansas
Fireflies search for one another in a field of alfalfa.

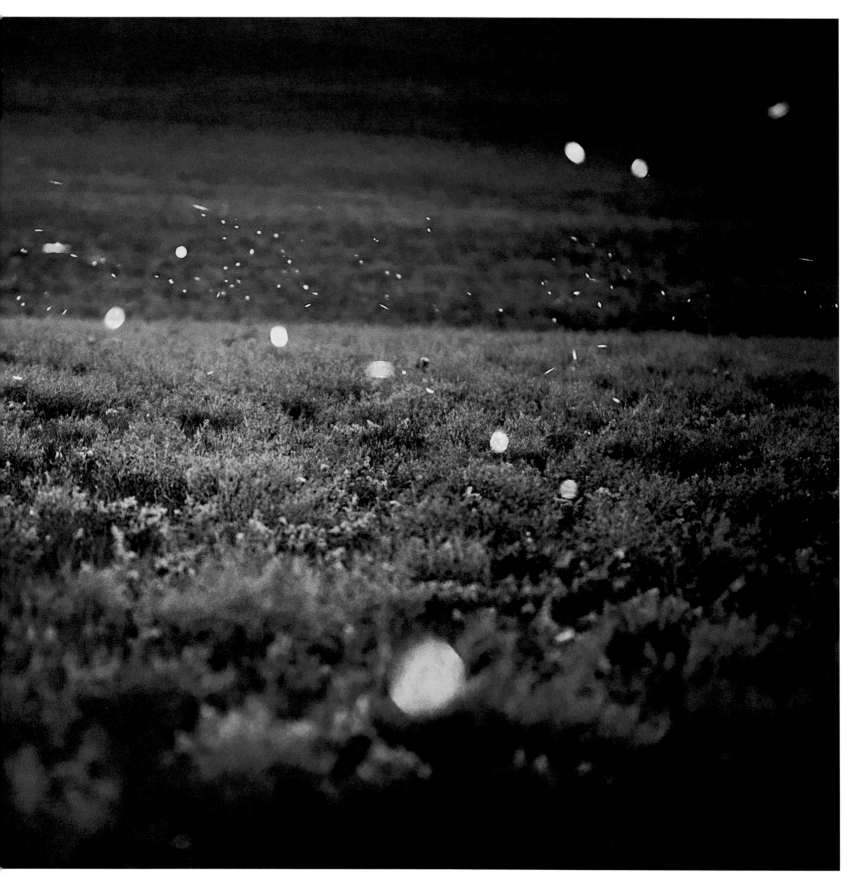

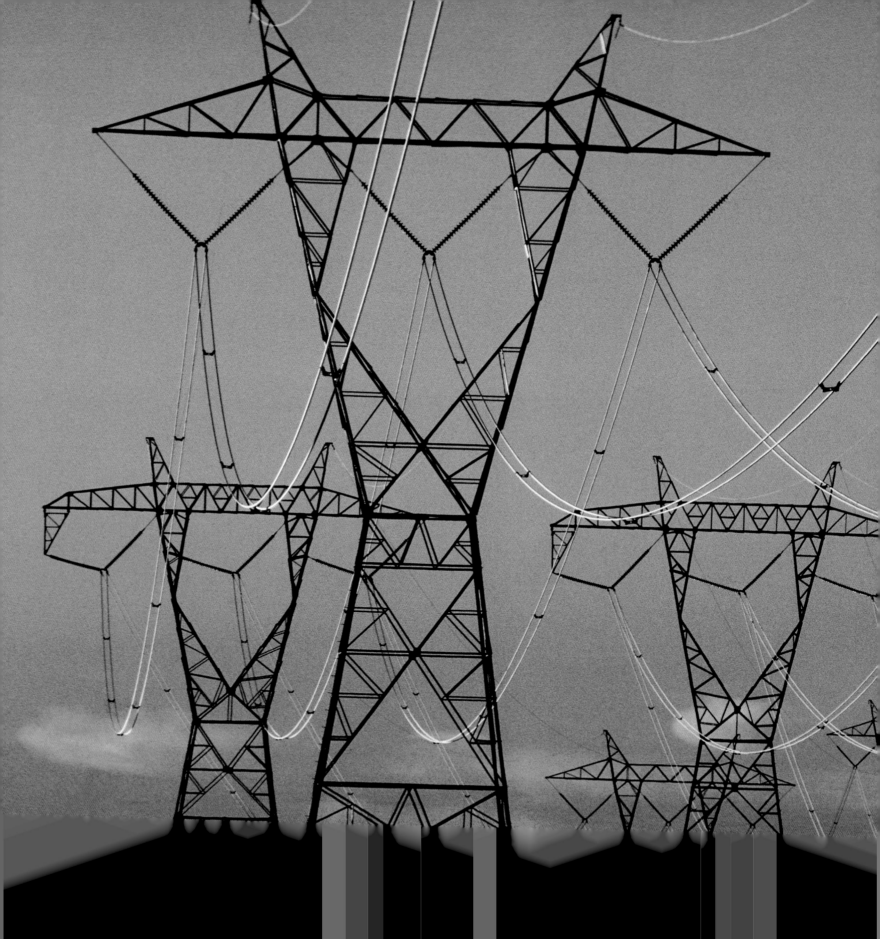

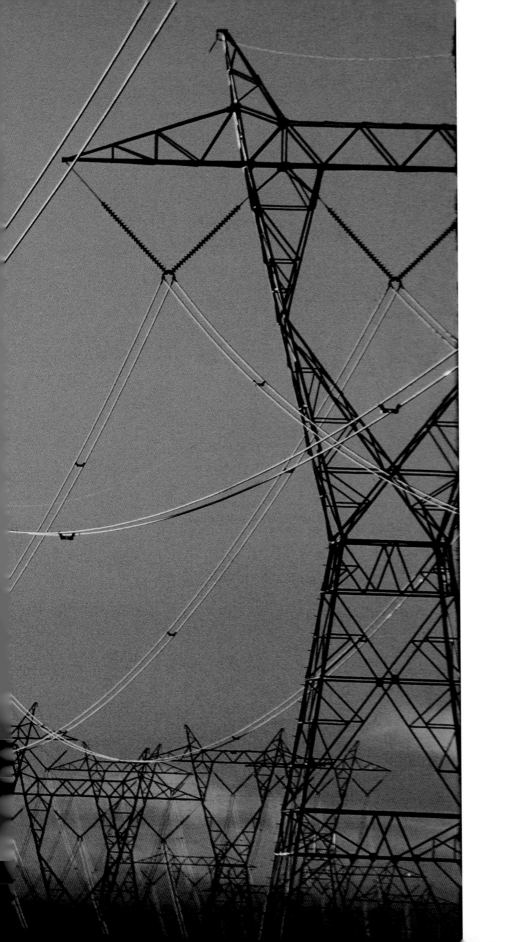

BURT GLINN | ARIZONA
*The power lines and towers of Arizona's Salt River Project
catch the fading sunlight to create a geometric masterpiece.*

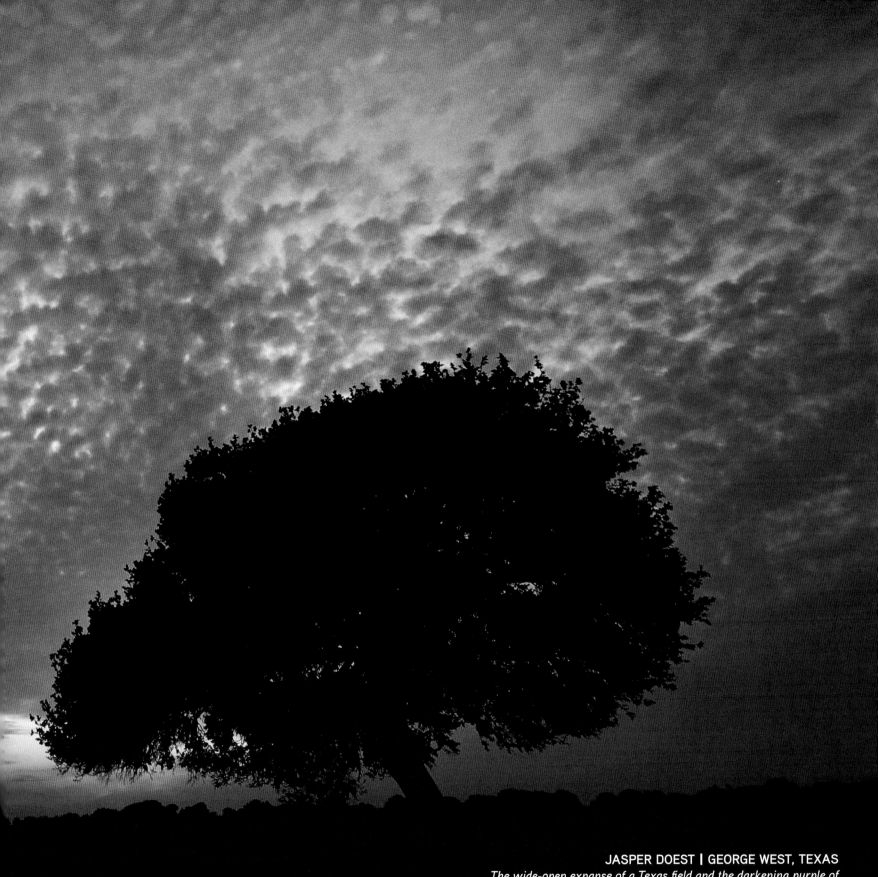

JASPER DOEST | GEORGE WEST, TEXAS
The wide-open expanse of a Texas field and the darkening purple of an after-sunset sky create a vivid silhouette of a lone live oak tree.

NIGHT

DARKNESS COMES IN

many shades. It can be pitch-black or star-dazzled. It can turn almost day-like in cold, full moonglow. Night's a time of wonder, of dreams and fantasies, fears and fulfillment, magic, romance. Nighttime brings out civilization's sizzle as we light up our streets and houses. In fact, these days you have to look hard to find the true darkness that started it all.

Nighttime brings out secrets. We reach and touch, we stumble and grope, we whisper and confide. The sweetest moments of intimacy, the deepest moments of fear: Nighttime and its absence of light can evoke either. The imagination fills in what the eyes cannot, and the result may be more grotesque or more sublime than anything seen in the light of day.

The Aztec visualized nine lords of the night who rose and fell as the hours passed: gods associated with turquoise, jade, and obsidian, rain and mountains, maize and flowers, sin and the underworld. The ancient Greeks, according to Hesiod, believed that out of Chaos was born Nyx—Night—who spawned a slew of fatherless children: Sleep, Dreams, Blame, Pain, Fate, Death, Destiny . . . our darkest imaginings run wild.

Yet that same Nyx one day meets Erebus—Darkness—whose union brings forth Brightness and the Day. Dive down into night's mystery. Rest there a while, enjoying the darkness, knowing that perhaps too soon sweet daylight will return.

THOMAS MARENT | DANUM VALLEY CONSERVATION AREA, MALAYSIA *A bioluminescent fungus glows with a cold light in a forest on the island of Borneo. It creates very little heat with its otherworldly glow.*

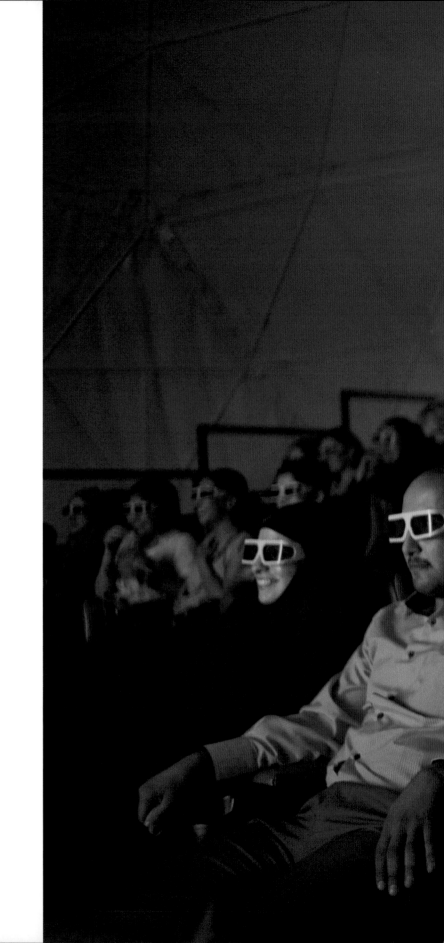

LYNSEY ADDARIO | BAGHDAD, IRAQ
*Moviegoers in Baghdad get an extra thrill from shaking seats
and wind machines during a 3-D science-fiction film.*

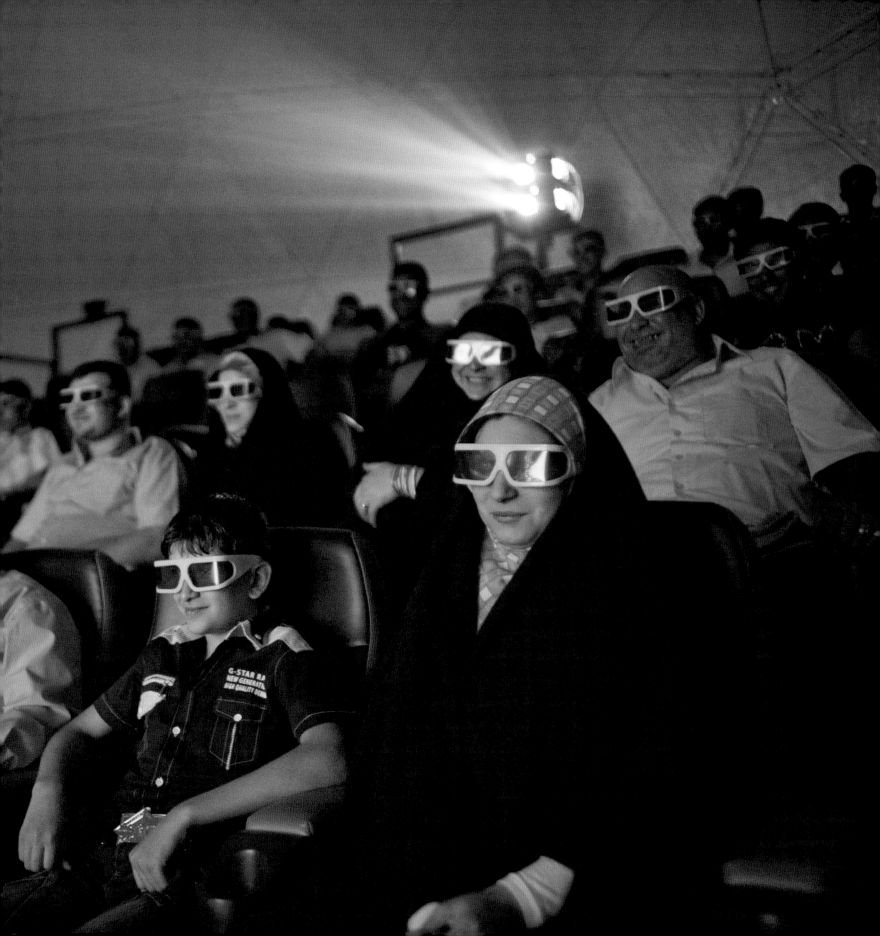

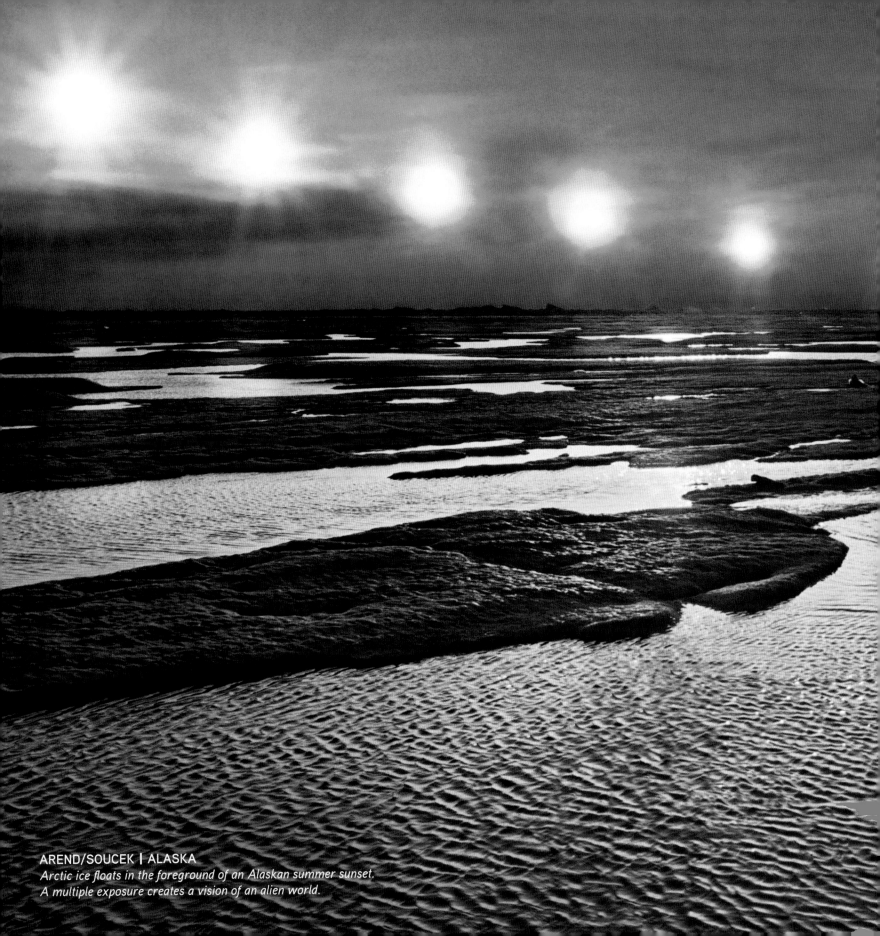

AREND/SOUCEK | ALASKA
Arctic ice floats in the foreground of an Alaskan summer sunset.
A multiple exposure creates a vision of an alien world.

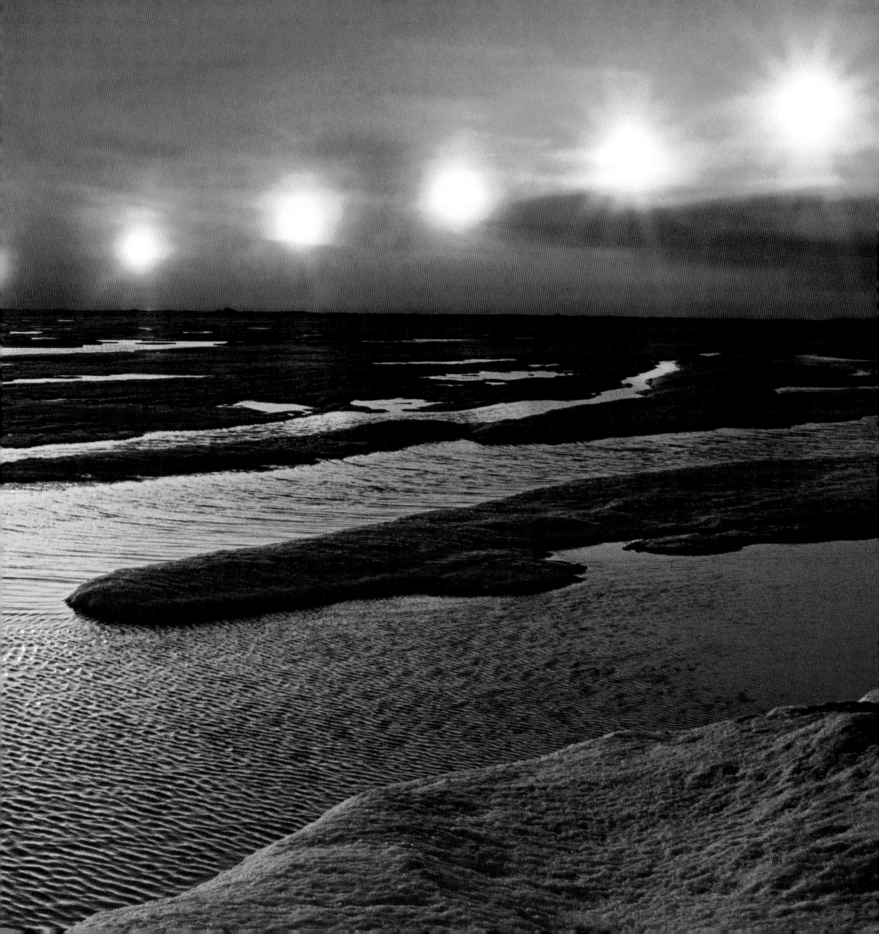

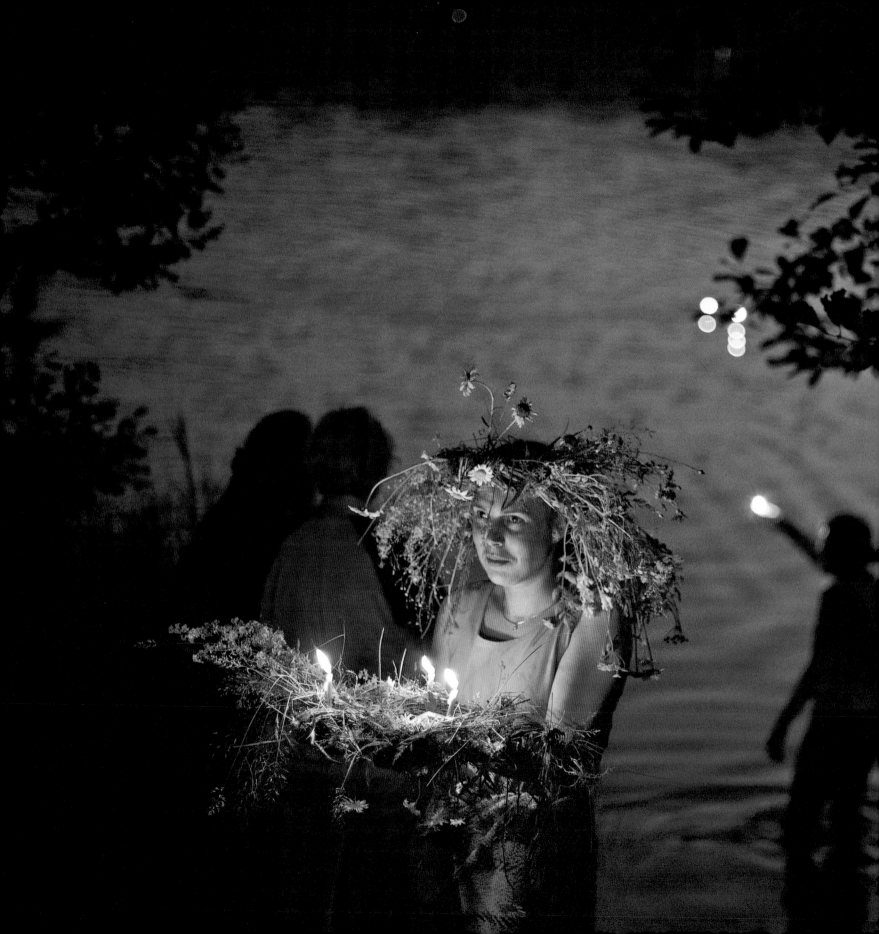

My candle burns
at both ends;
It will not last
the night;
But ah, my foes,
and oh, my friends—
It gives a lovely light!

—EDNA ST. VINCENT MILLAY

JONAS BENDIKSEN | VLADIMIRSKOYE, RUSSIA
*Candles and flower garlands mark the festival of Ivan Kupala (St. John
the Baptist) in Vladimirskoye, Russia. Celebrants walk three times around
Svetloyar Lake in hopes of making their wishes come true.*

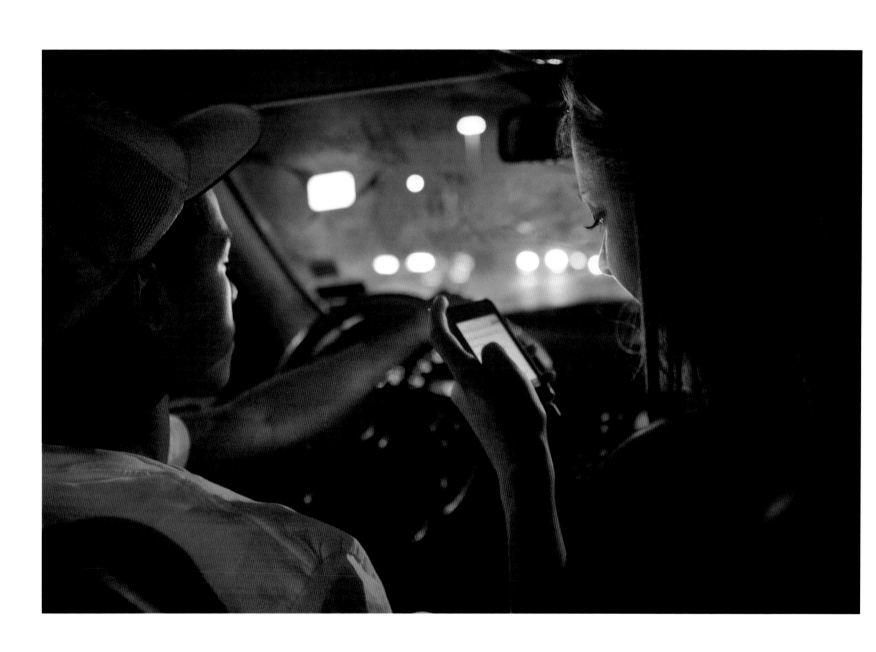

KITRA CAHANA | AUSTIN, TEXAS
*A teenage girl sends a text on her way to a party. Cell phones add just
another dimension to the challenges teenagers face as their brains mature.*

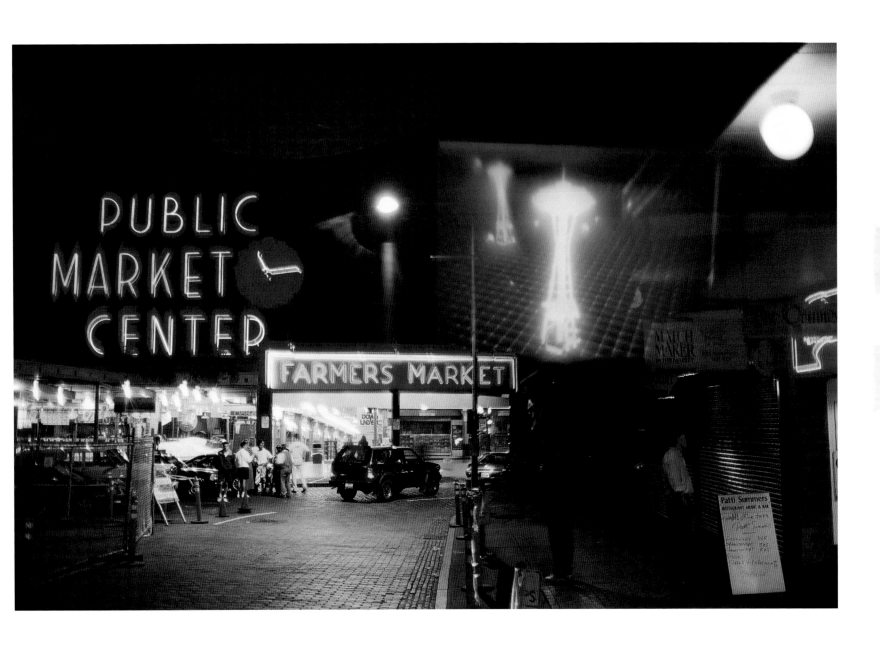

GEORGE STEINMETZ | SEATTLE, WASHINGTON
*Seattle's Pike Place Market comes alive at night. The historic district
sprawls across nine acres, including its iconic neon sign.*

359

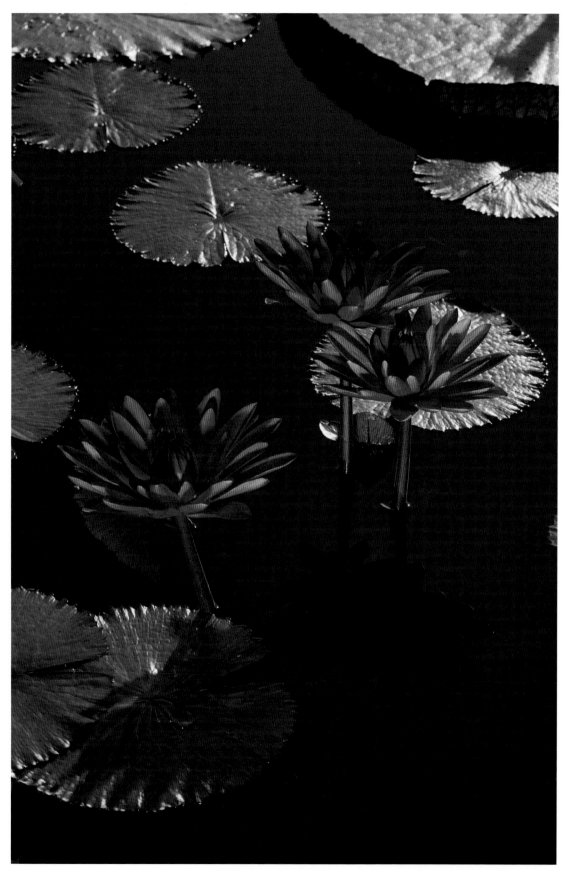

For an assignment on night gardens,

we looked for gardens with cultural and historical relevance to the night. Longwood Gardens in Pennsylvania has Pierre du Pont's illuminated fountains and, as an added bonus, an amazing water lily display, including this tropical, night-flowering lily that blooms only two nights per year. It's all about patience, planning, and being in the right place at the right time—in this case under a full moon. The night of this photo, the moon came up around 7 p.m. and we took the picture at 12:44 a.m. Using only natural light, we exposed it for 276 seconds, grateful there was no wind. A magical, perfectly clear August night helped make this picture so crisp, illuminating the beautiful pink petals and lily pads.

DIANE COOK AND LEN JENSHEL
Longwood Gardens, Pennsylvania
A full moon illuminates a night-blooming lily.

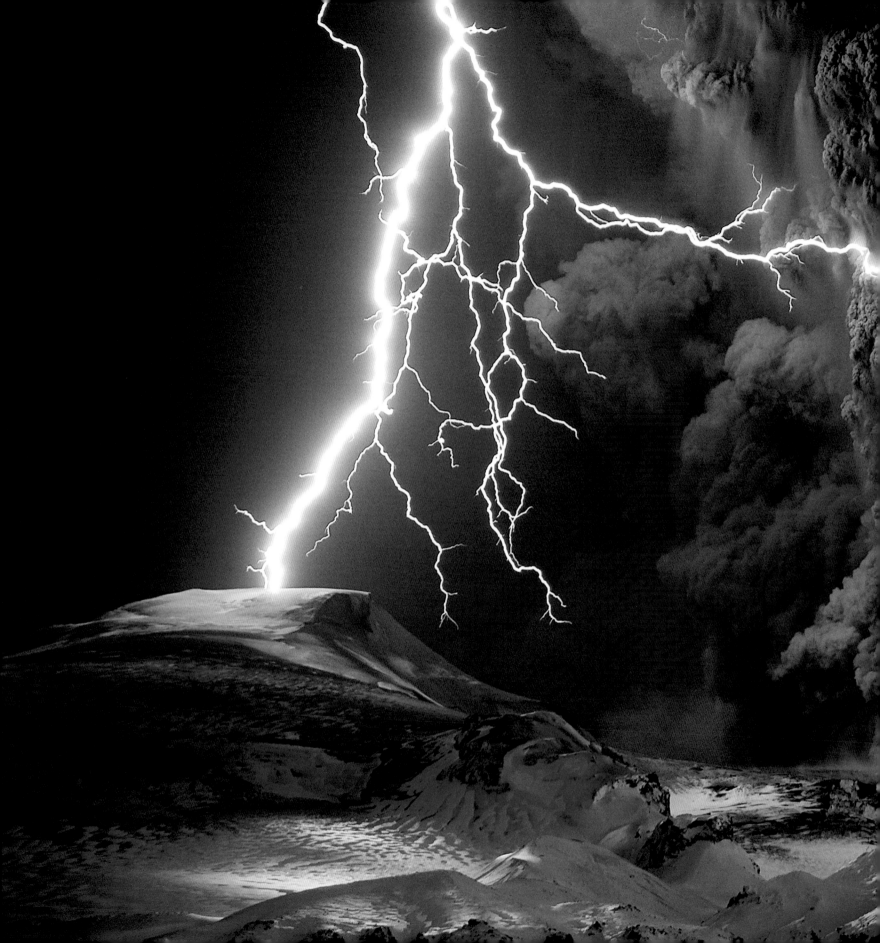

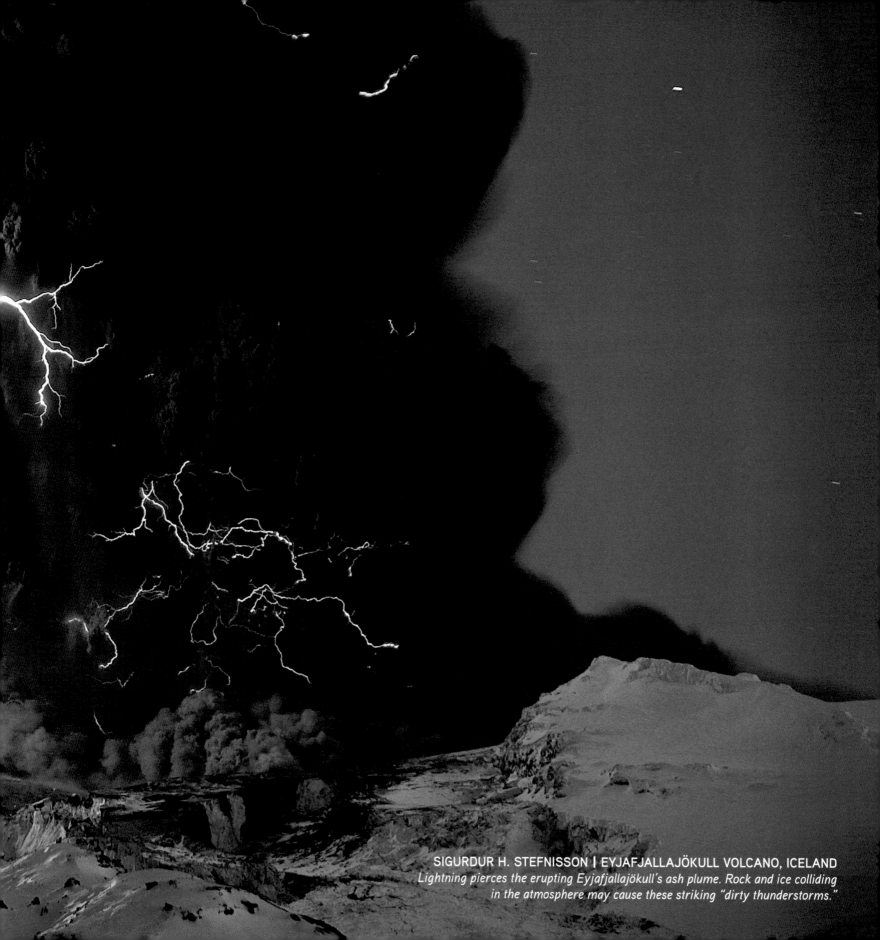

SIGURDUR H. STEFNISSON | EYJAFJALLAJÖKULL VOLCANO, ICELAND
Lightning pierces the erupting Eyjafjallajökull's ash plume. Rock and ice colliding in the atmosphere may cause these striking "dirty thunderstorms."

To thine own self be true, and it must follow, as the night the day, thou canst not then be false to any man.

–WILLIAM SHAKESPEARE

ALEX MAJOLI | CAIRO, EGYPT
Cairo streets come alive with a nighttime protest.

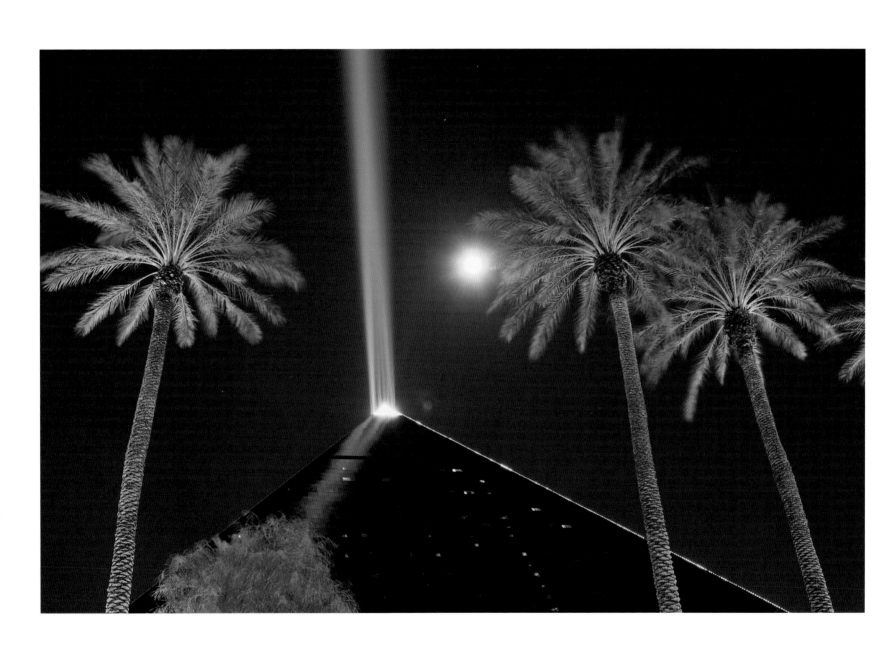

JIM RICHARDSON | LAS VEGAS, NEVADA
*As the moon shines down, curved mirrors focus 39 lamps into a single
beam aimed at the heavens from the top of Las Vegas's Luxor Hotel.*

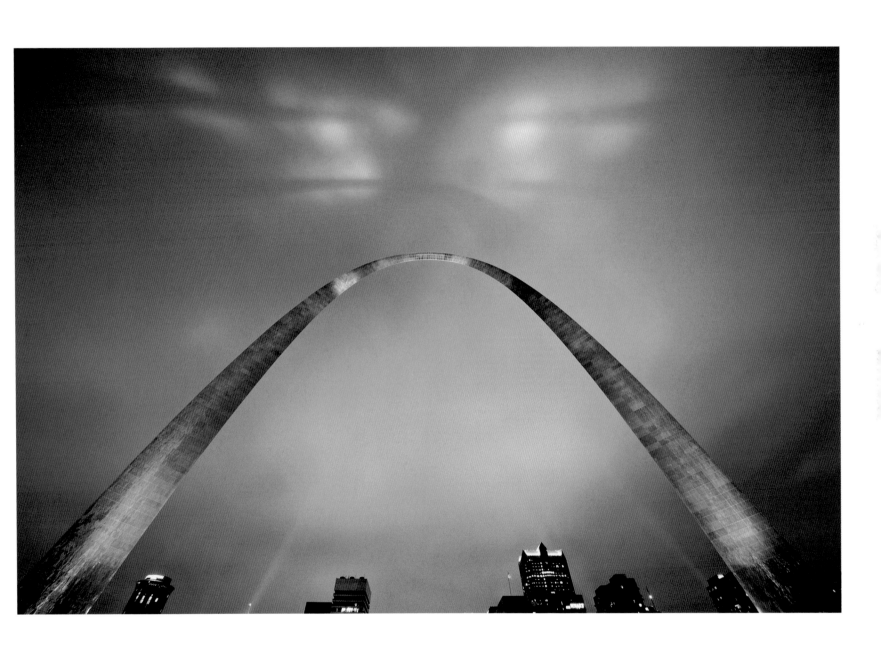

JIM RICHARDSON | ST. LOUIS, MISSOURI
Theatrical spotlights and low clouds turned salmon by St. Louis city lights give the stainless steel surface of the 630-foot-tall Gateway Arch a nighttime sheen.

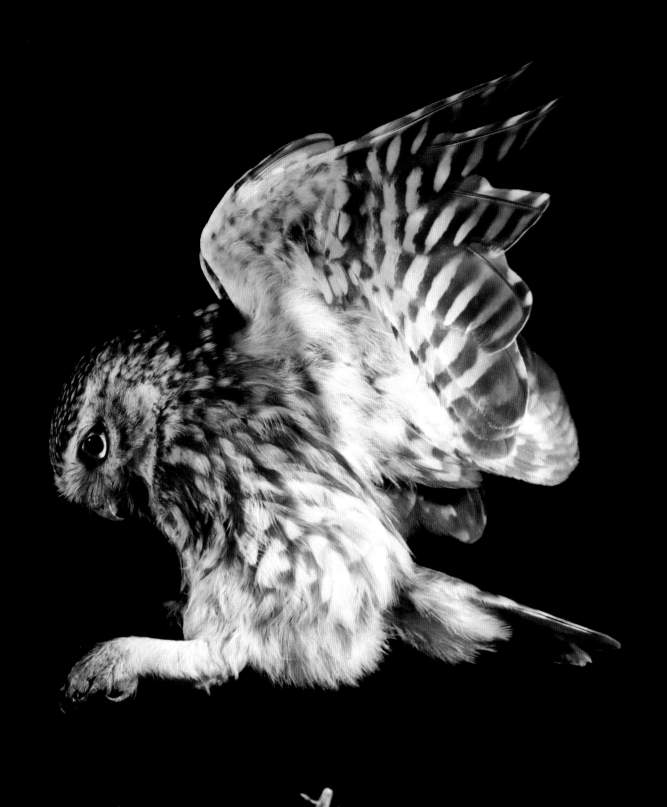

ADRI HOOGENDIJK | NETHERLANDS
A little owl swoops in for the kill. These slight owls weigh less than a pound and can also be seen hopping on the ground looking for food.

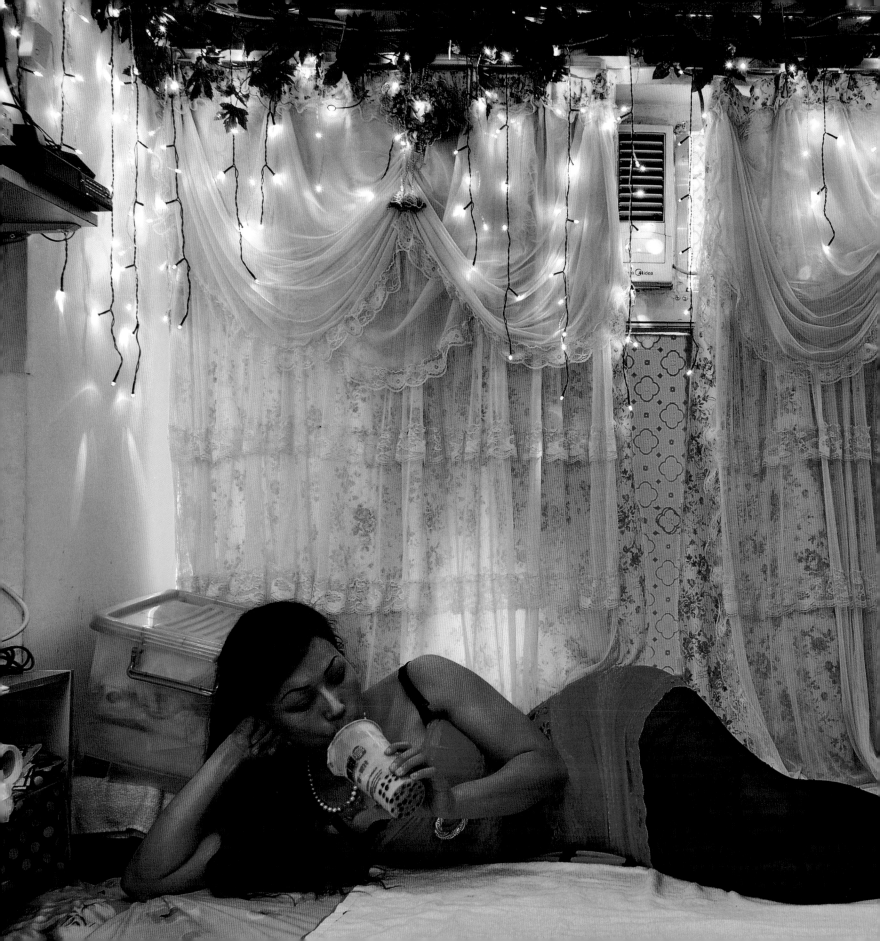

MARK LEONG | HONG KONG, CHINA
From a boudoir draped in lights, a 32-year-old woman
operates her own brothel. Prostitution is legal in Hong Kong,
but sole proprietorship is the only kind allowed.

371

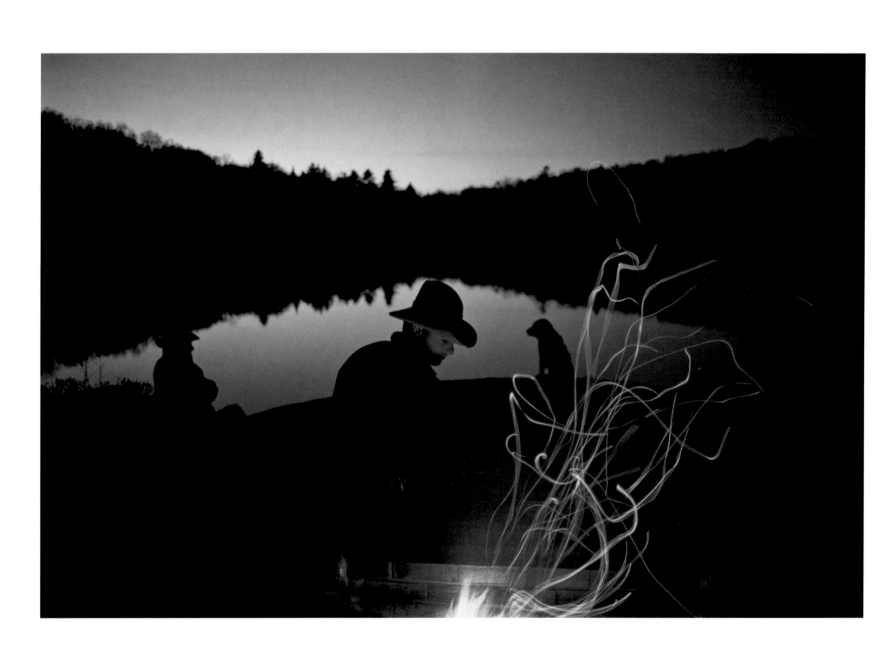

SAM ABELL | ADIRONDACKS, NEW YORK
*Sparks fly as Tim Brune watches a campfire at the North Woods Club
in the Adirondacks. The setting inspired some of the most important
work of American painter Winslow Homer.*

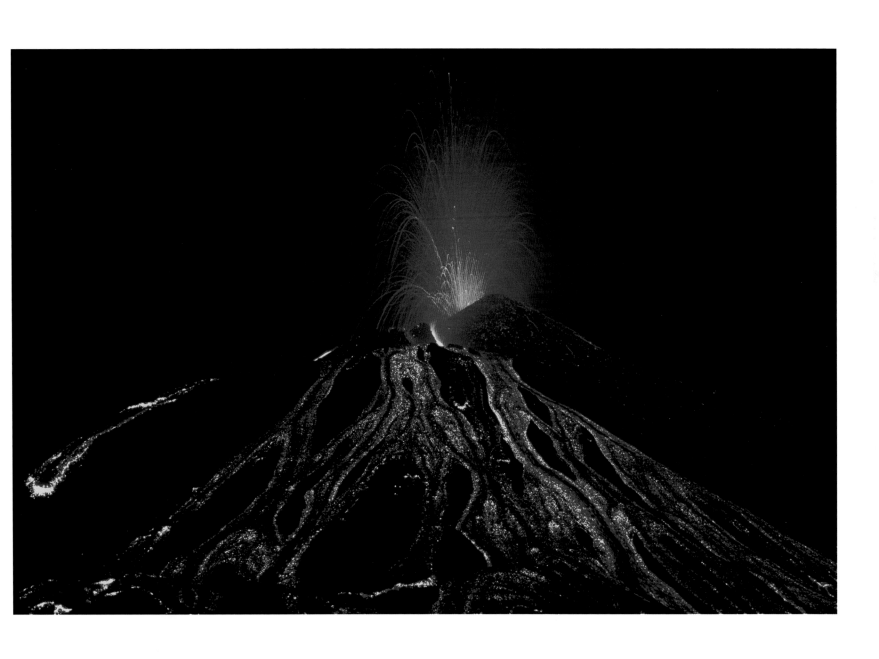

CARSTEN PETER | MOUNT ETNA, ITALY
Lava pours down the slopes of Sicily's Mount Etna during a nighttime display. "It's a fantastic force of nature, with terrific noise and a very real danger of getting hit," says Peter.

I took this picture during a carnival

procession in Santiago de Cuba. I stuck with this group from beginning to end, and by the time of this photo I had become part of their circle and was closely following two or three people. If you stick with one group—or any subject—and get integrated, then you will go with the flow at all times. I don't just jump in and out. This picture was taken just before the parade passed through the reviewing stand. Someone spoke to this girl and she turned around. I didn't think she would turn all the way around but would turn toward the left and wave to the reviewers. Then she turned before I thought she would. It was a stroke of luck, but I was prepared. As with many of my pictures, there was a bit of planning and a bit of serendipity.

DAVID ALAN HARVEY

Santiago de Cuba, Cuba
A brightly colored carnival procession passes by on a Cuban street.

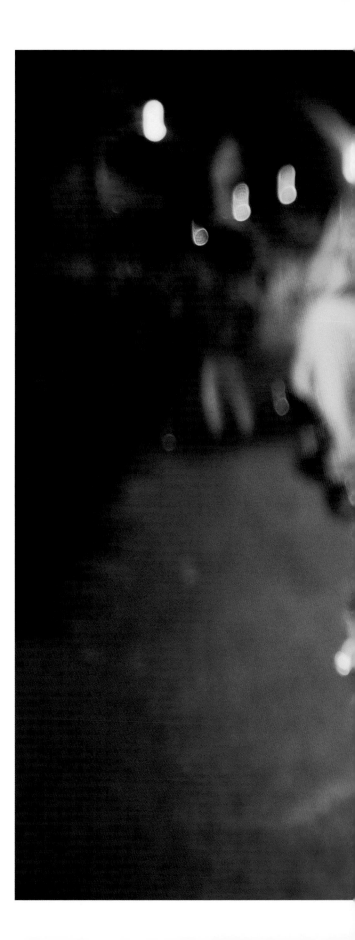

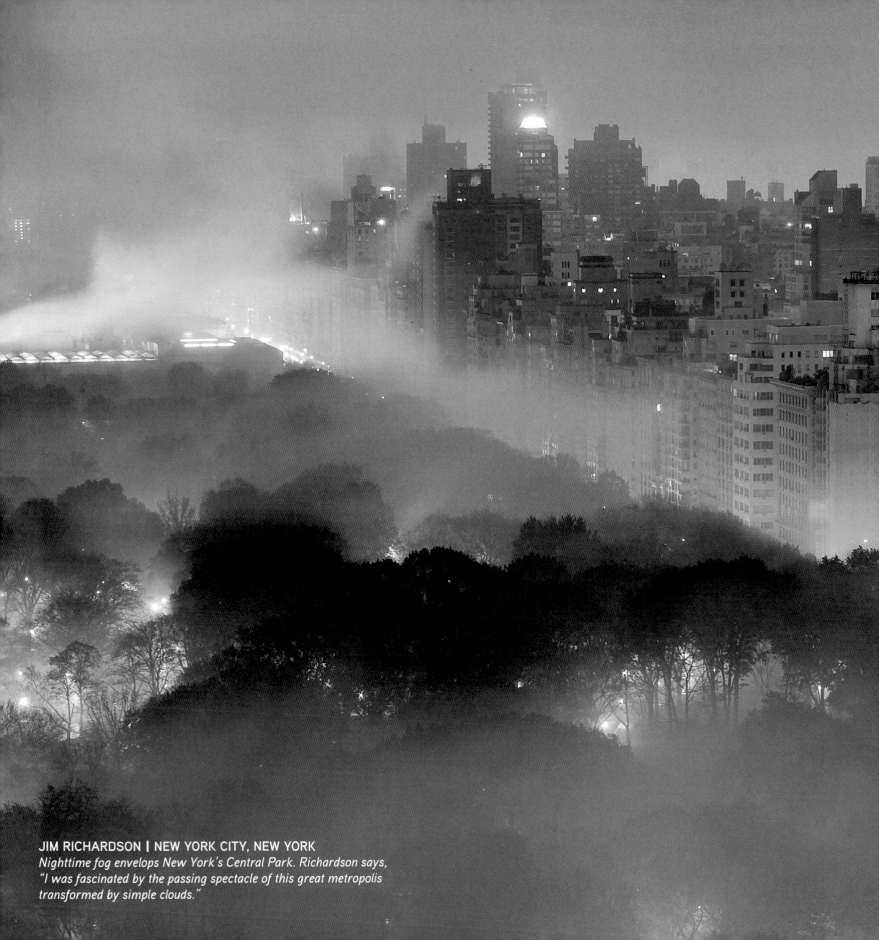

JIM RICHARDSON | NEW YORK CITY, NEW YORK
*Nighttime fog envelops New York's Central Park. Richardson says,
"I was fascinated by the passing spectacle of this great metropolis
transformed by simple clouds."*

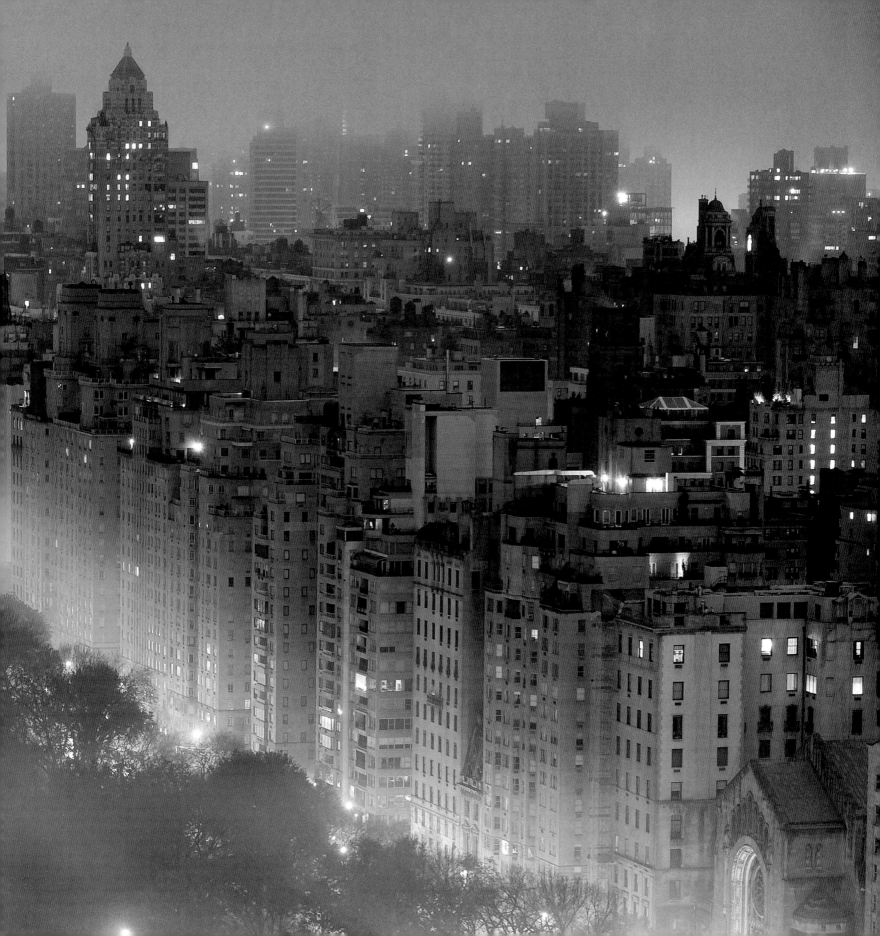

Moonlight
is sculpture.

〜

-NATHANIEL HAWTHORNE

MICHAEL MELFORD | ALLAGASH WILDERNESS WATERWAY, MAINE
Moonlight shines through thin clouds to reflect on the still waters of the Allagash Wilderness Waterway. Paddlers use the park's 92 "blue" miles for solitude and refreshment.

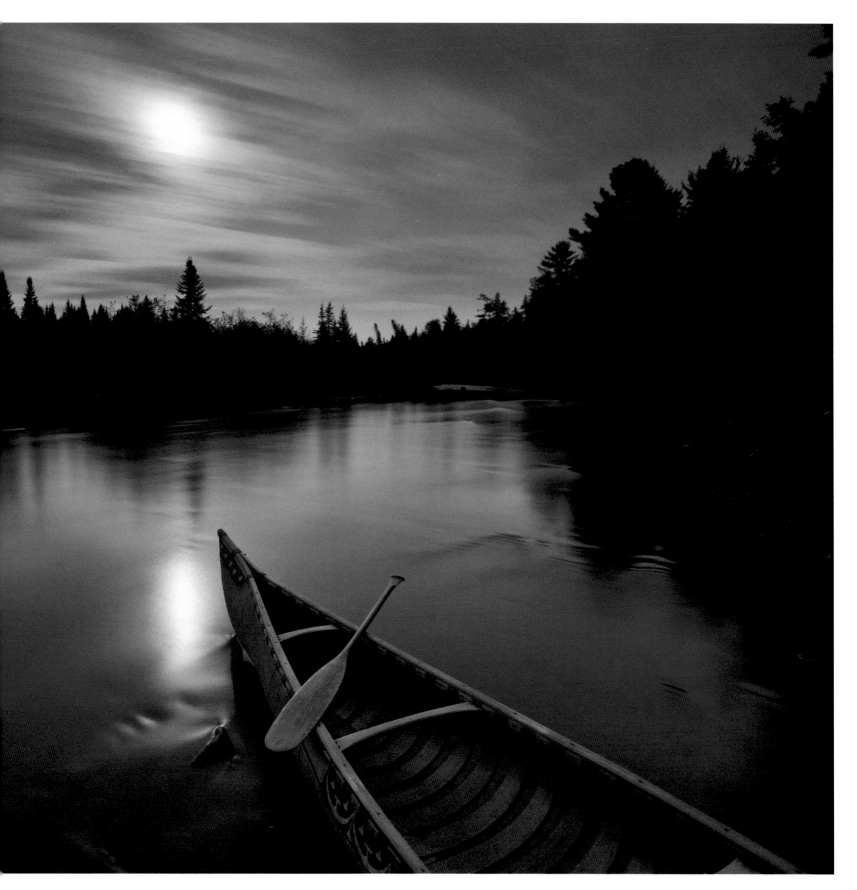

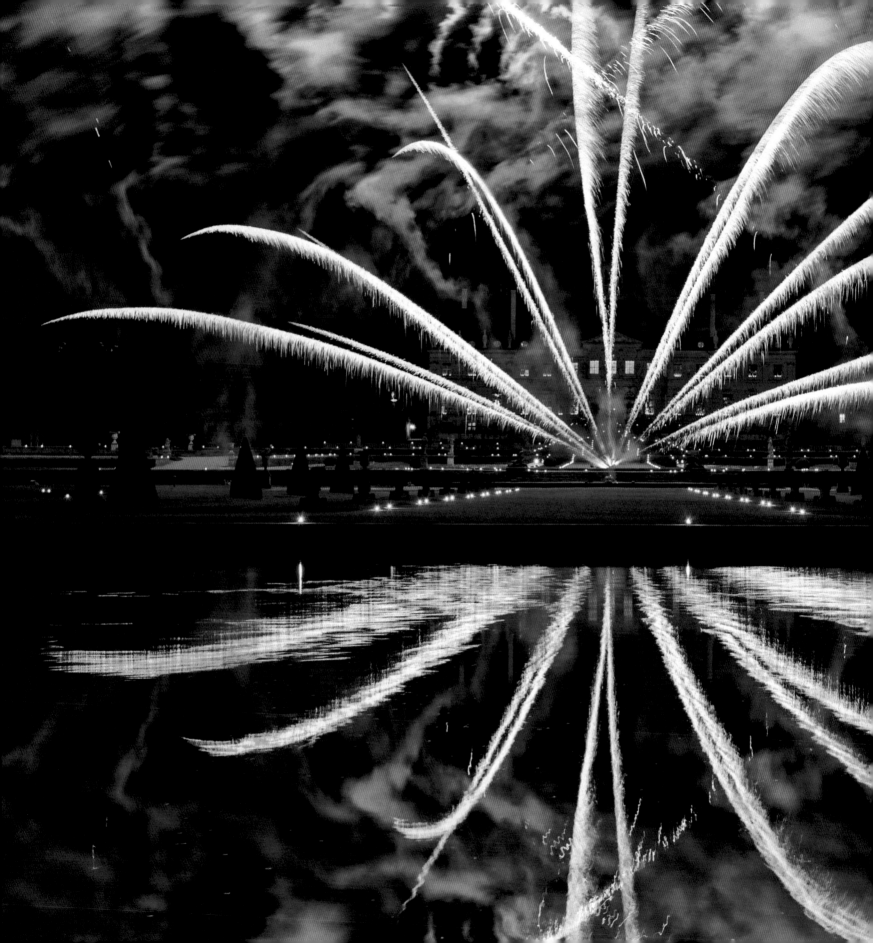

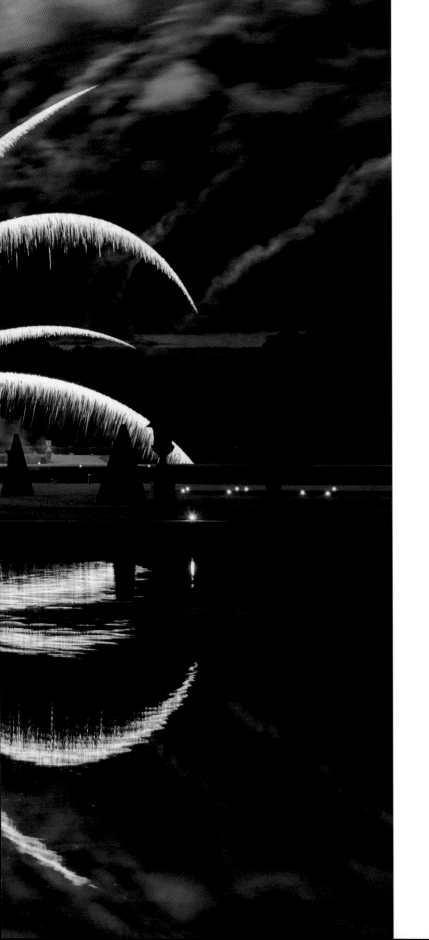

DIANE COOK AND LEN JENSHEL | MAINCY, FRANCE
Spidery fireworks fan out from the gardens of Vaux-le-Vicomte. The 17th-century castle and garden became a masterpiece of baroque design.

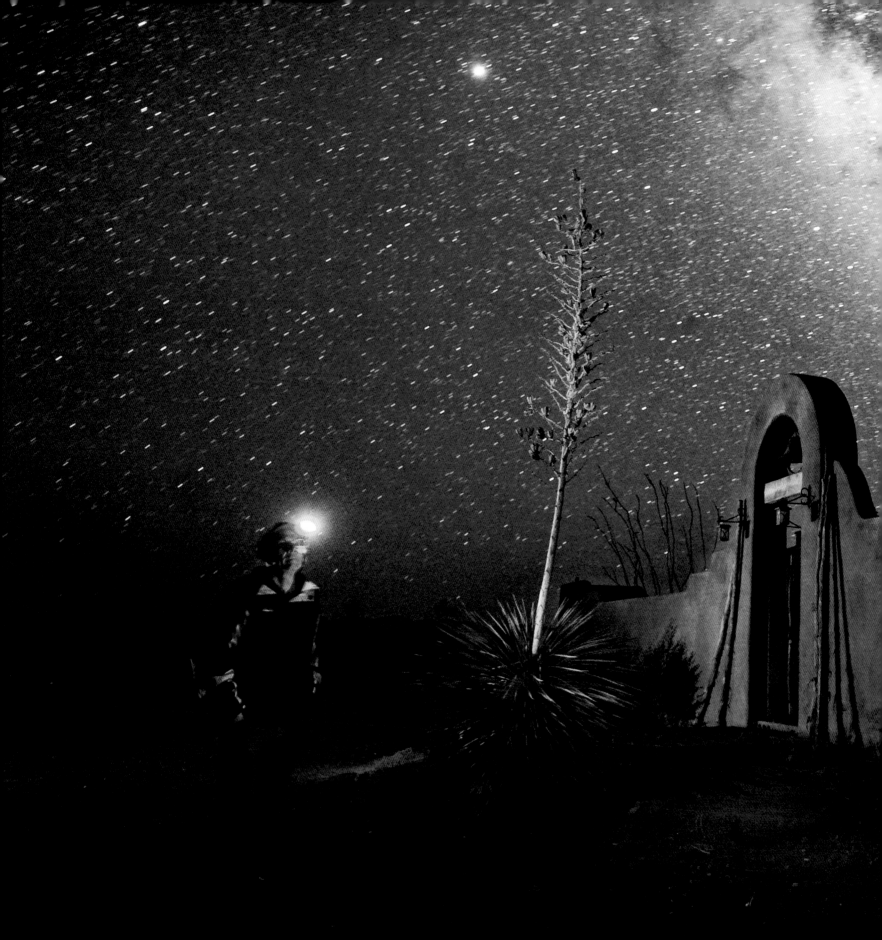

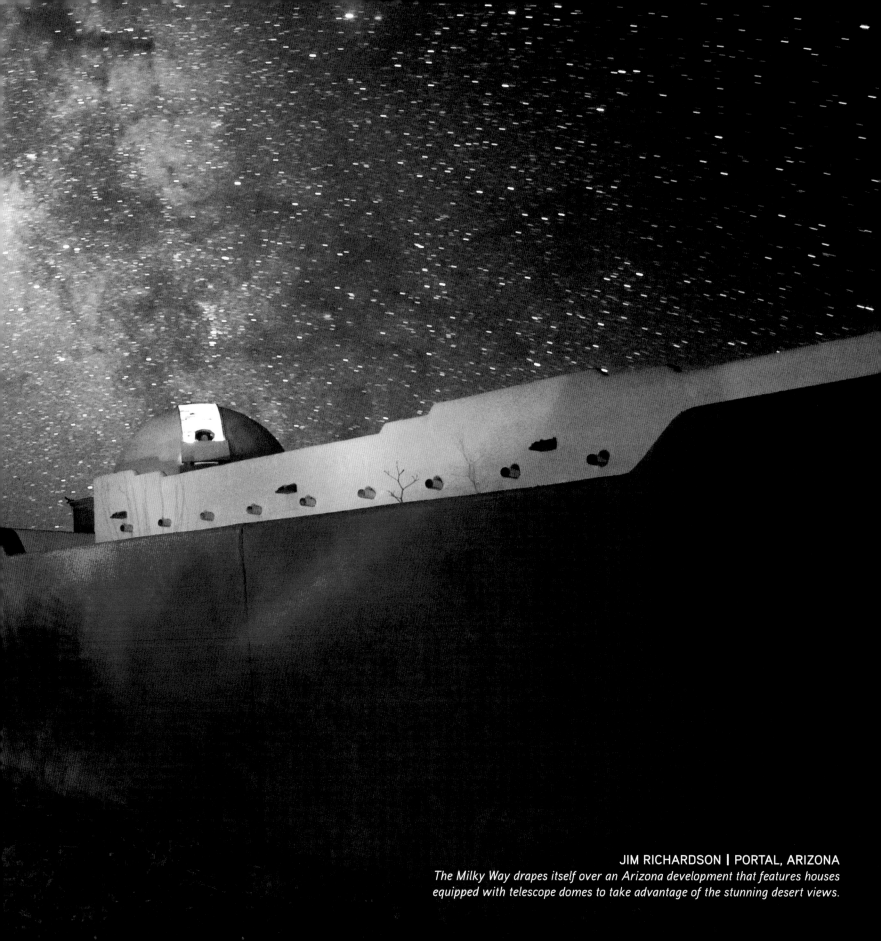

JIM RICHARDSON | PORTAL, ARIZONA
The Milky Way drapes itself over an Arizona development that features houses equipped with telescope domes to take advantage of the stunning desert views.

GEORGE STEINMETZ | PINACATE BIOSPHERE RESERVE,
SONORA STATE, MEXICO *Under an ultraviolet flashlight, a giant
hairy scorpion kills one of its own. These nocturnal scorpions—North
America's largest—thrive in the Mojave and Sonoran Deserts.*

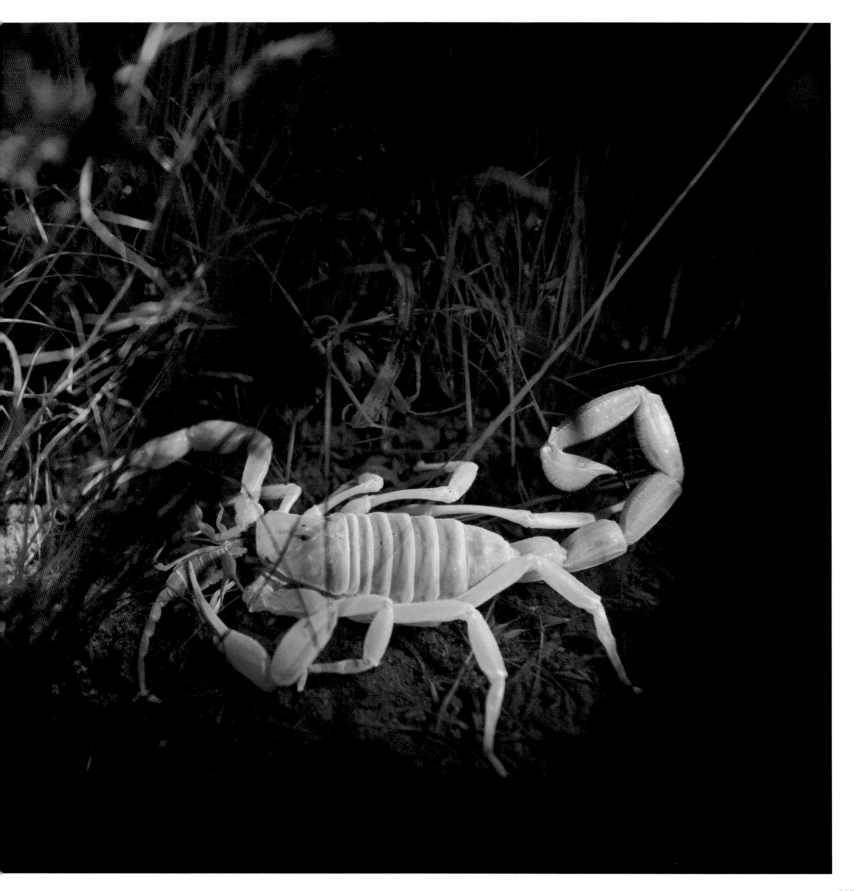

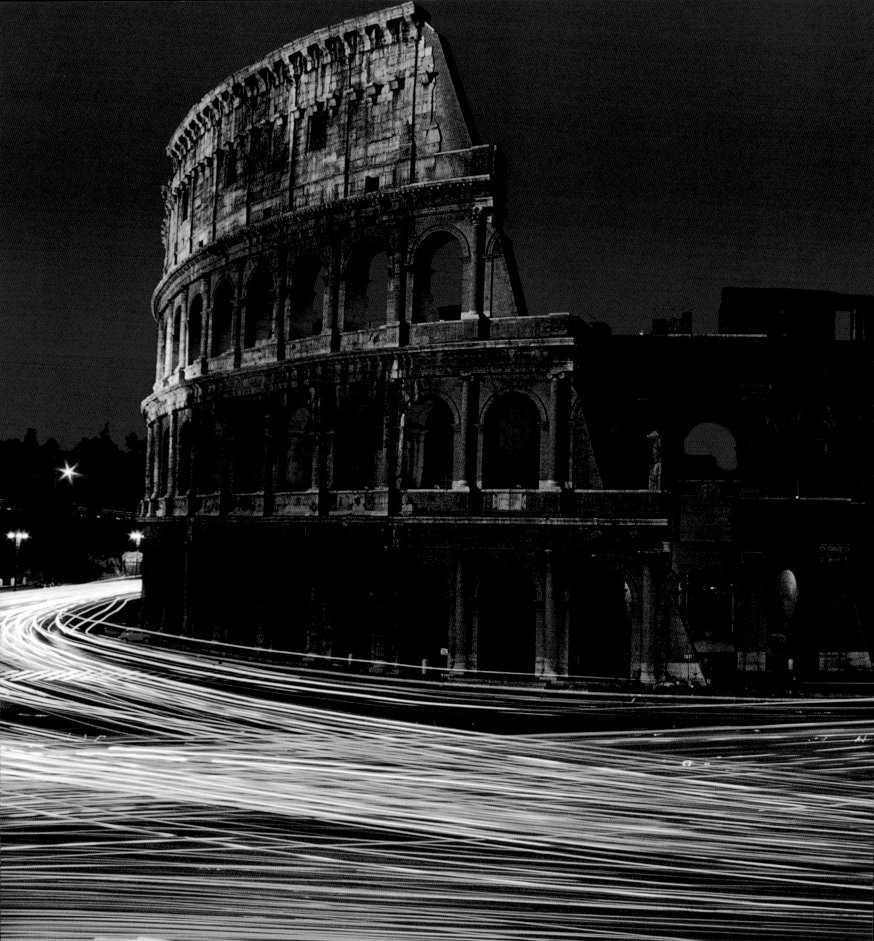

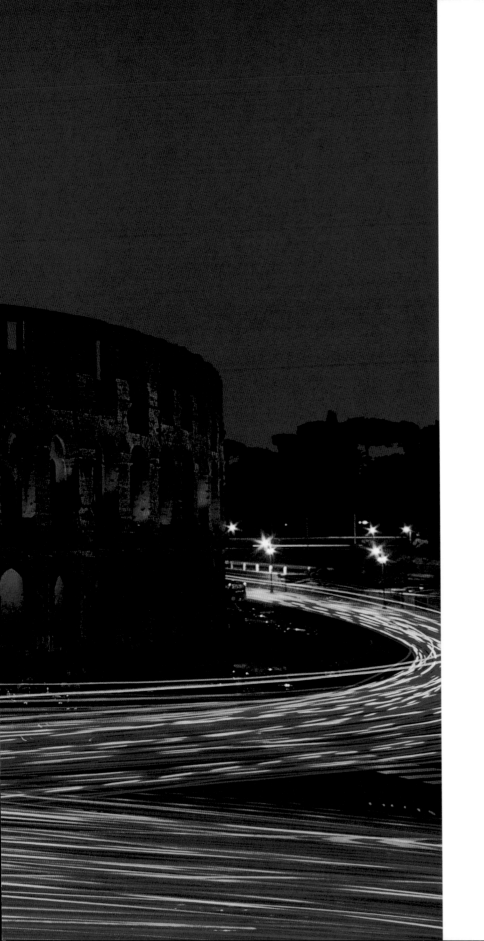

WINFIELD PARKS | ROME, ITALY
Traffic circles the ruins of the Roman Colosseum.
Earthquakes, lightning, and vandalism have damaged
the structure, which at its heyday held 50,000 spectators.

As the Arctic sun skims low across

the horizon for hours on end, the light becomes a rich, golden color. For me, however, subtle light sometimes works better. In many situations this light would have been too flat to illuminate a colorful subject, but in this case, it provides the perfect black-and-white feel to this beautiful, yet sad scene of a mother polar bear and her cubs stranded on land.

It was late in the evening and a gentle overcast sky provided just enough light to illuminate the black basalt rocks on the coast of Spitsbergen. The bears, standing patiently against the dark rocks, provide the perfect focus and sense of place for the image. They also tell a tragic story, for polar bears are now threatened by extinction as Arctic ice disappears and with it their main source of survival—seals to hunt. Not only does this mother bear need seal meat to survive, she also needs to provide the same nutrition to her cubs. Thus this beautiful picture also becomes haunting.

PAUL NICKLEN

Svalbard, Norway
A mother polar bear and her cubs stand out against dark rocks.

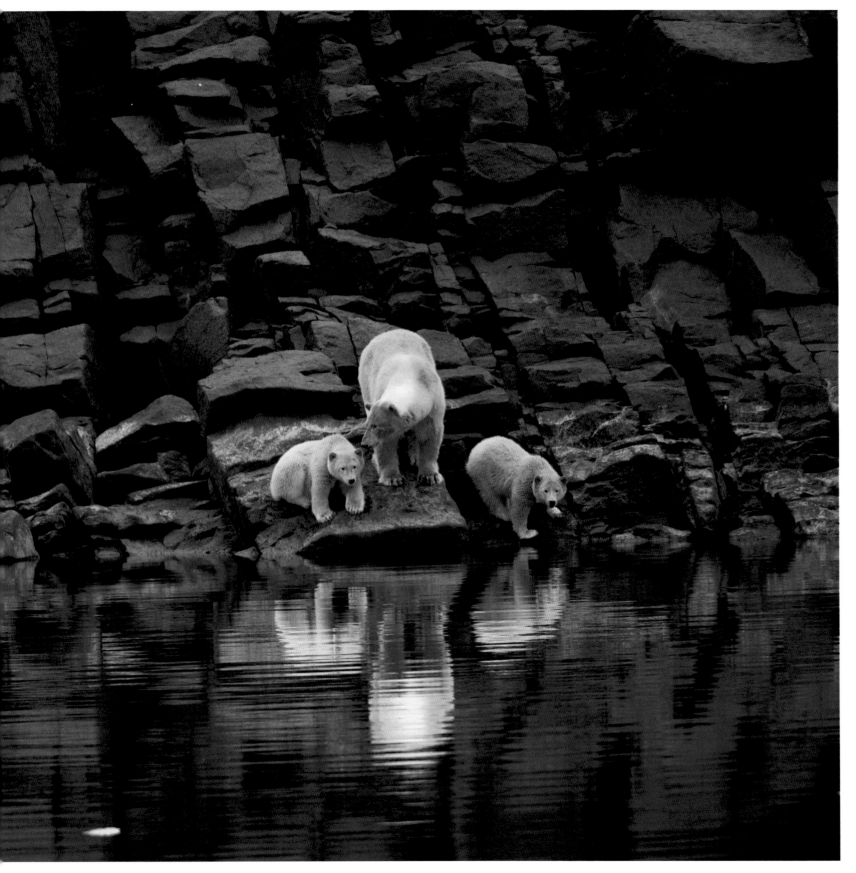

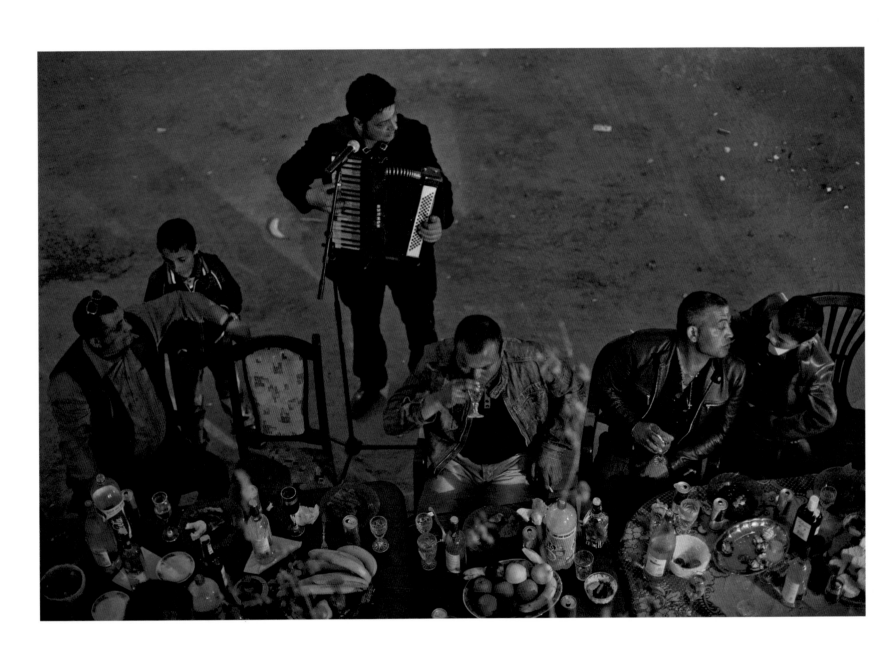

IVAN KASHINSKY AND KARLA GACHET | BUZESCU, ROMANIA
Friends and family gather to celebrate a baptism with music, food, and drinks. Roma traders from this small Romanian town turned an entrepreneurial spirit into riches.

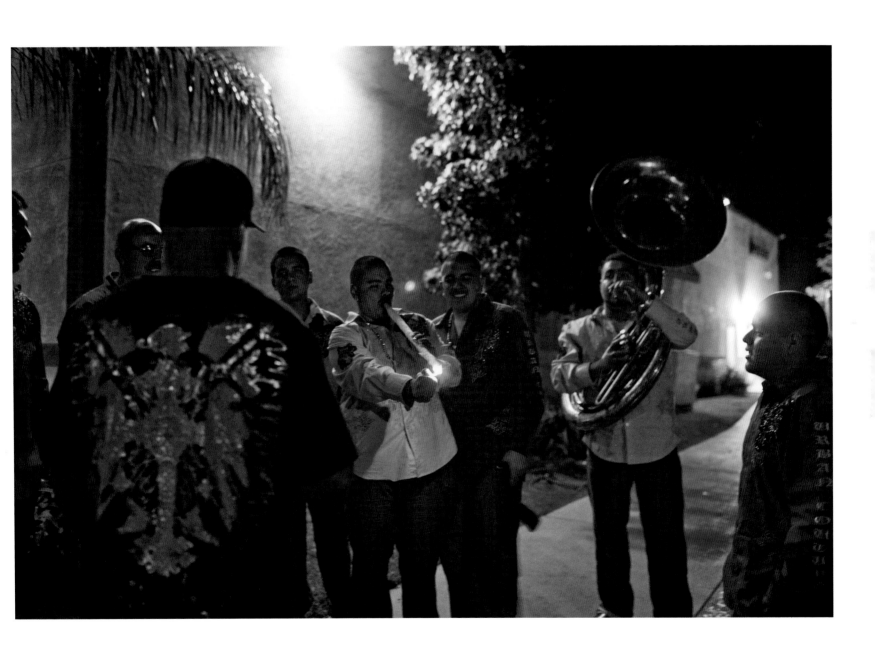

SHAUL SCHWARZ | MORENO VALLEY, CALIFORNIA
Music hits the streets as a narcocorrido *group plays outside a popular Mexican nightclub. Their songs deal with life and death among Mexico's drug gangs.*

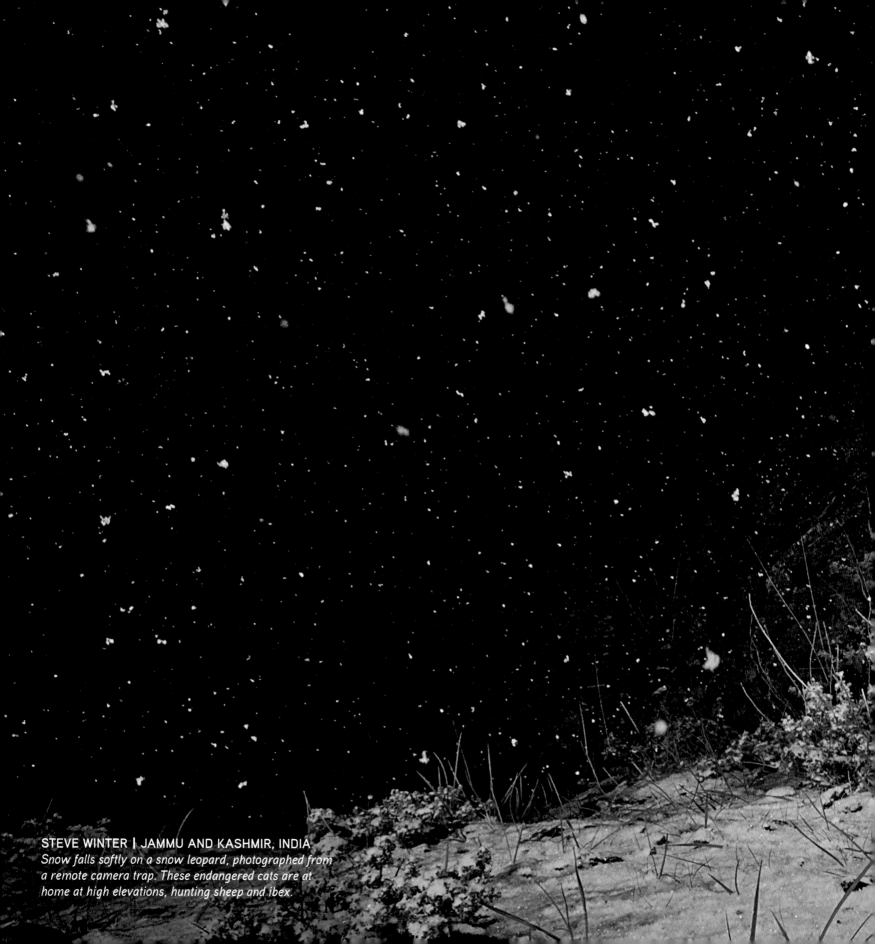

STEVE WINTER | JAMMU AND KASHMIR, INDIA
Snow falls softly on a snow leopard, photographed from
a remote camera trap. These endangered cats are at
home at high elevations, hunting sheep and ibex.

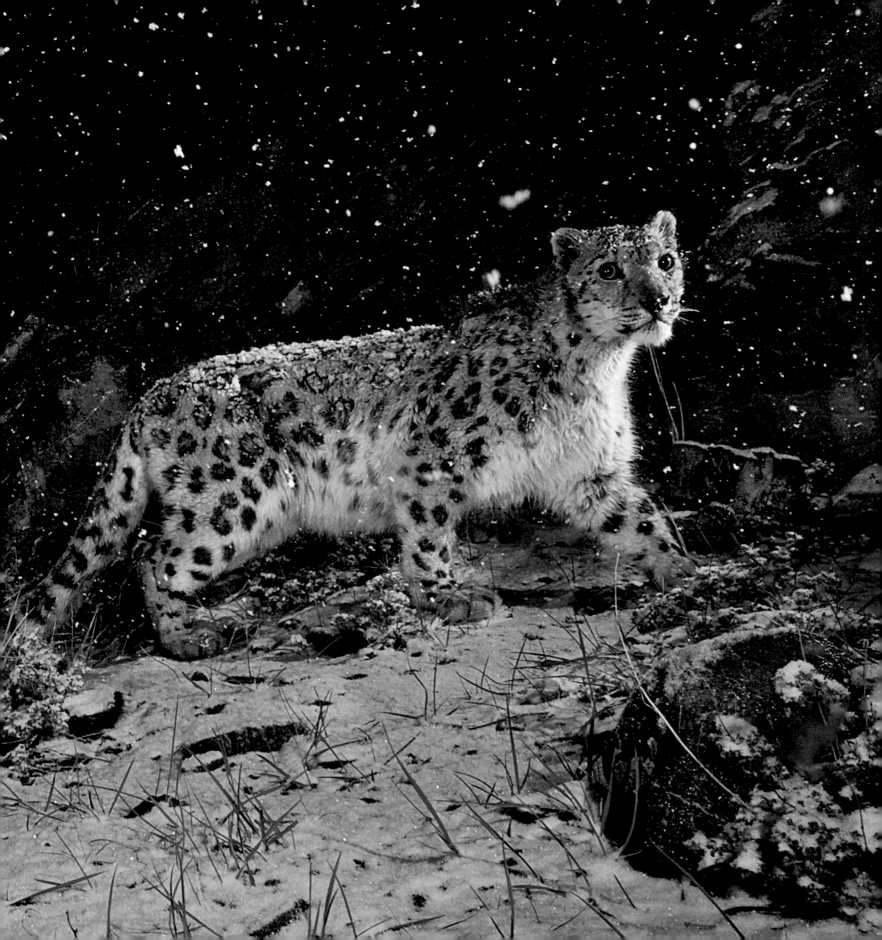

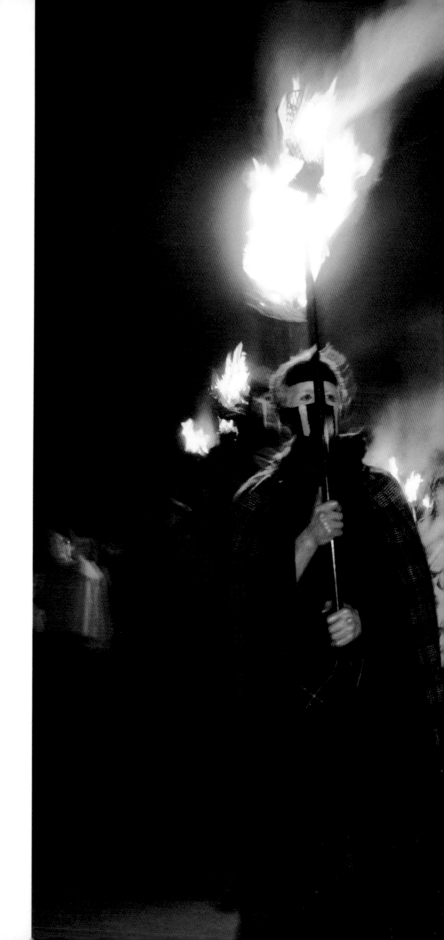

Fire is at home in the night.
Certain of our spirits will
only come out when
night is present.

–JIM RICHARDSON

JIM RICHARDSON | EDINBURGH, SCOTLAND
Costumed parade participants on the eve of the Beltane Fire Festival celebrate the beginning of the summer growing season in a festival with Celtic roots.